THE DIGITAL PHOTOGRAPHY SOFTWARE GUIDE

John Lewell

Course Technology PTR

A part of Cengage Learning

COURSE TECHNOLOGY
CENGAGE Learning™

Australia, Brazil, Japan, Korea, Mexico, Singapore, Spain, United Kingdom, United States

COURSE TECHNOLOGY
CENGAGE Learning™

The Digital Photographer's Software Guide
John Lewell

Publisher and General Manager,
Course Technology PTR:
Stacy L. Hiquet

Associate Director of Marketing:
Sarah Panella

Manager of Editorial Services:
Heather Talbot

Marketing Manager:
Jordan Casey

Executive Editor:
Kevin Harreld

Project/Copy Editor:
Kezia Endsley

Technical Reviewer:
Ron Rockwell

PTR Editorial Services Coordinator:
Erin Johnson

Interior Layout:
Shawn Morningstar

Cover Designer:
Mike Tanamachi

Indexer:
Broccoli Information Management

Proofreader:
Anne Smith

For product information and technology assistance, contact us at
Cengage Learning Customer & Sales Support Center, 1-800-354-9706

For permission to use material from this text or product,
submit all requests online at **cengage.com/permissions**
Further permissions questions can be emailed to
permissionrequest@cengage.com

Library of Congress Control Number: 2008931073

ISBN-13: 978-1-59863-543-0

ISBN-10: 1-59863-543-3

Course Technology
25 Thomson Place
Boston, MA 02210
USA

Cengage Learning is a leading provider of customized learning solutions with office locations around the globe, including Singapore, the United Kingdom, Australia, Mexico, Brazil, and Japan. Locate your local office at: **international.cengage.com/region**

Cengage Learning products are represented in Canada by Nelson Education, Ltd.

For your lifelong learning solutions, visit **courseptr.com**

Visit our corporate website at **cengage.com**

Printed in Canada
1 2 3 4 5 6 7 12 11 10 09

For Sam & Kit, photographers both

Acknowledgments

The author wishes to thank everyone who has been involved in bringing this book to print, especially agent Carole McClendon, editor Kezia Endsley, and executive editor Kevin Harreld.

About the Author

John Lewell is the author of *Computer Graphics* and *The A-Z Guide to Computer Graphics,* plus two earlier books on audio-visual technology as well as the biographical encyclopedia *Modern Japanese Novelists* (Kodansha, NY, 1993). Born in England, he was educated at Framlingham College and went on to gain MA (Hons) in English & Fine Art at Peterhouse, Cambridge. His lifelong interest in photography began when he was a teenager, taking pictures for local businesses and on long trips to Italy in support of his studies of Italian art. After a year at Guildford School of Art, he worked in film and television as a researcher, and then joined the audio-visual manufacturer Electrosonic, moving to the United States to establish a New York office for this market-leading company.

It was in Los Angeles that John Lewell turned to full-time writing, becoming West Coast Editor of *Computer Pictures* magazine and U.S. correspondent for several European journals. With extensive contacts in the computer industry and the press, he returned to London to form his own PR consultancy called Technology Relations. He continued to explore new fields and created the world's first online guide to commercial Internet software, which he later sold to Mecklermedia as Internet ProductWatch. Invited to become European correspondent for InternetNews.com, he contributed several thousand news articles on all aspects of the online industries.

John Lewell now combines his expertise in photography and digital technology to inform and educate via books, articles, and Internet projects. He is married to Thai cookery writer Oi Cheepchaiissara.

Contents

Chapter 3
Exif Tools 27

Chapter 4
Utility Software 35

Chapter 5
Cataloging 49

Chapter 6
Digital Asset Management (DAM) 59

Chapter 7
RAW Converters 69

Chapter 8
Image Processors 83

Chapter 9
Quick-Fix Software 103

Chapter 10
Image Editors 119

PART II
REFINING, SIMULATION, AND ENHANCEMENT 143

Chapter 11
Masking Tools 145

Chapter 12
Black and White Conversion 153

Chapter 13
Film Simulation and Effects 161

Chapter 14
Art Simulators 173

Chapter 15
Special Effects 181

Chapter 16
Sharpening Software 195

Chapter 17
Noise Reduction 205

Chapter 18
Red-Eye Removal 215

Chapter 19
Skin Tone Enhancement 219

Chapter 24
Panorama Software: Photo Stitching and Virtual Tours 257

PART IV
PRESENTING YOUR IMAGES 277

Chapter 25
Digital Scrapbooking 279

Chapter 26
Photo Album Creation 291

Chapter 27
Slide Show Creation 305

PART V
PREPARATION FOR PRINTING 317

Chapter 28
Image Rescalers 319

Chapter 29
Color Management 327

Chapter 30
Color Tools 345

Chapter 31
RIP Software 353

Chapter 32
Virtual Proofing 371

PART VI
KEEPING IT ALL RUNNING SMOOTHLY 379

Chapter 33
Backup Software 381

Chapter 34
Data Recovery 393

Chapter 35
Pro Studio Software 405

Chapter 36
Pro Tools for Web, Wireless, and Remote Access 417

Chapter 37
Analysis and Diagnostics Software 425

PART VII
TAMING THE WORKFLOW 431

Chapter 38
Two Featured Products 433

Index 453

Introduction

The speed at which digital photography has taken over film has been astonishing. In the latter half of 1999, Nikon allowed a mob of eager journalists to touch the first pre-production units of its D1 camera. Six months later at the PMA trade show in San Francisco, Canon introduced a mysterious new product with a nameplate concealed by black tape. It turned out to be the D30, the first "all Canon" DSLR. With these products, professional digital photography took off, followed rapidly by the launch of an even larger enterprise when, in 2003, Canon introduced the world's first sub-$1,000 digital camera with interchangeable lenses: the EOS 300D. Meanwhile, point-and-shoot cameras of ever-increasing quality were being snapped up by an eager public who purchased 30 million of them in the United States and another 3.3 million in the United Kingdom during 2006 alone.

The role played by software in this extraordinary revolution has been greatly under-appreciated. At the lower but more valuable end of the market, image-processing techniques are embedded into point-and-shoot cameras where they work their magic unnoticed by the users. At the top end, in the professional graphic arts world, the majority of users have relied heavily on a single brand, Adobe Photoshop, around which has grown an entire industry of third-party plug-ins, actions, scripts, and droplets, plus magazines, books, videos, and training courses to help people use it well.

Yet the fact is that image processing predates the digital camera revolution by two or three decades. A huge body of knowledge about how to improve digital images had been gradually accumulating long before Nikon, Canon, Fuji, and Kodak made digital cameras available to the working photographer or the general public. Image processing was used on scanned photographic images in medicine, science, and engineering, and on data captured digitally from space probes, inspiring researchers to develop algorithms to reduce noise, sharpen the image, manipulate color and tone, correct lens distortion and perform many of the functions that people now take for granted in low-cost photographic software. When the Hubble telescope's optics proved to be imperfect, image processing techniques made them usable until a replacement could be fitted. Contrary to popular belief, Teflon has not been the only spin-off from the space program.

It was the relative maturity of image processing that ensured the rapid acceptance of digital photography. Without it, the quality of images from even the highest priced DSLRs would have been very disappointing. Users should be under no illusion—there are glaring deficiencies in sensor-based photography. To match film quality you need to

capture at around 15 megapixels, still some way beyond the 10 megapixel threshold that manufacturers in their popular ranges struggled so hard to reach. Acceptable image quality for enlarged prints is made possible only by the ingenuity of the advanced techniques of image processing.

The Software Revolution

Having inherited the rich legacy of image processing, digital photography has prompted a new software revolution. For example, one effect of being able to capture images without using film stock has meant that users are more inclined to take a greater number of shots than they did previously. Some professionals (and quite a few non-pro enthusiasts) take a few thousand shots in a single day. Inevitably, this has led to file handling, sorting, and selection problems, especially for those who are reluctant to delete any of their work. Exposure bracketing, with capture of three, five, or more frames at a time, and JPEG+RAW shooting has multiplied the problem. The response of the software industry has been a plethora of image viewers and sorters, together with cataloging, archiving, and digital asset management systems. There is even a new breed of downloading software that can take the initial captures, rename them, and sort them into appropriate folders. All this before you even start to look at the images.

Some photographic errors, like camera shake, are best solved at source, at the capture stage. Although you can acquire software to correct camera shake very effectively, it is much better to use a tripod or equipment with vibration reduction built into it. Other errors can be resolved completely in software. If you tilt the camera and cause perspective distortion, no problem; software can squeeze the image at the bottom and stretch it at the top. Crooked horizon? Software can level it. In fact, software can cure even the most glaring deficiencies of the camera system, such as its miserable dynamic range, its lack of depth-of-field in macro photography, and its never-enough megapixels. In this book you can find brilliant software for addressing these particular issues, all of which are solved by taking multiple shots, and then combining them on the computer.

The digital photo revolution would not have been so quick if photographers had been obliged to jettison all their accumulated wisdom and techniques. Many of them were surprised to discover that software could precisely simulate the effects achievable with chemicals and film, even to the extent of imitating the characteristics of Velvia, Kodachrome, Tri-X, and other old favorites. Somewhat unnervingly, it became apparent that in some instances software could actually do it slightly better and certainly with more convenience. However complex the procedure, software could imitate it in the blink of an eye. Techniques like "bleach bypass" have been beautifully implemented and even the need for optical filters has partly diminished now that software filters are available to do the job.

What all this adds up to is a new software industry looking after the needs of photographers whatever their level of expertise. At the highest levels, users can choose between wide-gamut color spaces with linear or gamma curves, while at lower levels beginners use "one-click" or "quick-fix" software to correct everything at once. There are now so many packages you could easily spend tens of thousands of dollars on them. Fortunately, you need only a few to have most bases covered because of their overlapping functionality. Which software you choose depends on whether you are aiming for quality, speed, or ease-of-use, or perhaps the best possible compromise among all three.

Open for Business

Nikon's "vibration reduction" is Canon's "image stabilization." It is difficult to imagine that camera manufacturers will ever embrace an entirely open approach to camera design, because they are reluctant even to use the same words for similar technologies. At first they insisted on having on-board processing, proprietary RAW formats, and non-detachable lenses. Each camera was a closed system, their makers fully prepared to do battle on the grounds of output quality, over which they had full control. Yet software was able to move them slightly toward more openness by encouraging the rapid growth of the DSLR with its detachable lenses. Proprietary RAW formats were unlocked (by Dave Coffin) and desktop-based RAW processing software started to become popular among photographers who wanted to extract the last ounce of quality from the original file. As for non-detachable lenses and their unquestionable advantage in banishing dust problems—why be restricted to a single lens when software can so easily remove dust spots as well as hot, stuck, and dead pixels?

Manufacturers now accept that digital photography has become a more open medium where total control by a single company is neither possible nor desirable. Nowhere is this trend better demonstrated than in color management. Until recently, the only way to manage color effectively was to ensure a perfect match between each pair of devices. You still need to do this, but the devices are now interchangeable, thanks to the efforts of the International Color Consortium (ICC). Color calibration, with resulting profiles embedded by software into image files, has taken the whole industry forward, starting with the professional user but already filtering down to home use in low-cost products.

The Adobe Effect

Software developers are much more canny than hardware manufacturers about the virtues of openness. You could scarcely have a more open format than TIFF, devised by Aldus Corporation before the 1994 merger with Adobe. Photoshop itself owes some of its success to third-party developers with all their plug-ins for the main program. Now Adobe is promoting its DNG format as a common denominator for all RAW files, thus

ensuring that future generations will be able to open our image files long after their original proprietary format has become obsolete.

Ironically, Photoshop's openness has had a somewhat stifling effect on the commercial growth of other companies. This software has been so dominant, ever since Layers in 3.0 allowed users to isolate parts of the image and work on them separately, that most graphics art professionals regard it as a "must-have" product. Even the difficulty of learning Photoshop, generally considered to be its only weakness, has brought commercial benefits to its developer because people are reluctant to learn new software once they have invested time and effort elsewhere.

Yet the market is changing. Many photographers expressed a desire for software that had functions relating specifically to photography rather than all the painting, drawing, and design functions of Photoshop. Recognizing this as a valid argument, Adobe created Lightroom and packed it with viewing, sorting, and processing features, plus a one-click option to dip into Photoshop for retouching and other specialized work. Without doubt, future development will see features like retouching being transferred to Lightroom, making it potentially the new leader in an increasingly competitive market.

The User Response

Users devise strategies of their own to stay alive in the digital world. One successful strategy has been to ignore the full Photoshop product in favor of the lower-cost, entry-level Photoshop Elements edition, and then—and here is the vital point—load it with plug-ins. This has given many users the best of both worlds: access to the most popular functions of Photoshop, plus the latest third-party algorithms for such processes as sharpening, rescaling, and noise reduction.

Users who try to steer clear of Photoshop find they still need a host editor to get the benefits of all the available plug-ins. Many, but not all, plug-ins work with other editors such as Corel Paint Shop Pro Photo, which is itself becoming increasingly sophisticated. Having acquired Ulead Technology, the third-placed developer of image editors, Corel is in a much stronger position to mount a genuine challenge to Adobe's dominance.

A third strategy, one that is becoming increasingly viable, is to use a selection of stand-alone software from different vendors. Nikon users are fortunate in having the option to use Nikon Capture NX to its full extent, as it provides RAW conversion for Nikon output, plus image editing of JPEG and TIFF files from any camera. Nikon Capture becomes substantially more powerful with every new release and with the addition of Nik Software's U Point technology it allows you to work on specific parts of the image without the need for Photoshop-style masks, selections, or layers. If you then want to add best-of-breed sharpening, noise reduction, and image rescaling, you can purchase another stand-alone product to do the job.

There is a fourth strategy that currently suffers from limited choice: the total workflow solution. It is a brave developer who addresses every stage of the workflow and tries to put it all together in a single package, but it has been done. ACDSee Pro is marketed as an end-to-end solution that allows its users to view, process, edit, organize, catalog, publish, and archive photo collections. It really is a very comprehensive program with a user manual that runs to 292 pages. Many enthusiasts find such a program more than adequate for their needs, whereas professionals have their own new breed of production software to process schools and sports photography.

All of these strategies apply to the photo enthusiast, pro-am, and professional user, but what about those who take pictures only occasionally using a point-and-shoot camera? They, too, need viewing and browsing, image correction, printing, and other facilities in general categories similar those used by professionals. The difference is that software for the home user has to be more highly automated, with step-by-step wizard interfaces being a particularly good way of implementing an otherwise complex workflow. Here the alternative is software that makes an intelligent guess about what the user is trying to achieve, and then fixes it immediately. Do not underestimate these easiest-to-use programs; some of them are excellent and can make huge improvements to the image.

Faking It

The one class of software to avoid completely is fake software. Obviously it is not included anywhere in this book, but it is out there, waiting for your credit card. You can stumble across it if you hunt online using Google. Suddenly you find yourself in a netherworld of fakery where the download sites, vendor sites, and review sites all collude to convince you that a certain brand is highly effective when in fact it is completely useless. You can even download trial copies, run them on your computer, and verify that some of the tools are operational although others in the seemingly impressive GUI (graphical user interface) fail to work. Some users do not get suspicious at this point because they blame themselves for the error. They think that if they buy the software, the features will unlock and all will be well. Nothing could be further from the truth.

Mischievous programmers can go to absurd lengths to hoodwink the customer. It would probably be easier for them to develop genuine programs, but they prefer the fun of faking it. One of the most outrageous is a program called "Blood Eye Remove," which purports to remove the red-eye effect. In a helpful blog, the vendor quotes that wonderful phrase beloved of reviewers: the software "does exactly what it promises." This, at least, is true. It gouges out a hole, King Lear-style, effectively removing red-eye, but leaving a rectangular (afraid so) white hole where the eye once was.

The Eye of the Beholder

In the fake software described in the last section, it is possible to detect a symbolic blinding of the user by the unscrupulous vendor, or at least, that is how Susan Sontag (*On Photography*, 1977) might have seen it. If beauty, like color, is in the eye of the beholder, there is ample opportunity for vendors to pass off second-rate software without raising too many objections. This is particularly true in special effects manipulation where even the touchstone of reality has disappeared. Only practice and a "good eye" can tell you whether software is adding real value to an image.

Photography will always be more dependent on what happens in front of the camera than back in the virtual darkroom. This is why we travel to the farthest corners of the planet or hunt for the most unusual or attractive people to photograph. Because software merely improves or alters what is already there, the best images tend to be those that start with a great original. At least half the software represented here has been produced with the intention of rectifying deficiencies in the digital photographic process. Lack of resolution, focus, or dynamic range, insufficient sharpness, too much noise, not enough "snap"—software deals with all these issues in turn. When it is successful, as it is more often than not, it turns a good photograph into a great one. The digital photographer cannot work without it.

About This Book

In a single volume, *The Digital Photographer's Software Guide* brings together information on over 300 software packages and plug-ins for the benefit of photographers of all levels of expertise. You'll find solutions to meet every photographic need, not only image processing and editing, although these important tasks are covered at length, but also software color management, image rescaling, film simulation, slide show creation, professional studio management, and much more. This book is a map that will lead you to additional, in-depth information about each product on the Internet, where you can download and try nearly all the software it introduces.

Here's a smidgen of what you'll find in this book:

- Concise descriptions of photographic software, from downloaders to RIPs
- Review-style comments about each program and its suitability for purpose
- Introductions to each software category, its scope, and development
- Technical specifications such as operating system, host program, and supported file formats
- Full contact information, including developers' street and Web addresses
- In-depth reviews of Apple's Aperture and Adobe Lightroom
- Information to help you build low-cost alternatives to the full Adobe Photoshop

Whom This Book Is For

The Digital Photographer's Software Guide is for anyone who loves digital photography and wants to learn additional software skills. Enthusiasts on a relatively low budget will find it invaluable as a source of information about third-party plug-ins that can be used with Photoshop Elements or Corel Paint Shop Pro Photo. For complete beginners it introduces all the steps of the digital photographic workflow and points the way to the best and most usable software now available. Even advanced professionals will find useful information about software for organizing their studios, managing digital assets, analyzing optics, creating high dynamic range images, or performing such tasks as data recovery and virtual proofing.

Whatever your level of expertise, this book contains vital information that can help you become more efficient, more creative, and more satisfied with the final output from your digital camera.

How This Book Is Organized

The Digital Photographer's Software Guide is divided into seven parts containing a total of 38 chapters, each of which covers a particular category of photographic software.

Chapter 1, "Downloaders or Camera-to-PC Transfer," introduces pro-level software for downloading images from a digital camera, renaming them, and filing them in your computer.

Chapter 2, "Image Viewers," is a survey of dedicated image-viewing software that will enable you to browse images efficiently, without the additional overhead of too many editing functions. Here, the spectrum ranges from rapid browsing of thousands of images to the highest quality, whole-screen display of individual images.

Chapter 3, "Exif Tools," covers tools that let you gain more convenient access to Exif data, and edit them as well. No longer routinely lost during JPEG editing, Exif data are preserved by most quality image editors and they contain a wealth of information about your pictures.

Chapter 4, "Utility Software," covers the gamut. If it is really useful but does not have a category of its own, the software is likely to be represented here. Among other functions, utility software helps you with JPEG compression, photo resizing, screen capture, watermarking, plug-in management, and test strip proofing.

Chapter 5, "Cataloging," covers the fact that, as your collection of digital images grows, so does the need for cataloging them. Specialist software has the most comprehensive set of features, allowing you to classify every image so that you can find it easily at a later date.

Chapter 6, "Digital Asset Management (DAM)," discusses how companies and institutions use DAM to catalog and manage all their digital assets, from documents and images to videos and film clips. Here are the main systems, many of which can be used by photographic studios or individual photographers.

Chapter 7, "RAW Converters," looks at a wide selection of RAW converters that are not specific to any individual brand of camera. All photographers should try more than one or two RAW converters and there are now plenty from which to choose.

Chapter 8, "Image Processors," covers both general purpose and some highly specialized image processing software, all of which is designed to give you precise control over the balance of color, light, and shade in your images. Image processing lies at the very heart of digital photography, making this chapter one of the most important in the book.

Chapter 9, "Quick-Fix Software," comments on the remarkable abilities of some packages to detect common faults and make brilliant corrections. By no means limited to amateur photographers, quick-fix software is designed for people in a hurry, whether they are beginners or professionals.

Chapter 10," Image Editors," is based on the premise that Adobe Photoshop is not the only game in town, although it features prominently here as the industry standard. If you want to try the alternatives, this is the place to look.

Chapter 11, "Masking Tools," begins part II. If you frequently matte images together, inserting a foreground subject into an alternative background, you may need special masking tools. Many were developed in Hollywood for the movies, but enterprising developers have packaged them for use by digital stills photographers.

Chapter 12, "Black and White Conversion," shows that there is more to black-and-white conversion than using the desaturate option in your image editor. Excellent tools are available that allow you to control the contribution made by each color channel.

Chapter 13, "Film Simulation and Effects," covers the software for film simulation. Digital photography has long overtaken film in the range of effects it can achieve. One subset of these effects is film simulation, a technique that not only imitates the unique qualities of a particular emulsion, but also its processing and printing.

Chapter 14, "Art Simulators," looks at the best of the art simulators and discusses how they can serve as useful tools for the artist. No one expects instant Rembrandts, but art simulators are becoming increasingly accomplished at turning photographs into what appear to be outline sketches, watercolors, or oils, not to mention 101 other techniques.

Chapter 15, "Special Effects," covers the software for simulating the aging process, filter sets for frames, textures, edges, borders, and mosaics, plus 3D simulation and thousands of other effects. Each special effects package seems to have its own personality, offering a repertoire of techniques that can change your images dramatically.

Chapter 16, "Sharpening Software," looks at the latest programs that are dedicated to sharpening and describes the different algorithms that are being used in this highly competitive section of the market. DSLR users who shoot in RAW mode need to sharpen their images using either the facilities provided by their image processor or editing program, or else by using specialist software to obtain optimal results.

Chapter 17, "Noise Reduction," discusses excellent noise reduction software that enables you in many cases to eliminate noise altogether. If you shoot at ISO400 or above, the chances are that your images will have some *noise* (patterns of undetermined pixels that often appear in pictures taken in low light).

Chapter 18, "Red-Eye Removal," covers software for replacing unwanted, flash-induced eye colors in both human and animal portraits. Quick, dedicated software for removing the "red-eye" effect in flash photography can be useful, even if you have these facilities in an editing program.

Chapter 19, "Skin Tone Enhancement," is a "must" for the portrait photographer. This chapter describes what is currently available in skin tone enhancement software. Some developers have addressed this topic comprehensively, enabling you to make very subtle changes to skin tones.

Chapter 20, "Photo Restoration," discusses the best specialist software for this task. Photo restoration pre-dates the digital revolution, but today's software can turn the most faded, torn, or stained photograph into a pristine digital image.

Chapter 21, "High Dynamic Range," begins part III. Some experts believe HDR is the future of digital photography, with specialist display monitors becoming more affordable. But there is no need to wait; you can begin experimenting now by downloading and trying some of the software described in this chapter.

Chapter 22, "Depth-of-Field Tools," explains how to make images of exceptional quality. If you are frustrated by the constant tradeoff between shutter speed and f-stop, why not investigate the technique of merging multiple images in order to retain sharp focus from foreground to background. These are especially useful in micro- and macro-photography.

Chapter 23, "Lens Distortion Correction," looks at software that can both correct common lens distortions and introduce similar distortions for creative effect. Whichever approach you adopt, you will find the tools here to do it perfectly, often by taking account of the lens manufacturer's own specifications.

Chapter 24, "Panorama Software: Photo Stitching and Virtual Tours," covers the packages that let you make virtual tours by linking panoramic images together—ideal for the hard-pressed realtor with properties to sell. Whatever digital camera you use, it is easy to make ultra-high resolution images if you stitch several of them together to make a panel or a full panorama.

Chapter 25, "Digital Scrapbooking," begins part IV. Often dubbed "America's favorite hobby," scrapbooking has gone digital, with several packages offering thousands of visual accessories to enhance the end result. If you are not certain which one to use, or if you are unhappy with the one you have, this chapter will help.

xxviii The Digital Photographer's Software Guide

Chapter 26, "Photo Album Creation," helps you choose from dozens of good alternatives in this area. Whether you want to create virtual albums with page-turning simulation, or real, printed albums with clever layouts and classy bindings, this chapter will point you in the right direction.

Chapter 27, "Slide Show Creation," covers the gamut. Some readers will want quick-and-easy slide shows, others might want to create professional shows with images synchronized to a soundtrack. Whatever your need, or if you simply want to give slide show creation a try, this chapter shows you what can be done.

Chapter 28, "Image Rescalers," begins part V. Making digital images larger for printing is more challenging than resizing them for the Web. The image rescalers described here are capable of adding millions of pixels while taking account of edges and other image content.

Chapter 29, "Color Management," describes the basic principles and lists many of the most effective tools. No longer the exclusive territory of the pro photographer, color management is available to all, and there is no better starting place than this chapter.

Chapter 30, "Color Tools," is for those really, really into color. It looks at specialist programs, some of which are far from the mainstream of photographic software. Color theory may be hard, but learning to use these plug-ins will help you gain a better understanding of it.

Chapter 31, "RIP Software," contains a wide selection of RIPs, with their strengths and weaknesses. So you are already using a RIP, either embedded in your printer or running separately as software. But is it the right one for your style of photography? Find out here.

Chapter 32, "Virtual Proofing," describes some of the different approaches that are finding popularity, including Web-based proofing services. The elimination of paper proofs by simulating them on calibrated screens is revolutionizing the creative arts industry.

Chapter 33, "Backup Software," begins part VI. Do you trust your operating system to make comprehensive, fail-safe backups, or do you want to check out what the most advanced third-party software can do? The backup software described here goes beyond the capabilities of today's standard operating systems.

Chapter 34, "Data Recovery," contains a good selection of leading solutions, for recovering data from memory cards, disk drives, and optical media. It may be the kind of software that you turn to only in an emergency, but every photographer needs to know about data recovery.

Chapter 35, "Pro Studio Software," is a good chapter for wedding, portrait, school, and event photographers who need to keep track of customers' details as well as look after forward planning, inventory control, and a host of other demands. The pro studio software described here offers a variety of solutions, from general bookkeeping to dedicated features that only a photographer needs.

Chapter 36, "Pro Tools for Web, Wireless, and Remote Access," discusses professional tools that do not fit easily into other categories. This includes including software for image uploading to Websites, an FTP server for wireless image transmission, and an Internet image library system for pro photographers and agencies.

Chapter 37, "Analysis and Diagnostics Software," is for the technically minded photographer. Lens analysis and computer diagnostics software is something to be used for its own sake as well as for its ability to correct systemic faults. Turn to the software described in this chapter if you are a perfectionist.

Chapter 38, "Two Featured Products," is the only chapter in part VII. In greater depth than available space permitted in previous chapters, this final chapter discusses two popular workflow products—Apple's Aperture and Adobe Lightroom. These reviews drill down into hands-on, how-to details, describing the interfaces and features of each product in turn. Which of the two is better? When you read this chapter, you'll be able to make an informed choice.

Part I

Browsing, Organizing, and Editing

This part includes the following topics:

1

Downloaders or Camera-to-PC Transfer

A relatively new category of photographic software, somewhat underpopulated as yet, downloaders nail the file-naming problem at the source: when you bring files into the computer for the first time. If you find it confusing to look at folders with names like 137CANON and 138CANON (and who doesn't?) you can rename them immediately with one of these utilities. Downloaders also allow you to use shooting data such as image capture time, camera model, or ISO to sort your images into relevant folders.

Downloaders are inexpensive utilities, and very useful for bringing RAW or RAW+JPEG files into the computer. Both Downloader Pro and RoboImport take good care of the metadata and have full support for GPS coordinate stamping.

The Photo Downloader feature of Photoshop CS3 was generally acknowledged as one of that edition's best new features, having already appeared in Lightroom. Like the stand-alone programs mentioned previously, it gets your workflow off to a flying start. It has also been implemented in Photoshop Elements. To use it, launch the Photo Downloader dialog box from the File menu.

Downloader Pro

Vendor: Breeze Systems

Purpose: Downloads images from camera to computer with renaming and GPS tagging

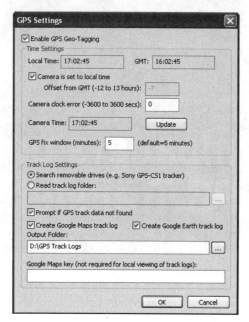

Figure 1.1

Downloader Pro's GPS Settings dialog box, with Track Log feature.

Description

Downloader Pro enables photographers to transfer images from a card reader or camera to a computer, to rename them and, if necessary, to tag them with GPS coordinate information. The program also reads shooting metadata from all major formats.

Without a facility like Downloader Pro, a DSLR dictates the names of the files and folders, which are usually incomprehensible and give no indication of their contents. By renaming the files at an early stage you can group them together for batch processing, such as sharpening or curves. Downloader fully integrates with the vendor's RAW processor BreezeBrowser Pro, allowing these tasks to be accomplished in tandem.

Downloader Pro has full support for portable hard drives like Delkin PicturePad, NixVue Vista, and ImageBank, and is good at identifying the duplicate images that these devices generate every time you insert a memory card. It downloads directly from nearly all Canon DSLRs, and allows you to synchronize the clock on a Canon camera with the one on your PC.

Comments

Downloader Pro is a genuinely useful product that fulfills a real need. Canon users in particular will appreciate the features that are specific to their brand. It accepts RAW files from all major DSLRs as well as Hasselblad and Leica cameras.

Version: Downloader Pro 2.1 (2008)

OS: Windows 98 SE, ME, 2000, XP, and Vista

RAM: 128MB

Supported file formats: Major RAW formats, JPEG, TIFF, and DNG

Price level: Approx. $30

Address: Breeze Systems Limited, 69 High Street, Bagshot, Surrey GU19 5UH, United Kingdom

www.breezesys.com

RoboImport

Vendor: PicaJet.com

Purpose: Camera-to-PC image transfer solution

Description

RoboImport specializes in file transfer from cameras (Canon) and card readers to computers. When it brings files into the PC it renames them automatically and places them into appropriate folders. At this point, one of the vendor's other programs (the PicaJet photo organizer) can take over and provide more extensive cataloging functions.

RoboImport uses default file/folder renamer schemes unless you choose to customize them by setting up renaming schemes of your own. This is a reasonably straightforward task and once in place it directs the software to put incoming images with their new filenames into the new folder structure.

There are many other features that make RoboImport a particularly versatile image import utility: auto-rotation during transfer, separating of RAW+JPEG files into RAW and JPEG folders, batch conversion from RAW to Adobe DNG format, automatic fill-in of IPTC data fields, automatic backup to several locations, and GPS coordinate stamping. RoboImport preserves the Exif data when importing files from leading DSLR brands. Multilingual support includes French, German, Italian, Korean, and Russian.

Comments

You can use RoboImport with PicaJet or other brands of image organizer, but if you want to bring in files direct from a camera it has to be a Canon. There are many file-renaming utilities available, but this one is a product that can be used by professional photographers. It has many features in common with Downloader Pro from Breeze Systems (see that entry).

Version: RoboImport 1.2.0.66 (2008)

OS: Windows 98, 2000, XP, ME, 2003, and Vista

RAM: 128MB

Supported file formats: Most RAW formats and Adobe DNG, TIFF, JPEG, JPEG2000, PCX, BMP, ICO, CUR, PNG, WMP, EMF, TGA, PXM, PSD, FAX, PCD, CUT, AVI, QuickTime, MPEG/2/4, and WMV

Price level: Single license $30, family license $60

Address: PicaJet.Com, Pacific Business Centre, P.O. Box 34069 #381, Seattle, WA 98124-1069, United States

www.picajet.com

RoboFolder

Vendor: PicaJet.com

Purpose: Picture file-renaming utility

Description

RoboFolder is best described as an image renamer and folder reorganizer. It allows you to rearrange your folder structure in a logical way, while at the same time renaming files to make them more easily identifiable. Its renaming system prevents duplicates and can include such information as camera model name and capture date and time.

Other features of RoboFolder include lossless rotation of the images, Exif thumbnail support, automatic sorting of RAW and JPEG into separate folders, autofill of IPTC details, and full undo with roll-back manager.

Comments

If you have not yet decided to invest in a full downloader, you may find RoboFolder to be a time-saving utility, well worth its nominal cost. By renaming files and reorganizing folders, it brings a degree of order to the typical chaos of a day (or month or year) of taking pictures. It is especially useful if you like to go back to your unprocessed images long after you have taken them. Filenames that jog the memory by indicating time and place are more effective than the camera manufacturer's original naming. RoboFolder has multilingual support for German, Korean, and Russian.

Version: RoboFolder 1.2.0.66 (2008)

OS: Windows 98, 2000, XP, ME, 2003, and Vista

RAM: 128MB

Supported file formats: Most RAW and major image formats

Price level: $25

Address: PicaJet.Com, Pacific Business Centre, P.O. Box 34069 #381, Seattle, WA 98124-1069, United States

www.picajet.com

Summary

Only professional photographers and amateurs who take very large numbers of images need be concerned with the specialist downloading software described in this chapter. If you like to catalog your original images simply by the date they were taken, you can safely ignore this section. However, many professionals find downloaders useful for these tasks and more: for renaming files automatically, specifying the download path, and even automatically rotating the images to their correct orientation.

Image Viewers

The life cycle of an image viewer, like that of a farm animal, can be nasty, brutish, and short, but it can also be the opposite: long and ultimately rewarding to the originator who gets it right.

The people behind the programs listed in this chapter have all "got it right" in one way or another. Every image viewer seems to have a personality of its own, from disciplined to gregarious. To the prospective user, the best advice I can give you is to download several of them, try them out, and see which is the most congenial. There is no need to accept the standard Microsoft or Apple way of handling pictures, although both companies do a good job of it. One photographer may want browsing speed, another ease-of-use, while still another may be looking for the best way to rename files. There is a product for everyone, and you can customize most of these products to fit your needs exactly.

If you scour the Internet for image viewers you can find lists that contain 150 or more products, all of them capable of displaying images as clickable thumbnails that expand to fit a large window on your screen. Some are still at the embryonic stage: the pet project of a novice programmer who is learning the craft with every new line of code. Others have moved on from this level to become fully featured viewers handling several hundred file formats, with cataloging and editing functions galore. Eventually, an image viewer may have aspirations to become an end-to-end workflow product, but few of them ever make it that far.

By its very nature, image viewing is the most fluid category in this book. After all, every piece of photographic software, whatever its application, needs to display images and make them viewable. For example, is BreezeBrowser an image viewer with RAW conversion facilities, or a RAW converter with viewing facilities? Several software packages with wonderful viewing and image shuffling features (like Apple's Aperture, Adobe

Lightroom, and ACDSee) have been placed into alternative categories because the title "image viewer" scarcely does justice to them. Arguably, you could say the same about ThumbsPlus and CompuPic Pro, but then, every category here needs applications that perform at least one specialist task supremely well. In this case it is browsing: an activity so enjoyable that no quirk of the user interface should interfere with it.

Adobe Photoshop Album

Vendor: Adobe Systems

Purpose: For newcomers to photography: view, find, fix, and share your photos, for free

Description

Adobe Photoshop Album now comes as a Starter Edition for photographic beginners, after which, for more experienced or skillful users, Adobe's browsing and image organizing software becomes subsumed into the higher value products: into Photoshop Elements for "casual photographers" and then into CS4 or Lightroom for enthusiasts and professionals.

Photoshop Album Starter Edition has some basic functions that allow you to view and organize a small collection of images. It takes an instant one-click approach to fixing common photographic errors like red-eye, color, and brightness. Other facilities include image emailing, send by mobile phone, and easy ways of getting prints and photo books.

Comments

Adobe does not give away too many packages, so this is a treat—and well worth having if you do not have a more elaborate browser. It lets you view your images in a full-screen slide show, or in calendar view that puts them in chronological order. You can tag your images and track them down later with search facilities. The whole idea is to introduce beginners to the procedures of handling digital photos and to leave them wanting more.

Versions: Photoshop Album Starter Edition 3.2 (2008)

OS: Mac OS X

RAM: 256MB

Supported file formats: Major image and movie formats

Price level: Free

Address: Adobe Systems Incorporated, 345 Park Avenue, San Jose, CA 95110-2704, United States www.adobe.com

ArcSoft RAW Thumbnail Viewer

Vendor: ArcSoft

Purpose: Free Windows utility for easily locating and browsing your RAW files

Description

ArcSoft RAW Thumbnail Viewer is a handy utility that allows you to browse your RAW files. It displays thumbnail versions instead of the generic icons normally displayed by Windows Explorer. The developer lists support for RAW files from the following camera manufacturers: Canon, Hasselblad, Kodak, Leica, Mamiya, Nikon, Olympus, Pentax, Ricoh, Samsung, Sigma, and Sony, together with Adobe (DNG) format.

Comments

If you have a reasonably sophisticated image editor or processor, you may not need ArcSoft RAW Thumbnail Viewer. But it is a genuinely useful product that adds functionality to Windows. Although the developer does not list Fuji RAF files, it does in fact display them as well.

Version: ArcSoft RAW Thumbnail Viewer 1.0 (2008)

OS: Windows 2000 and XP

RAM: 128MB

Supported file formats: Major RAW formats (see previous)

Price level: Free

Address: ArcSoft Corporate Headquarters, 46601 Fremont Blvd., Fremont, CA 94538, United States www.arcsoft.com

Canon ZoomBrowser EX

Vendor: Canon

Purpose: You can download images from your camera, organize and edit them, and then email or print them

Description

For the PC (there is another product called ImageBrowser for Mac), ZoomBrowser lets you download images from your camera, sort them, adjust the color and white balances, and then email or print them. You can select which images you want to download, including RAW files from any Canon camera. In the viewing area, zoom, scroll, and preview modes let you examine the images in different ways, many at a time, greatly enlarged, or complete with metadata. You can compare images side by side or view them in slide shows.

Organizing functions let you rename the images or assign them star ratings. You can search the pictures by shooting date, modification date, by the comment attached to the image, or by the star rating.

Editing includes automatic red-eye correction, color and brightness adjustment, and some basic movie-editing features. ZoomBrowser comes with PhotoRecord printing software that supports borderless printing, index printing, and photo albums with comments.

Comments

Bundled with Canon cameras, ZoomBrowser and ImageBrowser are quite capable as basic organizers. Like a kit lens, they fill a gap with an adequate solution: in this case making sure that all camera owners can at least get their images into a computer, look at them, and print them. They usually form part of Digital Photo Professional (DPP), Canon's bundled software for DSLRs, which has additional dust delete functions. If you lose the CD that came with your Canon camera, you have to install an earlier version of ZoomBrowser (available online) before you can obtain the latest upgrade from Canon.

Version: ZoomBrowser EX 6.0 (2008)

OS: Windows 2000 (SP4), XP (SP 1&2), and Vista; Mac OS X

RAM: 512MB

Supported file formats: Canon RAW; JPEG and TIFF

Price level: Free with camera

Address: Canon U.S.A., Inc., One Canon Plaza, Lake Success, NY 11042, United States

(Japanese only) web.canon.jp

(Windows) web.canon.jp/imaging/software/zbex5-e/index.html

(Mac) www.canon.co.jp/imaging/software/ib5-e/index.html

CompuPic Pro

Vendor: Photodex

Purpose: Multi-featured software to manage, view, and use multimedia content

Description

CompuPic Pro is a commercial software package that allows you to manage, view, and use all the images, movies, and sounds on your computer. It is a very fast image browser (faster than any other on the market, according to the vendor) and it also has excellent batch-conversion facilities. However large your image collection, CompuPic Pro can make light work of browsing it.

Features include batch editing with the ability to apply crop, resize, text, and image watermarking to many images at once. There are image enhancement features such as auto-correction, red-eye removal, drop-shadow, and text effects. You can adjust brightness, contrast, color, and hue, as well as resize to any size and rotate to any angle.

Output facilities include online publishing with customized Web pages and an option to create Photodex PictureCDs that include the viewing software. You can create Picture Index contact sheets and go on to print your photos at any size, or simply create screen savers and desktop wallpaper. Sharing is easy because the vendor supports a lot of online sites (and has one of its own, Photodex.com, which is free to join). You can also use the integrated email feature.

Comments

CompuPic Pro is much more than an image viewer. Like ACDSee, it is becoming a complete workflow product. One early criticism of it was that it lacked support for 48-bit TIFF files, but this has now been corrected. However, at the time of writing it still lacks support for RAW files, which might be an inconvenience for many users. Its chief virtue is its amazing speed; it enables you to search thousands of images "by eye" with a minimum of fuss. With its support for MPEG, AVI, and MOV formats, there is no better application for browsing media downloaded from the Web (the possible exception being PicLens).

Version: CompuPic Pro 6.23 (2008)

OS: Windows 95, 98/ME, 2000, and XP

RAM: 128MB

Supported file formats: Reads more than 100 formats, including JPEG 2000 and 48-bit TIFF files; writes more than 20 formats

Price level: Approx. $80, CompuPic Express $25, CompuPic $40

Address: Photodex Corporation, 925 Westbank Drive, Austin, TX 78746, United States

www.photodex.com

FastStone Image Viewer

Vendor: FastStone Soft

Purpose: A fast and efficient image browser, file converter, and editor

Description

If you want to neatly organize a few hundred pictures in your computer, all you need for quick browsing and display is the FastStone Image Viewer. It has an easy-to-use interface. It lists folders Explorer-style on the left, which, on opening, display their contents in contact sheet format. When you open an image it displays full-screen immediately, complete with zoom tools, while the contact sheet converts to a hidden, scrollable top bar, discovered when you move the cursor to the top of the screen. What could be simpler? The program supports all major formats including JPEG 2000 and the popular digital camera RAW formats.

Additions to the FastStone Image Viewer have expanded its capabilities, with file conversion and many editing functions. It gives you a choice of 11 resampling algorithms for resizing alone. Then there are rotate and flip, cropping, sharpen, blur, and controls for brightness and contrast. Special features include watermarking, annotation, drop shadow, framing, and bump mapping. You can use it to make slide shows, with 150+ transition effects and music support. With batch processing for renaming files, full Exif display, dual-monitor support, and contact sheet building capabilities, FastStone Image Viewer is a versatile and useful product.

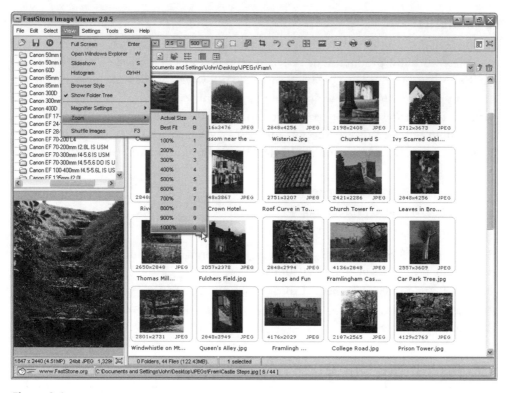

Figure 2.1
FastStone Image Viewer, showing thumbnails, file structure, and the preview box.

Comments

I would not normally recommend a product from a source that gives no mailing address or company details, but this product is an exception. I have used FastStone Image Viewer for several years with no problems whatsoever. Fast and convenient, it has everything you need for quick browsing without the clutter of an image editor. Files can remain in any group of folders on your computer: FastStone handles them all with ease.

Version: FastStone Image Viewer 3.5 (2008)

OS: Windows 98, ME, 2000, XP, and Vista

RAM: 128MB

Supported file formats: Major RAW formats, BMP, JPEG, JPEG 2000, GIF, PNG, PCX, TIFF, WMF, ICO, and TGA

Price level: Free to home users, commercial use approx. $35

Address: support@faststone.org

www.faststone.org

FastStone MaxView

Vendor: FastStone Soft

Purpose: Small, fast image viewer with support for all major graphic formats

Description

With the FastStone Image Viewer beginning to bloat with features, the developers saw a need for a lightweight viewer without all the editing options. FastStone MaxView fills the gap. With a borderless window and menus and toolbars that hide automatically, it takes the "uncluttered look" to another level. Zoom features and an on-screen magnifier are well implemented, and the slide show features are the same as those in the larger product, complete with background music in MP3, WAV, MIDI, or WMA format. Lossless JPEG rotation, quick panning/scrolling of large images, and a customizable magnifier all help to make this product a real winner.

Figure 2.2
FastStone MaxView minimizes screen clutter for whole screen browsing.

Comments

This is an astonishingly well-made utility that is a joy to operate, especially in full-screen mode. Move the cursors to the corners of the screen to access menus; scroll to zoom in one mode, move to the next image in another. What could be simpler or more effective?

Version: FastStone MaxView 2.1 (2008)

OS: Windows 98, ME, 2000, XP, and Vista

RAM: 128MB

Supported file formats: Major RAW formats; loads JPEG, JPEG 2000, GIF, BMP, PNG, PCX, TIFF, WMF, ICO, CUR, and TGA; saves JPEG, JPEG 2000, TIFF, GIF, PCX, BMP, PNG, and TGA

Price level: Free to home users, commercial use approx. $20

Address: support@faststone.org

www.faststone.org

iPhoto

Vendor: Apple

Purpose: Fast image viewer with full-screen display and RAW support

Description

Apple's iPhoto is the natural image viewer of choice for Mac users who are not running Aperture. It can provide browsing facilities for a database of up to 250,000 photos, can open RAW files (including those from Leica and Leaf), and makes it easy to publish on the Web or to obtain custom cards.

iPhoto's full-screen editing means that you can display images at full resolution, with a minimum of panning and scrolling needed to view them. Menus, palettes, and toolbars are well implemented—they appear when you want them and disappear when you have finished with them. It is all part of the Apple design philosophy, which pays as much attention to the look of the tool as it does to its use.

iPhoto has always been presented as consumer software, with emphasis on sharing family photographs or purchasing albums, cards, and calendars. With a .Mac account you can use what Apple calls *photocasting*, which is an easy way to put your pictures online. Yet the software also comes with keywording facilities for categorizing your pictures, and support for Exif data and RAW files, so it clearly has some appeal for the photo enthusiast as well.

Comments

The upgrade from iPhoto 5 to 6 earned Apple four-and-a-half mice in *Macworld,* but received some criticism for its ability to catalog off-line images. In this it fell short of applications like iView Media Pro, which has since been acquired by Microsoft to reemerge as Expression Media. The introduction of iPhoto '08 saw some major improvements, notably

the use of *Events,* a feature that enables you to group photos chronologically. Being able to copy photo adjustments from one image to another was also hailed as improving the product's ease-of-use. Users who like to print their photographs were given extended facilities, including multi-picture layout. However, iPhoto remains a consumer product, useful for many Mac users but not highly appealing to serious photographers.

Version: iPhoto '08 (2008)

OS: Mac OS X 10.5

RAM: 256MB

Supported file formats: Major RAW formats; major image formats

Price level: Complete iLife suite approx. $80

Address: Apple Inc., 1 Infinite Loop, Cupertino, CA 95014, United States

www.apple.com

IrfanView

Developer: Irfan Skiljan

Purpose: Small, fast graphic viewer with a reputation for innovation

Description

IrfanView (pronounced "ear-fan vicw") has long had a great reputation among photographers for being a fast, lightweight image viewer, with IPTC editing and an excellent range of innovative features. It was the world's first viewer to offer animated GIF support. Limited editing facilities include sharpen, blur, rotate, and crop. There are good file searching features, an email option, a multimedia player, and lots of shortcuts to speed the workflow. All its features are carefully explained on the developer's Website.

IrfanView supports plug-ins to add multimedia players, filters, email, Exif, and FTP, all of which can be downloaded as a single file.

Comments

Irfan Skiljan says he has had 49,000 emails congratulating him on IrfanView, software he continues to develop and improve. With "a million downloads per month" since 2003, it is one of the most popular pieces of photo-related software around. Its interface is unusual in that it adjusts the window size to the size of the images, displaying them on your desktop as large as possible.

With version 4.1, IrfanView offered a new plug-in called Paint, which lets users paint lines, circles, and arrows, and straighten images. Dozens of other effects and improvements have also been added, many of them courtesy of third-party enthusiasts. For example, it now includes "green- and yellow-eye" reduction, useful in animal photography, and a lossless JPEG crop facility.

Figure 2.3
IrfanView can display the hexadecimal as well as conventional views.

Version: IrfanView 4.1 (2008)

OS: Windows 9x, ME, NT, 2000, XP, 2003, and Vista

RAM: 128MB

Supported file formats: Reads more than 100 formats; writes major formats, including JPEG 2000, PDF (with plug-in)

Price level: Free for non-commercial use

Address: Irfan Skiljan, Postfach 48, 2700 Wiener Neustadt, Austria, Europe

www.irfanview.com

Lightbox

Vendor: Conceiva

Purpose: A file browser that attaches itself to any application for quick access to images

Description

Lightbox is an image browser with a difference: it attaches itself to any selected application so that users have easy access to all their image folders. For example, if you attach it to Word, its thumbnail viewer and file browser become physically attached to the bottom of the Word window until you click Remove in the Lightbox Manager window. It works with all popular applications including Adobe Photoshop, Dreamweaver, Illustrator, InDesign, and Fireworks; Macromedia FreeHand; CorelDRAW, and Paint Shop Pro; and so on.

Aimed at graphic designers, Web designers, and digital photographers, Lightbox has full drag-and-drop support, enabling users to select and place images immediately into their applications. Other features include a color picker, animated thumbnails, favorites, history, user-defined thumbnail sizes, and an "instant viewer" that displays a large version of the image on double-clicking.

Comments

An ingenious concept, Lightbox stands or falls according to whether individual applications have a need for it. Most have their own browsing facilities—even MS Works Word has Insert>Picture>From File—which brings up an image browser. When Lightbox gets better editing features, such as resizing and cropping, it will become much more useful. However, its current support for many different file formats is noteworthy, as is its ability to display both Exif and IPTC metadata.

Version: Lightbox 3.0 (2008)

OS: Windows 2000, XP, and Vista

RAM: 256MB

Supported file formats: 150 file formats including all popular image, digital camera, Web, video, audio, and document files, including 50 RAW formats

Price level: Approx. $30

Address: Conceiva Pty. Ltd., Monash Business Park, 21 Business Park Drive, Notting Hill 3168, Victoria, Australia

www.concciva.com

Photo Mechanic

Vendor: Camera Bits

Purpose: Image browser for professional photographers with good IPTC support

Description

An image browser aimed at professional photographers, Photo Mechanic from Camera Bits provides exceptional control for applying "IPTC stationery" (a template containing details of city, state, photographer's name, copyright, and so on) and XMP metadata. It is also extremely fast, with a multi-threaded architecture to keep itself a few steps ahead

of the user. It offers full-screen viewing, side-by-side comparison, scalable contact sheets, photo tagging, sorting into folders, back-up facilities, and single-step features that allow you to combine several operations to speed the workflow.

Comments

Although its functionality is limited to browsing, sorting, and keywording, Photo Mechanic is so efficient that it is the viewer of choice for thousands of photographers. Why? Partly because of its time-saving features, such as being able to copy to two different destinations (or drives) at the same time, or accepting data from multiple cards on multiple readers. Its Batch Captioning facility is first-rate, thumbnail display speed is almost instant, and it can open most RAW files although it does not fully convert them. It has stiff competition from Apple's Aperture, Adobe Lightroom, and Microsoft's Expression Media (formerly iView Media Pro).

Version: Photo Mechanic 4.5.3 (2008)

OS: Windows XP, 2000, and Vista; Mac OS X 10.3

RAM: 256MB

Supported file formats: Most RAW formats; JPEG and TIFF

Price level: Approx. $150

Address: Camera Bits, Inc., 4055 NW Columbia Ave., Portland, OR 97229, United States

www.camerabits.com

Picasa

Vendor: Google

Purpose: Fun-to-use viewer with Geotagging and photo-sharing facilities

Description

Google's image viewer is a great organizational tool. It automatically indexes every image on your computer at launch; finds "the pictures you forgot you had" (and wish you had deleted); and then lets you move them all around until you are happy with them. The interface is luxurious and very convenient for rapid browsing. It lets you rename pictures from within the program or caption them while they are being displayed. If you also have Google Earth, the Geotagging feature lets you place a thumbnail of the image directly on to a Google aerial photo/map, clickable to the original.

Among Picasa's most useful features is Timeline, which lets you scroll through your pictures in chronological order. Picasa is available in many languages, including Thai, Tagalog, and Turkish.

Figure 2.4
Picasa can index every image on your computer at rapid speed.

Comments

Picasa has a Google personality, much like the Google Toolbar or even the company itself: very clever, a bit aggressive, and has a tendency to ferret out material without asking. But it is free, so it could scarcely be a better value, and it has some professional features (like RAW support) that are lacking in certain commercial browsing software. Note: it is not an online application and requires Windows.

Version: Picasa 2.7 (2008)

OS: Windows 2000 and XP

RAM: 64MB (128MB recommended)

Supported file formats: Major RAW formats; JPEG, BMP, GIF, PNG, PSD, and TIFF; AVI, MPEG, WMV, ASF, and MOV

Price level: Free

Address: Google Inc., 1600 Amphitheatre Parkway, Mountain View, CA 94043, United States

www.google.com

PicLens

Vendor: cooliris

Purpose: Creates a "3D wall" effect to help you browse images on the Web

Description

PicLens is a browser add-on for Firefox, Internet Explorer, or Safari that lets you view images from the Web by automatically presenting them in a 3D wall. You can pan across the wall, zoom into individual images, and double-click them to show them full-screen with navigational thumbnails.

Related products—PicLens Lite and PicLens Publisher—allow bloggers and Webmasters respectively to provide their readers with the same cinematic-style experience. With the PicLens Plug-in for WordPress, bloggers can add full-screen slideshows to their WordPress blogs. With PicLens Publisher, Webmasters can enable full-screen slideshows on their sites.

You can use the basic (and free) PicLens viewer to view images on Facebook, MySpace, Flickr, Deviant Art, and Google image search.

Figure 2.5
PicLens creates a spectacular panoramic wall of images.

Comments

For image junkies, PicLens is a must-have product. It has won almost universal acclaim from users, partly because of its initial "wow factor." However, whether it is useful to the serious photographer is for the individual to judge. If you store your images on a PicLens-enabled Website, it offers you a remarkably fast and elegant way of browsing them. On the other hand, you may dislike having hundreds of images flicking past your eyes, with "in-your-face" presentation upon selecting one of them. Photographers usually prefer viewers that enable them to make side-by-side comparisons and assemble portfolios of the preferred images. PicLens serves another purpose, namely Internet browsing, and does it very effectively indeed.

Version: PicLens v.1.6.1 (2008)

OS: Windows XP or Vista, with IE6 or IE7; Mac OS X

RAM: 1.1MB

Supported file formats: As browser

Price level: Free

Address: Menlo Park, CA, United States

www.cooliris.com

STOIK Imagic

Vendor: STOIK Imaging

Purpose: An all-in-one photo browser, viewer, and image and video editor

Description

STOIK Imagic brings together the functions of a photo browser, viewer, and image and video editor into one package, enabling users to organize, fix, edit, and share photographs and videos.

Unlike many of STOIK's products, this one is aimed more at the hobbyist than the professional. It lets you fix red-eye, adjust skin tones, and remove noise defects. You can create and print calendars, collages, and greeting cards or generate slide shows, screensavers, and Web albums. It is certainly very versatile and offers a substantial collection of artistic filters and effects, together with the option of working in 48-bit color. One of its novelty effects is the ability to turn an image into a 15-piece mosaic or jigsaw puzzle.

Comments

The unusual combination of functions (especially video editing combined with photo browsing) may not meet everyone's needs, but it is here if you want it. Much of the functionality is well-implemented, especially the novelty effects.

Version: STOIK Imagic 4.0 (2008)

OS: Windows 98 SE, 2000, XP, and Vista

RAM: 128MB

Supported file formats: JPEG, TIFF, GIF, BMP, PNG, TGA, and PCX

Price level: Approx. $50

Address: STOIK Imaging, Ltd, P.O. Box 48, Moscow 119049, Russia

www.stoik.com

ThumbsPlus

Vendor: Cerious Software

Purpose: Fast, mature image and movie viewer with loads of features and 48-bit support

Description

ThumbsPlus is a fast, well-established image viewer that can display images in over a hundred different formats, including RAW files if you have the Digicam plug-in. It allows you to load, view, edit, and save 16 bits per channel images. It preserves the alpha channels in 24-bit and 48-bit images, offers a range of printing options with print preview, has image resizing capabilities, thumbnail and viewing options for movies, and useful support for Exif and IPTC metadata.

The key features of ThumbsPlus are its image handling, viewing, and thumbnail sorting capabilities. It has multiple monitor support, a feature that is becoming increasing important to photographers. It provides user-defined fields for categorizing and searching, with various sort options such as similarity, orientation, and image size. As a result you can find duplicates easily, build slide shows, and upload collections of images to online photo processing sites.

ThumbsPlus comes in Standard and Pro editions, the latter having support for client/server databases (such as MySQL and IBM DB2), Photoshop and Cerious plug-in support, RAW file handling, and 16- and 48-bit image editing. Full-blown network licenses are also available. With the client/server version of the product you can build a database of images and make them accessible to others using the ThumbsPlus WebClient over an Intranet or the Internet. Being browser-based (IE/Firefox), WebClient runs on Mac and Linux machines as well as on Windows.

Comments

By any standard a great application, ThumbsPlus has been totally revamped in recent times with a new user interface. New features like "Return to Last Folder" and "Forward to Next Folder" are a delight, whereas full screen viewing has always been perfectly implemented. ThumbsPlus is highly customizable. You can change the size of the thumbnail index, change the fonts, change practically anything—without getting lost.

Version: ThumbsPlus 7.0 (2008)

OS: Windows 98, ME, 2000, XP, 2003, and Vista

RAM: 48MB (128MB recommended)

Supported file formats: Major RAW formats (requires the Digicam plug-in, Pro edition only); plus internal support for more than 100 formats, including JPEG, JPEG 2000, TIFF, PSD, DCR, DCS, PNG, scanned images (TWAIN), and so on. Can support more with Object Linking and Embedding (OLE)

Price level: Standard edition $50, Professional edition $90 (both approximate)

Address: Cerious Software Inc., 1515 Mockingbird Lane, Suite 1000, Charlotte, NC 28209, United States

www.cerious.com

XnView

Developer: Pierre-E Gougelet

Purpose: Image viewer that handles most file formats

Description

XnView is probably the most versatile freeware image viewer available. It not only supports a huge number of file formats, including animated GIF and multipage TIFF, it also displays IPTC and Exif metadata, offers IPTC editing, and has an increasing number of editing facilities. Multilingual support is excellent (44 languages), but only in the Windows edition.

XnView's editing functions include brightness and contrast adjustment, color modification, filters, crop, and lossless rotation, and special effects such as blur, emboss, and edge detection. It has batch processing and batch renaming capabilities, together with some limited Web-page creation functions. Its interface allows you to compare images side-by-side or view them in full-screen mode.

Comments

XnView's interface offers so many options that it can easily become confusing, but fortunately it defaults to a sensible configuration. It works best in Windows, where it offers TWAIN support together with print and drag-and-drop features that are not (yet) implemented in other environments. Its great strength is in being able to open unusual formats. Even JPEG 2000 still defeats many image viewers, but not this one.

Version: XnView 1.93.6/1.7 (2008)

OS: Windows 95, 98, NT, 2000, ME, XP, and Vista; Mac OS X; Linux

RAM: 128MB

Supported file formats: Imports 400 formats, exports 50 (both approx.)

Price level: Free, commercial use $25

Address: contact@xnview.com

www.xnview.com

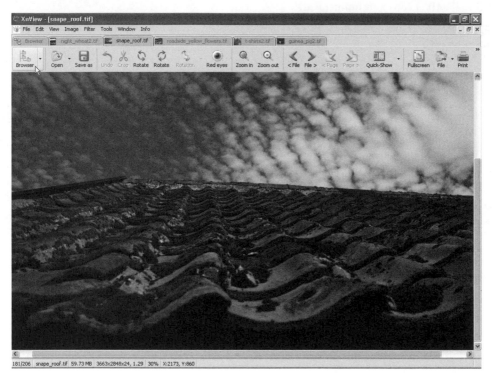

Figure 2.6
XnView offers a tabbed browser display with a large main window.

Summary

Even though there are many choices of software for viewing and browsing images, many users, sometimes to their detriment, stick with the program they know best. This can be a serious error. Even some of the best all-purpose image editors are not necessarily great for browsing. Quite often a photographer simply needs to take a quick look at a collection of images without launching a full cataloging, image management, or editing application, all of which allow you to browse in one form or another. Some image viewers are superb for churning through thousands of thumbnails (Picasa), whereas others are excellent for displaying whole screen, high-res images in rapid succession (FastStone MaxView). All of the image viewers discussed in this chapter are worth trying, and PicLens is a "must-have" product.

3

Exif Tools

Exchangeable image file format, or Exif (commonly but not officially capitalized as EXIF), is a file format standard that enables digital cameras to record metadata about each photograph along with the image data. It stipulates how the image data should be recorded—compressed files in JPEG and uncompressed files in TIFF. Image viewing software can then extract the metadata, which may include details such as date, time, camera model, and shutter speed, and make it available whenever the image is displayed on a monitor.

One of the limitations of Exif data is its tendency to become corrupted during JPEG compression. JPEG is a "lossy" format, which means it compresses the data, unlike TIFF, yet Exif takes its method of structuring metadata from the TIFF format, placing them within the image file itself.

In spite of its limitations, Exif does at least provide a framework in which metadata can be stored and retrieved. In addition to the make and model of the camera, date, and time of capture (plus location, if you have a GPS receiver connected to your DSLR), date/time of saving after processing, and the type of post-processing software used, Exif data may contain many other details. They can include exposure time in seconds, f-number, exposure program used, spectral sensitivity of each channel, ISO speed, shutter speed, subject distance, metering mode, flash/no flash, focal length, equivalent focal length, XY resolutions, white balance mode, image gain adjustment, and so on. It is a long list, made longer by the manufacturer's proprietary information about, for example, exposure programs for portraits as opposed to landscapes. Many photographers agree: "It beats the hell out of taking notes."

Most image viewers provide facilities to read a truncated version of Exif data, but once you install a program such as ExifTool you will see the full extent of the data recorded automatically by the camera. To write Exif data you need special software, such as that described here, or what's included with image handling and cataloging software.

Professional photographers also use IPTC metadata, defined by the International Press Telecommunications Council, to identify the copyright holder and other information about the image. The latest version uses Adobe's "Extensible Metadata Platform" (XMP) to embed the data into JPEG, TIFF, JPEG 2000, GIF, PNG, HTML, PostScript, PDF, SVG, Adobe Illustrator, and DNG files. A good product for inserting and editing IPTC metadata is the IMatch image management tool (see Chapter 5, "Cataloging").

ExifPro Image Viewer

Vendor: Michal Kowalski

Purpose: An image viewer that pays especial attention to preserving and presenting Exif data

Description

ExifPro Image Viewer allows you to display, manipulate, and browse photographs in different view modes, as well as pay especial attention to the Exif data embedded in JPEG photographs. The project to develop it grew out of the earlier (and free) EXIF Image Viewer that displayed Exif data for comparative purposes together with an image histogram. The new version is more elaborate, as it can append not only IPTC file information but also GPS information showing longitude/latitude location. ExifPro is a genuine image browser with copying and resizing tools and a side-by-side display facility. Note: it does not decode RAW images but extracts embedded JPEGs.

Comments

Michal Kowalski has created a terrific utility in ExifPro Image Viewer and continues to keep it up-to-date by adding XML support. His Website (especially the Help section) is a model of clarity that puts many corporations to shame.

Version: ExifPro Image Viewer, Build 201 (2008)

OS: Windows 98, ME, NT, 2000, XP, and Vista

RAM: 256MB

Supported file formats: JPEG

Price level: Approx. $20

Address: mike@exifpro.com

www.exifpro.com

Despite being a standard, Exif allows different manufacturers to place their own custom format metadata into a section of the file called the *makernote* tag. Canon, Nikon, and others can use this to encode really useful technical information about focusing

modes, shooting modes, and post-processing that cannot be decoded except by their proprietary software. However, the contents of makernote tags are usually opened unofficially by hackers and published on the Internet.

ExifTool

Vendor: Phil Harvey

Purpose: Reading, editing, and writing metadata in image, audio, and video files

Figure 3.1
ExifTool displays every scrap of Exif data when you drag and drop a photo onto its icon.

Description

ExifTool is a platform-independent Perl library, also available as a stand-alone application for Windows or Mac, for reading, editing, and writing Exif and other metadata in media files. The emphasis is on "and other" because, despite its name, ExifTool also supports GPS, IPTC, XMP, JFIF, GeoTIFF, ICC Profile, Photoshop IRB, FlashPix, AFCP, and ID3, as well as the makernotes of digital cameras from Canon, Casio, Fuji, JVC/Victor, Kodak, Leaf, Minolta/Konica-Minolta, Nikon, Olympus/Epson, Panasonic/Leica, Pentax/Asahi, Ricoh, Sanyo, Sigma/Foveon, and Sony.

ExifTool allows you write whatever information you require; it extracts thumbnail images, preview images, and JPEG images embedded in RAW files; it lets you add your own tags; and it recognizes thousands of different tags from thousands of different camera models.

Comments

Described as "the mother of all EXIF utilities" in Open Photography Forums, Phil Harvey's ExifTool is widely recognized as being the most powerful Exif tool available. However, some functions rely on a command-line interface, which users may find archaic. Do not let this put you off. It shows the full Exif information if you simply drop an image file onto the program's icon (in the Windows version). Richard A. Victor has also written an interface for it called ExifAuto, so you do not need to use the command line at all.

Version: ExifTool 7.3 (2008)

OS: Is a platform-independent Perl library and requires Perl 5.004 or later; stand-alone executables Windows 2000 and XP; Mac OS X

RAM: 128MB

Supported file formats: Reads ACR, AI, AIFF, AIF, AIFC, APE, ARW, ASF, AVI, BMP, DIB, DOC, FLAC, FPX, HTML, HTM, XHTML, JP2, JPX, M4A, MPEG4, MIFF, MIF, MOV, MP3, MP4, MPC, MPEG, MPG, OGG, PDF, PICT, PCT, PPT, QTIF, QTI, QIF, RA, RAF, RAW (Kyocera), RIFF, RIF, SR2, SRF, SWF, WAV, WMA, WMV, X3F, XLS, and XMP; reads and writes major RAW formats, including CR2, NEF, and DNG; DCM, DC3, DIC, DICM, ERF, GIF, ICC, ICM, JPEG, JPG, MOS, PS, EPS, EPSF, PSD, THM, TIFF, TIF, and WDP

Price level: Free

Address: See README of the full distribution

http://www.sno.phy.queensu.ca/~phil/exiftool/

Opanda IExif Pro

Vendor: Opanda Studio

Purpose: Utility for viewing Exif, GPS, and IPTC data

Description

IExif Pro supports the Exif 2.21 standard and allows you to view Exif, GPS, and IPTC data. It supports JPEG and TIFF image formats and camera manufacturers' special tags, including those from Canon, Nikon, Sony, Fujifilm, and Sigma. It runs not only as stand-alone software in Windows but also as a plug-in for Internet Explorer and Mozilla Firefox.

Comments

It should be noted that this is a viewer only. If you want to edit Exif data, you need a different utility, such as Opanda PowerExif.

Version: Opanda IExifPro 2.3 (2008)

Plugs into: Internet Explorer and Mozilla Firefox

OS: Windows 98, ME, 2000, XP, 2003, and Vista

RAM: 256MB

Supported file formats: JPEG, TIFF, and Exif template files

Price level: Approx. $20

Address: Opanda Studio, 4569 Blue Spruce Lane, Marietta, GA 30062, United States

www.opanda.com

Opanda PowerExif

Vendor: Opanda Studio

Purpose: Utility for editing Exif data in images

Description

Opanda PowerExif allows the photographer to edit Exif data with great flexibility, using a maximum of 60,000 characters per record. It supports all standard Exif 2.21 tags and has special extension tags to carry information about the lens, film, filter, scanner, and flashlight used.

Easy to use with an effective interface, PowerExif has very good sorting facilities and offers various views and modes. The developers have also provided a hex edit mode for the benefit of fellow programmers. If you use GPS data, PowerExif supports all 31 standard GPS tags.

There are two editions of PowerExif—Standard and Professional—the latter with batch processing and TIFF support.

Comments

Exif data are extremely convenient, but easily lost when manipulating JPEG images. PowerExif helps you keep the Exif data under control and add extensive user comments to each record.

Version: Opanda PowerExif 1.2 (2008)

Plugs into: Internet Explorer and Mozilla Firefox

OS: Windows 98, ME, 2000, and XP

RAM: 256MB

Supported file formats: JPEG, TIFF (Pro only), and Exif template files

Price level: Standard edition approx. $50, Pro edition approx. $90

Address: Opanda Studio, 4569 Blue Spruce Lane, Marietta, GA 30062, United States

www.opanda.com

Figure 3.2
Opanda PowerExif lets you edit as well as view Exif data.

BR's EXIFextracter

Vendor: BR Software

Purpose: Utility for extracting Exif metadata from JPEG photos

Description

BR's EXIFextracter is a free utility that enables you to extract Exif metadata from JPEG files, automatically placing the data into a folder and saving them in a CSV (Comma Separated Values) file. Many applications such as Microsoft Excel, Microsoft Access, and the vendor's own PixFiler cataloging software can read CSV files—as can most databases. This utility lets you make greater use of Exif metadata than would otherwise be possible.

Comments

Not everyone agrees that separating Exif metadata from the images to which they relate is necessarily a good idea. However, it certainly makes the data more easily manipulated and searchable. The vendor plans to introduce a commercial version of this software in 2008-9, which promises to be able to extract IPTC data as well.

Version: BR's EXIFextracter 0.9.5 Beta

OS: Windows 98, 2000, XP, and Vista

RAM: 256MB

Supported file formats: JPEG

Price level: Free

Address: BR Software, Nedre Frydendal 92, 1384 ASKER, Norway

www.br-software.com

Summary

As digital photography becomes more sophisticated, users tend to attach increasing importance to Exif data. Gone are the days when these data were nearly always mangled by JPEG editing. More photographers shoot in RAW mode, preserving and then using the metadata later in the workflow. Some software applications, such as those for correcting lens distortions, need to make direct use of Exif data for manipulating the image. At the very least, Exif data can save you hours of noting down f-stops and shutter speeds. If you want to explore this subject in depth, including Exif editing, the software discussed in this chapter will help you do it.

4

Utility Software

Various utilities that do not fit easily into other categories appear here. They include two "plug-in managers" to help you gain a measure of control over all those plug-ins you installed. When your computer has to load plug-ins that you never use, the host editor (Photoshop or another program) will load more slowly and occupy more RAM.

JPEG handling tools abound, because the JPEG format was around long before digital cameras became popular. With broadband transmission and low-cost storage there is not so much concern today over image compression, but these JPEG utilities are available when you need them. JPEG Wizard has terrific batch-handling facilities, whereas Advanced JPEG Compressor can compress selected parts of the image more than others.

If you want to capture an image of your whole computer screen, with whatever is showing at the time, FastStone Capture is a convenient tool for the job. From the same vendor comes FastStone Photo Resizer, a wonderfully versatile image conversion and resizing utility.

Finally, at either end of the workflow, there are NEFView, which makes Nikon RAW files show up as thumbnails in Windows, and Test Strip Proofer, which emulates darkroom test strips so that customers will know if printed output is likely to meet their expectations.

Advanced JPEG Compressor

Vendor: WinSoftMagic

Purpose: JPEG compression and resizing with four selectable interpolation methods

Figure 4.1

Advanced JPEG Compressor has large "before and after" windows for easy comparison.

Description

Advanced JPEG Compressor for Windows offers both compression and resizing facilities in one package: ideal for resizing for the Web. It has four selectable interpolation methods (Bicubic, B-Spline, Bell, and Mitchell) and allows you to save a compression profile along with resizing information then apply it to other images with similar characteristics.

There are many other features built into Advanced JPEG Compressor, including color modification, brightness, color levels, color temperature, and saturation, as well as a sharpness control and a rotate facility in 90-degree increments.

Comments

It is useful for photographers to have a specialist JPEG compression package, and this is one of the best. One of its more unusual features is an ability to compress some parts of the image more than others—for example, lossless compression for a face, slightly lossy for the background.

Version: Advanced JPEG Compressor 5.1 (2008)

OS: Windows 98 and up

RAM: 256MB

Supported file formats: JPEG

Price level: Personal version approx. $35, Business version approx. $50

Address: WinSoftMagic, Inc., 901 North Pitt St., Suite 325, Alexandria, VA 22314, United States

www.winsoftmagic.com

Digital Photo Resizer

Vendor: Icegiant Software

Purpose: Popular batch resizer, with enhancement, watermarking, and slide show features

Figure 4.2
Digital Photo Resizer has batch resizing and 1:1 display for quality checking.

Description

If you have a lot of images to resize for the Web, Digital Photo Resizer is an easy-to-use tool that can resize many images for you in two easy steps. You just point it at the directory containing the images and click Resize. The software creates a new directory of resized images while leaving your originals untouched.

As well as its main resizing functionality, Digital Photo Resizer has other features that make it even more useful. It can generate thumbnails, Websites, slide shows, and screensavers, package images into ZIP files, add watermarks, carry out some image enhancement, and upload images and entire Websites via its own FTP facility. The 2006 version added support for TIFF files and introduced a "search for file" feature, together with a properties description and various print options.

Comments

Consistently rated one of the most popular resizing tools on the Internet, Digital Photo Resizer is just what you need when you have hundreds of images to prepare for a Website. It has a clean interface that lets you view the images in Explorer mode, plus it includes an expandable dialog box that lets you specify "resize to" by percentage or pixel height at a chosen quality level. It is aimed at photo labs, Web designers, and both novice and professional photographers.

Version: Digital Photo Resizer 2006 (2006/8)

OS: Windows 95, 98, ME, NT, 2000, XP, and Vista

RAM: 128MB (although depends on size and quantity of the images being processed)

Supported file formats: JPEG, GIF, PNG, TIFF, and BMP

Price level: Approx. $10

Address: Icegiant Software, 10704 Seven Oaks, Austin, TX 78759, United States

www.icegiant.com

FastStone Capture

Vendor: FastStone Soft

Purpose: Screen-capture utility for taking a whole or partial snapshot of the text/images on your screen

Description

FastStone Capture lets you capture any of the images, text, browser windows, or scrolling Web pages that are open on your computer screen. It is much more sophisticated than the early one-click screen capture programs. This one allows you to capture just part of the screen image, in a rectangle or freehand, as well the whole screen. It has tools for resizing, cropping, text annotation, printing, and emailing, plus a screen magnifier.

When do you need it? Once you have a copy you will find many uses for it, the chief one being to email a complete screen capture rather than sending just a link or a downloaded image. It is useful to be able to show the context of an image as well as the image itself.

Comments

When you download this utility, a small floating Capture Panel appears on the screen—when you select the area of the screen you want to capture the full interface launches automatically. Users love it. It is discreet, easy to use, and genuinely useful.

Version: FastStone Capture 6.2 (2008)

OS: Windows 98, ME, 2000, XP, and Vista

RAM: 128MB

Supported file formats: Saves as BMP, JPEG, JPEG 2000, PNG, GIF, TIFF, TGA, and PDF

Price level: Free to home users, commercial use approx. $30

Address: support@faststone.org

www.faststone.org

FastStone Photo Resizer

Vendor: FastStone Soft

Purpose: Image conversion and resizing tool, with watermarking and add-text features

Description

From the same people who brought us the two great image viewers (FastStone Image Viewer and MaxView) comes this image conversion and resizing tool. It offers drag-and-drop mouse operation, conversion and renaming in batch mode, plus a whole host of other features including the ability to crop, rotate, change the color depth, add text, and add water marks. As with all FastStone products, every feature is well implemented and easy to use.

Comments

Being free for personal use and extremely well designed, FastStone products could scarcely be a better value. Ongoing development keeps them up with the very best lightweight utilities.

Version: FastStone Photo Resizer 2.5 (2008)

OS: Windows 98, ME, 2000, XP, and Vista

RAM: 128MB

Supported file formats: Major RAW formats; loads JPEG, JPEG 2000, GIF, BMP, PNG, PCX, TIFF, WMF, ICO, CUR, and TGA; saves JPEG, JPEG 2000, TIFF, GIF, PCX, BMP, PNG, and TGA

Price level: Free to home users, commercial use approx. $20

Address: support@faststone.org

www.faststone.org

JPEG Wizard

Vendor: Pegasus Imaging Corporation

Purpose: For creating smaller, faster downloading images with good visual quality

Description

Aimed at Webmasters and photo enthusiasts, JPEG Wizard lets you create smaller, faster downloading images without compromising quality. The vendor claims it can obtain between 20% and 70% more compression than other utilities, while keeping a comparable quality image.

JPEG Wizard's key feature is that it does not introduce generational loss with each compression. In other words, you can recompress without recompression loss. It allows you to compress different regions at different settings, with the option (in a higher priced edition) to do this in batch mode. Other features include cropping, appending, creating thumbnails, color adjusting, rotating, watermarking, and adding image comments and text.

Still many other features include automatic red-eye removal, lossless contrast/brightness/color/tint adjustment, email facilities, and Photo CD support.

Comments

If you are looking for a way of handling lots of JPEGs efficiently, especially for uploading to the Web, this program could be ideal. It has excellent batch processing features and performs quite elaborate operations on hundreds of pictures automatically. Another point in its favor is its reliable handling of Exif data, easily lost by some applications.

Version: JPEG Wizard 2.0 (2008)

OS: Windows 95, 98, 2000, ME, and XP

RAM: 128MB (more for batch handling)

Supported file formats: JPEG

Price level: Without batch facility $30, with batch $70 (both approx.)

Address: Pegasus Imaging Corporation, 4001 N. Riverside Drive, Tampa, FL 33603, United States www.pegasusimaging.com

NEFView

Vendor: SoftWhile

Purpose: Lets you view thumbnail images of NEF and JPEG 2000 files in Windows

Description

NEFView is a small utility that allows you to view thumbnail images of Nikon Electronic Image Format (NEF) and JPEG 2000 files automatically within Windows. Installation is a three-click process.

Comments

NEFView is useful for Windows owners who find they lack the capability to view NEF files from cameras such as the Nikon D80, D70, D200, D1, and D2.

Version: NEFView 2.0 (2008)

Plugs into: Windows shell

OS: Windows 98, ME, 2000, and XP

RAM: 128MB

Supported file formats: NEF and JPEG 2000

Price level: Approx. $9

Address: info@softwhile.com

www.softwhile.com

PixVillage

Vendor: PixVillage

Purpose: Peer-to-peer (P2P) software for sharing photos privately

Description

PixVillage is a P2P file sharing utility that lets you share photos privately with family and friends. With this software there is no need to use email or to upload the images to a server. PixVillage gives you instant digital photo sharing, for free.

To use PixVillage you authorize your private contacts to see the photos you have selected on your hard drive. You can make a specific photo available, or many thousands. Transfer is via the vendor's proprietary P2P online photo sharing technology.

Comments

PixVillage makes economical use of bandwidth, giving users direct access to images on your hard drive. It is a real P2P system in that it uses a special algorithm to copy photos to every authorized user. This means that people can have access to your images even when you are offline. Naturally, it works best when there is a network of users to spread the load.

Version: PixVillage 2.0 (2008)

OS: Windows 2000 and XP

RAM: 128MB

Supported file formats: JPEG, TIFF, GIF, PNG, and BMP

Price level: Free

Address: BBCG SARL, 242, bd Voltaire, 75011 Paris, France

www.pixvillage.com

Plugin Commander

Vendor: The Plugin Site

Purpose: Manage all your plug-ins, actions, and tubes

Description

If you create lots of effects with your image editor, or acquire them from other sources, Plugin Commander can help you view and manage them efficiently. It comes in two editions: Lite freeware and a Professional commercial edition with many additional features.

Plugin Commander Pro acts as a library from which you can select the plug-ins and effects to be displayed in the host application—which can be Photoshop, Premiere, Paint Shop Pro, and many other editors. When working with Photoshop, it deals directly with image formats, plug-ins, and effect types and allows you to apply plug-ins to the images, one at a time or in batches.

Plugin Commander Pro can batch convert between different formats, resize and rename images, and convert among four Filter Factory plug-in formats and operating systems—Photoshop, Premiere, Windows, and Macintosh.

Comments

The Pro edition of Plugin Commander not only works with Photoshop-compatible filter plug-ins but also lets you view Photoshop Actions, Paint Shop Pro Tubes, QuarkXPress XTensions, QuickTime Extensions, and many others. You can enable/disable any of them, whatever the host, but you cannot necessarily change the category or use the picture editor on them. The Lite edition is very limited by comparison to the commercial edition and runs significantly slower.

Version: Plugin Commander 1.60 (2008)

OS: Windows 95, 98, ME, NT, 2000, and XP

RAM: 256MB

Supported file formats: Major formats (Lite edition only BMP and JPG)

Price level: Lite edition free, Pro edition approx. $50

Address: Contact by Web form

thepluginsite.com

Plugin Manager

Vendor: I.C.NET Software

Purpose: Helps you take control over installed plug-ins

Description

Plugin Manager is a utility that will help you manage plug-ins made with the Filter Factory module (provided with Photoshop), regardless of their host application. It works with plug-ins for Photoshop, Paint Shop Pro, PhotoLine, Premiere, Painter, After Effects, Illustrator, and so on.

Features include a customizable user interface; ability to store keywords, descriptions and up to 100 preview images for each plug-in; comprehensive search engine for keywords, author, and category; renaming and moving between categories; and a quick launch bar for frequently used plug-ins.

Comments

Once you have acquired a few dozen plug-ins, you need to manage them. Plugin Manager, from this reliable vendor, does it very effectively. Its rival is the freeware Plugin Commander.

Version: Plugin Manager 2.1 (2008)

OS: Windows 95, 98, 98 SE, ME, NT4, 2000, XP, and Vista

RAM: 128MB

Supported file formats: Major formats in RGB, CMYK, and grayscale

Price level: Approx. $25

Address: I.C.NET Software GmbH, Michael Johannhanwahr, Robert-Bunsen-Str. 70, 28357 Bremen, Germany

www.icnet.de

SnagIt

Vendor: TechSmith Corporation

Purpose: Comprehensive screen capture utility, with 32-bit capture together with edit and share tools

Description

SnagIt is long-established, consistently improved software for screen capture, editing, and sharing. It allows you to capture anything on the screen: the whole screen, an individual window, or a scrolling Web page. It is invaluable for people who write technical documentation because it can capture a single menu or cascading (multiple-layer) menus from Windows applications. Text capture is easy, too, even where normal cut-and-paste methods fail to work, such as when copying file lists from Windows Explorer.

Figure 4.3
SnagIt provides up to 32-bit screen capture and a host of features.

Two other areas where SnagIt comes in useful are in Web page capture, because it can capture all the images, video, and audio files from a Website; and video screen capture, because it allows you to record a short video of your desktop activity, enabling you to make tutorial presentations to share over the Internet.

SnagIt lets you set a screen capture profile, with selections for image quality, destination folder, and other settings. You can save the profile for subsequent use, but there are also some default profiles to get beginners up and running immediately. You do not need to launch the program from the Start menu every time you need a screen capture. Just assign a hotkey combination (such as Control+F12) to start the capture process. A rectangle appears around the window on which you are working, easily changed to include other windows or the whole screen by moving the mouse. A left click then launches the interface.

SnagIt's Editor has paint tools that let you enhance your screen capture with arrows, lines, shapes, callouts, cursors, stamps, or text. You can also add special effects such as drop shadow, torn edge, wave edge, and more, or image-processing effects, such as sharpen, blur, and emboss. Other facilities include borders, watermarking, magnify, spotlight, dim, time-delayed screen capture, and cursor inclusion/exclusion.

Comments

SnagIt has a distinguished history, having been first introduced in 1991 and then regularly updated to become one of the best utilities around. According to the vendor there are now seven million SnagIt users worldwide, many of whom use it professionally to capture menus and windows for illustrating textbooks and other teaching materials. Its video capture feature led directly to the development of TechSmith's screen video recording tool Camtasia Studio. Many illustrations for *The Digital Photographer's Software Guide* were generated by SnagIt, using its 32-bit capture mode.

Version: SnagIt 8.2 (2008)

OS: Windows 2000, XP, and Vista

RAM: 256MB

Supported file formats: N/A

Price level: Approx. $40

Address: TechSmith Corporation, 2405 Woodlake Drive, Okemos, MI 48864-5910, United States

www.techsmith.com

Test Strip Proofer

Vendor: TS Proofer

Purpose: Darkroom test strip emulator for making proofs in 9x1 strips or 3x3 grids

Description

Test Strip Proofer lets you make calibration proofs for any size printer so that customers can be assured that the final result will meet their expectations. It is a relatively simple program that offers three options: Proof Size, Color Choice, and Amount. It comes in two editions: Home, with proof sizes of 4" × 5" up to 12" × 15", and Pro, with proof sizes up to 36" × 45". In Color Choice, you can select "all colors" for a color variation ring-around, or individual red, green, blue, cyan, magenta, or yellow. By selecting Amount (for example: Red 5%, 10%, 15%, 20%, and so on), you instruct the program to generate images with these variations in the chosen color.

Comments

With color profiling becoming commonplace, the need for test strips has diminished. Developed by Kirk Lyford, who founded PhotoTune in 2003 (acquired by OnOne Software in 2007), Test Strip Proofer is a revised version of the author's previous award-winning program, Vivid Details Test Strip. It does not have all the color correction tools and layout choices of the earlier version although all the essential features are available. The software appears consistently in magazines as a top-rated plug-in.

Version: Test Strip Proofer 1.1 (2008)

Plugs into: Photoshop CS and CS2

OS: Windows 95 to Vista; Mac OS X 10.2 and up

Supported file formats: 8-bit or 16-bit RGB images

Price level: Approx. $60, Pro version $130

Address: TS Proofer, 11612 Linnet Court, Penn Valley, CA 95946, United States

www.tsproofer.com

UltraSnap PRO

Vendor: Mediachance

Purpose: Screen capture utility with additional editing functions

Description

UltraSnap PRO takes commonplace screen capture to a new level by adding a complete WYSIWYG graphics editing capability. Instead of capturing a screen image and then opening an image editor to add captions, annotations, cursors, or arrows, the user simply takes advantage of the tools provided. Its editing is non-destructive, enabling the addition of shadows, bevels, and objects, complete with multiple anti-aliasing for improved image quality. It even offers standard photo-processing features, such as gamma control, contrast, brightness, color boosting, and histogram adjustment, together with resizing tools.

Comments

UltraSnap PRO is one of those utilities that you download for fun, and then find yourself using quite frequently. If, for whatever reason, you are in the habit of making screen captures, UltraSnap (especially this Pro version) is a must-have tool. With a simple click on the Edit button it switches into a full editing mode, complete with a magnifying lens function. It is not only fun to use but also genuinely useful.

Version: UltraSnap PRO 2.3 (2008)

OS: Windows 95, 98, NT, 2000, XP, and Vista

Supported file formats: N/A

Price level: Approx. $38

Address: Ottawa, Canada

www.mediachance.com

Watermark

Vendor: Twiga Ltd.

Purpose: A simple utility that places a plain watermark on your images

Figure 4.4
Watermark does what it says, and absolutely nothing else.

Description

Watermark is one of the simplest of all utilities: it adds text to an image so that owner-ship is clearly identified. There are very few controls: just input boxes for text, text color, and text transparency, together with positioning instructions (top, middle, or bottom of the picture). It handles only JPEG files, and will reject TIFFs and other formats. It is very basic, but effective.

Comments

There is plenty of watermarking shareware available, but it is a relief to find this com-mercial example that's not inclined to place assorted adware/spyware on your computer. Watermark was created originally for one of the developer's clients, a wedding photog-rapher, who uses it when selling images via an ecommerce site. If your photo editor doesn't have watermarking facilities, this little utility can help.

Version: Watermark 1.6 (2008)

OS: Windows 98 and XP

RAM: 128MB

Supported file formats: JPEG

Price level: Approx. $25

Address: Twiga Ltd., 27 Lime Avenue, Melksham, Wiltshire, SN12 6UY, United Kingdom

www.twiga.ltd.uk

Summary

A utility is something useful, exemplifying the utilitarian philosophy of adding to the sum total of human happiness. That may be overstating the case in this instance, but all the products described in this chapter can make life a little bit easier for the photographer. They offer image resizing and compression, watermarking, traditional test strip proofing, plug-in management, file sharing, and the one absolutely essential utility: screen capture. You can certainly find these facilities embedded in larger applications, but sometimes you need to obtain them separately. All the products listed here fulfill this need—and that really is useful.

5

Cataloging

Sorting and cataloging are normally two very different activities in photography. Sorting takes place immediately after the shoot when the photographer decides which shots have the potential to advance further in the workflow. At what precise stage these selected shots should be given names and keywords is a subjective decision, but they should never be stored or archived without cataloging. Millions of great images languish nameless in archives, never to see the light of day again because nobody knows they exist.

Magazines and newspapers that assign photographers to different jobs tend to combine sorting and cataloging at the earliest opportunity, using a product such as Photo Mechanic (which is described in Chapter 2, "Image Viewers"). This is because they are dealing with so many images from so many sources, each with copyright and permissions data; they would soon lose track without doing so. Even a regional newspaper may originate over a million shots a year, each one needing unique identification.

There is little doubt that cataloging is a tedious business, only marginally more satisfying than completing a tax return. Because it requires thought, it is impossible to automate completely. Most cataloging systems provide predefined categories into which you can drop the images, or standard keywords you can apply to the images. It is important to use a defined vocabulary, otherwise a search for "car" will yield nothing if you have tagged them all as "automobile." Better still, use as many keywords as possible. They all help to cross-reference your images and allow you to refine a search until you are left with a manageable selection for browsing.

Digital asset management (DAM) systems, which are covered in a separate category in this book because they handle other media as well as images, are totally dependent on good cataloging. They all have cataloging facilities of their own, often brought to bear

on a collection long after the pictures have been archived. A well-managed photo studio should not wait for the DAM "ingestion" treatment but should make the image collection searchable at an early stage. It saves a lot of time and effort later and may even yield some short-term commercial benefits.

Cataloging the different cataloging products is not easy, as you can see by the absence of Photo Mechanic (see Chapter 2, "Image Viewers"). Another product that has been difficult to classify is ACDSee Pro, which is renowned for its cataloging abilities but has grown to become a complete workflow solution. It seems more at home here, if a little big for the nest, rather than in a category by itself.

ACDSee Pro Photo Manager

Vendor: ACD Systems

Purpose: End-to-end workflow solution for digital photographers

Description

ACDSee Pro Photo Manager is a "complete solution" for digital photography, allowing users to view, process, edit, organize, catalog, publish, and archive photo collections. Well established in the market, having had input from many professional photographers in the years since its launch, it offers comprehensive RAW support, fast processing of large files, and efficient image handling and cataloging facilities. As an image editor it is not a rival to Photoshop, but has many quick editing features and comes with full color management support for ICC and ICM profiles.

Moderately priced, ACDSee Pro Photo Manager is worth the money for its image sorting capabilities, which have always been its greatest strengths. Its features include visual tagging, which allows you to find your pictures more quickly. Traditionally, its RAW support has always been strong, and it now has integrated support for Adobe's DNG (Digital Negative specification). It provides full control over white balance, exposure, sharpness, and noise.

ACDSee's publishing facilities include PDF creation, slide show creation with audio, customized Web galleries, email with auto-resizing, and high-quality contact sheet printing.

A less expensive edition, really a separate product, is the ACDSee 10 Image Manager, aimed at "photo enthusiasts with a growing image collection." See the vendor's Website for a full comparison.

Comments

Having so many features in a single package is undoubtedly an advantage, but it is difficult to supply "best of breed" quality for every one of them. Despite its "pro" title, ACDSee Pro Photo Manager has not quite kept up with the furious pace of development in RAW processing, although its image sorting facilities remain among the best.

Figure 5.1
ACDSee Pro is the original workflow tool with best-of-breed cataloging.

It has many points in its favor: a clean interface with a very large main panel, very good noise reduction algorithms, and a greater number of features than most equivalent products, including the ability to handle an exceptional number of file formats.

Version: ACDSee Pro 2 Photo Manager (2008)

OS: Windows 2000, XP, and Vista

RAM: 512MB (1GB recommended)

Supported file formats: Most RAW; all major image formats, including JPEG 2000, and more than 100 others

Price level: Approx. $130, ACDSee 10 $50

Address: ACD Systems International Inc., 200 – 1312 Blanshard Street, Victoria, British Columbia, Canada, V8W 2J1

www.acdsee.com

DigitalPro

Vendor: Pro Shooters

Purpose: Image browsing, sorting, cataloging, and publishing software

Description

To make it easy to conceptualize the scope of DigitalPro, the vendor refers to four categories: load, review, catalog, and publish. This means that DigitalPro addresses the two ends of the photographic workflow. At one end it allows you to bring images into the browser, and then examine, sort, and catalog them by assigning captions, keywords, and categories. At the other end it offers publishing facilities, with image resizing and format conversion, built-in sharpening, proof sheet printing, automatic watermarking, contact sheet printing, and Web gallery generation.

DigitalPro treats images captured in RAW+JPEG as a "single file," so that the users see them as one file and continue to treat them in this way, even deleting them as a single image. Many photographers find that this feature saves time and avoids confusion. The program can also accommodate Adobe Photoshop RAW processing, which integrates fully with DigitalPro. Its file handling now includes support for JPEG 2000 files.

DigitalPro's review facilities are first-rate, with features such as a multi-threaded Light Table for reviewing images quickly, a "digital loupe" for checking sharpness, and dual monitor support. Every thumbnail image can be tagged with metadata that displays directly on the image. This metadata can tell the users whether the image has been cataloged, given IPTC data, was taken with/without flash, whether it has any exposure compensation, and the tone setting. Again, this is an extremely useful feature for professionals, the little data tags being called "Smart InfoIcons" by the vendor. By clicking on these InfoIcons you can play any audio file associated with the image, or bring up the RAW data for editing.

For cataloging, DigitalPro has a wealth of features: IPTC-compatible color-coded priority tagging; automatic captioning with copyright, credit, camera profile, and color space information; and efficient database management with keywording, image tracking, and all the necessary functionality to find images quickly. Sorting is by file date and capture date, the latter being accomplished by using Exif data.

DigitalPro comes in two editions: Standard and Pro. Several features, like batch IPTC captioning of selected images and image event logging and reporting, are exclusive to the Pro edition.

Comments

The product of collaboration between professional wildlife photographer Moose Peterson and software developer David Cardinal, DigitalPro works well for both Nikon and Canon shooters, although Peterson always shoots on Nikon. Each major upgrade of the software has been acclaimed by professionals, thousands of whom now use it. Its combination of image browsing, color-managed workflow, and real-time cataloging is clearly one that works for them, although it lacks full processing and editing facilities. Because most pros use Photoshop or specialist applications for retouching, DigitalPro does not attempt to compete in that area.

Version: DigitalPro 4.3 (2008)

OS: Windows 2000 and XP

RAM: 256MB

Supported file formats: Inputs Nikon and Canon RAW; JPEG, TIFF, GIF, JPEG 2000, Photo CD, and PSD; outputs JPEG, JPEG 2000, TIFF (CYMK), Compressed TIFF and JPEG 4:1:1 (Pro edition only), Photoshop, PNG and JPEG:4:1:1, and DNG

Price level: Standard $180, Pro $260 (both approx.)

Address: Pro Shooters LLC, 3130 Alpine Road, Suite 288 PMB #151, Portola Valley, CA 94028, United States

www.proshooters.com

IMatch

Vendor: Mario M. Westphal

Purpose: Image management tool widely used by individual photographers

Description

IMatch is an image management tool for viewing, editing, and organizing a digital image collection. It is popular among photographers because it supports all major digital camera RAW formats, handles Exif, IPTC, and XMP data, and allows you to manage large collections containing (the vendor says) "hundreds of thousands of images."

IMatch has excellent support for XMP, with the ability to display XMP data next to each thumbnail. Its built-in IPTC editor is regarded as one of the best available. It allows you to categorize your images by project, client, location, theme, equipment, and date/time. Comprehensive filtering facilities help you find the images you seek. A sensible licensing policy enables a photographer to run the software on both desktop and laptop computers, with a facility to replicate the database from one to another.

Comments

This is a professional image management tool at a home user price. It comes with a tutorial and there are over 450 pages of online help, should you need them. The product has ongoing development: always a good indication of success. Another sign is the liveliness of the IMatch User Forum, where you can find thousands of messages explaining all aspects of the program. A new photools Wiki (wiki.photoolsweb.com) carries a Scripting Tutorial and script attachments written by users to accomplish over 400 specific tasks such as "Export to ACDSee," "Rename Canon Panorama Files," and "Copy Filename into IPTC Record." The vendor offers a 30-day evaluation copy.

Version: IMatch 3.6 (2008)

OS: Windows 2000, XP, 2003, 64-bit Vista

RAM: 512MB

Supported file formats: Major RAW formats; JPEG, TIFF, and 100 other image file formats; non-image formats including MPEG, PDF, MP3, and DOC

Price level: Approx. $65

Address: Mario M. Westphal, Albert-Franke-Str. 4a, 61250 Usingen, Germany

www.photools.com

PicaJet

Vendor: PicaJet.com

Purpose: Image organizer, with indexing, tagging, and sharing features

Description

PicaJet is a photo organizer for keen family photographers looking for speed, ease-of-use, and a full set of cataloging features. It performs its specialist functions extremely well, offering facilities such as easy tagging, indexing, unlimited categories, category-nesting levels, and keyword importing. It lets you sort your pictures by capture data, folders, ratings, comments, or keywords. Although secondary to its major cataloging function, PicaJet also provides several editing features, including crop and rotate, auto-enhance, red-eye removal, sharpen, and filters. With its batch processing capability, you can make changes to several images at once.

Figure 5.2

PicaJet makes it easy to edit Exif and IPTC metadata while cataloging your collections.

PicaJet includes full support for most RAW images, including Adobe DNG format, and allows you to write image annotations directly into DNG files. It has good support for IPTC metadata and can use Exif data within searches.

Output from PicaJet is to CD and DVD without the need for any extra software. You can print in various sizes, add frames and dates, or simply view the photos as a slide show. A multilingual interface (with Italian, Spanish, German, Chinese, French, Russian, and so on) completes the package: a one-stop solution for handling digital images.

Comments

PicaJet is a natural competitor to Google's Picasa, being pitched at the same category of user. Most reviewers have found it superior to Picasa, and the phrase "Picasa-killer" has been occasionally mentioned. Given Google's reach, that was never going to happen, especially as Picasa is also completely free. Yet PicaJet has so many virtues, such as speed of import, RAW support, and efficient sorting, that it could well be useful to serious photographers with large collections of images.

Version: PicaJet FX 2.5.0.495 (2008)

OS: Windows 98, ME, NT, 2000, and XP

RAM: 128MB

Supported file formats: Most RAW formats and Adobe DNG; TIFF, GIF, JPEG, JPEG 2000, PCX, BMP, ICO, CUR, PNG, WMP, EMF, TGA, PXM, PSD, FAX, PCD, CUT, AVI, QuickTime, MPEG/2/4, and WMV

Price level: Single license $48, family license $80

Address: PicaJet.Com, Pacific Business Centre, P.O. Box 34069 #381, Seattle, WA 98124-1069, United States

www.picajet.com

PixFiler

Vendor: BR Software

Purpose: Cataloging software for tens of thousands of images, with report, print, and contact sheet facilities

Description

PixFiler is image catalog software to help you organize your images, even if you have tens of thousands of them. It provides tools to make it easy to categorize and annotate them, provides hierarchical categories, and lets you make reports, prepare contact sheets, and organize printing.

Among PixFiler's advanced features are extraction of Exif and IPTC metadata, bulk updating to update several fields at once, and an ability to find images that have been moved to different folders or even to different disks.

Comments

Baard Riiber, the Norwegian developer of PixFiler, is a keen photographer and understands what is needed in cataloging software. PixFiler is his second-generation product, the first being BR's PhotoArchiver, which lacked the bulk update facility. Written in C++, it appears to be a stable and reliable product from a vendor who is a member of the Association of Shareware Professionals.

One recently added feature is the use of Exif-GPS information for displaying on a map the locations where images have been taken. This feature works in conjunction with the vendor's PixGPS software that enables you to Geotag your photos using a GPS receiver.

Version: PixFiler 5.2 (2008)

OS: Windows 98SE, ME, NT4, 2000, XP, and Vista

RAM: 128MB

Supported file formats: All major RAW; JPEG, TIFF, PNG, and other image formats

Price level: Approx. $40

Address: BR Software, Nedre Frydendal 92, 1384 ASKER, Norway

www.br-software.com

Shoebox

Vendor: KavaSoft

Purpose: Catalogs photos on Mac by content, "who, what, where, and when"

Description

Shoebox is a Mac-only application that enables its users to organize digital photos by content. It has categories that behave like virtual folders for people, things, places, and dates, or "who, what, where, and when," as the vendor puts it. You can create or edit categories in the "category drawer" or import ready-made categories from the vendor's Website. For example, if you import the category called "United States" it comes with all 50 states and their capitals as subcategories.

Once photos have been ingested to the appropriate categories, together with cross-referencing between them, searching becomes very straightforward. You just type in the first few letters of the category (or favorite, or date) to go straight to the correct folder. You can also save a search to your favorites list and run it again later.

One of the benefits of putting photos into Shoebox is being able to surf your collection by content. For example, if you are displaying a beach scene, you can click to see similar scenes. Other features include password-protected catalogs, photo sharing by email or save-to-the-Web, and backup to DVD. Supported languages are English, French, German, Dutch, Italian, and Japanese. The Express edition limits you to two catalogs of 10,000 photos each; the Pro edition is unlimited.

Comments

Shoebox is much appreciated by many users who like its straightforward layout, logical structure, and powerful searching. Bringing images into a cataloging system—any cataloging system—is always a chore, no matter how the categories are structured. But once done, the "digital asset management" benefits become obvious. On an Apple Cinema Display, surfing your photos in Shoebox becomes compulsive, with switching between thumbnail, list, and slide show views in full screen mode. It even supports dual displays, so you can have thumbnails on one and whole-screen photos on the other. Shoebox may lack the processing features of Aperture, but it is a big step up from iPhoto and able to handle half a million pictures.

Version: Shoebox 1.7.2 (2008)

OS: Mac OS X 10.4 or later

RAM: 256MB

Supported file formats: Major RAW; DNG, JPEG, CRW, NEF, PDF, PNG, TIFF, GIF, and so on

Price level: Express $30, Pro approx. $80

Address: info@kavasoft.com

www.kavasoft.com

Summary

In the absence of software to classify images automatically by their content (it will come eventually), photographers must use cataloging software that demands the input of text descriptions. Software in this category is therefore somewhat demanding of user time, but it can be time well spent because it enables more effective searching at a later date. ACDSee remains the benchmark, but other packages offer plenty of facilities at a competitive price. Check out PixFiler for its Geotagging features, or IMatch with its excellent handling of Exif, IPTC, and XMP metadata.

6

Digital Asset Management (DAM)

Film libraries, photo libraries, music collections, and text documents were once entirely separate from each other, requiring different storage conditions and the expertise of librarians with different skills. Now, computer bits have become the lowest common denominator, reducing all media to digital data that can reside on identical storage devices. With this change has come a new profession and a new category of software, both called Digital Asset Management.

Most organizations have a disparate collection of media, stored away in various archives or still present on the hard drives of employees' desktop computers. DAM attempts to leverage this valuable asset, making it possible to extract value from it and to use it in current work. It makes a lot of sense, especially now that printed documents are held in digital form, along with photographs, presentations, sound recordings, video, and film clips. The art of DAM involves making these media accessible, preferably without having to change their physical location.

There are 1,001 ways to organize digital assets, a fact that has led to highly customizable systems. Image data, in particular, present a big challenge because of the demand for different formats: archived RAW originals, high-res TIFFs and PDFs for print, low-res JPEGs for the Web, and so on. If software can handle images satisfactorily, it is a relatively small step to make it handle other media. Several DAM solutions have started as image management systems and have gone on to embrace the whole spectrum of media, such as Extensis Portfolio and Microsoft's Expression Media.

The criteria for good DAM software are many—scalability comes near the top of the list for growing companies, but excellent browsing facilities are equally important.

Free-text searching provides a powerful tool for locating documents, but picture content is much harder to identify unless individual images have been tagged appropriately. There is no shortcut in this respect. However intelligent, software cannot tell if an image depicts an oil rig in the North Sea or the Gulf of Mexico unless someone has attached these keywords to it. With good indexing in place, DAM systems can create huge savings and even generate new revenue streams for some organizations.

The software listed here ranges from inexpensive, single-user packages right up to systems that cater to the needs of multinational enterprises.

Asset Bank

Vendor: Bright interactive

Purpose: High-performance DAM solution for corporate image management and ecommerce

Description

Asset Bank is a powerful solution to image management for corporations that need to make all their digital assets easily available, whatever format they are in. It handles all file types including images, videos, PDFs, and presentations, and provides an interface that can be configured to suit the organization using it. One of its key features is a sophisticated access rights structure, which gives a high degree of control over access privileges to the stored data.

Users can preview short clips of video files as well as a thumbnail of the first frame. They can also convert and resize image files before downloading them. Search facilities are comprehensive, with full keyword search of text within documents, quick keyword searching of the file structure, and view/search of the IPTC and Exif data. On the client side, Asset Bank is browser-based, is compliant with the World Wide Web Consortium's Accessibility Guidelines, and has no need for plug-ins or JavaScript.

On the administration side, Asset Bank offers some important features: reports and statistics to show how people have been using the system, whether or not their searches have been successful, and a list of their chosen keywords.

For companies that want to sell images online, Asset Bank can be integrated with the vendor's ecommerce system that allows you to use payment providers such as WorldPay or PayPal. It lets you configure the interface with the customer, for currency, tax, and the permitted period between payments and download. You can also integrate Asset Bank with a content management system (CMS) such as Interwoven, Rhythmyx, Documentum, or the vendor's own EccoCMS. (A CMS enables updating of Web content without disturbing the basic structure of the site.)

Comments

Written entirely in Java, Asset Bank is designed to be easily customized by Web developers with CSS and HTML skills. In the UK, where the development team is based, it has found a market among corporations, charities, universities, and councils. Its nearest direct competitor is FotoWare Cameleon.

Version: N/A

OS: Windows 2000, XP, and Vista; Linux

RAM: N/A

Supported file formats: All (vendor says: "you can add files of any type whatsoever to Asset Bank")

Price level: Approx. $9,500, by subscription $400 per month

Address: Bright interactive, Brighton Media Centre, 68 Middle Street, Brighton, BN1 1AL, United Kingdom

www.assetbank.co.uk

Canto Cumulus

Vendor: Canto Software

Purpose: Digital asset management software for workgroups

Description

One of the best-known DAM products, Canto Cumulus has been around since 1991 with ongoing development and several thousand server licenses sold. It lets workgroups find, share, and publish their files, wherever the files are stored. Its facilities, which include full support for RAW image files, make it particularly suitable for creative professionals such as designers, publishers, advertising agencies, and large photographic studios.

Cumulus handles all the digital assets of a company—images, sounds, video, and presentations—whatever the file format. You drag files into it to catalog them, and drag them out to use them. Being a client/server system, it allows everyone to access the assets, with permissions, and can be used across the Web. This means you can let people know where to find assets, such as a large image file, without having to retrieve and send them personally.

Comments

Cumulus Server Solutions are aimed at corporations larger than the average photographic studio, yet there are several photographers using this product. It is very good for sharing assets with clients, under password control. However, it may be overkill for smaller studios. For individuals, Canto recommends MediaDex, which is built on the same digital asset management technology. (See that entry.)

Version: Cumulus 7.5 (2008)

OS: (Server) Windows 2000 (SP4), XP, Server 2003 (SP1), and Vista; Mac OS X version 10.5; SOLARIS 8

RAM: 128MB minimum

Supported file formats: More than 130 file formats

Price level: Cumulus Server Solutions from $2,500

Address: Canto GmbH, Alt-Moabit 59-60, 10555 Berlin, Germany;

Canto Software, Inc., 221 Main Street, Suite 460, San Francisco, CA 94105, United States

www.canto.com

Expression Media

Vendor: Microsoft Corporation

Purpose: Digital asset management tool for cataloging and managing 100 different media formats

Description

Expression Media is a management tool for professionals who need to catalog and organize their digital assets for easy retrieval and presentation. It is based on iView MediaPro, a product that is still widely used by photographers and was acquired by Microsoft in 2006. It provides integrated search tools so that you can find your files quickly wherever you have stored them: in folders, hard drives, DVDs, or on a network.

The six words Microsoft uses to describe what Expression Media does are "import, organize, search, annotate, repurpose, and archive" digital files. The files in question do not have to be images. They can be PDF documents, video, or any digital media you care to name.

To the surprise of many, Microsoft launched a Mac version of Expression Media along with the Windows version. From a photographer's point of view they are more or less identical. However, the Windows version contains a video encoding tool called Expression Media Encoder. It brings additional functionality lacking on the Mac version. It will let you import, crop, and enhance video from different sources, helping you add metadata, markers, and overlays. With its gift for cumbersome terminology, Microsoft calls this technology "Windows Presentation Foundation/Everywhere" (WPF/E), but it represents a big step forward in publishing video for cross-platform viewing on the Web.

Comments

Like many organizations, Microsoft is betting that photography will become videography in the not-too-distant future. If it does, this product is ready and waiting for it. If it does not, you will have spent only a little bit extra on a facility you may never need. Expression Media still has excellent facilities for handling still photographs, quite apart from its forward-looking features.

Figure 6.1

Expression Media is a powerful multimedia asset management tool, with great browsing/displaying/cataloging features.

The software allows you to store up to 128,000 files in each catalog. Powerful search facilities enable you to find them wherever they are— on hard drives, CDs, or media cards. You can save popular searches for future use, a feature that opens up new ways of cross-referencing a media collection.

Expression Media is also surprisingly easy to use, given its huge range of features. The basic layout of the interface is superb, with immediate access to catalog creation, followed by display with three tabs: list, thumbnail, and media. These take you to practically everything you need to know about your files, with a full description (the list) and a large displayed image (the media) that can be edited from a floating panel. Tagging and sorting facilities go way beyond what is available in popular workflow software. If you really want to tame your ever-growing stock of digital assets, Expression Media is a "must try."

Version: Expression Media 2.0 (2008)

OS: Windows XP and Vista; Mac OS X 10.4.8 or later

RAM: 1GB

Supported file formats: Nearly all major formats (more than 120)

Supported languages: English, French, German, Spanish, Italian, Japanese, Chinese Simplified, Chinese Traditional, and Korean

Price level: Approx. $300

Address: Microsoft Corporation, One Microsoft Way, Redmond, WA 98052-6399, United States www.microsoft.com

Extensis Portfolio

Vendor: Extensis

Purpose: Digital asset management software for professional use

Description

Extensis Portfolio is a well-established digital asset management package for ingesting and retrieving images, sounds, movies, and documents. It offers a huge number of options, and for that reason the learning curve imposed on the user is quite demanding. However, it is very well documented, has one of the best user-written FAQs on the Internet, and includes excellent training materials provided by the vendor.

Portfolio can catalog any digital file. When handling images, it extracts thumbnails, displays screen previews, and extracts metadata from most formats. Its list of supported file formats is formidable, and it can batch convert many imaging formats to JPEG and PixelLive VFZ/PFZ, Celartem Technology's compression format for scaling images along edges to preserve detail (see www.celartem.com). For previewing, tagging, cataloging, editing metadata, and Web publishing, Portfolio has a very full set of features. Version 8 introduced the concept of scratchpad galleries: temporary baskets where you can sort, edit, and merge files from searches of other galleries. This is the kind of feature that continues to make Portfolio popular with newspapers and photo agencies.

Comments

A good archiving tool, Portfolio has some excellent features like auto-synchronization of folders. However, it now faces stiff competition from Microsoft's Expression Media at the higher end of the DAM market.

Many users appreciate the Portfolio Express palette, a floating palette that makes the contents of a catalog instantly available inside any application by offering a global keyboard shortcut. With this feature you do not even have to open Portfolio itself: a time-saver for busy workers.

Version: Portfolio 8.5 (2008)

OS: Windows 2000, XP, and Vista; Mac OS X 10.4.9 – 10.5.1

RAM: 512MB (recommended)

Supported file formats: Major RAW formats; image formats BMP, JPEG, JPEG 2000, GIF, PCD, PICT, PNG, PSD, TGA, TIFF, WMF, VFZ/PFZ, STN Genuine Fractals, and SID MrSID; document formats INDD, PDF, PSD, AI, PPT, TXT, FHX, QXD, DOC, and XLS; audio visual formats AIFF, AU, AVI, SWF, Mac Sound File, MIDI, MPEG1/2/4, MP3, MOV, WAV, DV, 3GPP, and 3GPP2 Mobile Phone Video

Price level: Approx. $200

Address: Extensis, Inc., 1800 SW First Avenue, Suite 500, Portland, OR 97201, United States

www.extensis.com

FotoStation PRO

Vendor: FotoWare

Purpose: Digital asset management, with workgroup collaboration tools, data mining, and image enhancement

Description

FotoStation PRO is a fully customizable DAM workstation, with image editing features, data mining, workgroup collaboration, and over 70 sort options. It has extensive organizing capabilities, allowing you to append detailed text descriptions to images and perform multi-archive searches. Features like drag-and-drop image placement with auto-cropping make it especially useful in a newspaper or magazine environment.

One of FotoStation PRO's key selling points is its data mining feature, which allows the user to find images without formulating a specific search. It lets you hunt for appropriate images by using a "word list" that can locate all files with those words in a given XMP text field, or by a single keyword, date, or range of dates. You can assemble collections of images as named projects with complete project descriptions.

FotoStation PRO can also index the contents of offline media such as DVDs, creating offline archives that are fully searchable. It has plenty of image editing features, such as hue and saturation settings, curves, manual color balance adjustment, and a sophisticated noise reduction feature called SmartClean. Color management with ICC profiles is fully implemented. A start-up wizard makes it easy for new users, whereas experienced users can customize the interface according to their preferences.

Comments

FotoStation PRO is one of a new breed of image organizer that imposes an additional level of indexing on an existing collection. You could call it an "image reorganizer," as it can help to tame archives and make it easier to find pictorial content to illustrate published articles. Version 6.0 saw a shift from IPTC to XMP metadata; the introduction of SmartColor, an automatic image enhancement tool; and SmartClean, a server-based solution to reduce noise and improve color saturation in the stored images.

Version: FotoStation PRO 6.0 (2008)

OS: Windows 2000, XP, and Vista; Mac OS X 10.4.6 or higher

RAM: 512MB (more recommended)

Supported file formats: Most RAW formats; all major image, sound, and movie formats

Price level: Approx. $600

Address: FotoWare a.s, Holbergsgt.21, N-0166 Oslo, Norway

www.fotoware.com

FotoWare Cameleon

Vendor: FotoWare

Purpose: Scalable DAM system for small businesses to large enterprises

Description

FotoWare Cameleon is a digital asset management system that can meet the needs of small businesses while also scaling to address those of large enterprises. It comes in three editions:

- Standard, for small offices, where people have a need to store and share images, PDF files, video, sound, and PowerPoint presentations. It comes with image-enhancement tools, full color management, import from digital cameras, scanners, DVDs, CDs, and other sources, and has a storage capacity of 100,000 files. It supports two FotoStation PRO client workstations.

- Professional, for small to medium size companies with a greater number of digital assets. Features include high-speed search and simultaneous indexing of new files, plus a storage capacity of 200,000 files. It supports five FotoStation PRO client workstations.

- Web, described as a "complete solution for the corporate market," in which a single client using FotoStation Pro can configure and maintain the archive, whereas everyone else accesses the system via Web browsers. Storage capacity again is 200,000 files.

Comments

Used by (among others) Philips, MyTravel Group, and the UK's Defence Image Database (www.defenceimagedatabase.mod.uk), FotoWare Cameleon handles large volumes of images with ease. One of its key features is scalability, enabling businesses to move up to a larger edition as they grow. Another is adaptability, the vendor noting the following: "We adapt to your environment, like a cameleon" (hence the name and British spelling). By removing the need to make major changes in existing workflows, FotoWare has gained sales in what has become a very competitive market for powerful DAM systems. The company has offices throughout Europe and representation worldwide.

Version: N/A (2008)

OS: Windows XP and Vista; Mac OS X 10.4.6 or higher

RAM: 512MB (more recommended)

Supported file formats: Major image, sound, and video formats; PDF, Illustrator, Photoshop, InDesign, Word, PowerPoint, and QuarkXPress formats

Price level: Standard $2,400, Pro $8,000, Web $12,000

Address: FotoWare a.s, Holbergsgt.21, N-0166 Oslo, Norway

www.fotoware.com

MediaDex

Vendor: Digital River

Purpose: Catalogs, organizes, finds, and shares digital media files

Description

MediaDex is a digital asset management tool for creative professionals and serious amateurs. It lets you catalog, organize, find, and share digital assets such as images, layouts, multimedia, video, audio, and text.

MediaDex is a particularly powerful solution for photographers, with support for RAW files, Exif, IPTC, and XMP metadata formats, as well as professional ICC-approved Image Color Management (ICM). Cataloging is assisted by a drag-and-drop option, with bulk cataloging supported. There is no limit to the number of files you can archive. MediaDex creates a record for each cataloged digital file and provides a readout of the information associated with it. Search facilities allow you to search by keyword or any other metadata information. For sharing images, MediaDex has custom slide show creation, WebAlbum publishing, and customizable printing layouts.

MediaDex includes Pixel Image Converter, a feature that allows you to convert any cataloged image, on-the-fly, into any of these formats: JPEG, TIFF, BMP, ScitexCT, PNG, PCX, and PDF.

Comments

Based on Canto's Cumulus Single User product, acquired from Canto in 2005, MediaDex can create catalogs as large as 4GB in size. It is still recommended by Canto, but may have suffered by no longer enjoying the same brand name.

MediaDex 2.0 added new image pre-processing tools, enabling conversion of files on-the-fly into a different color space or file format. With this release, the maximum catalog size went up to 4GB. However, anyone upgrading from an earlier version would need to spend a lot of time transferring files from one system to another in order to benefit from the new features. Hopefully, this can be avoided in future upgrades.

Figure 6.2
MediaDex's powerful sorting facilities are easy to access and use.

Version: MediaDex 2.0 (2008)

OS: Windows 2000 and XP; Mac OS X 10.3.9 or later

RAM: 128MB

Supported file formats: Major file formats, including JPEG 2000, and video formats such as MPEG, AVI, RealMedia, and DivX

Price level: Standard edition $50, Pro edition $80

Address: MediaDex FZ-LLC, info@MediaDex.com

mediadex.com

Summary

A special breed of software that goes way beyond viewing and cataloging, digital asset management enables the owners of media collections to leverage their assets by making them available for additional uses. Individual photographers may find benefits in some of the smaller systems, such as MediaDex, but most DAM software is aimed at corporations and institutions. With video, multimedia, audio, still images, and documents being held on various physical platforms, from hard drives to legacy floppies, the larger users require a comprehensive solution to bring all these assets together in a virtual, accessible space. DAM meets this need, but individually tailored solutions can be expensive.

7

RAW Converters

The first step in the digital photographic workflow is to convert the RAW file. Many photographers rely on their camera to perform this conversion, a procedure that manufacturers believed would be almost universal when DSLRs were first introduced. It was not long, however, before photographers started noticing that RAW files devoted four extra bits to the image. What happened, they wondered, to all the extra information encoded by those four bits?

When people gained practical experience with RAW files, it soon become apparent that additional information could indeed be extracted from them, given sufficient processing time. Desperate in particular for greater dynamic range, photographers jumped at the opportunity of using RAW instead of in-camera JPEGs, sometimes shooting in dual mode to gain the best of both worlds. The only problem, apart from speed, was the fact that RAW was not (and still is not) a single format but a multiplicity of proprietary formats. Canon has CRW, Nikon has NEF, Olympus has ORF, Pentax has PTX, and so on. No one publishes the source code, obliging users to accept the official conversion package usually but not always supplied with the camera.

To be effective, RAW conversion needs to do a lot more than "de-mosaic" the image, although this is an important step that has a fundamental impact on resolution. The mosaic of red, green, and blue filters, with two green pixel sites for every red or blue one, becomes converted into complete RGB pixels by a process that guesses the missing values. The predominance of green provides a convenient luminance channel that serves as a guide for the overall light level. Once converted, the image is inevitably slightly soft, because of the overlapping values. It may also be noisy or have an incorrect color cast. Through no fault of the user it can have lens errors such as barrel distortion, vignetting, or chromatic aberration. All of these imperfections can and should be corrected at the earliest possible stage, in a processing package shortly after basic RAW conversion. It is for this reason that RAW converters, like Topsy, just seem to grow.

The Incredible Dave

Dozens of RAW processors from around the world owe their existence to the efforts of Dave Coffin, a Boston-based programmer who has cracked all the proprietary RAW file formats and made them available to the Open Source world. The result of his work is an ANSI C program called dcraw (pronounced "dee-see-raw") that can decode RAW images "from any digital camera on any computer running any operating system." It also extracts thumbnails and displays metadata, as its author explains—in both English and Esperanto—on his Website. An entire industry has grown up on the foundation of Dave's work, securing him a place in the annals of digital photography. You can find dcraw code in nearly 50 different brands of software (see a full list at cybercom.net/~dcoffin/dcraw), including the following:

- ACDSee
- Adobe Photoshop
- BreezeBrowser
- IrfanView
- LightZone
- SilverFast DCPro

A photographer needs only one RAW conversion tool, but which one? That rather depends on what other software you use, or intend to use. Some packages, like ACDSee, are extremely feature-rich, having become "workflow tools" to address all the software needs of the photographer, from RAW input through to archiving and printing. Other packages, like LightZone, are more focused on the processing tasks that need to be done in the early part of the workflow. The following descriptions can help you decide which software to try, with the aim of moving the workflow through its first vital stages.

BibblePro

Vendor: Bibble Labs

Purpose: Well established and widely used RAW workflow package with plug-in architecture

Description

With platform-specific optimizations, BibblePro offers very fast RAW conversion together with many other tools, including noise reduction, healing, cloning, and image correction. It has a younger brother called Bibble Lite, which has all the core features of the professional version, but without pro-style support for tethered shooting and the like.

To convert a RAW image you simply drop it on a "batch queue," a feature that can greatly speed up your workflow by making copies of the original and creating Web galleries. The program also enables fast printing using a similar "print queue" feature.

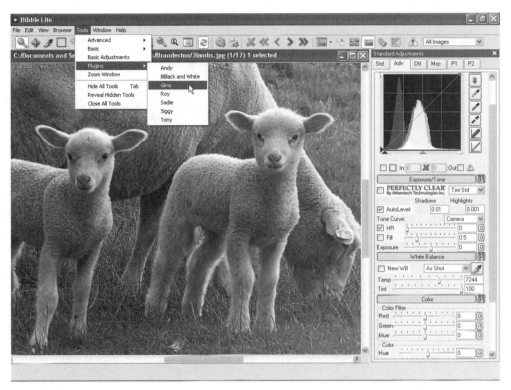

Figure 7.1
Bibble accepts many terrific plug-ins and offers full featured RAW conversion.

BibblePro, like one or two other great RAW converters, is evolving into a full-blown image processor with functions such as lens correction, a fill-light tool for High Dynamic Range, multi-CPU support, and above all a plug-in architecture that has brought a whole new range of functionality from third-party developers, such as these from Nexi:

■ AndyPRO: Simulations of B&W film, paper, and developer combinations, with varying exposure times (see full entry)

■ AnselPRO: To alter a histogram according to the theory of light zones (see full entry)

■ GinaPRO: For correction and enhancement of skin tones, using Tone, Saturation, and Glow controls (see full entry)

■ Roy: Color correction and adjustment plug-in for changing tint, brightness, and saturation

■ Marky: To apply watermarking to images, with signature, copyright notice, or studio logo

- Matty: Lets you create borders, frames, or mats around your images; useful for the Web

- Percy: For perspective correction, fisheye remapping, skewing, aspect change, scaling, and rotation

- SharpiePRO: To sharpen/blur an image using "contrast enhancement," "luminance blur," and "pixel punch" filters (see full entry)

Comments

Eric Hyman founded Bibble (named after his cat) in 2000 to decode RAW files from the Nikon D1. Since then he and his team have maintained a furious pace of development, keeping the product at the forefront of digital photography year after year, despite stiff competition. It is a superb program, with non-destructive processing and exceptionally good batch facilities. Version 4.3 added BPTLens correction, for uncurving the distortions of ultra-wide-angle lenses. IPTC editing is well implemented. Black-and-white conversion comes with spot coloring in two colors. The list goes on—and all this for a fraction of the cost of Capture One.

Version: Bibble 4.10 (2008)

Plugs into: Pro version Photoshop 7 and later; Lite version Photoshop Elements 2.0

OS: Windows 98 SE, ME, 2000, and XP; Mac OS X 10.3.9 or higher; Linux 2.4 or later

RAM: 512MB

Supported file formats: RAW (nearly all); JPEG and TIFF

Price level: Approx. $130, Lite $70

Address: Bibble Labs Inc., 11940 Jollyville Road, Suite 115-N, Austin, TX 78759, United States www.bibblelabs.com

BreezeBrowser Pro

Vendor: Breeze Systems

Purpose: RAW converter with a browser-style interface, batch processing, and Web page generation

Description

BreezeBrowser Pro not only converts RAW images but can also generate Web pages, produce proofs and contact sheets, and conduct a whole range of post-processing operations. It offers a huge range of features, including options such as levels, gamma correction, saturation adjustment, resizing, and sharpening. It offers RAW conversion for Canon, Nikon, Pentax, Minolta, and Olympus cameras, with preservation of Exif metadata. One distinguishing feature that sets it apart from other processors is its "combined conversion," obtaining excellent coloration with a first conversion combined with a second pass to improve highlight detail.

BreezeBrowser's Web page generation facility is very helpful to photographers with a Web presence. Plenty of templates are available; new ones are often appearing on the vendor's own site. It even allows you to create an online ordering system with a PayPal shopping cart: surely a novel extension for a RAW converter?

Equally strong are the areas of proofing, printing, and batch conversion. It gives you the option of printing directly to your printer or saving for later output to a photo lab. The vendor claims that the scaling interpolation is "superior to bicubic interpolation found in many image editing packages." The batch features include many of those already mentioned: RAW, Web pages, contact sheets, image rotation, and lens distortion correction. It also has a keyword editor for adding and editing keywords in batches of images. As one photographer has said: "Point it at a directory with 1,200+ images and it handles them with ease."

Comments

Chris Breeze's highly acclaimed software began as a Canon-only tool, then expanded to include other brands. It boasts a longer list of favorable reviews and customer comments than most software can claim, with endorsements from many professional wedding and landscape photographers. Ongoing development keeps it at the leading edge, with consistent upgrades to accommodate output from the latest cameras. A GPS template lets you link Geotagged images to online maps and create Web galleries. Competitively priced, it is an excellent value and for certain photographers it provides just the workflow they need.

Version: BreezeBrowser Pro 1.8 (2008)

OS: Windows 98 SE, ME, 2000, XP, and Vista

RAM: 512MB

Supported file formats: RAW (most); TIFF, JPEG, PNG, JPEG 2000, GIF, BMP, Photoshop PSD, and Paint Shop Pro

Price level: Approx. $70

Address: Breeze Systems Limited, 69 High Street, Bagshot, Surrey GU19 5UH, United Kingdom

www.breezesys.com

Capture One

Vendor: Phase One

Purpose: High-volume RAW file conversion for busy photographers

Description

Aimed at professionals like all Phase One products, Capture One is a powerful converter package that can turn RAW files into TIFF-RGB, TIFF-CMYK, or JPEG images on the fly, with excellent image quality and minimal noise. The software also comes in a "light" version, Capture One LE, for low-volume users.

Among the dozens of features in Capture One are instant high-res preview, multiple side-by-side preview, white and color balance adjustment, exposure/contrast correction, level/curves adjustment, histograms, cropping, IPTC templates, and acceptance of third-party ICC color profiles. It lets you correct unwanted color casts, has an overlay feature for easy alignment, a banding tool to suppress digital banding, Moiré suppression, and various sharpening and noise reduction tools.

Version 4 represented a major upgrade, allowing the user to open 12 images simultaneously at full resolution. You can also make multiple variants of a single RAW image without disk or performance overhead. Usefully for professionals, the licensing is transferable, enabling you to install the software on two computers with the option of using one or the other.

Comments

Capture One 4 is hard to beat for high volume processing of RAW files in a professional setting. It is not inexpensive but it comes with two free major updates. Its output quality is excellent, with fine details clearly rendered, and it generates large thumbnails and working images very quickly. However, it requires time to learn how to use it properly. The light version is much more suitable for beginners.

Version: Capture One 4.1.1 (2008)

OS: Windows Vista; Mac OS X 10.4.11 or higher

RAM: 512MB

Supported file formats: RAW (nearly all); JPEG and TIFF

Price level: Approx. $500

Address: Phase One A/S, Roskildevej 39, DK-2000 Frederiksberg, Denmark

Phase One Inc., 200 Broadhollow Road (Suite 312), Melville, NY 11747-0983

www.phaseone.com

LightZone

Vendor: Light Crafts

Purpose: RAW processor and image editor with zonal editing capability

Description

LightZone is an image editor that has a set of masking tools based on Ansel Adams's zone system. It supports all major camera RAW formats with native custom processing, uses small files to store image edits, and in these and other respects is not dissimilar to Adobe Lightroom.

The key feature of LightZone—and where it differs from other image editors—is the way in which it allows you to create regions by drawing lines rather than by painting. This means you can adjust the boundary of the region at any time: much more convenient for editing landscape photographs. You can blend the region smoothly into the

surrounding area with automatic "feathering." LightZone makes the zone system easier to understand with an interactive grayscale image analyzer called ZoneFinder. It segments a small version of the image into 16 grayscale zones, each differing by half an f-stop (50% brightness) from the next.

A companion tool, ZoneMapper, shows the zones in a graduated scale, over which you can position the mouse to see the corresponding zone highlighted in ZoneFinder. Using the two tools together you can find the white and black points, fix the exposure and obtain good, deep blacks, using luminosity-based adjustments. For example, when you expand a zone by moving the mouse in ZoneMapper, you get brighter values and increased contrast in the identified region. "This ability," says the vendor with some justification, "has been the missing element in truly moving the zone system into the realm of digital imaging."

You can also make color adjustments in LightZone using RGB values. Other tools include sharpen, blur, noise reduction, clone, crop, spot, and rotate. LightZone comes with an illustrated, 82-page book in PDF format that explains everything about its philosophy and operation in detail.

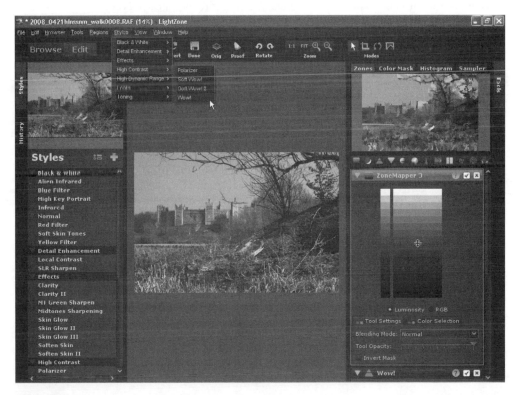

Figure 7.2
LightZone implements Ansel Adams's theories and provides a complete zonal editing capability.

Comments

With its attractive interface, LightZone is a pleasure to use and deserves to secure a share of the highly competitive image editing market. Its implementation of the zone system is logical and genuinely useful to photographers. Launched in 2005, it won *MacWorld* "Best of Show" the following year and the "Editors' Choice" award at the end of 2007. Ongoing development, excellent documentation, and favorable reviews have established it as a serious contender.

Above all, LightZone succeeds in partially automating the task of processing digital images without sacrificing quality control. For example, the built-in "instant styles" feature lets you select styles from categories such as high dynamic range, local contrast, and toning—and then tweak them to your taste. It is an innovative and effective approach that appeals to the unashamed control freak in every true photographer.

Version: LightZone 3.5 (2008)

OS: Windows 2000 with SP4, XP with SP2 (32-bit or x64), and Vista; Mac OS X 10.4.3 or later; Linux

RAM: 1GB (2GB recommended)

Supported file formats: Major RAW formats; JPEG, TIFF, and linear DNG

Price level: Approx. $250, Basic edition without multi-image editing and batch processing $150

Address: Light Crafts, Inc., 200 Sheridan Avenue, Suite 307, Palo Alto, CA 94306-2037, United States

www.lightcrafts.com

Raw Therapee

Developer: Gábor Horváth

Purpose: Free RAW converter and digital photo processor

Description

Based on Dave Coffin's freely available dcraw conversions of RAW code, Raw Therapee is a free RAW converter and digital photo processing software package.

Raw Therapee, which stands for "THe Experimental RAw Photo Editor," should not be underestimated. It has a very wide range of features, including contrast and white balance adjustment, custom curve support, temperature/green tint correction, independent shadow and highlight controls, luminance modification in CIELab color space, unsharp mask sharpening, color denoising, image flipping and rotation, cropping, and simple lens distortion correction. Most importantly, it produces superb quality RAW conversions.

Raw Therapee's interface is well laid out, with multiple panels including a large central image area. Other components of the interface are the Directory Browser, File Browser, Histogram, Image Processing Adjustments panel, a small Postprocessing Profile Switcher, Save/Preferences Buttons. It also includes other panels for zoom, rotate/flip, quick information (about shutter speed, aperture value, ISO sensitivity, and focal length), and finally a Tools panel.

Comments

Raw Therapee uses an enhanced version of Keigo Hirakawa's adaptive homogeneity-directed demosaicing algorithm, which fully matches the quality of demosaicing found in commercial software. Adaptive routines use rules based on the actual content of an image. Here, the software uses a special mapping technique (homogeneity mapping) to detect unwanted color artifacts and direct the interpolation away from them. Side-by-side comparison of the resolution achieved by Raw Therapee and other RAW converters is significantly in the favor of this shareware-style product. It was very well received by users when the developer first announced it on dpreview.com in mid-2006. One user said "...the best demosaicing yet." More recent versions have greatly improved the processing speed, while also adding ICC color management and user interface enhancements.

Version: Raw Therapee 2.4 (2008)

OS: Windows 2000, XP, and Vista; Linux GTK+ 2.10 series (see www.gtk.org)

RAM: 512MB

Supported file formats: Most major RAW and JPEG

Price level: Donation requested

Address: Budapest, Hungary

www.rawtherapee.com

RAW Developer

Vendor: Iridient Digital

Purpose: Powerful RAW image conversion for Macintosh only

Description

RAW Developer is a low-cost package with some powerful features, including non-destructive image processing and flexible batch conversion. It handles 16 bits per channel (48-bit RGB) and for some operations such as image sharpening can go up to 32 bits per channel using high dynamic range floating point numbers. It supports files from over 150 digital camera models, offers fast, high-quality image previews, flexible histogram viewing, and full support for Exif metadata.

Other RAW Developer features include ICC color management support through ColorSync, tone curves, color correction, exposure compensation, white balance, contrast,

saturation, noise reduction, and four advanced sharpening methods: unsharp mask, gaussian, hybrid, and (Mac OS X 10.4 or later) *Richardson-Lucy Deconvolution,* an iterative technique often used by astronomers to recover latent images that have a known amount of blurring. RAW Developer also offers filters for removing *hot pixels,* those tiny sparks of color that appear as blemishes on low-light scenes taken with a long exposure, and *dead pixels,* which are from individual photosites on the camera's sensor that have no response to light and always read zero.

Comments

RAW Developer from tiny Iridient has been compared very favorably with software coming from large corporations. It produces terrific image quality with a real "film look." Sharpening controls are first-rate, with no in-built tendency to oversharpen. Although it lacks the high-throughput features of Capture One, its quality is comparable. Keen photographers should certainly try it. The trial version is fully functional.

Version: RAW Developer 1.7.2 (2008)

OS: Mac OS X

RAM: 512MB

Supported file formats: RAW (most), JPEG, TIFF, PNG, and JPEG 2000

Price level: Approx. $100

Address: sales@iridientdigital.com

www.iridientdigital.com

SILKYPIX Developer Studio

Vendor: Ichikawa Soft Laboratory (ISL)

Purpose: RAW file processing package with adjustments for color, tone, and white balance

Description

It might not be the first choice of RAW developer for a photographer in Europe or the United States, especially after trying to read the (machine translated?) Website. Yet SILKYPIX Developer Studio is highly rated by many users, especially by reviewers on account of its outstanding tonal quality and high level of detail. Not the least of its attractions is the incredible speed with which ICL responds to the launch of a new camera, usually being the first third-party developer to offer a RAW conversion for it.

Features include adjustment for color, tone, and white balance, chromatic aberration control, unsharp masking, and lots of "taste functions" that emphasize different aspects of the scene such as blue sky, red enhancer, and even "nostalgic toy camera." It supports ICC profiles, batch development, contact sheet printing, and Adobe RGB and sRGB color spaces.

Comments

SILKYPIX is the new rendering engine used for RAW processing PEF files in Pentax's Lab software. It is also the supplied RAW converter with Panasonic Lumix cameras. It is impossible to fault SILKYPIX either in terms of quality or the number of features it offers. It is a seriously good RAW tool with plenty of ongoing development to keep it at the forefront of this competitive sector of the market.

Version: SILKYPIX Developer Studio 3.0.9.2 (2008)

OS: Windows XP, 2000, and Vista; Mac OS X 10.2

RAM: 1GB

Supported file formats: RAW (nearly all), JPEG, and TIFF

Price level: Approx. $150

Address: Ichikawa Soft Laboratory Co., Ltd., Makuhari Technogarden Bldg. CD5F, 1-3, Nakase, Mihama-ku, Chiba-city, Chiba, 261-8501, Japan

www.isl.co.jp/SILKYPIX/english/

U.S. distributor: Shortcut Software International Inc., 14252 Culver Dr. # A319, Irvine, CA 92604

www.shortcutinc.com

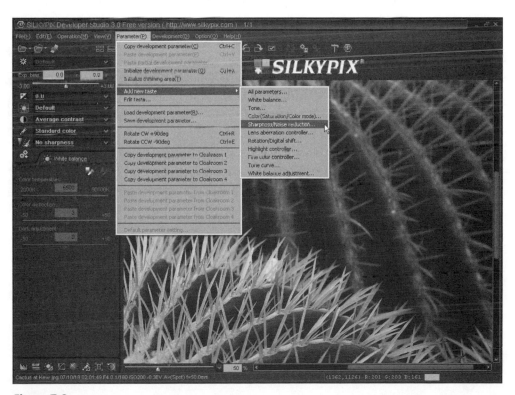

Figure 7.3
SILKYPIX Developer Studio lets you apply various "taste functions" to the RAW image.

Silverfast DCPro

Vendor: LaserSoft Imaging

Purpose: RAW conversion and image enhancement for all major digital cameras

Description

Silverfast DCPro is a RAW conversion suite with sorting capabilities and image processing. It has three applications within it:

- Virtual light table
- Development
- Print processing

On the light table you can browse through your folders, sort the images into groups, tag them with keywords, and place them in queues for batch processing. The development facilities offer many controls for exposure correction, sharpening, and two types of noise reduction. It has what the vendor calls "Selective Color Correction," enabling you to identify a specific color in the image and change it. The print processing module contains several templates together with facilities to create your own.

Silverfast DCPro is an adaptation of the vendor's well-known scanner software, and, as such, it comes with scanner-type features. "Adaptive Color Restoration" automatically brings back faded colors, while another function eliminates grain. These features have limited appeal to the digital photographer but are useful to photo restorers. The development user interface is somewhat cluttered with floating windows rather than the sliding panels of the latest purpose-built processors.

Comments

In side-by-side tests with other RAW converters, Silverfast DCPro has scored high for resolution, sharpening, and exposure quality; poorly for speed, features, and value for money. Discussion among digital enthusiasts on dpreview.com tended toward negativity, many people being unhappy with its image quality and most people disliking its slowness. However, its color tools are first-rate and it may well have just the features required by certain users.

Version: Silverfast DCPro 6.5 (2008)

OS: Windows 2000 with SP2, XP with SP4; Mac OS X 10.8 and higher recommended

RAM: 256MB

Supported file formats: Reads major RAW formats, TIFF, and JPEG; writes JPEG, TIFF, PDF, and EPS

Price level: Approx. $300

Address: LaserSoft Imaging AG (Germany), Luisenweg 6-8, 24105 Kiel, Germany

LaserSoft Imaging, Inc., 3212 Gulf Gate Drive, Unit B, Sarasota, FL 34231, United States
www.silverfast.com

Raw Photo Processor

Vendor: Andrey Tverdokhleb

Purpose: Mac-only RAW conversion for almost all digital camera RAW and DNG formats

Description

Raw Photo Processor (RPP) is a Mac-only RAW converter that offers some advantages over the standard Adobe Camera RAW processing in Photoshop and Lightroom. It is especially good at bringing out detail in heavily underexposed images and in getting accurate rendition of subtle blues and grays. It supports custom camera profiles; has excellent four-channel white balance control; uses high precision math to preserve shadows and highlights; has a facility to increase contrast without greatly impacting overall tonality; and offers a sophisticated monochrome mode for producing black and white, sepia, and other monochrome styles.

RPP supports several different ways of working with white balance—automatic detection, "as shot" (taken from camera), custom white balance from neutral areas, and color tone adjustments on a "cold/warm" scale. Its treatment of color saturation differs from others by taking a more sophisticated approach, according to its developer Andrey Tverdokhleb (who does not elaborate on this topic). However, the first rate result speaks for itself.

Comments

As the developer readily admits, user interfaces are not his strongest suit. That said, RPP is an excellent processor in nearly all other respects. It has won a following from hordes of DSLR photographers, particularly from users of Fuji cameras who strive for exceptional dynamic range. RPP maximizes the in-built advantage of the Fuji S3, S5, and so on, cameras with their special highlight-gathering sensors. It also helps to bring other cameras closer to the Fuji standard by helping to recover lost highlights. It is especially good at eliminating purple fringing, although there is no special code in the software to do it. ("It just works," says the developer.)

Version: Raw Photo Processor 3.7 (2008)

OS: Mac OS X (10.4 or 10.5)

RAM: 256MB

Supported file formats: Most RAW

Price level: Free

Address: San Francisco, California, United States

www.raw-photo-processor.com

Summary

Its ever-growing popularity among serious photographers has led to the inclusion of RAW conversion in the best image processing and editing software. Both Apple and Adobe have improved their integral RAW converters in Aperture, Photoshop, and Lightroom. However, there remains an excellent selection of RAW converters, both from camera manufacturers and independent developers, that help you go the extra mile to extract maximum quality from your original capture. Space has not permitted the inclusion of all the camera-specific software (such as Fuji's FinePixViewer with its brilliant RAW conversion but widely criticized user interface). Whatever brand of camera you normally use, both LightZone and SILKYPIX Developer Studio are "must-try" products.

8

Image Processors

In a sense, all photo enhancement utilities could be called "image processors" because they all process the image in one way or another. RAW converters and image editors are certainly image processors, but in between them there is a large group of software that deals with fine-tuning the image, using tools that could well be found in either of the other two categories. The difference is they do not make RAW conversion the center of their activities, nor do they have the image editor's graphical capabilities (although you may find one or two of them heading in that direction).

In general photography, image processing is intended to improve the look of the image, but in science and engineering, it is used for identifying different aspects of the image's content. For this reason, scientific image processors with all their measurement and analysis tools tend to be more elaborate and costly. Image Pro Plus from Media Cybernetics, one of the most popular image processors in labs and industry, has an entry-level edition that uses third-party plug-ins to extend its functionality.

The best way to consider the software in this category is to look at each one individually rather than trying to make comparisons between them. Any one of them could have something to offer your workflow, or you may find that you already have these bases covered. Some merely offer an alternative way of achieving standard fine-tuning enhancements for shadows, highlights, color, and saturation. I considered some other packages for this category, but rejected them on the grounds that they did not offer any new techniques beyond the choices already available. A few products that were here originally have migrated to Chapter 9, "Quick-Fix Software," where speed of enhancement is the governing factor.

AnselPRO

Vendor: Sean Puckett

Purpose: Bibble plug-in to alter a histogram according to the theory of light zones

Description

AnselPRO is designed to give you complete control over the lighting in a digital image, worked out according to Ansel Adams's theory of light zones. It has quite a complex user interface: two of them, to be precise. The big one looks like the mixing desk in a recording studio, with nine slider controls for each of nine zones including black and white. There are four more slider controls for the film curve: contrast, shadows, balance, and highlights; and two more for exposure: linear and midtones. Finally, there are two "modifiers," one for adjusting total luminance, the other to control how much of the "Ansel Effect" gets applied to the image. The alternative UI collapses the zones into tabs, which makes it look somewhat less intimidating.

The secret to using AnselPRO is to follow the developer's instructions and try not to start adjusting zones immediately. Start at the top of the interface and work your way down, one step at a time. It is really very well conceived and it incorporates many of the developer's ideas from his previous work.

Comments

If you find Ansel Adams's zone system inscrutable, as some photographers do, this is obviously not the ideal tool. But it obliges you to consider the shadows separately from the midtones, and both independently of the highlights. This is good photographic practice, whatever your style or genre. AnselPRO is definitely a product to use in conjunction with reading Adams's classic instruction manuals (*The Camera, The Negative*, and *The Print*).

Version: AnselPRO 1.1 (2008)

Plugs into: Bibble Pro (Note: Upgrade when Bibble upgrades)

OS: As host

RAM: 256MB

Supported file formats: As host

Price level: $20

Address: seanmpuckett@gmail.com

www.nexi.com

ArcSoft PhotoStudio Darkroom

Vendor: ArcSoft

Purpose: Non-destructive imaging processing for RAW, JPEG, and TIFF image files

Description

With a built-in photo browser and extensive RAW support, ArcSoft PhotoStudio Darkroom offers a full range of standard image processing features, including exposure and white balance adjustment, lens correction, curves and levels, crop and straighten, red-eye removal, and one-click spot/patch removal. It supports the most popular color spaces, has batch export facilities, and can convert RAW files to Adobe DNG for archiving.

PhotoStudio Darkroom's interface has the modern arrangement of thumbnail strip at the bottom, histogram at top-right, and a large viewing area for the images. You can see your pictures in "Before-After" viewing mode or in "Side-by-Side" mode for comparison and selection. The lens correction utility can fix purple fringe, vignetting, barrel, pincushion, and perspective distortions. Export of the processed RAW files is to high-quality JPEG or TIFF (24- or 48-bit) format.

Comments

ArcSoft PhotoStudio Darkroom was placed by *Popular Photography* as No.2 in a list of five top RAW converters. That is quite an achievement, given the competition. Its RAW format support is particularly strong, including output from Hasselblad H2D and Mamiya ZD cameras. Like most ArcSoft products, it is aimed at both professionals and hobbyists, a dual personality that may tend to confuse its image in the market. Essentially it is a low-cost alternative to Apple's Aperture, with support for Windows.

Version: ArcSoft PhotoStudio Darkroom 1.5 (2008)

OS: Windows 2000, XP, and Vista; Mac OS X 10.3 and 10.4

RAM: 512MB

Supported file formats: Most RAW formats; JPEG and TIFF

Price level: Approx. $100

Address: ArcSoft Corporate Headquarters, 46601 Fremont Blvd., Fremont, CA 94538, United States www.arcsoft.com

ColorWasher

Vendor: PhotoWiz

Purpose: A set of tools for correcting, enhancing, and restoring photos

Description

With ColorWasher, you can correct the colors, contrast, exposure, and saturation of 8-bit and 16-bit photos. The vendor, Harald Heim of The Plugin Site, suggests that you use it after RAW conversion to fine-tune the adjustments.

ColorWasher has seven methods called *cast types* for reconstructing lost colors and detail. Its tools go beyond ordinary brightness and gamma correction by boosting contrast, hiding noise, maintaining steady saturation, and increasing the number of colors in the image. Its Auto Contrast and Exposure Fix features can be set to several different levels, while this software also offers the option of manual adjustment in percent and EV values. It has excellent histograms: 10 types in four styles for expert use. There is also an Easy Mode, in which the program starts by default. Most of the time you can stay in this mode except when faced with a difficult image. At this point you need to read the vendor's "Tips for Tough Cases" in the very detailed user manual.

Comments

ColorWasher is prized especially by enthusiasts for its ability to help the user correct colorcasts. Independent tests by many reviewers were unanimous in praising its ease-of-use and overall effectiveness.

Version: Windows ColorWasher 2.02c; Mac OS X 2.01 (2008)

Plugs into: Photoshop, Elements, Paint Shop Pro, PhotoImpact, Photo-Paint, Fireworks, and so on

OS: Windows 95, 98, NT, ME, 2000, XP, and Vista; Mac OS X

Supported file formats: 8-bit and 16-bit RGB and grayscale images

Price level: Approx. $50

Address: Nuremberg, Germany

www.photocorrection.com

Curvemeister

Vendor: Mike Russell (sold through order.kagi.com)

Purpose: Specialist curve control software to manipulate images in wide gamut CMYK space

Description

Mike Russell's Curvemeister is a Windows-based plug-in for Photoshop 5 and above. It works with all versions of Elements, which means you can turn Elements into an excellent curve machine without having to buy the full-blown version of Photoshop. It has a huge range of features, many of which are not in the host program.

Curvemeister has a color wizard to speed up color correction; a threshold function to locate shadows/highlights and to spot clipping immediately; switching between color spaces on-the-fly; a "hue clock" to help you judge colors such as skin tones; multiple curve adjustment; optional histogram overlay; corner-fill; curve rotation; and plenty of tutorial help. Once you have created a curve, it can be yours forever—the program saves every curve automatically, allowing you to look it up by date, time, and image filename. Curvemeister gives you a choice of working in different color spaces and then returning the file to Photoshop in RGB.

The hue clock, a particularly innovative feature in Curvemeister, displays copies of a one-handed clock to show the hue and saturation of any part of the image. When you click on a small group of pixels, the clock displays the color across its face while the hand indicates the level of RGB/CMY. All you have to do is remember the appropriate "time" (color) for skin, sky, or foliage, and you can see instantly whether any correction is needed.

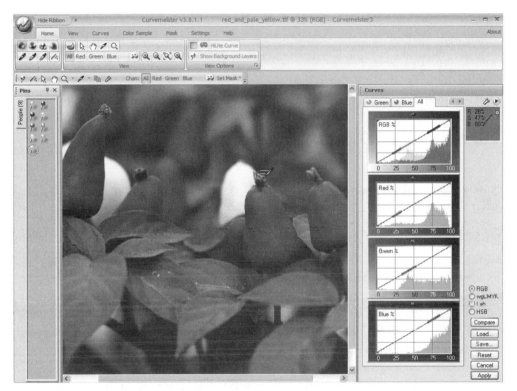

Figure 8.1
Curvemeister provides comprehensive curves adjustment from this compact window.

Comments

Highly regarded by editing experts, Curvemeister gives you a choice of working in different color spaces and then returning the file to Photoshop in RGB. Wide gamut CMYK (wgCMYK) is excellent for adjusting shadows; Lab is preferable for adjusting highlights, brightness, and saturation.

New features in Curvemeister 3 include 8- and 16-bit masking and some highly innovative improvements to the user interface. For example, HiLite Curve commands show which part of the image is affected by a particular area of a curve; Microsoft Office 2007–style Ribbon Bars appear at the top of the screen; and Color Worms allow you

on the curve preview to visualize the range of colors in the image sample (pointed at by the mouse).

Version: Curvemeister 3 (2008)

OS: Windows 98, NT4, ME, 2000, or XP

Plugs into: Photoshop version 5.5 and later; all versions of Photoshop Elements

RAM: 1.24MB

Supported formats: 8- or 16-bit images in RGB, CMYK, or Lab

Price level: Photoshop version approx. $90, Photoshop Elements version approx. $45

Address: Berkeley, CA, United States

www.curvemeister.com

Farrar Focus Digital Darkroom

Vendor: Farrar Focus

Purpose: A regularly updated set of professional Photoshop scripts and actions for 16-bit digital image development

Description

Farrar Focus Digital Darkroom is a set of Photoshop scripts and actions likely to appeal to advanced landscape photographers looking for bracket and blend scripts and post-processing actions such as denoising and sharpening. Its complete list of features is quite extensive, divided into Common Actions like curves, denoise, desplotch, and add grain; Color Space Action Sets to create zone layers, sharpen, and restore dark detail before printing; Linear Specific Actions to convert from ProPhotoRGB color space; Gamma1.8 Specific Actions to convert documents to ProPhotoRGB; and Gamma2.2 Specific Actions to convert to Adobe RGB 1998 or sRGB. There are also scripts for blending, contrast sharpening, and various batch processing options.

Comments

Authored by Timothy Farrar originally for his personal use, Farrar Focus Digital Darkroom has acquired a following among advanced users who benefit from his expertise. Each new release concentrates on one or two specifics: FFDD 5 focused on noise reduction, sharpening, and enlargement, whereas FFDD 6 (2008) adds tools for an efficient High Dynamic Range stitching workflow. FFDD straddles the leading edge of digital image manipulation, with one foot in accepted practice and another in purely experimental territory. It is not expensive to join the author's quest for ultimate quality —and you get free updates for a year.

Version: FFDD 6 (2008)

Plugs into: Photoshop CS and CS2

OS: Windows 2000, XP, and Vista; Mac OS X

RAM: 256MB

Supported file formats: As host

Price level: Approx. $90

Address: Farrar Focus LLP, 714 W 63rd St., Unit 202, Westmont, IL 60559, United States

www.farrarfocus.com/ffdd (see sitemap for latest link)

Kodak DIGITAL SHO

Vendor: Eastman Kodak Company

Purpose: Software to reveal lost detail in shadow areas of a digital image

Description

Kodak DIGITAL SHO (SHO stands for "Shadow and Highlight Optimization") analyzes an image and automatically brings out the detail in the shadows, without sacrificing highlight detail. It is a specialist tool that could be useful to anyone who has a lot of underexposed pictures to correct. You can treat multiple images by recording the procedure as a Photoshop action.

There are two editions of Kodak DIGITAL SHO: the standard edition that handles 8-bit images and the pro edition for 8- or 16-bit images which also has additional features. For example, the user can set the threshold between shadow and highlight, as well as control the degree to which the shadows are lightened or the highlights darkened independently of each other.

Comments

Kodak does not explain the acronyms SHO, ROC, or GEM very prominently (ROC color restoration and GEM soft focus and image sharpening software being other products in the same suite). This is a pity because they do at least identify what the software actually does. One reviewer thought SHO did exactly the same as GEM, when in fact it has a completely different function. Other reviewers found SHO more impressive than ROC, recognizing that it delivers exactly what it promises—shadow and highlight optimization. For more information on DIGITAL ROC, see Chapter 20, "Photo Restoration." For DIGITAL GEM, see Chapter 17, "Noise Reduction."

Version: Kodak DIGITAL SHO 2.1 (2008)

Plugs into: Photoshop 5.0 and up; Elements 1.0 and up; Windows only—Paint Shop Pro 7 and up

OS: Windows 98 and up; Macintosh OS 8.6 and up

RAM: 256MB

Supported file formats: As host

Price level: Approx. $50, Pro edition $100

Address: Kodak's Austin Development Center (KADC), Austin, TX, United States

www.asf.com

Kubota Image Tools

Vendor: Kubota Photo-Design

Purpose: Sets of Photoshop Actions in different editions, plus layout software and RAW work-flow training

Description

Developed by educator Kevin Kubota, the Kubota Image Tools are mostly Photoshop Actions for image enhancement, filtering, and special effects, but there are also other products in the line-up including a RAW workflow training CD and the AutoAlbum magazine album layout software utility.

The Photoshop Actions are packaged in several different editions: Artistic Tools vols. 1–4, Production Tools vol. 1 (with the implication that there will be more volumes), and Sloppy Borders vol. 1 (again, more to follow?). If you are feeling bold, you can purchase all of them in one complete package called Studio Set, which even includes the Digital Photography Bootcamp book, as used in the workshops run by the author.

Production Tools has over 50 Photoshop Actions, such as batch resizing, batch color correction, tonal correction, rotations, retouching setups, and saving multiple file copies in one step.

Artistic Tools also comes with 50+ Actions in each volume, notably black-and-white conversion, which has been highly praised by specialists, but also many others including glowing skin effects, organic film grain, backlight compensation, and soft filters. Volume 2 goes over the top with some adventurous processing (*Lord of the Rings, Hawaiian Punch,* and so on).

Sloppy Borders has over 100 ready-to-use sloppy border variations for giving prints a "retro look."

Comments

Although not inexpensive, the Kubota Image Tools can save a lot of time in the "digital darkroom." They have a very good reputation among photographers, picked up two "Hot One" awards from *Professional Photographer* at the Imaging USA 2007 show, and are based on long practical experience in digital photography.

Version: New Actions in new volumes

Plugs into: Photoshop 7.0 and up (some Actions require Photoshop CS2 and up)

OS: Windows 98, 2000, NT, ME, XP, and Vista; Mac OS X

RAM: 256MB

Supported file formats: As host

Price level: Studio Set $1,200, Production Tools $150, Artistic Tools $150

Address: info@kubotaimagetools.com

www.kubotaworkshops.com

LightMachine

Vendor: PhotoWiz

Purpose: Specialist software for correcting brightness, contrast, color, and saturation in specific image areas independently from each other

Description

If you are looking for a specialist light correction tool, this could be the answer. It has some clever masking options that allow you to separate parts of the image for independent processing. A brightness/contrast mode operates globally, but there is also a shadows/highlights mode that gives you complete control over dark and bright areas anywhere in the image. Virtual Studio modes then allow you to arrange shadow and light spots very much as though you are placing studio lights, with control over the intensity, size, "ovality" (spot shape), angle, hardness, and reflection properties of each spotlight.

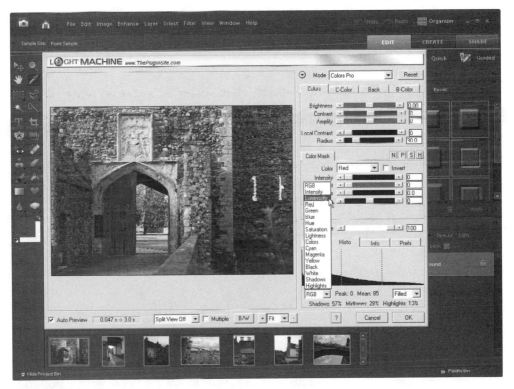

Figure 8.2
LightMachine has complex tools, but also provides many presets for correcting color, lighting, shadows, and highlights.

Comments

LightMachine works very effectively, although it can be time-consuming to perfect the masking with its highly precise adjustment parameters. It has a full complement of presets, with some excellent "pseudo HDR" effects. Most reviewers were agreed that it represented good value for money at its launch—and it is now substantially cheaper. For those who want to gain ultimate mastery over shadows, highlights, and colors, this is definitely a plug-in worth trying.

Version: Windows 1.02, Mac OS X 1.0 (2008)

Plugs into: Photoshop, Elements, Paint Shop Pro, PhotoImpact, Photo-Paint, Fireworks, and so on

OS: Windows 95, 98, NT, ME, 2000, XP, and Vista; Mac OS X

Supported file formats: 8-bit and 16-bit RGB and grayscaled images

Price level: Approx. $70

Address: Nuremberg, Germany

www.photocorrection.com

Lobster

Vendor: FreeGamma

Purpose: Lets you make changes to a luminosity layer in Photoshop without affecting either hue or saturation, and vice versa

Description

Lobster is a companion (or "droplet") application that lets you experiment with Curves and Levels in almost unlimited ways. To use it, you drag and drop Photoshop files directly onto the Lobster icon. Lobster creates four new layers from an RGB file: luminosity, plus a red-green-blue "chromaticity set" (hue and saturation), but at the same time it lets you continue to work in RGB mode. This means you can make changes to luminosity without affecting color, an adjustment not normally possible in RGB. The converse is also true: you can lock luminosity into place and use the chromaticity set to change either hue or saturation, or both. Other features include new tools such as dodge and burn and the ability to set the black and white points in Levels and Curves without changing hue.

Comments

Lobster is fast and efficient and does not take up much room on your computer. However, a Lobster file is around three times the size of a single-layered version, so you need plenty of memory to cope with it. It is aimed at experienced Photoshop users rather than beginners, but has excellent documentation online.

Version: Lobster 2.0 (2008)

Works with: Adobe Photoshop 7 to CS3 (Note: Lobster is a stand-alone application, but requires Photoshop)

OS: Windows XP with SP2; Mac OS X 10.3.9 and up

RAM: At least 1GB

Supported file formats: 24-bit/48-bit Photoshop RGB (flat files only)

Price level: Approx. $100

Address: FreeGamma Pty Ltd., Melbourne, Victoria, Australia

www.freegamma.com

Optipix

Vendor: Reindeer Graphics

Purpose: Suite of plug-ins for enhancing digital photographs, with Refocus and JPEG Cleaner

Description

Optipix is a suite of plug-ins for solving common photographic problems. The key features of the software are as follows:

- Auto Contrast: With zone system integration and control over midtones
- Blend Exposures: For blending two or more images to improve contrast
- Detail Sharpener: To improve textures and fine detail
- Interactive Interpolation: "Up-rezzing" tool for rescaling images
- Refocus: Removes blurriness and softness without sharpening artifacts
- JPEG Cleaner: Removes JPEG *blockies* (compression artifacts) for a cleaner image

The software comes with a 60+ page Optipix Guide and has a wealth of other features. It is intended for 16-bits per channel workflow from capture to print.

Comments

Optipix can be used by relative beginners, but experienced photographers will love features like Power Median, which lets you remove noise that has a specific shape or orientation. Another outstanding feature is Blend Exposures, which allows you to blend bracketed images together to obtain perfectly exposed highlights, midtones, and shadows. One of the best documented of all the packages described in this book, Optipix was widely praised by reviewers, both at its introduction and at the launch of the major 3.0 upgrade. Seek, buy, enjoy...

Version: Optipix 3.1 (2008)

Plugs into: Photoshop 7, CS, CS2, or compatible

OS: Windows 95, 98, ME, NT4, and 2000, XP; Mac OS X 10.2 and up

RAM: 128MB (minimum)

Supported file formats: Major file formats

Price level: Approx. $150

Address: Reindeer Graphics, Inc., P. O. Box 2281, Asheville, NC 28802, United States

www.reindeergraphics.com

PhotoKit

Vendor: PixelGenius

Purpose: A toolkit for replicating over 140 analog photographic effects by digital means

Description

PhotoKit is a Photoshop plug-in that lets photographers create analog effects in an analog-style way. It works only on RGB images (not CMYK, Lab, or Grayscale). All the effects create a new layer that's labeled with the name of the effect. Hence, all the procedures are completely non-destructive.

The effects are grouped in sets, such as the Toning Set, the Burn Tone set, the Color Balance set, Dodge Tone set, Image Enhancement set, and so on. Together they make up a powerful battery of weapons with which to tackle the task in hand. It is particularly strong on grayscale conversion, the color-to-black and white set having 12 effects. The same is true of Tone Correction, which has 25 effects. It is a package that appeals especially to landscape photographers seeking the highest quality images.

Comments

From the same team that brought us PhotoKit Sharpener, PhotoKit can speed up the workflow while contributing to image quality.

Version: PhotoKit 1.2.6 (2008)

Plugs into: Photoshop 6 and up (does not run on Photoshop Elements; needs CS or greater for 16-bits per channel RGB images)

OS: Windows 98, SE, ME, 2000, and XP Home/Pro; Mac OS 9.1, 9.2.x, or Mac OS X 10.1.3–10.3.3 or above

RAM: 128MB

Supported file formats: JPEG, TIFF, and Adobe PDS

Price level: Approx. $50

Address: PixelGenius, 624 West Willow Street, Chicago, IL, 60614, United States

www.pixelgenius.com

Photo-Plugins

Vendor: George Fournaris

Purpose: A collection of "free plug-ins for the serious photographer"

Description

The free Photo-Plugins collection consists of the following:

- B/W conversion, with complete control over red, yellow, green, cyan, blue, magenta, and intermediate hues

- Selective saturation, which lets you define a saturation zone by setting its center/range with two sliders

- Local contrast enhancement, brings out detail by heightening local contrast

- High pass sharpening, with adjustment of filter radius, and blending control

- Soft focus, applies a soft focus effect for portraits or fashion

- Lens correction, corrects barrel and pincushion distortions

- Contrast mask, reduces overall contrast, brings out details in highlights/shadows

- Gradient blur, to draw the viewer's attention to the photograph's main subject

Comments

Developed by George Fournaris while he was co-administrator of Digital Photography Greece (www.dpgr.gr), Photo-Plugins are variable in quality. The B/W conversion produces better results than gradient blur. Many people say they have found them useful, according to the on-site forum.

Version: 1.0 (2008)

Plugs into: Photoshop, Elements, Illustrator, ImageReady, IrfanView, XnView, VCW VicMan's Photo Editor, and imageN

OS: Windows 2000 and XP

RAM: 128MB

Supported file formats: Major formats

Price level: Freeware

Address: info@photo-plugins.com

www.photo-plugins.com

Power Retouche Plug-ins

Vendor: Power Retouche

Purpose: Tools for changing or enhancing digital photographs

Description

For Photoshop and compatible editors Danish artist Jan Esman has developed an entire range of plug-ins that are among the most highly regarded in the industry. They are as follows:

- Black & White Studio—A "digital darkroom" to convert color images to black and white, in 8 or 16 bits per channel

- Illumination Editor—For editing the illumination and shade in a photo, with "set light direction" feature

- Dynamic Range Compressor—For full control over all aspects of dynamic range

- Sharpness Editor—Unsharp masking with optional anti-aliasing

- Lens Corrector—For correcting common lens distortions, including barreling and pincushion

- White-Balance Corrector—Cures any color temperature imbalance, even mixed neon and halogen

- Noise Corrector—Includes five different methods to filter noise, plus detail-preservation masking

- Film Grain—Emulates traditional film grain and lets you add it to your photos

- Graduated Color—Lets you apply one or two graduated colors when retouching

- Toned Photos—Adds color tones such as sepia, kallitype, silver gelatin, cyanotype, and so on

- Golden Section—Draws golden sections, golden spiral, golden triangles, rule of thirds, and harmonic triangles

- Exposure Corrector—Corrects under- or overexposure in the whole photo or selected areas

- Histogram Repair—Uses interpolation to fill in missing values caused by processing

- Radial Density Corrector—For total vignetting control over radial exposure and brightness

- Anti-Aliasing—Gets rid of edge roughness and "jaggies"

- Black Definition—Lets you adjust black as though it were a color channel

- Contrast—Lets you control black/white contrast independently of color-contrast, without changing color or saturation

- Saturation—Edits saturation without splitting the image up into primary colors

- Color Corrector—Removes colorcasts from images

- Posterizer—Independently posterizes color hues and values and applies blending modes

- Edgeliner—Can turn photos into line drawings, with toneline lithfilm emulation

- Transparency Editor—Makes the background or other parts of the image transparent

- Soft Filter—Imitates traditional lens soft-filters, by controlling strength and spread of the softness without blurring

- Brightness Editor—Edits brightness while preserving color

Comments

The most economical (and sensible) way to buy the Power Retouche plug-ins is as a complete bundle. Most of them support images that are 8- or 16-bit in RGB, Grayscale, Duotone, CMYK, Multichannel, or Lab color spaces. However, some are much more fully featured than others. The most highly praised is Black & White Studio (see that separate entry), some are reinventions of the wheel, others have very useful, unique features.

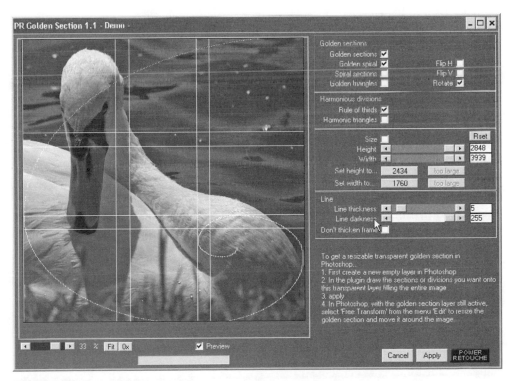

Figure 8.3
Power Retouche plug-ins cover most bases, including Golden Section analysis.

Golden Section is a particularly neat implementation of the classical rules of proportion: great if you have sufficient resolution for heavy cropping. They will plug into a very extensive range of editors, listed in full on the vendor's Website.

Version: (Pro Pack) 7.1 (2008)

Plugs into: Windows and Mac—Photoshop all versions; Windows only—Photoshop Elements, Paint Shop Pro, Fireworks, CorelDRAW, and many other editors

OS: Windows (any version that can run the host program); Mac Classic and OS X

RAM: 256MB

Supported file formats: As host

Price level: Complete set approx. $125, individually $32–$63

Address: Power Retouche/Jan Esmann, Tagensvej 109B st, tv, DK-2200 Copenhagen N., Denmark

www.powerretouche.com

Tone Adjuster

Vendor: SoftWhile

Purpose: Adds to Photoshop's standard tonal adjustment functionality

Description

Tone Adjuster adds further controls over tonal adjustment for Photoshop users. It provides a Cubic Bézier spline to help tame the tonal curve, together with probes that can be placed on the displayed image for an instant readout on a graduated black/white tone bar. The plug-in gives you a choice of three different brightness models (HSL, HSV, and YCbCr), together with a brightness only preview. A full histogram indicates the tonal distribution.

Comments

Like its companion product Color Adjuster, this one works best if the image is 16 bits per channel. Not everyone finds B-splines easy to use, but Tone Adjuster is intended for advanced users. It is a good tool for the enthusiast, but most photographers will find sufficient tools in other editors.

Version: Tone Adjuster 1.3 (2008)

Plugs into: Photoshop 7 and greater; Elements

OS: Windows ME, 2000, XP, and Vista

RAM: 128MB

Supported file formats: Major formats

Price level: Approx. $30

Address: info@softwhile.com

www.softwhile.com

ToneUp S3

Vendor: Todd Gibbs

Purpose: Powerful, very low-cost image processing with NEF conversion and custom curve-loading

Description

A low-cost alternative to Nikon Capture, Todd Gibbs's ToneUp enables you to upload custom curves to a Nikon DSLR. It also converts raw NEF files for editing in Photoshop and other image processing applications, using Nikon's NEF conversion algorithm. It allows you to perform image processing on images from any camera, including adjustment of brightness, contrast, exposure, saturation, channel mixing, sharpness, color balance, and white balance. Its "hot swap" feature lets you load your five favorite curves and switch them quickly so you can shoot with a chosen curve. With ToneUp you can change the comment field in the photo to the name of the curve, so that it shows up in Exif data. If you want, you can make your own curves and load them, or use Nikon Capture curves from the ToneUp database.

Comments

An ongoing project by a professional games developer, ToneUp is becoming a more general application as it evolves. If you are using Windows Vista or XP it allows you to carry out time-lapse photography over a set time span. Other new features include cropping and resizing, and batch processing. It is an excellent value.

Version: ToneUp S3.204 beta (2008)

OS: Windows XP, 2000, and Vista

Supported file formats: RAW (most); TIFF, JPEG, and PNG

Price level: Approx. $15

Address: Oxford, United Kingdom

www.toneupstudio.com

Turbo Photo Editor

Vendor: Stepok Image Lab

Purpose: Photo processing software with some original features, including a "what's wrong?" wizard

Description

This "digital darkroom" package comes from an emerging developer in the People's Republic of China, from the same team that brought us the Recomposit photo masking and compositing tool. Turbo Photo Editor has a powerful RAW Importer module that lets you bring in files from most makes of DSLR. It gives you control over both exposure and color, and then goes on to provide a range of cropping, resizing, retouching, special effects, image management, exporting and printing, and batch processing tools.

Turbo Photo Editor's "Digital Beauty" feature makes it easy to erase spots and blemishes from portraits while tuning the skin tone and level. A professional version of this feature is available separately and provides tighter control over all the parameters.

Especially strong on batch processing, Turbo Photo Editor lets you batch resize, convert format, rename, rotate or flip, defog, reduce noise, sharpen, add dates, and make basic adjustments to color and exposure. One other feature of the software that is particularly notable is the "what's wrong?" wizard. It can detect common faults and suggest remedies. For example, if you have taken a series of handheld photographs of the same subject, it can analyze for camera shake and correct it.

Comments

At the time of writing, Turbo Photo Editor is being upgraded every two months. At this rate it could become a powerful challenger to other, established editors in the United States and Europe. Among its many features is an excellent removal tool for taking out unwanted objects and then repairing the gap neatly and automatically. If you are unhappy with the result then a second or third iteration will always improve it. If you can overcome the stilted English of Stepok's explanations you will find many other well implemented and useful features in the software. Incidentally, according to the vendor "StepOK" means "the final step to achieve destination."

Version: Turbo Photo Editor 6.0 (2008)

OS: Windows 2000, XP, and Vista

RAM: 128MB

Supported file formats: RAW Canon RAW CR2, CRW; Kodak RAW DCR; Adobe DNG; Konica Minolta MRW; Nikon NEF; Olympus ORF; Fujifilm RAF; Leica RAW, Contax RAW, Casio RAW; Sony SRF, JPEG, GIF, PNG, TIFF, and BMP

Price level: Approx. $60 (with unlimited free upgrades)

Address: No.89 ShuTongJie, JiNiu Qu, Chengdu, Sichuan, People's Republic of China, 610036

www.stepok.net

Two Pilots Software

Vendor: Two Pilots

Purpose: Around two dozen separate image-editing programs, including Color Pilot color correction software

Description

Two Pilots software comes as multiple stand-alone programs for specific editing tasks, rather than as one big package. The first was Color Pilot, also available as a plug-in, which lets you make color changes to images. Others are as follows:

- Beauty Pilot—Removes skin imperfections in portraits

- Exif Pilot—Create, view, and edit Exif data

- Layer Pilot—Makes image posters

- MakeUp Pilot—Adds makeup effects directly to portraits

- Perspective Pilot—For perspective correction

- Pet Eye Pilot—Removes red, blue, and green eyes from pet photos

- Photo Print Pilot— For quick and easy printing

- Print Pilot—Creates picture cards

- Red Eye Pilot—Removes red eyes from portraits (see Chapter 18, "Red-Eye Removal")

- Resize Pilot—Photo resizing software with unique enlarging algorithm

- Retouch Pilot— Removes imperfections and unwanted objects

- Rotation Pilot—Rotates images

- Secret Photos—Puzzle creation software

- Silver Pilot—Converts negatives into positives

- Slide Show Pilot—Makes slide shows and screensavers

- Wire Pilot—Removes unwanted linear objects from outdoor scenes

Comments

Poor value in today's market if purchased "en masse," Two Pilots software is simple to use but limited in functionality. Individual packages may be helpful if you have specific tasks and no other means of accomplishing them.

Version: Various

Plugs into: Photoshop, PhotoDeluxe, Photo-Paint, Paint Shop Pro (Color Pilot, Red Eye Pilot, and Wire Pilot only)

OS: (All versions) Windows 98, ME, 2000, and XP; (Color Pilot, Curve Pilot, Red Eye Pilot, and Spool Pilot) Mac OS X 10.4 and up

Supported file formats: JPEG, JPEG 2000, TIFF, and PNG

Price level: Approx. $30–$50 per program

Address: ul. Serdlova 39, 2 Bol'sherech'ye, Omsk, 646670, Russia

www.colorpilot.com

Summary

Distinct from all the cropping, resizing, and other designer-style facilities offered by image editors, image processing software manipulates the exposure, color balance, contrast, highlights, and other attributes that determine the appearance of the photograph. This category is the engine room of digital photography, with dozens of packages and plug-ins that allow you to adjust every nuance of luminance and color. Many experienced photographers have taken the trouble to pass on their knowledge in the form of companion software containing recommended curves and levels for typical subjects. See the ever-expanding Power Retouche lineup for an innovative approach to traditional photographic problems, or Curvemeister for the ultimate curve machine.

9

Quick-Fix Software

Two types of users have a need for quick-fix software: professionals who have very large quantities of digital photographs to adjust and home users who lack the necessary knowledge, skills, and software to adjust images manually. That said, there is no need to be snobbish about it. As soon as the "quick-fix" software starts doing a better job than you can, you might as well give up and let it take charge.

Quick-fix software is now very good at analyzing the content of a scene and making an intelligent guess about correct color balance, exposure, brightness, and contrast. The best packages and plug-ins offer both quick-fix and fine-tuning tools, the latter being essential if you want to achieve results comparable to those of an all-manual system. Quick-fix is also a feature of digital cameras. They, too, analyze the scene and make adjustments accordingly unless you choose otherwise. When the camera gets it wrong, or if you want to start from freshly converted RAW data, desktop-based quick-fix software can take over.

iCorrect EditLab ProApp is one of the best-known quick-fix applications, with integral noise reduction and sharpening as well as exposure controls. You should not rule out the others, one or two of which have original and even remarkable abilities. For example, Retina from XtraSens is a "must-see" product on because of its ability to inject what photographers variously call "punch," "snap," or possibly "oomph" into the image. Take a look (and try not to say "wow").

PhotoTune

Vendor: onOne Software

Purpose: Quick-fix package for professionals, with skin color correction and other sophisticated tools

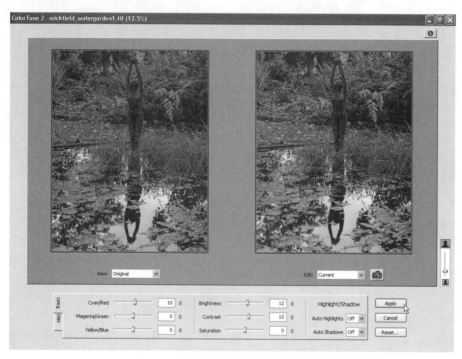

Figure 9.1
onOne's ColorTune technology in PhotoTune gives quick results.

Description

PhotoTune is a professional-level product, aimed at simplifying color correction. An Adobe Photoshop plug-in, it incorporates two products developed by PhotoTune Software, namely the 20/20 Color MD color correction tool and the highly regarded SkinTune technology based on in-depth research into skin color. Both tools are easy to use and have dramatic time-saving features.

The color correction technology, now renamed ColorTune, has been designed as a six-step process taking around 15 seconds per image. The vendor says it "works like an eye exam" to figure out what is wrong with an image and then fix it. Its whole purpose is speed and ease of use. Its Color Wizard cuts down the bewildering number of options that are normally presented to users, narrowing down the choices until you reach the right one. Step one sets dynamic range; step two is brightness; steps three to six deal

with color. At each step it offers side-by-side previews from which you can select the one that appears most correct before moving on to the next adjustment. This is similar to Photoshop's Variations and is also used in Adobe's online service called Photoshop Express.

SkinTune technology brings several benefits to wedding, portrait, and fashion photographers. Based on thousands of image samples depicting all types of skin color, SkinTune has been designed to make skin tones easier to adjust for working photographers. The vendor explains that skin color represents less than 1% of all available colors, but that even the slightest variation can be apparent to anyone who knows the person in the image. Each of SkinTune's color libraries contains between 125,000 and 150,000 colors, composed of various combinations of hue, brightness, and saturation, to match the coloring of individuals from Africa, Asia, Northern and Southern Europe, the Middle East, and other parts of the world.

Comments

Most professional photographers will want to take longer making adjustments to their images, but others are under pressure to produce hundreds of pictures very quickly. PhotoTune is for anyone who values time. A demo version is available and (by definition) does not take long to try.

Wedding and portrait photographers should certainly try this product, on account of its novel approach and unusual pedigree. You can open RAW images in Photoshop then correct them in ColorTune. Slider controls add greatly to its fine-tuning capability, whereas a new dynamic range control lets you set highlights and shadows. From a marketing perspective, SkinTune appears somewhat diminished in prominence now that it has been incorporated into PhotoTune (and all the name changes are confusing), but it remains an excellent tool for busy photographers.

Version: PhotoTune 2.2 (2008)

Plugs into: Photoshop CS2 or CS3; Photoshop Elements 4 or higher

OS: Windows XP, Vista, or higher; Macintosh OSX 10.4.8 or higher

Supported file formats: 8-bit or 16-bit RGB images

Price level: Approx. $160

Address: onOne Software, Inc., 15350 SW Sequoia Parkway, Suite 190, Portland, OR 97224, United States

www.ononesoftware.com

AutoEye

Vendor: Auto FX Software

Purpose: Unique enhancement method rebuilds color detail, sharpness, and image vibrancy

Description

AutoEye reclaims lost color and detail, using a different method to those in Photoshop or other image editors. In most processing software, you have to tweak several controls one after the other to get the right result. However, AutoEye's patented Intelligent Visual Image Technology works in the background to make adjustments to all the settings at once. This makes it much easier and quicker to enhance the image.

Like the vendor's other software, AutoEye is both a stand-alone program for Windows and Mac, but also behaves as a plug-in for Photoshop and compatible editors. It has a customizable interface: pretty, but it has no affect on the workflow. Live updating from the Internet is a more useful housekeeping feature.

Comments

If you want to fine-tune your images to achieve naturalistic effects, you are probably better off with another package, but if you want to achieve some creative effects—perhaps to make the image punch more—AutoEye might be the answer. As the vendor rightly says, some of the "looks" it can achieve are very hard to create in other software.

Version: AutoEye 2.0 (2008)

Plugs into: Adobe Photoshop 4.0 CS; Photoshop Elements 1.0 or higher, and compatible editors

OS: Windows 98, NT, 2000, ME, and XP; Mac OS 9.0, native in OS X or higher

RAM: Windows 256MB; OS 9 256MB; OS X 512MB recommended

Supported file formats: Loads and saves PSD, TIFF, BMP, JPEG, GIF, and PNG

Price level: Approx. $130

Address: Auto FX Software, 141 Village Street, Suite 2, Birmingham, AL 35242, United States www.autofx.com

Corel MediaOne Plus

Vendor: Corel Corporation

Purpose: Easy-to-use all-in-one package for photos and video, with enhancement, organizing, and scrapbooking features

Description

Corel MediaOne Plus is one of the new breed of all-in-one packages that lets you handle both photos and video, with quick cataloging, enhancement, and scrapbooking facilities. Whether you want to create a slide show, make a few edits to a video clip, or change the brightness, color, and contrast of an image with a single click—MediaOne Plus can help you do it.

With MediaOne Plus you can remove blemishes, whiten teeth or paint on a sun tan; convert pictures to black and white or add picture frames and text. You can rotate, crop, and resize images; fix red-eye effects; and even back up your entire photo collection online, automatically.

Comments

Aimed at the home user of a point-and-shoot camera rather than the serious photographer, Corel MediaOne comes in two versions. The full Plus edition has all the features operating in perpetuity. The Starter edition provides a 30-day trial of the more sophisticated features like trimming video clips or the facility to whiten teeth in portrait images, while still giving many non-expiring features such as downloading, resizing, emailing, printing, and back-up. This is a good approach: although not used very frequently by photo software vendors.

Corel MediaOne Plus is a redesign of the former Snapfire product (which is still available at the time of writing, and free, at www.snapfire.com). However, MediaOne Plus is significantly faster than Snapfire, both in start-up and operation. Created with plenty of feedback from customers, it successfully complements point-and-shoot photography and for many people it will provide the stimulus to progress to DSLR photography.

Version: Corel MediaOne Plus 2.1 (2008)

OS: Windows XP with service packs and Vista

RAM: 256MB (512MB or greater recommended)

Supported file formats: Major formats

Price level: Approx. $50

Address: Corel Corporation, 1600 Carling Avenue, Ottawa, Ontario, Canada, K1Z 8R7

www.corel.com

iCorrect OneClick

Vendor: PictoColor Corporation

Purpose: One-click correction of white balance, exposure, and saturation

Description

PictoColor iCorrect OneClick is a Photoshop plug-in that specializes in making one-click corrections of white balance, exposure, and saturation. To use it, you simply click on a neutral color such as white, black, or neutral gray, and the software does the rest. It removes any existing colorcast, corrects the tonal range, adjusts overall brightness, and gives the image a more vivid look. In addition, it offers conversions to black and white or sepia tone.

Comments

Like all the best quick-fix software, iCorrect OneClick lets you make an instant correction, then, if you want, tweak the result. In theory, this gives you the best of both worlds: speed and quality. It is certainly very speedy and on this account has earned the plaudits of several independent reviewers. *Photoshop User* magazine also found that it gave more balanced results than those obtained by alternative solutions. As the vendor says, it certainly "takes the guess work out of color correction," although photographers with the most exacting standards may find it removes some of the judgment as well.

Version: PictoColor iCorrect OneClick 1.5 (2008)

Plugs into: Photoshop and Photoshop Elements

OS: Windows XP and Vista; Mac OS X, v 10.2.8–10.5

RAM: 512MB

Supported file formats: As host software

Price level: Approx. $50

Address: PictoColor Corporation, 151 West Burnsville Parkway, Suite 200, Burnsville, MN 55337 United States

www.pictocolor.com

iCorrect EditLab ProApp

Vendor: PictoColor Corporation

Purpose: A complete color correction and management system with a SmartColor Wizard interface

Description

iCorrect EditLab is designed to make color correction as easy as possible. It is particularly strong on those parts of the workflow that involve using the Levels control in Photoshop. Its SmartColor Wizard feature is a "mini-workflow" all by itself, with four tabulated tasks that are conducted in strict order:

1. Color balance: For color cast removal and white balance correction.

2. Tonal range: For setting black point, white point, and midpoint.

3. Brightness/contrast/saturation adjustment.

4. Hue-selective edits: For fine-tuning the color.

If you are frustrated by the trade-offs and compromises of using Levels or Curves, iCorrect EditLab rationalizes the process and minimizes the errors. For color-managed workflows, it lets you save correction parameters as ICC profiles.

iCorrect EditLab comes as a stand-alone product (ProApp) or as a plug-in for Photoshop and compatible editors.

Comments

Aimed at the serious photographer, iCorrect EditLab ProApp can be integrated with a RAW workflow although it does not handle RAW images directly. It is a very mature application with ongoing development that has added new features like automatic black and white conversion, sepia toning, and color toning. Whether it really is "the best shortcut to perfect color" as the vendor claims is for users to judge, but it could well be true. It has scored highly in all reviews.

Version: PictoColor iCorrect EditLab Pro 5.5; iCorrect EditLab ProApp 6.0

Plugs into: Is a stand-alone product; plug-in version needs Photoshop CS2, or CS3; Photoshop Elements 4–6

OS: Windows XP and Vista; Mac OS X, 10.4, and 10.5

RAM: Pro 512MB, ProApp 768MB

Supported file formats: BMP, JPEG, and TIFF

Price level: ProApp, approx. $150, Pro approx. $100

Address: PictoColor Corporation, 151 West Burnsville Parkway, Suite 200, Burnsville, MN 55337 United States

www.pictocolor.com

Intellihance Pro

Vendor: onOne Software

Purpose: Automatic digital enhancement software, giving 25 instant variations of the image for comparison

Description

Intellihance Pro is a long-established Photoshop plug-in that offers a very easy way of achieving image correction. It simply applies 25 presets to the image, each one making slightly different adjustments to color, contrast, and sharpness, and then displays the results side-by-side in a grid for comparison. You can print the variations as a contact sheet or view them on the screen.

There are 23 presets included with the package, but you can also create your own, either from scratch or by altering one of the existing presets. Once stored, your preset can be used in batch processing a number of images at once. Intellihance Pro has an excellent de-screening function that allows you to convert scanned magazine halftones into continuous-tone images.

Comments

Intellihance Pro takes the concept of bracketing and applies it generally to basic image-enhancement techniques. Formerly an Extensis product acquired by onOne in 2005, it was praised for its ease of use when it was first launched, but criticized by one reviewer

(in *Macworld*) for its implementation of color theory. It has limited usefulness for keen photographers.

Version: Windows Intellihance Pro 4.2; Mac 4.2

Plugs into: Photoshop CS2, CS3, or Photoshop Elements 4 (Mac and Windows) or later

OS: Windows XP SP2, and Vista; Mac OS X 10.4.8 or higher

RAM: 512MB

Supported file formats: Those of host program

Price level: Approx. $160

Address: onOne Software, 15350 SW Sequoia Pkwy, Suite 190, Portland, OR 97224, United States

www.ononesoftware.com

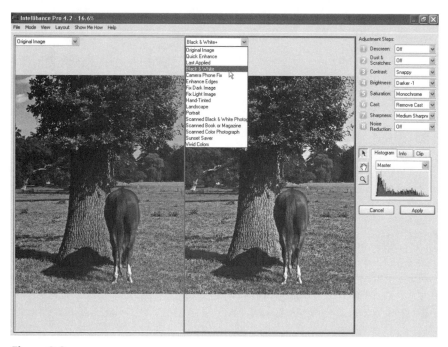

Figure 9.2
Intellihance Pro offers an easy step-by-step workflow for making better pictures.

Noromis PhotoLab

Vendor: Noromis

Purpose: Quick-fix then print lab-quality photos, all in one seamless session

Description

In one session you can load pictures from your digital camera to your computer, quick-fix them for common errors, and then obtain what the vendor calls "lab-quality photos" from your home printer, using Noromis PhotoLab.

The secret to the Noromis PhotoLab approach is its automatic adjustment for exposure, contrast, color balance, sharpness, saturation, red-eye, and digital noise. Its one-click editing tools let you carry out these operations, plus cropping, rotation left or right, and refining skin appearance. In addition to the auto-modes there are fine-tuning controls—and even these are automated with an Adjust Auto Fixes wizard.

Fortunately, Noromis PhotoLab is a non-destructive editor, so making all the changes does not degrade your images. It carries out the processing stages in the correct order, just as a professional service would do. Before it prints your photos, it replays the list of modifications, using it to produce superior quality output.

Comments

Noromis PhotoLab is big on hand-holding and strikes a good balance between ease-of-use and plenty of features. However, the claim of "lab-quality" from a home printer begs a lot of questions about inks, papers, printer brands and models, and color management. Yes, it can give good results, but not in every home.

Version: Noromis PhotoLab 2.2 (2008)

OS: Windows XP and Vista

RAM: 256MB

Supported file formats: Opens/saves BMP, JPEG, PNG, Slide Show (saved as PDF), and TIFF

Price level: Download version $30, CD version $40

Address: Noromis, 15 Vincent Place, Verona, NJ 07044, United States

www.noromis.com

Photobot

Vendor: Tribeca Labs

Purpose: "Zero-click" picture-correction software that fixes colors, red-eye, and exposure issues

Description

Billed at its 2007 launch as "The world's first zero-click picture correction software," Photobot brings together algorithms from several sources to cure common photographic problems automatically. Aimed at the amateur or home photographer, it has color enhancement technology from the vendor's Full Spectrum RGB program, exposure correction algorithms from Athentech's Perfectly Clear, and red-eye removal routines from FotoNation's Red. Working in tandem, the different routines make a quick job of brightening the image, deepening the colors, and beefing up contrast without blowing out the highlights.

Photobot comes with a free trial account at Swiss Picture Bank (www.swisspicturebank.com), an online photo hosting service.

Comments

When it comes to knowing what a picture should look like, Photobot is actually more expert than many home photographers who have not had the time or inclination to learn how to adjust their images. But "zero-click?" Yes, that is true, too. Photobot operates in the background, searching your hard drive for pictures and putting them to rights automatically. To many photographers, this will sound like their worst nightmare made reality. A do-gooding virus that imposes its own aesthetic. To others it will be a godsend, saving hours of work with an image processor.

Version: Photobot 1.0 (2008)

OS: Windows 2000, XP, and Vista

RAM: 64MB (128MB recommended)

Supported file formats: JPEG

Price level: Approx. $30

Address: Tribeca Labs, 648 Broadway Suite 700, New York, NY 10012, United States

www.tribecalabs.com

PhotoCleaner

Vendor: Digital Dozen

Purpose: Almost a one-click tool for enhancing digital images

Description

For the home photographer who takes occasional pictures, PhotoCleaner turns a poorly taken photograph into an acceptable one. It has been designed to be as simple to use as possible in recognition of the fact that many people find image processors hard to operate.

The key to success with this type of product lies in the interface, and here PhotoCleaner takes a different approach. Instead of making adjustments one at a time, allowing you to check the result and make further adjustments, it offers a panel of check boxes that you check before clicking Enhance Picture. Slider controls allow for individual adjustment of color saturation, "reveal shadows," noise reduction, apply vignette, and sharpen. But essentially this is a one-click tool that adds everything together for speed and ease of use. A Pro edition adds batch processing and the ability to create PhotoAlbums.

Comments

Introduced in 2001, PhotoCleaner won a following among point-and-shoot users, but as in-camera processing has improved, there tends to be less demand for this type of

product. Nonetheless, it serves a useful purpose for those who want to fine-tune their images quickly and efficiently.

Version: PhotoCleaner 3.4 (2008)

OS: Windows 98, ME, 2000, XP, 2003, and Vista

RAM: 32MB

Supported file formats: JPEG

Price level: Approx. $13, Pro edition $25

Address: Digital Dozen, LLC

www.photocleaner.com

Photo-D

Vendor: KlearVision

Purpose: Automatic photo correction product family for high-volume workflows

Description

Photo-D is a family of one-click photo correction products, available in many editions. The Starter edition has most of the features, including automatic exposure, brightness, contrast, gamma, sharpening, colorcast removal and white balance controls. The Pro editions are intended for professional photo labs and bring ICC workflow support and smart-scaling to predefined sizes.

The pro-level products in the line-up are as follows:

- Photo-D Pro IES (Intelligent Expert System)—A customizable IES with automatic digital image correction. Cropping and RAW handling are offered as optional add-ons.

- Photo-D RAW—A RAW conversion utility that uses the same expert system parameters, with the option to customize them.

- Photo-D Pro Hotfolders—For graphic arts automatic workflows, including large, mini, and micro photo labs. The lab owner defines both input and destination hotfolders to hold images before and after their automatic processing. The IES detects the command string that accompanies each set of images and acts upon it.

- Photo-D Pro Hotfolders PDF—Also for graphic arts automatic workflows. It extracts images from PDF files, corrects them, and then inserts them back into PDF.

Comments

Founded by Israeli color expert Moshe Keydar, KlearVision has a management team spread between Europe, the United States, and Israel. It has chosen to target the "one-click market" and has put a high price on its Starter Edition, whereas the Pro Editions are "priced on request." Photo-D won an "Innovative Digital Product" award from DIMA in 2005.

Version: N/A (2008)

OS: Windows 2000, XP, and Vista

RAM: 256MB

Supported file formats: Major file formats

Price level: (Starter) $550

Address: K.V.D. KlearVision digital Ltd., 109/7 Histradrut Street, Holon, 58347, Israel
www.klearvision.com

Photo Tools

Vendor: Microspot

Purpose: Quick-fix tools for Mac, including the PhotoFix editor/retoucher, with auto color, brightness, and contrast correction

Description

Fully compatible with Apple's iPhoto, Photo Tools consists of three formerly separate modules called PhotoXtra, PhotoFix and PrintmiX. Of these, PhotoXtra is an organizing, storage, and slide show creation utility, whereas PrintmiX is a drag-and-drop printing template. PhotoFix is the quick-fix editor with many manual options as well, making it attractive for both novices and experienced photographers.

PhotoFix has many customizable painting, drawing, and retouching tools, together with editing capabilities such as cloning, feathering, and masking. One of its key features is its ability to correct the color, brightness, and contrast of any image automatically.

PhotoFix also includes a dozen special effects filters, such as Add Noise, Distort 3D, and Posterize. It supports 32-bit color, has 32 levels of undo, and runs on just 5MB of free RAM (more is recommended to cope with image size).

Comments

Ten years ago, *MacFormat* compared PhotoFix software to Photoshop. It has been updated many times since then, but avoided the bloat until its incorporation into Photo Tools. Reviewers have liked its low cost, its feathering and transparency controls, support for masks, and good printing tools, but on close examination have found it lacking in CMYK support and tool functionality, the latter being somewhat corrected by the addition of the other modules. The company itself is better known for its MacDraft and Microspot Interiors software.

Version: Microspot Photo Tools (PhotoXtra 2.3, PhotoFix 3.5, and PrintmiX 1.2) (2008)

OS: Mac OS X 10.2 or higher

RAM: 6MB

Supported file formats: Major formats, including PICT, TIFF, and EPS

Price level: Approx. $80

Address: Microspot Ltd., Concorde House, 10-12 London Road, Maidstone, Kent, ME16 8QA, United Kingdom

www.microspot.com

PhotoPerfect

Vendor: Arcadia Software

Purpose: One-click fixes and a wealth of other features for home users and enthusiasts

Description

PhotoPerfect is a photo editor with a split personality: it offers one-click fixes and other time-saving features such as batch optimizing, while at the same time it provides sophisticated editing functions in depth. Whatever you want to do, it is very likely that PhotoPerfect can do it, from manipulating contrast gradients to cropping your images automatically in standard sizes for uploading to photo-sharing sites online.

In the "one-click" department, PhotoPerfect gives you access to built-in Xe847 Automatic Image Optimizing Technology, a German development by Digital Arts GmbH (www.xe847.com). This is a filter technology that makes images with a poor contrast range look much bolder and more lifelike. It is, incidentally, also available directly from its developer as a Photoshop plug-in. However, Xe847 is just one option within PhotoPerfect. There are others, including various "payware" extensions such as Perfectly Clear from Athentech Technologies (www.athentech.com) and i2E image enhancement from Colour-Science AG of Switzerland (www.colour-science.com). In an unusual interface design, all of them are made available in a single screen for direct, "multi-automatic" comparison.

Among its advanced image enhancement functions, PhotoPerfect has a range of softening and sharpening tools; Lab curves for editing images in Lab color space; a band filter for removal of symmetrical distortion; 16-bit support for RAW and TIFF files; colorcast removal; merging for High Dynamic Range (HDR) effects, or what the vendor calls Dynamic Range Increase (DRI); comprehensive masking; color vibrancy; intelligent retouching with repair and remove brushes; "replace masked area" function; color management; and Exif and IPTC data handling.

PhotoPerfect is a true photo editor with plenty of functions for reshaping, manipulating, and resizing the images. It has good tools for correcting lens distortions, including automatic pincushion reduction, vignetting reduction, and correction of converging lines. It lets you remove hot or stuck pixels with a few clicks, and has an integrated framing tool, a mosaic generator, stereo image creation, GPS support, slide shows, and so on. And for those who specialize in black and white, there is the MonochromiX extension for a full range of filters and film simulation.

Comments

If you are looking for full featured quick-fix software, PhotoPerfect is well worth trying. It is the anglicized version of FotoFix, from Joachim Koopmann Software (www.j-k-s.com). Its user interface has been thoughtfully laid out, with toolbars running vertically at the left and horizontally at the top of the screen. You can rearrange the layout, but it is feasible to have thumbnails at the bottom as a filmstrip (double-click and it shrinks to a two-thumbnail display) and several other directories, histograms, and floating windows open at the same time. Learning how to use all the features takes a little while, but if you are familiar with other editing software it all makes sense. However, the fundamental idea of combining quick-fix and fully-featured editing into a single package may not make a lot of marketing sense, even though, from a technical viewpoint, it is hard to fault.

Version: PhotoPerfect 2.90 (2008)

OS: Windows 2000, XP, and Vista

RAM: 512MB

Supported file formats: Major image formats

Price level: Approx. $60

Address: Arcadia Software AG, Hohenstaufenring 29-37, 50674 Cologne, Germany
www.arcadiasoftware.com

Figure 9.3
PhotoPerfect has one-step routines and a full image-editing toolkit besides.

Retina

Vendor: XtraSens

Purpose: 22 smart filters and functions to maximize perceived contrast, brightness, sharpness, depth, and resolution

Description

Based on the latest neuronal technology, Retina is a set of 22 adaptive filters for Photoshop to maximize perceived contrast, brightness, sharpness, depth, and resolution. It makes an astonishing difference to photographs that lack punch, giving them all the punch they need. The effect is like removing a veil, or cleaning a coat of varnish from a painting, as the "before/after" shots on the vendor's Website amply demonstrate.

Retina has five modes, called Automatic, Portrait, Landscape, Macro, and Advanced, plus Batch mode. Automatic mode is the main user interface for the software, providing a single-click enhancement option, whereas the others are "second level" interfaces with controls. The Advanced mode control panel gives access to all the different functions, for texture, lighting, artifact reduction, color, and perceptual/absolute tonal/light functions. There are also command buttons for refresh, zoom, profile selection, reload, and save.

The main retina function, itself called Retina, modifies local contrast pixel by pixel, while at the same time maintaining contrast in large areas of the picture. This makes a dramatic change, improving perceived sharpness, accentuating textures without increasing noise, and giving an apparent increase in depth. The other advanced functions—Digital Flash, Auto Color, and Perceptual—all make a contribution to the impact of the image.

Retina supports 8- and 16-bit RGB color, grayscale, and CMYK, but not multichannel, index color, or Lab color.

Comments

Retina is a rare tool that deserves to be better known. It is a genuinely intelligent product, based on research into human perception. To every image it imparts a super-real effect, revealing detail in shadows and highlights automatically while sharpening the picture as well. Although it is not at all flattering to portraits, which tends to rule out a large section of the market, for buildings, landscapes, and especially underwater photography it is truly outstanding.

Version: Retina 1.03 (2008)

Plugs into: Photoshop 7, CS, CS2, and CS3; Photoshop Elements

OS: Windows XP only

RAM: 256MB

Supported file formats: Major RGB formats

Price level: Retina lite $75, Retina $100 (both approx.)

Address: XtraSens Ltd., 10 Wellington Street, Cambridge, CB1 1HW, United Kingdom

www.xtrasens.com

Summary

For those in a hurry, quick-fix software is a godsend, instantly turning otherwise lack-luster pictures into images with vibrancy, punch, or "snap." Although they can never provide the subtlety and control that comes from working on each image individually in editing or image-processing software, quick-fix software solutions often deliver great results with little or no effort, knowledge, or skill. For this reason, they are aimed mostly, but not exclusively, at home users. However, other packages, such as PhotoTune from onOne Software, are aimed at professional photographers who need to take shortcuts because of the huge number of prints they produce. As software intelligence improves, so too will grow the efficacy of quick-fix solutions, although attempting to predict the intentions of the photographer might always remain just out of grasp.

10

Image Editors

Image editors bring techniques from the world of graphic design, such as object selection, transparency, and layering, to the service of photography. They allow you to crop and resize the image, while at the same time providing a set of retouching tools to remove blemishes and color casts. Some of them go very much further, adding full processing facilities such as RAW conversion and exposure adjustment, together with image browsing, sorting, and cataloging, plus all the output options of saving to the Web, printing, slide show creation, and DVD burning. On first acquaintance, their list of features and level of complexity can be a little daunting, as the number one image editor (Photoshop) amply demonstrates.

Professional designers automatically gravitate to Photoshop, and then, after climbing a steep learning curve, become understandably reluctant to learn other software. The resulting dominance of Photoshop in the market has had a stunting effect on other products, cutting off revenues that could otherwise fund further development. Most developers have adopted the "if you can't beat them, join them" approach by bringing out plug-ins for Photoshop, which sometimes obliges users to buy the Adobe product (or a compatible editor) simply to run a desired third-party plug-in.

The industry, however, is changing. Adobe's introduction of Lightroom specifically for photographers has highlighted the fact that photographic editing has different priorities than those of the graphic designer. Processing, shot selection, and color/tone adjustments come first, whereas retouching and special effects are secondary considerations. In the coming years, it is likely that Lightroom will siphon off from Photoshop all the tools that a photographer needs. Over at Corel, where the purchase of Ulead brings together two of Photoshop's closest competitors, Paint Shop Pro Photo and Ulead PhotoImpact, a similar evolution is taking place. Here, too, there is recognition that digital photographers need a different set of tools from those used by illustrators and designers.

Given time, the market eventually corrects itself and the dominance of Photoshop will be seen as an anomaly. Further challenges are coming from the developers of processing tools such as Nikon Capture—included here rather than among RAW converters because of its increasingly powerful editing functions. Then there are all those developers of plug-ins who now cover so many bases they have only to bring all the separate plug-ins together on a new platform to have a fully fledged rival to Photoshop itself. Even now it is possible to run dozens of third-party plug-ins within Photoshop Elements (Adobe's low-cost editor) and have a photographic tool that is arguably more powerful than CS3.

Adobe Photoshop

Vendor: Adobe Systems

Purpose: The industry standard editor for photographers, graphic designers, and Web designers

Description

Adobe Photoshop is the editor favored by most graphic arts professionals, with true non-destructive filtering, advanced compositing using multiple layers, 32-bit high dynamic range support, quick-selection tools, full RAW support, to-and-fro clickability with Adobe Lightroom, color management, and integration with selected printers from HP, Epson, and Canon. This is the full edition of Photoshop for photographers who will probably not need the Extended Edition with its 3D support and measuring capabilities for scientific imaging. (Both have the same system requirements.)

Photoshop's toolset is famously extensive, with tools to retouch images using cloning and healing techniques, single brush-stroke selection to isolate objects, edge-refinement, and accurate compositing. CS3 and, imminent at the time of writing, CS4 run noticeably faster than previous versions, taking advantage of native performance on Intel- and PowerPC-based Macs and PCs running Windows XP or Vista.

Where Photoshop differs radically from most other photographic editors is in its powerful set of customizable paint settings, brushes, and drawing tools that enable artists to create an original, realistic-looking image without any photographic capture whatsoever. With so many tools, there are naturally many palettes to take up valuable screen space. Many users take advantage of its dual monitor support to keep palettes conveniently open.

Besides RAW conversion, much photographic enhancement can now be done in Adobe Camera RAW (ACR), even adjustment of JPEGs and TIFFs if you are using Bridge. Although strictly a plug-in, ACR comes with Photoshop and offers slider controls for color temperature and tint, exposure, highlight recovery, and vibrancy/saturation. It has support for over 125 camera types and (obviously) the vendor's Digital Negative (DNG) format. ACR 4.0 was introduced with CS3.

Comments

There ought to be a good metaphor for Photoshop, but Swiss Army Knife does not quite capture its versatility or its serious professionalism. It is more like a Super Jumbo Jet, with an instrument panel to match. Reviewers tend to pay homage to it, rather than review it, yet there are occasional dissenting voices. Erik Vlietinck of *IT-Enquirer* found the new collapsible palettes to be "nerve-wrecking," which categorized him as a member of the "laity" in the eyes of some. When religious terminology is used for criticizing critics, you know some truth has been spoken. Or has it? *PC World's* Alan Stafford said the refinement he liked most one year (2007) was "the new palette treatment," the very feature most disliked by the other reviewer.

Yes, Photoshop is a great product, but it is clearly not ideal for everyone, and if you lack the patience to learn it you will be better advised to look at the other products in this book. There is also the question of price. It is expensive, but a good value in comparison to most single-feature products, including many of its own plug-ins. UK users must surely resent having to pay double the U.S. price at the Adobe UK store. All those bits are so heavy to transport across the Atlantic!

Version: CS3 (2008)

OS: Windows XP with SP2 or Vista Home Premium, Business, Ultimate, or Enterprise (certified for 32 bit editions); Mac OS X 10.4.8–10.5 (Leopard)

RAM: 512MB and 64MB of video RAM

Supported file formats: Most RAW formats; many others, including PSD, BMP, Cineon, JPEG, JPEG 2000, OpenEXR, PNG, TGA, and TIFF

Price level: Approx. $650

Address: Adobe Systems Incorporated, 345 Park Avenue, San Jose, CA 95110-2704, United States

www.adobe.com

Adobe Photoshop Elements

Vendor: Adobe Systems

Purpose: The consumer version of Photoshop for casual photographers

Description

Adobe Photoshop Elements is aimed at the "casual photographer," by which Adobe means the person who takes occasional pictures rather than one who takes them without care. Photoshop Elements is quite capable of taking very good care of your photos, with a substantial feature set including quick-fix adjustment of color, contrast, and lighting, auto red-eye removal and skin tone enhancement, correction for camera lens distortions, sharpening, fine-tuning of exposure, retouching with healing brushes, and shadow and highlight recovery. Just as in the main program you can work on specific parts of the image, using dodge, burn, and sponge tools. Support for 16-bits per

channel produces high-quality editing. Full RAW file support is also included, with export to Adobe's universal DNG format for long-term archiving.

Special effects range from painting simulation to surreal twisting, warping, and stretching of the image. There is black-and-white conversion, sepia toning, and the option to add depth with drop shadows, bevels, glows, and other effects. It lets you create composite images, erase backgrounds, assemble panoramas, and add text and graphics, shapes and decorative edges. The program includes 100 styles of frame, and plenty of scrapbook page layouts for the avid scrapbooker. Basic slide show creation is provided, with the option to add music and narration.

Output is one of its great strengths, with good sharing facilities, upload-to-the-Web directly from the application, print ordering, creation of greeting cards and albums, and hardbound photo book creation with delivery to the door. There are one or two unusual options like creating real, customized U.S. postage stamps and the ability to create maps that indicate automatically where in the U.S. you have taken your images. You can display the pictures on TV, a mobile phone, or another handheld device, or email them directly to friends.

Photoshop Elements has good downloading and organizing facilities, with fast scrolling even when you have accumulated more than 50,000 images. It can stack similar photos on top of each other to save space, and then sort, compare, and select images for printing. There is even an integrated online backup service provided by a company that specializes in document security.

Figure 10.1
Adobe Photoshop Elements with additional plug-ins may be all you need for image editing.

In Photoshop Elements 6, Adobe introduced an aspect of what academic researchers are calling "The Moment Camera," a technique in which the precise moment of capture may be spread over several seconds. Here, in group photography, it proves very useful, allowing you to combine the best facial expressions and body language from a series of shots. In this way, the Photomerge technology in Photoshop Elements lets you optimize a group photograph, avoiding the risk of (for example) someone blinking at the critical moment and spoiling an otherwise perfect shot.

Comments

Some reviewers are more effusive about Photoshop Elements than about the main Photoshop product; others say it moves down-market with each successive release. There is no doubt that Adobe has turned it into a distinctive editor, no longer a cut-down version but one with new features designed to appeal to home users. As more features are added, it becomes increasingly complicated to use, despite all the hand-holding, so perhaps the spin-off process will occur all over again with selected elements of Photoshop Elements repackaged into...Photoshop Fragments? In a sense, this has already happened in the form of the excellent and easy-to-use online service Photoshop Express.

Version: Photoshop Elements 6 (2008)

OS: Windows XP Professional, Home Edition, or Media Center Edition with SP2; (4.0) Mac OS X

RAM: 256MB (512MB recommended)

Supported file formats: Major RAW formats; major image formats

Price level: Approx. $100

Address: Adobe Systems Incorporated, 345 Park Avenue, San Jose, CA 95110-2704, United States www.adobe.com

ArcSoft PhotoStudio

Vendor: ArcSoft

Purpose: All-round photo editor for beginners, with some advanced features

Description

ArcSoft PhotoStudio is a photo editor with easy-to-use features suitable for beginners, but has some more advanced functions too, including layers support. There are the standard controls for adjusting exposure, color, and sharpness. It has good selection tools such as Magnetic Lasso and Magic Cut for separating objects and people from their surroundings. If you make a mistake, there are 99 levels of undo. Red-eye removal is well-implemented—you simply click on the eye to remove the redness automatically.

ArcSoft PhotoStudio is big on special effects, with Oil Painting, Watercolor, Charcoal, Wet Brush, Pastel, Impressionistic, Neon Edges, Bulge, Pinch, Stretch, Magic Mirror,

Mosaic, Splash, Texture, Cool, Moonlight, Solarization, Exposure, Wind, Frost, and more besides. The software also lets you add 3D titles to your photos, presentations, slides and Web pages.

Comments

Reviewers acknowledge ArcSoft PhotoStudio as a good all-round performer without being particularly outstanding in any one department. The lack of tutorials, hints, or tips has been criticized, although there is an extensive manual available online. There is no Exif support and sharing facilities are limited, but at least the special effects are extensive, making it an attractive package overall for many users.

Version: ArcSoft PhotoStudio 5.5 (2008)

OS: Windows 2000, XP, Vista; (PhotoStudio X edition) Macintosh OS X 10.3, 10.4

RAM: 64MB (128MB recommended)

Supported file formats: Major graphics formats

Price level: Approx. $80

Address: ArcSoft Corporate Headquarters, 46601 Fremont Blvd., Fremont, CA 94538, United States

www.arcsoft.com

Aurigma PhotoEditor

Vendor: Aurigma

Purpose: Web-based software for online photo editing

Description

Aurigma PhotoEditor is a complete image-editing solution for Websites. It enables users to rotate, crop, remove red-eye effects, and make adjustments to contrast, brightness, and saturation, and then place a virtual frame around their images for viewing online. It all works entirely over the Web in pure HTML/JavaScript without the need for any Flash, ActiveX, or Java components.

Being optimized for the Web, Aurigma PhotoEditor works well even over slower, modem connections. Web developers can customize the look and feel of it without modifying the ASP.NET source code, although the latter is included on purchase. Importantly, the software includes a server license for the vendor's Graphics Mill for .NET toolkit, which comes with the Red-Eye Removal add-on. Because red-eye is a common artifact in home flash photography, this feature is a powerful addition to PhotoEditor.

Many other features include adding sepia tones and other tints, black-and-white conversion, solarizing, posterizing, embossing, and swirling.

Comments

Many common applications have migrated to the Web, and basic image editing is no exception. Do not expect Photoshop facilities yet, but you can make huge improvements to your images with PhotoEditor, without having to install any software on your machine. The vendor provides a useful online demo that allows you to use all the features on a sample image.

Version: Aurigma PhotoEditor 2.0 (2008)

OS: At server—Windows 2000 Professional; Advanced Server with SP 2.0, XP Professional, Server 2003; at client—browser-based, with IE, Firefox, Safari

Supported file formats: JPEG

Price level: Non-commercial use $400, private label $950

Address: Aurigma Inc., 5847 S. Lawrence, Tacoma, WA 98409, United States

www.aurigma.com

GIMP

Developer: The GIMP Team

Purpose: Free image editor with powerful Levels and Curves controls

Description

The GNU Image Manipulation Program from the GIMP Team is freely distributed software for photo retouching, image composition, and image authoring. The GIMP can perform a huge range of image processing tasks, such as correct muddy colors, extend dynamic range, remove color casts, sharpen an image, and repair blemishes. Its Levels and Curves controls are not so different from those in Photoshop, whereas the hue-saturation dialog box lets you warm or chill the colors in the image. There is even a tool for isolating the subject and deemphasizing the background, if your fastest lens has not already achieved this effect. GIMP is also a computer graphics program with drawing, painting, and design facilities, including paths (Bézier curves) and gradients.

There are different GIMP projects to make it run on different operating systems, notably MacGIMP (MacGIMP.org), through which you can access vendors who package the free source code for the convenience of the user and sell it at a "fair price."

Comments

Over 150 people have contributed to GIMP since Peter Mattis and Spencer Kimball started work on it in 1995. The GNU Project itself dates from 1984 and continues to flourish, as the number of applications testifies (directory.fsf.org). Prospective GIMP users have nothing to lose by trying a free version.

Of particular note is the customizable interface that includes a full-screen mode and the tools for correcting common lens distortions. It is easy to correct lens tilt effects (converging verticals) and other problems like barrel distortion or vignetting. Best of all, it runs in any of the major environments, making it one of the most well-supported image editors around.

Version: GIMP 2.4 (2008)

OS: Windows XP and Vista; Mac OS X; Linux; Sun OpenSolaris; FreeBSD

RAM: 128MB minimum

Supported file formats: GIF, JPEG, PNG, TIFF, and rare format support via the GIMP plug-in registry, a repository of optional extensions

Price level: Free source code, sub-$100 packaged

www.gimp.org

Helicon Filter

Vendor: Helicon Soft

Purpose: All-round image editor for digital photographers, with many professional features

Description

Helicon Filter is a versatile, effective, but amazingly low-cost image editor. It supports template-based renaming, voice commenting, color profiles, and Exif/IPTC data. It lets you make lossless rotate, copy, delete, and move operations. Noise reduction is one of the program's strengths and it comes with both a dead pixels filter and a dust sensor filter. There are the usual contrast, gamma, and exposure controls, with a gradient haze compensation tool. It has one-click and manual white balance, B&W conversion, vignette correction, spectral sensitivity controls, and first-rate sharpening facilities.

Helicon Filter crops to all popular paper sizes, with batch cropping and presets for different monitors and mobile phones. Retouching—which is a set of functions that typifies an image editor—is another of its strengths, with edge-sensitive brushes for blurring, sharpening, and changing color, brightness, and saturation. It offers a distort brush "to fix protruding ears and similar problems." Processing tends to be a little slow, but is improved by using Helicon Filter Pro with its support for multiple processors.

There are three editions of Helicon Filter: free, home, and pro. After 30 days the home and pro evaluation versions revert to the free edition, losing the "expert modes" and some functionality, whereas the free version has full functionality for 30 days.

Comments

Developed in the Ukraine, Helicon Filter shows every sign of becoming a mature, capable editor. It is available in English, Russian, German, French, Spanish, Dutch, and Italian.

For anyone starting out in digital photography, perhaps reluctant to spend hundreds of dollars on another editor, it provides a wealth of features, with a bright, cheerful interface that has a sensible arrangement of windows and menus. It populates itself with your images on start-up, and then displays a "recommended workflow" help panel that you must turn off once you have memorized its simple message ("open file, set up filters, save the result").

Version: Helicon Filter 4.86 (2008)

OS: Windows 2000, XP, Vista, and Vista x64

RAM: 256MB

Supported file formats: JPEG, JPEG 2000, TIFF (24-bit, 48-bit, LZW compression), PNG, PSD, and BMP

Price level: Free, home edition $30, Pro edition $40

Address: Helicon Soft Ltd., per. Mekhanichesky 4, 61068 Kharkov, Ukraine

www.heliconfilter.com

Image Genius Professional

Vendor: Pixel Dragons Limited

Purpose: An image editor for batch processing many images with tasks like cropping, resizing, or adding text

Description

Image Genius Professional is a batch processor with a difference. It can monitor folders on a computer to check for new image files, and then process them automatically. It lets you program the operations by designing a flowchart to say what happens when. Other facilities include FTP upload, emailing, and database integration.

Among Image Genius's 100 (or so) image-processing operations are brightness, color balance, and contrast adjustment; rotate, invert, mask and auto-crop; smooth and sharpen; and many image-handling functions including "upload to Flickr."

Image Genius accepts plug-ins, the first of which is Stoik Imaging's Automatic Red-Eye Removal plug-in.

Comments

Founded in 2006 by two brothers-in-law, Andy Pike and Vito Serafino, Image Genius Professional addresses a niche and fills it extremely well. Its official product reseller is Share-it! (www.shareit.com). Version 3.2 was a major release, adding RAW file and CMYK TIFF/JPEG support. Additional features have also enhanced the software's pipeline architecture, with facilities to bring in otherwise unsupported files that have been processed by external programs.

Image Genius Professional can save busy photographers a lot of time by automating the main processing functions according to a customized pipeline created by the user. One reviewer reports that he processed over a thousand images in under two minutes: the kind of speed that makes it ideal for Web catalog creation.

Version: Image Genius Professional 3.2 (2008)

OS: Windows XP and later, with Microsoft .NET Framework 2.0 or later

Supported file formats: Opens and saves JPEG, TIFF, PNG, GIF, TGA, EMF, Exif, and WMF; opens only CMYK TIFFs and JPEGs, PSD, and many RAW formats

Price level: Approx. $80

Address: Pixel Dragons Limited, 196 High Road, Wood Green, London N22 8HH, United Kingdom www.pixeldragons.com

LEADViEW

Vendor: LEAD Technologies

Purpose: Image editing and paint package with support for RGB, HSB, HLS, CMY, CMYK, and Lab color palettes

Description

LEADViEW is an extensive image -editing package that supports RGB, HSB, HLS, CMY, CMYK, and Lab color palettes and offers gamma correction, color balance, hue remapping, color channel splitting and merging, and many other features for adjusting the image. Its masking facilities are first-rate, and include floater creation, selection feather, and manipulation and transformation tools. You can select regions to remove unwanted portions of a picture, get rid of red-eye, and change the color of selected items. Its Photo Album software helps you to manage large collections of photos. Worth noting, too, are its versatile batch file conversions, including TIFF to J2K and BMP to/from JPEG.

LEADViEW is particularly strong in optimizing images for the Web. It lets you create image rollovers; gives an image preview with estimated download times; includes an HTML mapping facility; has image preview from within the Web browser; and lets you export images as an HTML photo album. Its organizational abilities are equally good— you can categorize images and add unlimited notes to them. It lets you sort in ascending or descending order and search by date, category, or comments. It also has full drag-and-drop support.

Comments

The vendor, best-known for its application developer toolkits, claims that LEADViEW is "the most comprehensive image-editing software package available." It sounds like overstatement, but could well be true given the remarkable number of features, including facilities for digital painting. Other developers may purchase the software on an OEM basis to include in their own applications.

Version: LEADViEW version 4.0 (2008)

OS: Windows 95, 98, ME, 2000, NT, and XP

Supported file formats: Over 140 file formats, including JPEG 2000

Price level: Approx. $20

Address: Charlotte, NC, United States

www.leadtools.com

Nikon Capture NX

Vendor: Nikon Corporation

Purpose: Image editor for JPEG or TIFF files from any camera, plus RAW conversion and editing for Nikon NEF files

Description

Much more than a RAW converter, Nikon Capture has become a fully fledged image editor with tools for adjusting hue, saturation, and lightness using individual editor dialog boxes. The user interface is a multi-image window that displays a row of thumbnails above a larger panel containing the currently selected image. Nikon has made excellent use of Nik Software's U Point technology, so that you can now adjust black and white points, dynamic range, and all the dimensions of color across defined areas of the image, without the need for masks, selections, or layers.

Among its image manipulation tools are fisheye-to-rectilinear image transformation, which converts pictures made with the AF DX Fisheye Nikkor 10.5mm f/2.8G ED lens into either of two ultra-wide-angle image modes; vignette control to obtain near perfect center-to-edge-to-corner brightness; and an "image dust off" dust mapping utility which, once invoked, removes the effect of dust from subsequent images.

Extending functionality still further, Nik Color Efex Pro for Nikon Capture NX adds a wide range of digital photographic filters (75 in the Complete Edition) grouped into Traditional filters for mimicking conventional photographic processes and Stylizing filters for special effects. Nikon Capture NX also has extensive batch-processing facilities and remote camera control.

Supported file formats include PSD, PMD, TIFF, GIF, JPEG, JPEG 2000, PNG, BMP, PCX, EPS, PCD, DIB, and TARGA.

Comments

The manipulation of selected parts of the image using U Point technology is a breakthrough in interface design. This is one of very few software packages that have sufficient ongoing development, plus the financial backing, to compete directly with Adobe products. It applies non-destructive image processing to NEF files, but non-Nikon users

should note that repeated changes made to JPEG or TIFF files will affect the quality of the original. Capture NX has its own tutorial Website at www.capturenx.com.

Version: Capture NX 2.0 (2008), available as upgrade to Nikon Capture 4

OS: Windows XP and Vista; Mac OS X 10.4 or later

RAM: 1GB or more recommended

Disk: 200MB required for installation

Supported file formats: NEF, TIFF, and JPEG

Price level: $180

www.nikonimaging.com

Figure 10.2
Nikon Capture NX comes with an excellent implementation of Nik Software's U Point technology.

Paint Shop Pro Photo X2

Vendor: Corel Corporation

Purpose: The most popular image editor other than Photoshop—and somewhat easier to learn

Description

Paint Shop Pro straddles the two worlds of graphic design and photography in much the same way as Photoshop. It has always been the cheaper and less well-featured option, but as time passes the gap narrows. With beefed-up facilities for photographers, Paint Shop Pro Photo is a highly mature product, backed with massive experience and user feedback. It offers a full range of effects for users.

Among its many features are Levels and Curves controls, an enhanced crop tool, depth-of-field effects, film and filter effects, a photo-management center, and video capabilities. Paint Shop Pro Photo specializes in the "quick and easy" ways of achieving acceptable results; for example, in removing distracting objects from photos, correcting perspective, or changing the color of a subject's costume. Its professional-level options include 16-bits-per-channel editing and RAW file conversion. It also has an excellent built-in Learning Center to help you get started.

Every new version of Paint Shop Pro brings a wealth of new features. Version XI introduced new email features for sharing photos with friends and family; compatibility with Corel Painter and Corel Painter Essentials; and Time Machine to show what photos would look like if taken in another era.

Version X2 went further by introducing the time-saving Express Lab feature that enables you to work quickly on several images without needing to open them. HDR PhotoMerge adds high dynamic range features; black-and-white conversion is improved; and now there are watermarking facilities, too.

Comments

By emphasizing the novelty features of the product, the vendor indicates that Paint Shop Pro Photo is aimed more at the home user than the budding professional. Nonetheless, you can produce professional-level work with it, especially for the Web. It is exceptional value for the money.

Version: Paint Shop Pro Photo X2 (2008)

OS: Windows XP SP2, 2000 SP4, and Vista

RAM: 512MB recommended

Supported file formats: Over 50 file formats, including RAW and video

Price level: Approx. $80

Address: Corel Corporation, 1600 Carling Avenue, Ottawa, Ontario, Canada, K1Z 8R7

www.corel.com

Photo-Brush

Vendor: Mediachance

Purpose: Powerful image editor with media-painting, picture-retouching, and photo-enhancing tools

Description

Photo-Brush is much more than a retouching tool, although this is one of its strengths as you might guess from its name. It is also an image editor, capable of adjusting levels, gamma, curves, hue/saturation, and brightness/contrast; a painting program with texture, artistic, natural, and 3D brushes; scanning software with TWAIN 32 support and auto-dust removal; a texture and special effects generator; and an image browser.

Photo-Brush supports RAW images from over 100 cameras and has barrel and pincushion distortion correction and chromatic aberration removal. Its retouching capabilities include red-eye removal, auto color changing, whole object removal with a special bridge tool, and brushes to clean skin tones, lighten or darken the image, and remove scratches.

Comments

Founded by Czechoslovakian-born developer Roman "Oscar" Voska, who lives in Canada, Mediachance not only produces fine software but presents it very well. Photo-Brush has dozens of first-rate features, some of them unique. For example, in Version 4.0, the developer has included some powerful new selection tools that enable you to make changes to your selection on-the-fly. The Magic Wand selector has a live preview, making it possible to perform "click-and-drag" operations to the selected area, with highlighting shown by false colors.

Enthusiasts will find Photo-Brush well worth trying for its innovative selection tools, extensive list of shortcuts, and useful graphic effects.

Version: Photo-Brush 4.0 (2008)

OS: Windows 95, 98, NT, 2000, XP, and Vista

Supported file formats: RAW (from more than 100 cameras), PNG, JPEG, BMP, TIFF, PCX, TGA, and Adobe PSD

Price level: Approx. $45

Address: Ottawa, Canada

www.mediachance.com

PhotoMagic

Vendor: BenVista

Purpose: Home photo software suite to enhance, repair, and improve images

Description

Aimed at the home photographer, PhotoMagic is a software suite that has programs to enhance, repair, and improve images, including special effects and "lossless" enlargement. Of necessity, it has an easy-to-use interface that practically anyone can operate. It lets you enhance colors, sharpness, and contrast, has noise removal facilities, and various artistic tools to make photographs look like paintings. If you want to achieve traditional photographic effects in your prints, it offers simulations of sepia, cyanotype, platinum, silver gelatin, kallitype, Van Dyck, palladium, and many others.

One particularly interesting feature of PhotoMagic is the inclusion of the vendor's S-Spline algorithm, which means you can make exceptionally good enlargements with this consumer package. Although the vendor has improved the algorithm for its professional enlargement product (PhotoZoom Pro), the original version produced very good results.

Comments

The press was lukewarm about PhotoMagic when it first came out, but the product has good features, especially its enlarging module. Point-and-shoot users will like its cheerful interface, useful exposure correction facility, and artistic effects.

At one time, PhotoMagic was also marketed by Shortcut (www.shortcutinc.com), who dropped it in favor of the more comprehensive PhotoStudio 9 HOME.

Version: PhotoMagic 1.2.8 (2008)

OS: Windows 98, ME, NT4, 95, 2000, XP, and Vista; Mac OS X 10.3 and higher

RAM: 128MB

Supported file formats: As host

Price level: Approx. $50

Address: The Netherlands (contact by Web form)

www.benvista.com

Photobie

Vendor: Photobie Design

Purpose: Free image editor, with advanced layer support, templates, scrapbooking, and screen-capture features

Description

Photobie is a multi-featured (but entirely free) image editor that comes with transparency, masking, and layer merging, once found only in the most expensive design software. Its editing facilities include crop, copy, paste, and rotate/flip, and they are complemented by image-processing facilities such as brightness, contrast, saturation, gamma,

alpha, color swap, and color curve controls. To these the developers have added useful painting tools including pen, shape draw fill, airbrush, eraser, line/curve with arrows, and smudge. The screen capture tools and Plug-in Manager let you use free Photoshop .8bf filter plug-ins to create special effects.

If all this is not good enough value, there are also tools for GIF animation editing, complete with simple timing controls; a Flash Jukebox with a playlist manager that lets you add or remove Flash .swf files to/from your list; and—perhaps the key feature of all—template design and editing tools that allow users to create their own templates and share them with others.

To get full benefit from Photobie you really need to belong to the Photobie Club, the community of users who share their experiences, templates, and even some of their designs. The image editor itself comes in two versions: Photobie and Photobie Design Studio (Photobie DS), the latter of which is freely available to members, although it may eventually be spun off as commercial software. The club, which has a highly active online forum, is free to join.

Figure 10.3
Photobie offers transparency, masking and layers, all for free.

Comments

Photobie boasts over one million downloads worldwide, and it is not hard to see why it has become so popular. It has a huge number of features, offers a good introduction to the use of layers and transparency, and, most importantly, is free. This makes it especially appealing to people (including children) who have the time and patience to learn how to use it but who are working with no real budget.

Some reviewers have been too effusive about Photobie, one of them describing the screen capture tools as being "by far the best I ever encountered." This is going too far, considering there are specialist tools such as SnagIt that offer 32-bit capture plus a dedicated interface that allows you to select the window to be grabbed. Photobie has not reached these dizzying heights, yet. In fact, it remains something of a "homespun" project, but with serious aspirations now that professional designers and software developers are contributing their support. Its natural market is the digital scrapbooking community. It would have been included in that chapter of this book were it not for its powerful image-editing capability (and the skill level required to use it).

Version: Photobie 4.8 (2008)

OS: Photobie Windows 2000, 2003, and XP with .NET framework 1.1; Photobie Design Studio Windows XP with .NET framework 3 or Vista

RAM: 256MB

Supported file formats: Major image formats

Price level: Free for personal use

Address: Photobie Design, Boston, MA, United States

www.photobie.com

STOIK PictureMan Pro

Vendor: STOIK Imaging

Purpose: Image processing, editing, and retouching software in 48-bit color

Description

STOIK PictureMan Pro contains dozens of image-correction tools for advanced image processing in 48-bit color mode. The program also has all the functions of a full image editor, including multilayers, advanced painting, and plug-in support. It has over 120 image processing filters and special effects including a range of artistic simulations.

PictureMan Pro's retouching filters include dust cleaning, scratch removal, JPEG denoising, despeckling, sigma filter, sharpening, smoothing, shadow lightening, and a stamp brush. PictureMan Pro supports pressure sensitive tablets and has infinite undo-redo. It accepts Photoshop-compatible plug-ins on-the-fly without program restart.

Among PictureMan Pro's later features (v.5.0+) is a smart resize algorithm that allows you to create high-quality photo thumbnails and enlarge images up to 1,000 percent without significant loss of visual sharpness.

Comments

Formed in 1990 as a spin-off from the Soviet space program, STOIK Imaging is a significant player in the photo software market, developing code on an OEM basis for partners worldwide. PictureMan was the first image editor to be optimized for Intel's MMX technology. It has all the features that many photographers look for, including consistent color management and accurate color correction. By using 48-bit color (16 bits per channel), the developer avoids the degradation problems encountered with 24-bit color (8 bits per channel) processing, without seeking a full non-destructive solution. Degradation of the image is simply less likely to be noticed at the higher bit level.

PictureMan is certainly worth trying because of its competent image-editing features. Its user interface looks a little dated, but it has some excellent smooth filtering algorithms, ideal for portraiture and nature photography.

Version: PictureMan 5.0.2 Pro (2008)

OS: Windows 98, 2000, XP, and Vista

RAM: 256MB

Price level: Approx. $200

Address: STOIK Imaging, Ltd, P.O. Box 48, Moscow 119049, Russia

www.stoik.com

StudioLine Photo Classic

Vendor: H&M Software

Purpose: All-in-one package for organizing, editing, and backing up a collection of images

Description

One of a family of products, StudioLine Photo Classic 3 Plus is a versatile package that combines image viewing, organizing, and editing with layout, publishing, and backup. It is a serious product, aimed at enthusiasts and professionals. A cut-down, basic (and free) edition is available for novices.

StudioLine Photo Classic has a customizable interface that is laid out attractively in the modern style with switchable panes. There is a quick-step bar to guide beginners, a slider control to vary the size of the thumbnails, a property pane that displays information about the images, input features for ranking images with a five-star system, and an editing pane that shows the image tools currently being used.

The organizing utilities let you sort your images into albums and folders, mimicking, if necessary, the folder structure on your hard disk. You can place shortcuts within folders,

so that images can appear in different places at the same time. There is full control over IPTC and Exif metadata, and batch processing so you can apply the same descriptions, keywords, and ranking to multiple images. Powerful search options let you locate individual images quickly.

The integrated editing functions include all those you would expect in a package of this quality: one-click white balance; live histogram showing red, green, and blue channels; dual monitor support; image rotation; cropping; and quick red-eye/pet-eye removal. It detects and uses any available ICC color profiles.

Layout and publishing options include printing images and contact sheets in predetermined or customized formats, plus facilities to create scrapbook pages, newsletters, e-cards, or certificates. Export and email facilities are available with cropping and sharpening, and there is a basic slide show feature as well.

Backup controls are part of the package, plus an offload feature that lets you move large originals to DVD, leaving behind a lightweight proxy. Clicking on the proxy tells you where to find the original. Supported languages are English, German, French, Italian, and Spanish.

Comments

Developed in Germany, StudioLine Photo Classic 3 Plus offers so many features it seems too good to be true. However, professional reviewers have acknowledged its astonishing value, with the only proviso that users need to learn their way around a vast new interface if they are thinking of switching to it.

As an editor, StudioLine Photo Classic 3 Plus stores all settings with the unchanged original and thus lets you perform true, non-destructive editing. It works brilliantly as an image organizer, with search facilities that offer 75 system criteria as well as any descriptors you may have chosen. Publishing options include a versatile "custom print" option that caters to all sizing and page placement needs. Also useful is the space-saving offload facility that replaces images with lower-res proxies, with pointers to originals that have been transferred to CD or DVD. Altogether, it is an efficient, multi-featured package that by any comparison is great value.

Version: StudioLine Photo Classic 3 Plus 3.5.31 (2008)

OS: Windows ME, 2000, XP, and Vista 3.14 and up

RAM: 256MB (more recommended)

Supported file formats: Major RAW formats; TIFF, JPEG, GIF, BMP, PNG, PSD, PCD, RAS, WAV, AVI, MOV, MPEG, and MP3

Price level: Approx. $60 for the download, $70 for the CD

Address: H&M System Software GmbH, Senefelderstrasse 16, D-63322 Rödermark, Germany

H&M Systems Software Inc., 600 East Crescent Avenue, Suite 203, Upper Saddle River, NJ 07458-1846, United States

www.studioline.biz

Ulead PhotoImpact X3

Vendor: Corel Corporation

Purpose: Image-editing suite for managing, editing, and sharing digital images

Description

Ulead PhotoImpact X3 has a very extensive set of image-editing features, including "quick-fix" tools for rapidly fixing common photographic errors, right up to sophisticated features for creating images with high dynamic range (HDR). To say the least, the package is generous in the sheer quantity of extras it provides, including over a thousand royalty-free images, more than 2,000 Web elements, more than 2,000 objects, and more than 3,000 customizable effects. Bonus software includes Photo Explorer for transferring, browsing, and modifying images, PhotoImpact Album with its cataloging facilities, and Cool 360 for panorama creation.

PhotoImpact abounds with nifty features, including "dockable panels" that allow you to lock frequently used panels and toolbars together, one-screen split-view previewing, and intuitive image compositing using an object-based rather than layer-based approach. An object extraction wizard lets you quickly paint around the object, and then extract and refine it.

Output options are equally extensive: there are Web and blog page templates, an image map tool, and even JavaScript effects with cascading menus, rollovers, and scrolling text. The EasyPalette feature comes with DVD backgrounds, buttons, and frames for use in DVD authoring applications.

Among the new features in PhotoImpact X3 is a complete media management suite called Corel MediaOne Plus Digital Media Management. This not only helps you keep track of all your photos but also lets you create video slide shows for sending to friends and family. A new set of crop tools allows you to crop according to the "rule of thirds" or the "golden ratio." Finally, there is improved RAW file support for the increasing number of photography enthusiasts who shoot in this format.

Comments

Whatever you need—red-eye removal, white balance adjustment, noise reduction, object extraction, and so on—you are likely to find it in this product. The individual features may not all be "best of breed," but you can be sure they will be highly competent in the task they claim to do. RAW support, 16-bit image support, and powerful noise reduction with "anisotropic diffusion" help to make Ulead PhotoImpact a remarkably upmarket product, even though it tends to get overshadowed by the vendor's home-grown (formerly Jasc) Paint Shop Pro Photo.

Version: Ulead PhotoImpact X3 (2008)

OS: Windows XP (SP2) Home/Pro, XP Media Center, and XP Pro x64

RAM: 256MB

Supported file formats: Major RAW formats; 001, BAY, BMP, CLP, CRW, CR2, CUR, DCR, DCS, DCX, DNG, EPS, FAX, FPX, GIF, ICO, IFF, IMG, JP2, JPC, JPG, MAC, MRW, MSP, NEF, ORF, PBM, PCD, PCT, PCX, PEF, PGM, PIC, PNG, PPM, PSD, PSP, PXR, RAF, RAS, SCI, SCT, SHG, SRF, SVG (output), TGA, TIF, UFO, UFP, WBMP, WMF, and X3F

Price level: Approx. $70 for the download or boxed

Address: Corel Corporation, 1600 Carling Avenue, Ottawa, Ontario, Canada, K1Z 8R7

www.ulead.com/pi/

> **Note**
>
> At the time of writing, only the earlier version 12 appears on some regional versions of the Corel Website, so you might need to visit the address listed in this section to purchase X3.

UpShot

Vendor: Bellamax

Purpose: Photo-editing package aimed at professional portrait and wedding photographers

Description

UpShot is a photo-editing package aimed at professional portrait and wedding photographers who want fast results with a minimum of fuss. It has a one-cure-fits-all tool called FastFix that analyzes the content of a photo and makes specific adjustments based on scene recognition. Manual fine-tuning includes tools for cropping, straightening, flip/rotate, brightness/contrast, and sharpening. Retouching includes tools for softening wrinkles, whitening teeth and eyes, adjusting skin tone, cloning, under-eye circle removal, stray hair zapper, and so on.

UpShot has facilities for direct upload to Flickr, ImageShack, Shutterfly, SmugMug, Snapfish, Wal-Mart, and Webshots. From the outset it has been backed up with plenty of online tutorials and a user forum.

Comments

Described as "an excellent tool in the making" by one professional photographer, UpShot takes a sensible approach to photo editing by offering wedding pros a restricted set of useful tools rather than a bloated set of "might-come-in-useful" tools. If you want to use any of the uploading facilities or view the tutorials, as always a high-speed Internet connection is essential.

Version: UpShot1.0 (2008)

OS: Windows 2000 and XP

RAM: 512MB (1GB recommended)

Supported file formats: RAW, JPEG, and TIFF

Price level: Approx. $30

Address: Bellamax Inc., 388 Market St. Suite 1250, San Francisco, CA 94111, United States

www.upshotphoto.com

Zoner Photo Studio

Vendor: Zoner Inc.

Purpose: All-in-one photo solution for acquiring, editing, archiving, and publishing images

Description

Zoner Photo Studio, which is also marketed by other vendors under similar names (such as ShortCut PhotoStudio), is a complete all-in-one solution for image input, editing, archiving, and publishing. Its editing capabilities extend beyond the standard curves and levels and color and sharpness enhancement to defect removal, shadow brightening, red-eye reduction, and a whole range of retouching facilities including clone stamping, ironing, filling, and painting. It also has a full complement of tools for cropping, special effects creation and batch processing.

Other key features of Zone Photo Studio include printing, slide show creation, and Web gallery tools. But that is not all: among its most interesting features are facilities for composing high dynamic range (HDR) images by combining several photos into one,

Figure 10.4
Zoner Photo Studio has powerful features, including HDR and panorama creation, at a very competitive price.

and facilities for making 3D images (or *analglyphs*) using images taken from slightly different positions. For the latter effect, Photo Studio automatically combines the two source photos into a single image. When you view this composite image with special glasses that have one red and one blue lens, it appears to be three-dimensional.

Comments

The successor to Zoner Media Explorer, Zoner Photo Studio supports 26 bitmap formats, 6 vector formats, 9 video formats, and 10 audio formats. This makes it a multimedia tool as well as an all-in-one image editing/publishing package. At the time of writing, RAW processing support is limited chiefly to Canon CRW files in the Pro edition only, but this will undoubtedly be expanded in future versions.

Some users may find the vendor's marketing approach to be overly complicated, because there is continuing availability of four earlier versions, each of which is available in Professional, Home, Xpress, and Classic variants. Moreover, through the magic of OEM, the product crops up in the catalogs of other vendors under different branding. That said, no one can fail to be impressed by ZPS's extraordinary range of well-implemented features, not least of which are its HDR, analglyph, and panorama-creation tools. These, together with extensive editing/publishing tools, make it an exceptional value for money.

Version: Zoner Photo Studio 10 (2008)

OS: Windows 2000, XP, and Vista

RAM: 256MB

Supported file formats: Major image and multimedia formats, including BMP, JPEG, and PNG; Canon RAW (CRW)

Price level: Pro edition approx. $85

Address: ZONER, Inc., 51 Georgetown Dr., Dallas, GA 30132, United States

www.zoner.com

Summary

Image editors are multi-featured, often to the nth degree like Adobe Photoshop or Corel Paint Shop Pro Photo, perhaps the two best-known editors currently available. To be a true image editor, software must certainly have cropping, masking, retouching, and resizing features as well as provide image enhancement, sorting, printing, and sharing functions. To these the developer may add a selection of the features that are described elsewhere in this book, always at the risk of confusing the user with an embarrassment of riches. Adobe has added retouching facilities to Lightroom, although you still need to dive into the industry-standard Photoshop for a full set of editing features. If you have not looked at Nikon Capture for a while, check out the NX version with Nik Software's U Point technology. It offers a viable alternative to masking when you need to make alterations to specific areas of the image, thus reducing the need for an editor.

Part II

Refining, Simulation, and Enhancement

This part includes the following topics:

11

Masking Tools

Photoshop owes much of its success to its masking capability, which allows you to separate an object from its background. Despite this, there are many other tools that bring additional features, greater ease-of-use, or sheer speed to the process.

One of the classic applications of masking is changing the background in a portrait. This can present a serious challenge to the masking tool when there is fine hair detail seen against an in-focus background. Even if the background is out of focus, the task is beyond the scope of conventional tools that require manual tracing of the boundary.

Fortunately, specialist tools can come to the rescue. They tend to take two approaches—they either play it safe by insisting that you take the original portrait against a blue or green chroma key background, or else they use sophisticated sampling algorithms to differentiate between the pixels belonging to the background and those belonging to the foreground object. Primatte Chromakey from Digital Anarchy is a good example of the first approach; EZ Mask from motion picture tools specialist Digital Film Tools is a good example of the second.

The masking software listed here ranges from the low-cost (Recomposit) to the fairly expensive (Primatte Chromakey).

ArcSoft Cut-It-Out

Vendor: ArcSoft

Purpose: Speedy, accurate mask creation for separating objects from their backgrounds

Description

ArcSoft Cut-It-Out has features similar to Photoshop's Extract command, but has been designed to be slightly easier to use. It has fine-tuning options that let you attend to the edges and smoothing tools to cover up any mistakes.

Comments

ArcSoft is constantly in the process of beefing up its image-editing capabilities, Cut-It-Out being an example of a tool that will become part of a more advanced image editor than ArcSoft PhotoStudio. It does its job well, by all accounts, but the price is high for a single-function plug-in.

Version: ArcSoft Cut-It-Out 1.0 (2008)

Plugs into: Photoshop 6, 7, 8, and CS; Photoshop Elements; and ArcSoft PhotoStudio 5.5.

OS: Windows 2000, XP, and Vista

RAM: 128MB

Supported file formats: As host program

Price level: Approx. $100

Address: ArcSoft Corporate Headquarters, 46601 Fremont Blvd., Fremont, CA 94538, United States

www.arcsoft.com

EZ Mask

Vendor: Digital Film Tools

Purpose: Interactive image-masking tool for extracting objects from images

Description

EZ Mask, as its name suggests, is an easy-to-use masking tool, although it comes from a vendor of professional movie matting software. It cuts out a foreground object from the background, regardless of what is depicted in the image. Having created a mask, you can then composite the object with an alternative background, blending the two seamlessly together.

To use EZ Mask is very quick. You draw broad brushstrokes around the image to create samples that the software uses to calculate the difference between foreground and background pixels. This technique requires no precise drawing skills whatsoever. Once the software has the information, it makes the mask automatically.

Comments

It makes no difference whether you are dealing with fine hair detail, smoke, or reflections, EZ Mask can separate them from the background. For separating opaque objects you do not need such a powerful product: the vendor's Snap tool should do the job.

Version: EZ Mask 1.5 (2008)

Plugs into: Photoshop 7 and above, Elements 3 or 4

OS: Windows XP, Vista; Mac OS X 10.4 and higher (Rosetta emulation mode not supported)

RAM: 1GB for images up to 8 megapixels; 1.5GB for images up to 12 megapixels; 2GB for images up to 16 megapixels

Supported file formats: RGB formats

Price level: Approx. $150

Address: Digital Film Tools, LLC., Los Angeles, CA, United States

www.digitalfilmtools.com

Fluid Mask

Vendor: Vertus Tech

Purpose: Specialist cut-out tool, with new segmentation technology for optimal results

Description

Fluid Mask contains a new way of making image cut-outs. It uses an advanced segmentation technology that divides the image into dozens of segments with clearly defined edges. This enables you to select, group, and mask objects in the image, obtaining the cleanest possible separations between masked and unmasked areas.

An Edge Detection Option panel contains slider controls for edge sensitivity and in-focus edge width. Radio buttons offer a choice of high, medium, or low settings for edge contrast; and fine, medium, or coarse settings for a texture filter that groups areas of similar texture, such as grass, into larger groups for more efficient masking. However, this is not all, because Fluid Mask provides many more, easily accessible tools, including a Color Workspace that displays all the colors that are present in a selected region of the image. With this tool you can fine-tune the mask by assigning colors to "keep," "delete," and "complex" categories. It even has a "test rendering" tool that quickly renders a selected rectangle so that you can check the quality of the mask.

Fluid Mask can be used with Wacom tablets, with pen pressure linked to brush size. It has full support for 16-bit images.

Comments

Fluid Mask is one of the best Photoshop plug-ins because not only does it make near-perfect masks, it also has a well-designed interface to make mask creation easier than

you would have thought possible. Version 3.0 was a major release, with significantly faster processing speeds, better edge blending, and additional features such as new tools for fine mask selection. It is professional software with a price to match, but it is worth every cent if you need to make composite images without seeing a join.

Version: Fluid Mask 3.0 (2008)

Plugs into: Photoshop CS2 and later; version 3.1 will add QuarkXPress and Paint Shop Pro

OS: Windows XP with SP2, and Vista; Mac OS X v.10.3.9, v.10.4.9, or later

RAM: 512MB (1GB recommended)

Supported file formats: As host

Price level: Approx. $240

Address: Vertus Tech, 242 Elm St, South Dartmouth, MA, 02748, United States
Vertus Tech, Manning House, 22 Carlisle Place, London, SW1P 1JA, United Kingdom

www.vertustech.com

Mask Pro

Vendor: onOne Software

Purpose: Sophisticated set of masking tools for isolating subjects from their backgrounds

Description

Mask Pro is a set of specialist tools for really tough masking tasks such as separating a subject's hair from a background of clouds. Rather than taking a one-size-fits-all approach, it offers the right tool for the job, allowing you to work on different parts of the image using different tools.

You can use Mask Pro simply to make a selection, using one of the selection tools to create a clipping path. Alternatively, you can use the standard mode for masking a transparent item. A real-time preview gives you a good indication of the quality of the mask. Among the tools provided are Chisel for obtaining sharp edges without halos and Magic Brush for removing colors while maintaining transparency. The latest version has support for Wacom graphics tablets with pressure sensitivity.

Comments

The algorithms in Mask Pro are very good at removing colorcasts in transparent objects like smoke, fog, and glass. It does what all good plug-ins are meant to do: goes beyond what is available in the host program. One of its key features is its results preview, in which it shows you what the results will look like while you are creating the mask rather than after you have processed the whole image. This is a great professional tool, with full 16-bit support, offered at a competitive price.

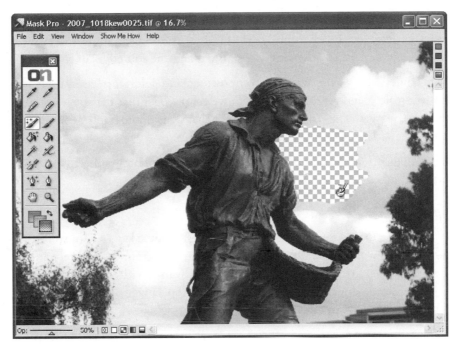

Figure 11.1
Mask Pro has a full set of tools for professional masking.

Version: Mask Pro 4.1.1 (2008)

Plugs into: Photoshop CS2 or CS3; Photoshop Elements 4 or later

OS: Windows XP SP2 and Vista; Mac OS X 10.4.8 and higher

RAM: 512MB

Supported file formats: Those of host program

Price level: Approx. $160

Address: onOne Software, 15350 SW Sequoia Pkwy, Suite 190, Portland, OR 97224, United States

www.ononesoftware.com

Primatte Chromakey

Vendor: Digital Anarchy

Purpose: Chroma key compositing plug-in for Photoshop, replaces blue background with pictorial content

Description

Primatte Chromakey is not a general masking plug-in but a true chroma key tool that replaces the blue background in a specially taken picture with an alternative background.

As you would expect, it gives a cleaner result than those achieved by other software working on images with pictorial backgrounds. It is ideal for studio portraiture and fashion shots because it can deal efficiently with wisps of hair and the soft edges of clothes.

The software comes with all the masking, compositing, and color-correction tools you need to create a superb end result. You can remove color tinges that may be noticeable in semi-transparent areas. The vendor recommends that users photograph their subjects against chroma key foam-backed fabric for best results.

Primatte Chromakey is aimed at professional and semi-pro photographers who work under strict deadlines and do not have time for hand masking.

Comments

Most reviewers judge Primatte Chromakey to be the best chroma key tool for stills photographers. It allows you to photograph your sitter and background separately, in the confidence they will matte together perfectly. If you want an alternative to a photographed background, you can use the vendor's Backdrop Designer product to create a pattern "similar to muslin drapery."

Version 3.0 of Primatte Chromakey brings a new interface together with a new automasking tool. This lets you try out a single-click automask procedure to see if you can obtain acceptable results before resorting to the full three-step procedure. Although limited to head-and-shoulder or three-quarter shots, automasking is a great time saver and can be applied as part of a batch action. Also in the latest version is a full set of color spill removal tools, including four groups of tools for removing bluespill. The results, examples of which are available online, speak for themselves.

Version: Primatte Chromakey 3.0 (2008)

Plugs into: Photoshop 5.5 and higher, Photoshop Elements 2.0 and higher

OS: Windows 2000, XP, and Vista; Mac OS X 10.4 and up

RAM: 256MB

Supported file formats: Major formats

Price level: Approx. $300

Address: Digital Anarchy, 167 Vernon Street, San Francisco, CA 94132, United States

www.digitalanarchy.com

Recomposit

Vendor: Stepok Image Lab

Purpose: Advanced photo masking and compositing tool with chroma key technology

Description

Recomposit is a specialist masking and recomposing package that allows you to isolate difficult subjects from their background. It uses traditional chroma key ("bluescreen") technology to separate foreground from background by their difference in the hue (chroma) channel. It supports inside/outside matting for when bluescreen matting is not feasible, such as in real-life images captured outdoors. Recomposit can also simulate lens blur in the background and has painting and retouching facilities.

Comments

If you do a lot of masking, download this software for a month's free trial. Its inside/outside matting, in particular, is highly effective. Many photographers will love the "background blur" feature, which makes the matted foreground object stand out from the background. With its combination of two advanced matting methods, Recomposit is exceptional value, although it lacks most of the fine-tuning tools of fully professional masking products.

Version: Recomposit 1.8 (2008)

Plugs into: Adobe Photoshop 3.0 and above (with extended edition)

OS: Windows 2000, XP, and above

RAM: 128MB

Supported file formats: JPEG, TIFF, and BMP

Price level. Approx. $40, (Extended edition) $80

Address: No.89 ShuTongJie, JiNiu Qu, Chengdu, Sichuan, People's Republic of China, 610036

www.stepok.net

Snap

Vendor: Digital Film Tools

Purpose: Interactive selection tool for extracting solid or opaque objects

Description

Snap is designed to separate solid or opaque objects from a background. It works effectively when there is a clean edge between object and background but is not suitable for separating fine hair detail, for which the vendor has another solution called EZ Mask. There are also manual path-creation facilities in Snap using X-Splines.

Comments

Snap is so called because it snaps an editable curve to an object's boundary. The software differs from the vendor's EZ Mask tool in not creating any changes in the foreground object, making it useful for product shots where the background needs to be changed.

Version: Snap 2.5 (2008)

Plugs into: Photoshop 7 and above, Photoshop Elements 3 and above

OS: Windows XP and Vista; Mac OS X 10.4 and higher

RAM: 256MB

Supported file formats: RGB formats

Price level: Approx. $50

Address: Digital Film Tools, LLC., Los Angeles, CA, United States

www.digitalfilmtools.com

Summary

Long used by the film and television industry to swap one background image for another, masking tools have been refined to a point where they can do much the same for high-quality photographs. Shooting against a color background in the chroma key method is one option, still preferred by exacting professionals. However, the development of powerful sampling algorithms allows photographers to separate a subject from its background, even when either one consists of many tones, shapes, or colors. Some of the specialist tools described here, such as EZ Mask, go beyond the masking capabilities of the major image editors.

Black and White Conversion

Digital technology has led to a renaissance in both the appreciation and the practice of black and white photography, especially in the United States. This is partly because most digital cameras are fundamentally black and white instruments, despite their ability to produce color. The Bayer filter adds color by placing red, blue, and green filters above the individual light-collecting elements of the camera's sensor, so to get the highest quality of black and white is simply a matter of removing its effect. There are at least six ways of doing this:

- Desaturate the colors
- Convert to grayscale
- Convert to Lab mode
- Use hue/saturation layers
- Use the channel mixer
- Use special software

Of these methods, simple desaturation of the color is least effective, because it produces images that look washed-out. Convert-to-grayscale is marginally better, as it takes account of the different weights given to the filtered colors. In Photoshop the conversion factor is 59% of the green, 30% of the red, and 11% of the blue channel. Converting to Lab mode makes the process easier because you can delete the "a" and "b" chroma channels to leave only the lightness channel. Playing with two hue/saturation adjustment layers in Photoshop is a time-consuming but very effective option.

Channel mixing requires even more time, letting you control each red, green, or blue channel separately, the percentages of which must add up to 100. Going above 100 will brighten (overexpose) the image; going below will darken (underexpose) it. You can find channel mixers in both Photoshop and Paint Shop Pro.

The alternative to these methods is to use special software that provides added facilities to make conversion easier or more accurate. The most sophisticated software offers dozens of presets and controls and can recreate the look of particular films, filters, lab effects, and photo papers while adding soft focus and other effects. Other software provides basic channel mixing with the option to save your settings for future use. The price range is $25–$75, but free software with very acceptable results is also available, such as B/W Conversion from Photo-Plugins (www.photo-plugins.com).

Andy

Vendor: Sean Puckett

Purpose: Black and white film simulator, with film/developer and paper/developer combinations

Description

If you are really, really involved with black and white photography and want to emulate the various film/paper/developer combinations of the past, this is the product for you. It provides 10 film and 10 paper simulations for free. But it goes further. If you obtain the pro version you get a much greater choice of simulation: 66 film/developer simulations and 52 paper/grade simulations, making a total of over 3,400 combinations.

Comments

Andy can keep the most erudite black and white photographer amused for hours, "developing" virtual Fujifilm Neopan 1600 with three different types (each) of virtual Fujidol, Microfine, D-76, or SPD. If you reach this stage you have come a long way from simply pressing the Grayscale button. Version 1.4 can treat each RGB channel separately if you select the RGB check box, enabling better preservation of white.

Version: Andy 1.4 (2008)

Plugs into: Bibble Pro (Note: Upgrade when Bibble upgrades)

OS: As host

RAM: 128MB

Supported file formats: As host

Price level: With 20 combinations free, with more than 3,400 combinations $20

Address: seanmpuckett@gmail.com

www.nexi.com/andy

B&W Pro 2

Vendor: Red Paw Media

Purpose: Black and white conversion with multiple controls and 16 bits per channel processing

Description

B&W Pro 2 is a color-to-black-and-white conversion plug-in that processes both 24-bit (8 bits per channel) and 48-bit (16 bits per channel) RGB files and produces professional results without unwanted artifacts.

On a single panel interface, B&W Pro 2 offers many different controls, including six sliders for sensor color response, plus gamma and contrast controls, per-channel contrast adjustment, exposure compensation, and black/white points, and the ability to add a color tint after processing. The top control lets you simulate a color filter placed over the lens at the capture stage. Red is the favored color, used for darkening skies. Here, the software simulation provides adjustment of the simulated filter from 0–100%.

Comments

There is no single "right way" to convert to black and white, although there is certainly a one-click "wrong way" (the "convert to grayscale" button in image editors). B&W Pro 2 has the tools to do it properly, in many different ways according to taste.

It produces excellent results, but you need a good understanding of black and white photography to get the best out of it.

Version: B&W Pro 2 (2008)

Plugs into: Photoshop and compatible editors

OS: Windows 2000, XP, and above

RAM: 128MB

Supported file formats: RGB formats

Price level: Approx. $30

Address: Alresford, Hampshire, United Kingdom

www.redpawmedia.com

B/W Styler

Vendor: PhotoWiz

Purpose: A comprehensive black and white package for conversion, effects, and styling

Description

For black and white enthusiasts, B/W Styler is a real treat. It lets you recreate the look of films, lens filters, lab effects, and photo papers popular in traditional B/W photography.

Even if your original color image is dull, B/W Styler can turn it into a vibrant black and white conversion, with options for adding color tones, simulating film grain, and adding special effects. You can manipulate brightness and contrast, add soft focus and glow, and put in some vignette blur and mist effects if you are so inclined.

Comments

This is an impressive black and white solution, with three user levels for inexperienced, intermediate, and advanced users. Whereas the basic Photographer's Mode gives you a choice of presets within a single dialog box, the top Expert Mode has more than 100 controls and nearly 200 local presets. Like all the software from this vendor, it is well conceived and delivers what it promises.

Version: B/W Styler Version 1.1 (Windows), 1.0 (Mac OS X) (2008)

Plugs into: Photoshop, Elements, Paint Shop Pro, PhotoImpact, Photo-Paint, Fireworks, and so on

OS: Windows 95, 98, NT, ME, 2000, XP, and Vista; Mac OS X

Supported file formats: 8-bit and 16-bit RGB and grayscale images

Price level: Approx. $50

Address: Nuremberg, Germany

www.photocorrection.com

PR Black/White Studio

Vendor: PowerRetouche

Purpose: A "digital darkroom" for converting digital color images to black and white, in 8 or 16 bits per channel

Description

PR Black/White Studio is an extremely versatile converter of digital images from full color to black and white. It offers masses of options: two pages of them in the Windows version, three pages on Macintosh. It contains presets that simulate professional films such as Kodak Tri-X and T-MAX, but it also lets you create your own light sensitivity curves and then store them for later use. It has a full range of color filters that imitate the effect of standard camera filters, plus full control over exposure, highlights, and shadows. A set of zone controls lets you make adjustments to three selectable zones.

PR Black/White Studio is capable of matching all the multigrade levels of traditional photographic paper, from 00 to 5. It even has an extra level at each end, proving, once again, that digital photography pushes the boundaries in unexpected ways. There are highlight and shadow alert options to warn you when you are losing tonal levels. The zone controls, used in conjunction with an eyedropper tool, are particularly well implemented with different colored crosses that remain in position to indicate the three selected zones.

Comments

Of all Jan Esman's great plug-ins, this is probably the best. It has been widely acclaimed by reviewers and users, most of whom rate it above other similar products. Many photographers are still wary of using digital to produce black and white, but those who try this black and white converter typically change their minds.

Version: PR Black/White Studio Windows 1.3; Mac 1.2 (2008)

Plugs into: Paint Shop Pro, Photoshop Elements, Macromedia Fireworks, CorelDRAW, and other editors

OS: Windows 3.1x, 95, 98, ME, NT, 2000, and XP; Mac OS 9 Classic and Mac OS X

RAM: 256MB

Supported file formats: As host

Price level: Approx. $70

Address: Power Retouche/Jan Esmann, Bolandsvej 1, 1mf, DK-2100 Copenhagen N, Denmark

www.powerretouche.com

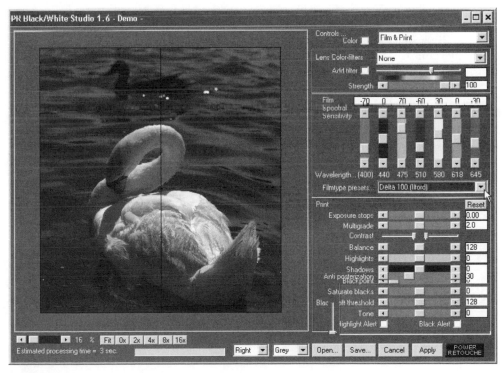

Figure 12.1
PR Black/White Studio lets you simulate traditional photographic films and papers.

rkflow Pro

Miranda

Purpose: Convert color to black and white, with dozens of preset options

Description

Brazilian photographer Fred Miranda, famous for his independent site for all things Canon, offers a range of software including this versatile black and white converter. It has manual modes if you want to make all the settings yourself, but it also comes with loads of presets. There are 8 preset filter selections, 32 duotone presets, 18 tritone presets, 6 quadtone presets, 3 film grain presets, and 4 dynamic range presets.

BW Workflow Pro gives you a live preview, lets you work in 16-bit mode, and even has a batch capability. There is an Add Grain feature to emulate the look of film grain. Add Dynamic Range opens up the shadows. The duotone, tritone, and quadtone modes allow you to create some excellent sepia and color-wash effects.

Comments

Several photographers have achieved excellent results with BW Workflow Pro. One or two have complained of a lack of features, particularly for tweaking the subtle tones in portraits. Black and white photographers who stick with film should certainly try this or a similar package.

Version: BW Workflow Pro 1.5 (2008)

Plugs into: Photoshop 5.5 and later

OS: Windows and Mac

RAM: 128MB

Supported file formats: As host

Price level: Approx. $30

Address: San Clemente, California

www.fredmiranda.com

RetroGrade

Vendor: Cybia

Purpose: Turn color into black and white with the classic look of film

Description

RetroGrade is an advanced Photoshop plug-in that turns a color image into a black and white one with the classic look of film, with its deep blacks, well-defined midtones and excellent local contrast. To do this it offers a lot of different controls: 11 sliders, a large dialog and preview area, reset buttons, percentage buttons for fast zoom, and 70 preset files "to help get you started."

With RetroGrade you can lighten the trees, darken the sky, and mix any combination of red, green, and blue to achieve a desired effect. There are controls for brightness and contrast, film grain, color response, and tone and tint. It has a 16-bit mode for 48-bit color images.

Comments

Steve Upham has packed more features into this low-cost plug-in than are available in his freeware black and white converters (see the section entitled "Fotomatic" in Chapter 13, "Film Simulation and Effects"). Reviewers have found it particularly effective on landscapes but almost as applicable to other photographs. The RGB Optical Filter sliders give you good control over the tonal values derived from each color channel.

Version: RetroGrade 1.2 (2008)

Plugs into: Photoshop and compatible editors

OS: Windows 95, 98, ME, 2000, and XP

RAM: 128MB

Supported file formats: Major formats

Price level: Approx. $8

Address: steve@cybia.co.uk

www.cybia.co.uk

Summary

Many image editors offer excellent black and white conversion facilities, going beyond simple color desaturation to provide more satisfactory ways of accomplishing the task. Some of them provide complete channel mixing so that you can vary the contribution made by each color channel to the final image. However, the specialist black and white converters discussed in this chapter go even further in offering many more presets, some of them having the ability to simulate the black and white response of different types of film stock.

13

Film Simulation and Effects

Digital processing can capture the exact "look" of practically every photographic emulsion ever made: you just need the right software to do the job. If you require the look of a certain black and white film, maybe even a particular combination of film/developer/paper, you should browse through the descriptions in Chapter 12, "Black and White Conversion." Here, in this film simulation chapter, the software deals not only with straightforward conversion to the look of a particular color film but also with special processes like "bleach bypassing" and various substitutes for optical filtering.

For a century and a half, photographers explored every aspect of the film medium, sometimes stumbling across great effects accidentally. The best of them (and some of the worst) live on in digital form, captured in algorithms that can be applied to just about any image. Software also reintroduces the imperfections of film, like the various grain patterns, matching them perfectly to the size of the image. This might not be to everyone's taste, but there is much to be said in favor of imitating the colors and response curves of classic films like Velvia or Kodachrome. The fact that the look of these films will always live on in digital media tends to confirm the theory that existing technology never entirely disappears, even when replaced in its traditional applications.

See also PhotoKit Color, which provides color correction as well as film simulation and is included in Chapter 30, "Color Tools."

Tiffen Dfx Digital Filter Suite

Vendor: The Tiffen Company

Purpose: Professional quality filters to simulate optical glass filters, lab processes, and other effects

Description

Tiffen Dfx is one of the most extensive sets of filters you can buy, with simulation of popular glass camera filters, specialized lenses, optical lab processes, film grain, matte generation, color correction, and a whole host of others. The software has support for both 8- and 16-bits-per-channel processing. They come in various editions for both stills photography and film/video use.

Among the filters are Black Diffusion/FX, Black Pro-Mist, Bleach Bypass, Blur, Bronze Glimmerglass, Center Spot, Chromatic Aberration, Color Compensating, Color Conversion, Cool Pro-Mist, Cross Processing, Day-for-Night, Defog, Defringe, Depth of Field, Diffusion, Double Fog, Dual Grad, Edge Glow, Enhancing, Faux Film, Flashing, Fluorescent, Fog, F-Stop, GamColor Gels, Glow, Gold Diffusion/FX, Gold Reflector, Grain, Halo, HDTV/FX, Lens Distortion, Light, Light Balancing, Low Contrast, Mono Tint, ND-Grad, Night Vision, Nude/FX, Old Photo, Pro-Mist, Rack Focus, Radial Exposure, ReLight, Rosco Gels, Selective Color Correct, Selective Saturation, Sharpen, Silver Reflector, Smoque, Sunset/Twilight, Telecine, Temperature, Three Strip, Ultra Contrast, Vari-Star, Vignette, Warm Soft/FX, Xray, and many more.

Tools are available within the package to apply multiple filters in a layering process, together with batch processing facilities. The product is also available as a plug-in for Apple's Aperture and always requires a three-button mouse.

Comments

Developed originally by Digital Film Tools (and called 55mm, after the standard filter size in film and TV), Dfx consists of fully professional tools that many photographers find indispensable. Designing a poster for a horror film? Try the Day-for-Night filter and turn daylight to moonlight just like they do in Hollywood. Got a portrait with a plain background? Add a lighting pattern to it with the Light filter to simulate the shadow cast by a window (there are 565 patterns to choose from in the GAM library—www.gamonline.com—which comes with the plug-in). Bearing in mind that the Light plug-in was once sold separately ($50), the whole set is an exceptional value.

Version: Tiffen Dfx (2008)

Plugs into: Photoshop, After Effects, Final Cut Pro, Avid Editing, and Discreet systems

OS: Windows XP Pro, XP Home, and Vista; Mac OS X 10.4 and above (not supported in Apple's Rosetta emulation mode)

RAM: 1GB (2GB or more recommended)

Supported file formats: RGB formats

Price level: Stand-alone edition approx. $200, Photoshop plug-in edition approx. $300

Address: The Tiffen Company, 90 Oser Avenue, Hauppauge, NY 11788-3886, United States

Tiffen Europe Ltd., Enterprise House, Weston Business Park, Weston on the Green, Oxford, Oxfordshire OX25 3SX, United Kingdom

www.tiffen.com

Bleach Bypass PRO

Vendor: Red Paw Media

Purpose: Simulates the traditional "bleach bypass" color film technique

Description

Bleach Bypass PRO simulates the traditional "bleach bypass" film technique that, in darkroom days, was a process that left out most of the bleaching stage of color film processing. As a consequence, a lot of the silver was left in the negative, together with the color dyes, creating an effect of a black and white image over a color one. Other characteristics are reduced saturation, increased contrast, and significant graininess.

Bleach bypass has been used in many movies, making its first appearance in *Her Brother* (1960, Kon Ichikawa), and later in *Saving Private Ryan* (1998, Steven Spielberg). The reason for simulating it in digital form and publishing it as a separate plug-in for stills photographers is because it gives a terrific visual effect—moody, gritty, but also flattering to its subjects.

A free version of Bleach Bypass with reduced functionality is also available.

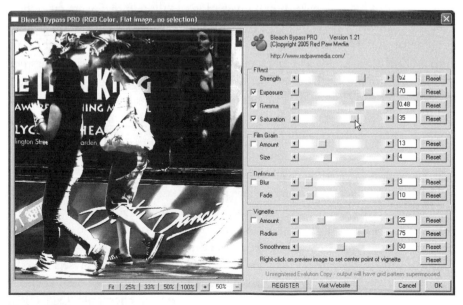

Figure 13.1
Bleach Bypass PRO can give your images a uniquely gritty, "streetwise" look.

Comments

Red Paw Media is a venture of British photographer Jon Read, who has developed many other useful plug-ins. This one has earned him high praise from other photographers. Although a relatively simple piece of software, it produces a distinctive and compelling "look" which you can fine-tune with exposure, gamma, saturation, grain strength, grain size, and effect strength controls.

Version: Bleach Bypass PRO 1.0 (2008)

Plugs into: Photoshop and compatible editors

OS: Windows 2000 and XP

RAM: 128MB

Supported file formats: RGB formats

Price level: Approx. $30

Address: Alresford, Hampshire, United Kingdom

www.redpawmedia.com

Exposure 2

Vendor: Alien Skin

Purpose: Film stock simulator that gives digital images the look and feel of Velvia, Kodachrome, and other films

Description

With Exposure 2 it is easy to make digital images look as though they were taken by a film camera loaded with a particular type of film stock. This package, from the vendor of Image Doctor and BlowUp, simulates the look and feel of Velvia, Kodachrome, Ektachrome, Ilford 3200 Delta, and many other types of film. It can even simulate stock that has been long discontinued but still lingers in the memories of photographers, such as Ektachrome EES and GAF 500. Whether color film or black and white, Exposure 2 always produces a convincing result. It also offers several manual controls for adjusting color, dynamic range, softness, and grain.

Comments

Exposure 2 has been widely praised by reviewers for its ease of use and accurate rendition of film characteristics. One reviewer complained that Velvia 50 (a favorite of many photographers) was missing from the first version of the product and the vendor responded by saying it was easy to import new settings or create your own and store them. This was true, but eventually the vendor decided to pack as many presets into the package as possible, including Velvia 50, making it hard to beat. Although Sean Puckett's Bibble plug-in Andy adds development processes, papers, and chemicals, Exposure 2 has 32-bit image support, which means you can work with high dynamic range (HDR) images in an elegant, easy-to-use interface.

Version: Exposure 2.0 (2008)

Plugs into: Photoshop CS2 or later; Photoshop Elements 4 or later

OS: Windows XP or later; Mac OS X 10.4.0 or later

RAM: 256MB

Supported file formats: Those of host program

Price level: Approx. $250

Address: Alien Skin, 1111 Haynes Street, Suite 113, Raleigh, NC 27604, United States

www.alienskin.com

Fotomatic

Vendor: Cybia

Purpose: Traditional photographic effects such as optical filters, film FX, and darkroom techniques

Description

Fotomatic is a series of plug-ins that simulates traditional photographic effects. They include:

- Hi-Spot, for converting to high-contrast black and white
- G-Force, which creates traditional monochromatic grain effects
- Techni-X, for high-contrast black and white with bleach-out of midtone grays
- NightScope, for a desaturated, slightly blurred "night-vision" effect
- Pseudo-IR, to simulate the look of infrared film
- SkyGrad, for tinting the sky in your photographs
- BW-Plus, for quickly turning your images into black and white
- FastFix, for quick access to enhancement controls though a single dialog box

Comments

Steve Upham's plug-ins often turn up on photo magazine CDs in the UK. Fotomatic is a useful collection aimed at digital beginners who may be more familiar with film techniques. As the developer admits, they work better on PC than Mac, having been created on the PC platform "using a more advanced compiler." Fotomatic is a series rather than a collection, and you need to download each one separately.

Version: (Windows) Fotomatic 1.3; (Mac) 1.1 (2008)

Plugs into: Photoshop

OS: Windows 95, 98, ME, 2000, XP, and Vista; Mac OS 8 or higher, OS X

RAM: 128MB

Supported file formats: Major formats

Price level: Free

Address: steve@cybia.co.uk

www.cybia.co.uk

RealGrain

Vendor: Imagenomic

Purpose: Simulates grain patterns, color, and tonal response of different films

Description

RealGrain is film simulation software that imitates the grain patterns, color, and tonal response of different films. It takes account of the size of the image, so that the grain size is proportional to it. It comes with an extensive library of popular color and black and white films, options for adding tints using the Grain Balance controls, plus full adjustment for hue, saturation, and brightness.

Having a versatile Color Filter simulation tool for black and white photography, RealGrain can also convert color images to black and white. You can add traditional tones to the image, such as sepia, platinum, and others, with full control over the way they affect highlights and shadows.

There is support for 8 and 16 bits per channel, batch processing via Photoshop Actions, and support for RGB, Lab, and (single channel) CMYK.

Comments

Reviewers have really liked RealGrain, mentioning how easy it is to get to grips with it quickly. It has a particularly generous list of film stocks, catering to most tastes. For graphic designers who want to create a "retro look" from a modern photograph, RealGrain has the tools for creating professional quality output.

Version: 1.0.1 (as of 2008)

Plugs into: Photoshop and Photoshop Elements

OS: Windows 2000, XP, and Vista; Mac OS X 10.3.x/10.4.x

RAM: 256MB

Supported file formats: Those of the host program

Price level: Approx. $100, also available with Portraiture and Noiseware as part of the vendor's professional plug-in suite, approx. $240

Address: Imagenomic, LLC, 309 Yoakum Parkway, Suite 1501, Alexandria, VA 22304, United States

www.imagenomic.com

The Light's Right Photoshop Action Sets

Vendor: The Light's Right Studio

Purpose: Free Photoshop action sets to enhance digital images

Description

Many skilled photographers have created Photoshop Action sets by recording the commands and tool operations they use for typical processing tasks. Those from Dr. Glenn E. Mitchell II come with full details on how to install and use them:

- TLR B&W Conversion: For high contrast, Ansel Adams-like black and white images from a color image

- B&W Toning: Stay in 16-bits per channel and RGB/CMYK/L*a*b* for black and white toning

- Color Compensating (CC) Filters: Replicate photographic CC correction filters

- Color Enhance: Creative color enhancement action set

- Color Temperature (CT) Filters: Replicate CT correction filters

- Color Overlay: Apply colored overlays like blue/sepia or cyan/sepia

- Cross-Processing: Simulate color film cross-processing effects

- Diffuse Glows: 25 actions for diffuse glows and soft focus effects

- Digital Noise Reduction: Include masking to preserve image details

- Digital Velvia: For the rich, saturated colors of color slide film

- Edge Effects: Add popular edge effects using Gaussian Blur

- Edge and Surface Masks: Sophisticated masking for sharpening

- Faux Infrared: Simulate the infrared look

- Image Resizer for Photoshop CS: Increase image size in small increments

- Image Resizer for Photoshop 7: Increases image size while keeping artifacts to a minimum

- Image Toner: Collection of duotone, tritone, and quadtone conversions

- Photographic Filters: Optical filter simulation, including Cokin CFS types

- Quick Selections: For graduated dodge and burn effects

- Saturation Mask: For use in color correction

- Sepia Tint: With contrast, saturation, and hue controls

- Sharpening Toolkit: For sharpening RGB, CMYK, L*a*b, and monochrome images

- Split Channels: For ultimate control during black and white conversion

- Split Toning: Apply color balance adjustment layers to your image

- Test Strips: Simulate the printing of test strips in a darkroom

- Tone Enhance: Adjusts tonal range more easily

- Tone Mask Toolkit: Isolates specific areas of an image: 1/2 tones, 3/4 tones, and so on

Comments

TLR actions enjoy an excellent reputation among photographers, many of whom prefer them to costly commercial plug-ins. For example, the Split Toning action actually has more features than a similar plug-in costing $100. The developer's site is a mine of information, with tips, tutorials, and videos.

Version: Various (2008)

Plugs into: Photoshop 7.0 and later

OS: Windows 2000, XP, and Vista; Mac OS X

RAM: 256MB

Supported file formats: As host

Price level: Free (donations requested if you find the resources helpful)

Address: The Light's Right Studio, 2114 Longview Dr., Tallahassee, FL 32303-7326, United States

www.thelightsrightstudio.com

Velvia Vision

Vendor: Fred Miranda

Purpose: Color and tone enhancement; adds warm afternoon light to images

Description

Velvia Vision is a plug-in that enhances the tonal range of an image while retaining highlight and shadow detail. Its main feature is its ability to add the warm colors of late afternoon sun to the image, not unlike Velvia film. It lets you load and save custom Velvia Vision profiles.

Comments

Although Velvia Vision is not a precise simulator of Velvia film, it certainly gives a similar look. Two or three users have commented (on DPReview.com) that it does an acceptable job, but that equally good (and free) plug-ins are available, such as TLR Digital Velvia.

Version: Velvia Vision 1.5 (2008)

Plugs into: Photoshop 6 and later

OS: Windows 2000, XP, and Vista; Mac OS X

RAM: 128MB

Supported file formats: JPEG and TIFF

Price level: Approx. $25

Address: San Clemente, California

www.fredmiranda.com

virtualPhotographer

Vendor: optikVerve Labs

Purpose: Apply high-quality, professional photographic styles to your digital images

Description

virtualPhotographer is freeware that allows you to apply the sort of photographic effects that professional film photographers love to use. It includes over 50 presets for automatic modification of your images. Effects include film grain, color modification, B/W conversion, soft focus, high contrast, and many specific types of tinted effect, like bronzed, silvered, greenback, lime juice, and toast. Using virtualPhotographer can save you hours of work in the virtual darkroom.

Comments

There are 12 additional download sets of effects, most of which seem to have that professional look familiar from published images. This is an exceptional piece of freeware, created by Colin Jones (an Englishman who lives in Oregon) and programmed by Peter Rowe. *Photoshop Creative* magazine called it "one of the best Photoshop plug-ins around" and that was spot on.

Version: virtualPhotographer 1.0 (2008)

Plugs into: Photoshop, Photoshop Elements, Paint Shop Pro, and Photo-Paint

OS: Windows 2000, XP, and Vista

RAM: 128MB

Supported file formats: Major image formats

Price level: Freeware

Address: contactus@optikvervelabs.com

www.optikvervelabs.com

Nik Color Efex Pro

Vendor: Nik Software

Purpose: Award-winning set of photographic filters for professional photographers

Description

More than just a set of filters, Nik Color Efex Pro allows you to apply photographic filter effects and enhancements to the whole image or selected parts of the image, using the vendor's U Point technology. With this unique interface, the software offers a whole new world of convenience because you no longer have to use cumbersome layer masks to isolate the parts of the image you wish to enhance. You simply click on the area to establish a control point and adjust the slider controls to refine your selection.

Once you have selected the part of the image to be enhanced (or perhaps the whole image on some occasions), you can invoke any of the filters provided. What are they? For this you really need to visit the vendor's Website because they are listed with mouse-over pop-ups that show the effect in each case. They range from Skylight Filter, Classical Soft Focus, and Bleach Bypass to the self-explanatory Darken/Lighten Center, High Key, Low Key, and Graduated Neutral Density. Film effects include Solarization, InfraRed, and the distinctly spooky Midnight (shades of François Truffaut's *Day for Night*). Recently added effects include Polaroid Transfer, Film Grain, and Glamour Glow for dreamy, soft effects in wedding and portrait photography.

Nik Color Efex Pro comes in three editions. There's a Standard edition with 15 filters. There's a Select edition with 35 filters and a core set of tools for what the vendor calls "absolute control over light, color, tonality, and detail" across a wide variety of photographic styles. Finally, there's the all-singing-dancing Complete edition with 52 filters, described by the vendor (a little solemnly) as "the most comprehensive set of filters for color correction, retouching, and creative enhancements available today."

Comments

Having included Nik Software's excellent Viveza package that controls color and light, as well as the same vendor's sharpening software Nik Sharpener Pro and noise reduction software Dfine 2.0, I was intending to leave this product with a mere passing mention. However, my technical editor insists otherwise, and on reflection I have to agree with him. Professional photographers love this product both for its stunning effects and its speed of operation. The U Point interface is very effective and speeds the workflow significantly. The filters themselves allow you to stylize your images in dozens of ways, most of them using analogies from the world of traditional film filters and processing. Although they need practice and good artistic judgment if you are to get the best out of them, the Nik filters give you superb control, unmatched convenience, and fully professional results.

Version: Nik Color Efex Pro 3.0 (2008)

Plugs into: Adobe Photoshop 7–CS3, Adobe Photoshop Elements 2–6, and compatible applications

OS: Windows 2000 Professional, XP Home Edition, XP Professional, and Vista; Mac OS X 10.4 and later

RAM: 256 MB

Supported file formats: As host program

Price level: Standard edition approx. $100, Select edition approx. $160, Complete edition approx. $300

Address: Nik Software, Inc., 7588 Metropolitan Drive, San Diego, CA 92108, United States www.niksoftware.com

Summary

There are several ways to convert images to black and white—the unsatisfactory desaturate method; converting to grayscale; converting to Lab mode; or using a channel mixer to vary the influence of each red, green, or blue channel on the final black and white image. The best approach is to use specialist conversion software, like the products described in this chapter. Only then can you get results that would impress a photographer who has spent years in a darkroom with papers and chemicals. Black and white converters can also simulate chemical processing techniques, along with the actual papers that were used in the pre-digital era.

14

Art Simulators

A close relative of special effects, art simulation is a category of software that turns realistic photographs into images that resemble artistic media, such as ink or pencil drawings, watercolors, and oil paintings. Sometimes the programs go a little bit further and start to imitate specific artists in these media, especially when the artist's style lends itself to being copied. It is relatively easy to write a program that breaks an image into an assembly of dots, in the manner of French artist Georges-Pierre Seurat, but rather more difficult to achieve the painterly effects of Diego Velasquez.

From an artistic point of view, it is best to regard art simulation as an experiment. It certainly has little to do with art. The suggestion by one vendor in its online advertising —that you no longer have to spend years in art college to create a beautiful drawing but simply click a few buttons instead— is too absurd to take seriously, yet it is possible that some people will be convinced by it. In the opinion of art critics, the output from art simulators is fake art. That is not to say it cannot make a very attractive graphic image, ideal for a magazine layout, or be used as an element in a real work of art. But presented on its own, it lacks vitality. The starting point of real art has to be the real world, whereas art simulation has two starting points—a photograph and a programmer's preconceived notion about artistic style.

Despite all the reservations, art simulation is a fascinating category of software. The latest programs can generate output that seems less wooden than the images produced by earlier versions. Artificial intelligence may yet outwit the art critic. The day may come when, in a variation on the Turing test, an art expert will not be able to tell whether a drawing was created by human hand or by artistic simulation. At that point, in some future edition of this guide, the negative comments about art simulation will changed. But not before.

Lucis Pro

Vendor: Image Content Technology

Purpose: For image correction and some unusual artistic effects

Description

Lucis Pro (pronounced "Lou-sis Pro") is stand-alone PC software that creates some highly original special effects, using a patented image-processing algorithm called Differential Hysteresis Processing (DHP). It reveals detail in bright and shadowed areas simultaneously, and provides a set of tools that allow you to change the appearance of the image so that it resembles (somewhat) the work of certain artists. For example, the Klimpt feature gives a sparkly, surrealistic effect not entirely unlike that of Gustav Klimpt. Winslow creates a watercolor effect and is named in honor of the great American water-colorist Winslow Homer. No attempt has been made to put an artist's name to the Sculpture effect, although this is one of the best in the package. Applied to portrait shots, the effects succeed in turning a nondescript photograph into a vibrant image.

Comments

To say the least, Lucis Pro is an unusual piece of software. Before dismissing it as just another art-imitation package, you should check out the many examples on the vendor's site. There is no doubt that it does have real value, more than enough to match its list price (which is high compared to other products in this category). However, it is one of the few programs of its kind that delivers unexpected and aesthetically pleasing results.

Lucis Pro sells chiefly to professional photographers, many of whom have become highly skilled at using it. Some of them take original images with a view to using Lucis Pro on them from the outset; others choose images that seem right for this kind of treatment. Either way, results have been stunning (especially in the work of Californian photographer Charr Crail, www.charrcrail.com), pushing the boundaries of the medium further than is possible with conventional tools. The vendor is also introducing a new plug-in version called LucisArt Pro for Windows and Macintosh. Unlike a discontinued earlier version, this will give you the full power of Lucis Pro 5.0 within Photoshop and Photoshop Elements.

Version: Lucis Pro 6.0 (2008)

OS: Windows XP and Vista

RAM: 256MB (or 5–7 times the image size)

Supported file formats: JPEG and TIFF (not PSD)

Price level: To be announced, LucisArt Pro approx. $600

Address: Image Content Technology LLC., 220 Rt12, Suite 5, PMB 344, Groton, CT 06340, United States

www.lucispro.com

PhotoArtist

Vendor: BenVista

Purpose: Photos-into-art with mixers and manipulators, on-screen canvas, and quality filters

Description

PhotoArtist lets you turn digital photographs into images that resemble paintings. It imitates not only the look of painting but also its method: you choose a style, mix different styles, and apply colors with a special brush to the on-screen canvas.

PhotoArtist generates automatic effects for those in a hurry, but the mixers and manipulators allow you to take your time to achieve the effect you want.

Figure 14.1
BenVista PhotoArtist makes photos look like paintings with the click of a button.

Comments

Like most vendors, BenVista allows you to try products for free before buying them. This is probably the best approach, because PhotoArtist will have limited functionality for serious artists. Nonetheless, the package is a lot of fun, and is particularly good for borderless portraits in which the subject blends into a plain white background.

Version: PhotoArtist 2 (2008)

OS: Windows 98, ME, NT4, 95, 2000, XP, and Vista; Mac OS X 10.3 or higher

RAM: Windows 128MB, Mac 256MB

Supported file formats: As host

Price level: Approx. $50

Address: The Netherlands (contact by Web form)

www.benvista.com

Sketch Master

Vendor: Redfield Plug-in

Purpose: Generates pictures with a realistic hand-drawn look

Description

Sketch Master, from Russian plug-in developer Redfield Plug-in, is real-time photo manipulation software that allows you to turn a photo into an image that looks as if it had been drawn with traditional tools such as pencil, pen, crayon, or charcoal. It uses separate settings for strokes, lines, and backgrounds, generating what appears to be a very good likeness of the sitter drawn by hand.

You can import different textures to represent the surface on which the artwork is supposed to be drawn, with built-in effects for canvas, leather, crepe, rag paper, and squared (graph) paper. By clicking on the random generator, called Dice, you can create images with random settings.

Comments

Professional graphic artists have found Sketch Master effective and easy to use. Some have had reservations about the interface, which could be better laid out. However, with practice, it is clear that you can get some attractive results with this plug-in, as the excellent pictures on the vendor's site demonstrate.

Version: Sketch Master 3.10 (2008)

Plugs into: Photoshop 7 and compatible editors

OS: Windows 95, 98, ME, 2000, NT4, and XP

RAM: 128MB

Supported file formats: Major formats

Price level: Approx. $40

Address: Moscow, Russia

www.redfieldplugins.com

SketchMatrix

Vendor: NeuralTek

Purpose: Create a realistic sketch from a digital image

Description

From a digital photograph, SketchMatrix enables you to produce an instant picture that looks like a hand-drawn sketch. It also provides several tools that let you refine the image, adjust the color, and add glazes.

Whereas most image-to-artwork conversion software produces a somewhat lifeless result, SketchMatrix uses various filters that try to mimic the human touch. The vendor calls it the "dynamic parameter paradigm," meaning that you can set different parameters such as outline, features, shading, and detail, and the software will use the settings to produce variations in the result. You can also vary the color, focus, intensity, and luminance of the sketch, applying these effects in a real-time preview mode so that you can see the changes as they happen.

SketchMatrix comes in four editions: Lite, Personal, and non-commercial/commercial Artist editions. The more expensive editions have additional features including Variable Realism and a perspective control.

Comments

Developed in consultation with a team of artists, SketchMatrix produces better results with freeform objects such as trees or fabrics than it does with the geometric shapes of architecture. No artist would draw a building with such perfect reproduction of shape and perspective—there would be no point, as photography does it better. Yet SketchMatrix can produce an interesting look for brochures, especially if the subject appears a little too ordinary in the original picture. See the SketchMatrix Website at www.sketchmatrix.com.

Version: SketchMatrix 2.1 (2008)

OS: Windows 98, ME, 2000, XP, and Vista

RAM: 128MB

Supported file formats: JPEG and BMP

Price level: Lite edition $20, Personal edition $50, Artist, non-commercial license $80, Artist, commercial license $200

Address: NeuralTek, P.O. Box 582, North Ryde Business Ctr., NSW 1670, Australia

www.blackmagic-color.com

Snap Art

Vendor: Alien Skin

Purpose: 10 Photoshop filters for stylizing photos, simulating pencil sketching, pen and ink, oils, and the like

Description

Snap Art is an art simulation package that lets you stylize your photos, turning them into images that simulate pen and ink sketches, or watercolor or oil paintings. It uses edge detection to separate objects from their backgrounds, and then it reinforces these outlines to create the pencil, pen and ink, or even comic book styles of drawing. With all these processes to carry out, Snap Art can run quite slowly. A faster version is promised for the future.

Comments

Could Georges-Pierre Seurat have created "Sunday Afternoon on the Island of La Grande Jatte" by taking a photograph and clicking Pointillism in Alien Skin's Snap Art? Probably not, but this software actually captures the surface texture of Seurat's style quite well. It is even better with the comic book style of Roy Lichtenstein, and it packs a mean "Impasto" with swirls that would intrigue Van Gogh (or drive him to cut off the other ear).

Reviewers have been largely unanimous in considering that Snap Art is great fun to use, does a good job of mimicking traditional art styles, and is reasonably good value. It is well worth a test drive.

Version: Snap Art 1.0 (2008)

Plugs into: Windows—Photoshop CS or later; Photoshop Elements 3 or later; Fireworks MX 2004 or later; Corel Paint Shop Pro XI or later; Mac—Photoshop CS2 9.0.2 or later; Photoshop Elements 4.0.1 or later; Fireworks CS3

OS: Windows XP and Vista; Mac OS X 10.4.0 or later

RAM: 512MB

Supported file formats: As host

Price level: Approx. $150

Address: Alien Skin, 1111 Haynes Street, Suite 113, Raleigh, NC 27604, United States

www.alienskin.com

TwistingPixels Plug-ins & Filters

Vendor: TwistingPixels

Purpose: Produces photo manipulation and art effects, with on-screen drawing and painting

Description

The TwistingPixels Plug-ins & Filters allow users to turn photographs into imitations of paintings, or add special computer-generated effects, textures, and patterns, including those of unusual papers and other materials. The different modules are bundled into seven groups:

- **ArtStudioPro Vol. 1.** "Natural Artistic Effects," with brush, pen, and crayon effects, including watercolor, crayon, and marker.

- **ArtStudioPro Vol. 2.** "Natural Artistic Effects," with oil painting, chalk, charcoal, pastel, and finger painting.

- **ArtStudioPro Classico.** Selected artistic effects, including Aged Paint, Cracked Paint, DaVinci, and Vintage Paper.

- **PixelCreation.** "Celestial-Style & Tonal Filters," 19 "heavenly" effects with names like Milky Way and Starry Night.

- **PixelPaper.** "Realistic Paper Filters," unusual paper effects like Crinkle, "Cumple," "ruch," and Curl.

- **PixelPack.** "Incredible Visual Filters," text extrusion effects, simulated labels, and fake stains like coffee cup rings.

- **PixelSampler.** "Film Style Filters," including black and white conversion, duotone, tonal streak, and film grain.

All the TwistingPixels products come as both stand-alone applications and as Photoshop compatible plug-ins.

Comments

David Gewirtz (www.zatz.com) gave the TwistingPixels Plug-ins & Filters a reasonably favorable review in *Connected Photographer* magazine, but that was back in June 2006. Although they offer a huge range of special effects, their user interface and documentation looks a little dated in comparison to the slickness of their marketing.

Version: PixelEffect Series PixelCreation/PixelPaper/PixelPack 1.33 (2008); ArtStudioPro 1.25

Plugs into: Photoshop 7 or later, Photoshop Elements 2 or later, Fireworks MX 2004 or later, Windows only: Paint Shop Pro 8

OS: Windows 2000, XP, and Vista; Mac OS X 10.2 or higher

RAM: 512MB

Supported file formats: JPEG

Price level: All PixelEffect products, bundled approx. $150, with ArtStudioPro Vols. 1 and 2, and ArtStudioPro Classico approx. $350

Address: techsupport@twistingpixels.com

www.twistingpixels.com

Summary

Art simulation software attempts with some success to simulate the hand-drawn, hand-painted appearance of artwork. Improvements in edge detection algorithms have produced a passable simulation of pencil sketching in some packages and plug-ins, whereas others generate the look of watercolors, oils, and pastels. Some go further in trying to imitate the techniques of individual artists, but most fail in this respect. Eventually, a real artist may create an original work of art using simulation software as a tool rather than as a one-click solution.

15

Special Effects

Whereas most photographic software is designed to make the image more realistic, special effects software introduces distortions, breaks the image into fragments, overlays new colors and textures, and generally moves the "viewing intent" away from reality towards abstraction or fantasy.

It all sounds very promising until you look at one major snag: if you are going to create abstractions or fantasies, why start with photographic reality? Illustrative tools give far more control and they allow you to start from scratch, building the image from a blank page. Yet photography has always served as a shortcut to artistic expression and not everyone has the skill to create beautiful illustrations. Special effects software allows you to create visual imagery that is practically impossible to achieve in any other way. It was certainly never available to film photographers years ago.

This section excludes specialist film simulation software, which has a category all of its own. Nonetheless, it remains a wide category, containing packages that offer useful facilities to the pro photographer as well as others that appeal only to hobbyists and scrapbookers. If you are a wedding photographer looking for new ways to frame and present your images, there are plenty of options to be found here. Special effects software with ready-made templates and customizing facilities can save you hours of work.

Andromeda Photography Plug-ins

Vendor: Andromeda Software

Purpose: 10 Photoshop special effects plug-ins with instant clear pool reflections, rainbows, twinkles, and so on

Description

The Andromeda Photography plug-ins let you apply a range of special effects to your images, including unusual ones like reflecting a building in a pool of water. With some justification, the vendor calls its Star plug-in "the ultimate star design tool," as it can add single or multiple glints, sparks, and glows to create some stunning effects.

The other Photography plug-ins in the bundle are as follows:

- cMulti and sMulti—Multiple lens and kaleidoscopic effects

- Designs—100 single-bit textures and patterns to bend and warp

- Mezzo Line-Screen—Conversion to black and white mezzo lineart

- Diffract, Prism, and Rainbow—For light effects with geometric controls

- Halo—For controlled highlight diffusion

- Velocity—For motion effects, including multiple ghosting highlight smears and fade-out

Comments

There are some terrific optical lens effects in this collection. Like the other Andromeda plug-ins, they are not the cheapest of their kind but can be used professionally to create very commercial images. Wedding photographers should certainly consider them.

Version: Photography Plug-Ins 2.4 (2008)

Plugs into: Windows and Mac Adobe Photoshop 5.5 and up; Photoshop Elements 1.0 and up; compatible editors

OS: Windows 98, 2000, ME, NT, and XP; Mac OS X/9.x

RAM: 256MB

Supported file formats: As host

Price level: Approx. $90

Address: Andromeda Software, Inc., 699 Hampshire Rd Suite 109, Westlake Village, CA 91361, United States

www.andromeda.com

DreamSuite

Vendor: Auto FX Software

Purpose: Three editions of layers-based software to create graphical effects

Description

The DreamSuite software allows you to create stunning visual imagery, using layers to isolate parts of the photograph while adding special textures and other effects. At the time of writing, the vendor is clearly working towards separating this highly successful product into Standard and Pro editions. Currently DreamSuite Pro is a free upgrade. It contains the vendor's SmartLayers technology, which combines masking, photos, effects, and color correction layers into a single document. You can composite photos together, and then change the layer opacity, or the order of the layers, all with the help of layer presets that can be loaded using visual thumbnails displayed in an on-screen catalog.

DreamSuite may appeal more to graphic designers than to photographic purists, but DreamSuite Series Two is aimed at graphically adventurous photographers and contains 14 unique visual effects for enhancing their images. For example, Mesh weaves together strips of photos in a creative mesh effect; PhotoStrips lets you slice and overlap image strips; and FilmStrip makes photos look like strips of movie or slide film.

DreamSuite Gel is more specialized, for illustrators who want the melted, radioactive jellybean look.

Comments

Describing special effects packages in words is nearly impossible. You are advised to check out the samples on the vendor's Website. DreamSuite has the ability to impart an instant professional look to an ordinary image, simply by duplicating it and pasting it into a neat layout (as in the 4x5 effect of Series Two). For ads and brochures it is a useful tool, especially if you want a quick solution. The vendor has created some detailed training videos (available for purchase), which take you step-by-step through each product.

Version: DreamSuite Series One, Series Two, DreamSuite Gel (2008)

Plugs into: Adobe Photoshop 4.0 and up; Photoshop Elements 1.0 or higher; compatible editors

OS: Windows 98, NT, 2000, ME, XP, and Vista; Mac OS 9.0, native in OS X or higher

RAM: Windows 128MB; OS 9 256MB; OS X 512MB recommended

Supported file formats: Loads and saves PSD, TIFF, BMP, JPEG, and PNG

Price level: Series One $200, Series Two $150, Gel $99, DreamSuite Bundle $400

Address: Auto FX Software, 141 Village Street, Suite 2, Birmingham, AL 35242, United States
www.autofx.com

Filters Unlimited

Vendor: I.C.NET Software

Purpose: 382 filters, including distortions, frames, gradients, paper backgrounds, and filter creation

Description

Filters Unlimited is a huge collection of filters in a single Photoshop compatible plug-in. Not only do you get those supplied by the vendor, but access to 2,000 other, free filters via links. It is also a filter development system that lets you build your own filter effects, just in case you cannot find the right one in the library.

The 382 filters come under the following headings: Buttons & Frames; Color Effects; Convolution and Distortion Filters; Edges; Frames; Gradients; Image Enhancement; Lens Effects; Noise Filters; Paper Backgrounds and Textures; Pattern Generators; Render (such as Smoke, Stone, and Wood); Special Effects (such as Focal Blur, Puzzle, and Venetian Blinds); Tile & Mirror; and Video effects.

Figure 15.1

Filters Unlimited will add flares, textures, frames, gradients, and hundreds of other effects.

Comments

Filters Unlimited was launched a few years back with less than half the number of filters it has today. Even then, some reviewers hailed it as the most useful Photoshop utility they had seen. It lets you stack multiple filters and toggle between the original and the filtered image. Other effects packages offer special effects that are more subtle and original, but few of them match Filters Unlimited on quantity and value.

Version: Filters Unlimited 2.0.3 (2008)

Plugs into: Photoshop 3 and up, CS1, CS2, and CS3; Photoshop Elements 2 and up; Paint Shop Pro 5 and up; CIEBV PhotoLine 5 and up; Micrografx Picture Publisher 7 and up; Ulead Photo Impact 4 and up

OS: Windows 95, 98, 98 SE, ME, NT4, 2000, XP, and Vista

RAM: 128MB

Supported file formats: Major formats in RGB, CMYK, and grayscale

Price level: Approx. $40

Address: I.C.NET Software GmbH, Michael Johannhanwahr, Robert-Bunsen-Str. 70, 28357 Bremen, Germany

www.icnet.de

HumanEyes Capture3D for Photographers

Vendor: HumanEyes

Purpose: Add depth illusion effects to ordinary photographs to simulate 3D for advertising applications

Description

HumanEyes Capture3D for Photographers creates a real ("peek-behind-it") 3D image from pictures taken with conventional photographic equipment, including an ordinary digital camera and a tripod/arm. It comes with guidelines for optimizing a 3D scene, but once you have taken suitable pictures, it goes to work using special algorithms to create the 3D effect.

Photographs taken with Capture3D can be used online or printed with the vendor's PrintPro 2.0 application, which also includes the creative software. There is an upgrade to PrintPro for those who need it. In print form its intended use is for business cards, direct mail, product packaging, posters, and point of sale materials.

Comments

Displayed on a computer with an animation effect to "look behind" the featured objects, the output from Capture3D works very well, but is naturally dependent on the quality of the initial captures. The photographer needs to make sure that the image contains good depth cues from perspective, lighting, texture, occluded objects, and relative object sizes.

These all help to maximize the result of changing the camera position very slightly to create the potential for 3D when the images are animated. Some of the examples given by the vendor are certainly stunning, and they play in a Java-based viewer.

Version: HumanEyes Capture3D (2008)

OS: Mac OS X 10.4.7 and later

RAM: 1GB recommended for production purposes

Supported file formats: Inputs TIFF, JPEG, and AVI; outputs TIFF, PS, EPS, and SCT

Price level: Approx. $200, upgrade to PrintPro 2.0 $500

Address: HumanEyes Technologies Ltd., 1-4 High Tech Village, Edmond Safra Campus, The Hebrew University, Givat Ram, Israel

HumanEyes Technologies Inc., 366 North Broadway, Suite 410-C1, Jericho, NY 11753, United States

www.humaneyes.com

Mystical Lighting

Vendor: Auto FX Software

Purpose: Photo-realistic lighting and shading effects for digital images

Description

Mystical Lighting is a package of 16 visual lighting effects with over 400 presets, all designed to make images look more dramatic or visually interesting. It lets you add edge highlights, soft diffused lighting effects, or even glowing fireflies to the image. The Surface Light feature can cast light through objects on to the background or across the whole picture, whereas Mottled Background gives a painted canvas effect that makes an attractive backdrop for a portrait.

There are dozens of features in Mystical Lighting to help you, including adjustable previews with a 1600% marquee zoom capability, layers, unlimited undos, visual presets, masking, and dynamic effect controls. You can save and replay your most successful effect settings, reducing the time it takes to enhance further images. Memory Dots recall your previous settings—just click on one of them to go back in time.

The effects are Edge Highlights, Ethereal, FairyDust, Flare, Light Brush, Light Caster, Mist, Mottled Background, Radial Light Caster, Rainbow, Shader, Shading Brush, ShadowPlay, Spotlight, Surface Light, and Wispy Mist.

Comments

Among special effects packages, this is one of the best. Most reviewers gave it a very high rating when it first appeared, although many of them complained about the interface, which is non-standard in Photoshop plug-in mode. The Memory Dot undo is cute, but limited.

But the effects themselves are outstanding if you have the skill to use them properly. In the right hands, it can help to produce highly professional results.

Version: Mystical Lighting 1.0 (2008)

Plugs into: Adobe Photoshop 4.0 CS; Photoshop Elements 1.0 or higher; compatible editors

OS: Windows 98, NT, 2000, ME, XP, and Vista; Mac OS 9.0, native in OS X

RAM: Windows 128MB, OS 9 256MB, OS X 512MB recommended

Supported file formats: Major formats

Price level: Approx. $180

Address: Auto FX Software, 141 Village Street, Suite 2, Birmingham, AL 35242, United States

www.autofx.com

Photo Aging Kit

Vendor: I.C.NET Software

Purpose: Make today's photos look like they belonged to Grandpa, complete with stains

Description

Forget photo restoration; how about some photo destruction instead? Photo Aging Kit lets you take a modern digital image and make it look a hundred years old or more. You can add a crumpled effect, stains, blotches, coffee cup rings, dust, dirt, scratches, and old-looking photo edges. If the color, saturation, and sharpness from your DSLR are too good (as they certainly will be), you can adjust them to make them substantially worse. There are 16 filters to help you create the perfect ancient photo.

Comments

Fun, free, and capable of faking old photos with uncanny accuracy, Photo Aging Kit will surely be used for both artistic and nefarious purposes. The only snag is that it requires you to buy Filters Unlimited, the vendor's general-purpose filter package.

Version: Photo Aging Kit 1.0 (2008)

Plugs into: Photoshop 3 and up; Photoshop Elements 2 and up; Paint Shop Pro 5 and up; CIEBV PhotoLine 5 and up; Micrografx Picture Publisher 7 and up; U-Lead Photo Impact 4 and up

OS: Windows 95, 98, 98 SE, ME, NT4, 2000, XP, and Vista

RAM: 128MB

Supported file formats: Major formats in RGB, CMYK, and grayscale

Price level: Free (requires Filters Unlimited 2.0)

Address: I.C.NET Software GmbH, Michael Johannhanwahr, Robert-Bunsen-Str. 70, 28357 Bremen, Germany

www.icnet.de

Photo/Graphic Edges

Vendor: Auto FX Software

Purpose: Set of 14 photographic effects that give images a unique, artistic look

Description

Photo/Graphic Edges 6.0 comes with a massive collection of 10,000 Edges, 1,000 Matte Textures, 175 Frames, 230 Effect Brushes, and 210 Light Tiles that have been created professionally using the software's 14 edge effects. Of course, it is not just edges—once you have defined an edge, you (or the software) can fill in the areas defined by the edges.

Built around SmartLayers technology, Photo/Graphic Edges allows you to turn on, turn off, clone, move, and add new layers. All the effects are non-destructive, with multiple levels of undo, no matter how many times you make editing changes.

Comments

Photo/Graphic Edges has much in common with the vendor's other software: similar interface, same platforms, system requirements, even price. But this one has been updated repeatedly, making it quite good value, especially with all the additional content. Stand-alone and plug-in versions are both included.

Version: Photo/Graphic Edges 6.0 (2008)

Plugs into: Adobe Photoshop 4.0 CS; Photoshop Elements 1.0 or higher; compatible editors

OS: Windows 98, NT, 2000, ME, XP, and Vista; Mac OS 9.0, native in OS X or higher

RAM: Windows 128MB, OS 9 256MB, OS X 512MB recommended

Supported file formats: Loads and saves PSD, TIFF, BMP, JPEG, GIF, and PNG

Price level: Approx. $180

Address: Auto FX Software, 141 Village Street, Suite 2, Birmingham, AL 35242, United States www.autofx.com

PhotoFrame Pro

Vendor: onOne Software

Purpose: Specialist framing software that adds border and edge effects to images

Description

PhotoFrame Pro gives you (literally) thousands of options for adding border and edge effects to complement your images, all with real-time preview. Some of the frames are brought together in special collections, chosen by well-known photographers. The interface allows you to find the right frame easily in a browser, while a preview grid lets you compare multiple frames at once. Adventurous people can even use the random frame generator, in the hope that serendipity will make the decision for them.

Comments

Bearing in mind that these are virtual frames rather than actual frames, PhotoFrame Pro is not cheap. But then, as a virtual framing tool it could scarcely be better or more comprehensive. Its appeal is to professional portrait or wedding photographers who want to offer novelty finishes to their prints. The vendor also offers the same product in a standard edition, minus the designer collections.

Version: PhotoFrame Pro 3.1 (2008)

Plugs into: Photoshop CS and later; Photoshop Elements 3 and later

OS: Windows 2000, XP SP2, and Vista; Mac OS X 10.3.9 or later

RAM: 512MB

Supported file formats: Those of the host program

Price level: Approx. $260, Standard edition approx. $160

Address: onOne Software, 15350 SW Sequoia Pkwy., Suite 190, Portland, OR 97224, United States

www.ononesoftware.com

Figure 15.2

PhotoFrame Pro is the Rolls-Royce of virtual framing tools: pricey but luxurious.

Pixel Ribs McFilters

Vendor: Pixel Ribs

Purpose: A set of 14 mask-controlled special effects filters for Photoshop

Description

Pixel Ribs McFilters use the selection mask as part of the filtering process to create some unusual special effects, each of which has been given a "Mc" name. This has nothing to do with Macintosh but stands for "Mask Controlled." Hence, the McClouds filter uses the selection mask to modulate the frequency and visibility of 2D "clouds" (fractal noise). McGamma applies gamma correction to the image, modulating the gamma parameter with the selection mask.

Other features are called McTwirl, McSharpen, McBlur, McGel, McHue, McMotionBlur, McLens, McZoomBlur, McScatter, McCels, and McTurbulence. They are all brought together in a consistent user interface that is easy for anyone to operate.

Comments

If McTurbulence sounds likes a truculent Glaswegian, it is actually a special effect created by modulating the turbulence parameter of the selection mask. McFilters use the mask in various ways, sometimes as a height map (as in McGel and McLens), or again as a weight map (McBlur and McMotionBlur). All the effects are intriguing; one or two are outstanding.

Version: Pixel Ribs McFilters 2.0 (2008)

Plugs into: Photoshop 4 or higher

OS: Windows 98, ME, NT, 2000, and XP; Mac OS 9.2.1 or higher (with Carbon Library), OS X 10.2 or higher

RAM: 128MB

Supported file formats: Major formats

Price level: Approx. $100

Address: Pixel Ribs d.o.o., Vlaska 79, 10000 Zagreb, Croatia

www.pixelribs.com

splat!

Vendor: Alien Skin

Purpose: A filter set for Photoshop that creates frames, textures, edges, borders, and mosaics

Description

splat! comes with 200MB of graphics content, enabling the photographer or designer to add frames, edges, borders, mosaics, or textures to create a huge range of effects.

- The framing utility alone allows you to choose among 100 frames, including traditional wood frames, Dover, and geometric borders.

- Edging provides decorative edge effects, such as halftone dots, torn paper, and pixelated edges.

- Border Stamp adds realistic drop shadows and other effects, including a facility for using any object (pebble, pill, ticket, and so on) as a border decoration to be replicated around the photo. Fill Stamp does the same inside the image.

- Mosaic features in the Patchwork module include light pegs, ASCII art, ceramic tile, and cross-stitch.

- Texture facilities are called "Resurface" in splat!—perhaps to underline the fact that photographers can use this package as well as designers who start with a blank page. Among the textures are paper, concrete, leather, brick, stone, metal, and wood.

Comments

This package appears to be aimed more at the scrapbooking market than at people who pursue serious photography. Like all Alien Skin products, there is plenty of bang for the buck, if rather too much bang for some tastes. Because of the huge size of the content files the vendor supplies the software on disk, with additional frame archives available online from many sources.

Version: splat! 1.0 (2008)

Plugs into: Windows and Mac—Photoshop 5.0 or later, Photoshop Elements 2.0 or later, Fireworks 3.0 or later; Windows only—Paint Shop Pro 5.0 or later; CADLink SignLab 7.5

OS: Windows 2000, XP, and Vista; Mac OS X 10.4.0 or later

RAM: 128MB

Supported file formats: As host

Price level: Approx. $100

Address: Alien Skin, 1111 Haynes Street, Suite 113, Raleigh, NC 27604, United States

www.alienskin.com

Still Effects

Vendor: Mega-Graphic Digitals

Purpose: Photoshop effects archive, on DVD and online, for professional photographers

Description

Still Effects is an online Photoshop effects library for professional designers and photographers, also available on DVD. It offers visual effects that can be added to images such as wedding or portrait photographs, poster prints, or Web graphics. All the effects

are ready-to-use, but you can customize them without any restrictions. The vendor lets you change the color, transparency, shape, size, or resolution of the effect, or even combine them by dropping them on top of each other.

The purely photographic effects have names like HighKey Mask, Translucent, Chalk, Hand-Printed, and Polaroid, which give some idea of what they look like. There are also other categories, such as Artistic Media, Graphic Print, Fabrics, and Nostalgie, each with several different styles.

Comments

Some wedding photographers say they have scoured the Internet for these kind of effects, without success until finding this online/DVD selection from the Netherlands. Others report that their sales of enlargements have increased since using them. The designs are undeniably attractive, being slightly understated in comparison to most of those available. They are definitely worth a look.

Version: Still Effects Premium Version 3 (2008)

Requires: Photoshop 7 and above; Photoshop Elements (all)

OS: Windows XP and Vista; Mac OS 9 and OS X

RAM: 128MB

Supported file formats: JPEG

Price level: DVD version approx. $260

Address: Mega-Graphic Digitals, P.O. Box 4843, NL 4803 EV, Breda, The Netherlands
www.stilleffects.com

Xenofex 2

Vendor: Alien Skin

Purpose: Special effects creation package for photographers, Web designers, and graphic artists

Description

Xenofex 2 is a special effects creation package that lets you make complex distortions of the image, transform your photos into jigsaw puzzles, or simulate natural phenomena such as lightning and clouds. The Filters have evocative names, which give you a good idea of what they do—Constellation, Electrify, Lightning, Little Fluffy Clouds, Crumple, Flag, Puzzle, Shatter, Stain, Television, Burnt Edges, Classic Mosaic, Cracks, and Rip Open.

Xenofex 2 uses the same interface as the vendor's Eye Candy 4000, familiar to many users.

Comments

Xenofex 2 is a lot of fun. It needs a fast machine with more RAM than the vendor recommends. The effects are first rate, easily capable of producing publication-quality work. Some of them are wonderfully subtle. The Stains filter adds precisely the sort of effect that photo restoration software is designed to eliminate.

Version: Xenofex 2.2.0 (2008)

Plugs into: Windows—Photoshop 6.0 or later; Photoshop Elements 2.0 or later; Fireworks CS3 or later; Corel Paint Shop Pro 7.0 or later, CADLink SignLab 7.5; Mac—Photoshop CS3, Photoshop Elements 4.0.1 or later

OS: Windows 2000, XP, and Vista; Mac OS X 10.4.0 or later

RAM: 64MB (see text)

Supported file formats: As host

Price level: Approx. $130

Address: Alien Skin, 1111 Haynes Street, Suite 113, Raleigh, NC 27604

www.alienskin.com

Summary

Digital images are infinitely malleable, the only limitations being the imagination of artists and the tools at their disposal. One of those tools, usually packaged as a collection, is special effects software. This is a category that is even more fun to use than art simulation, being less constrained by the appearance of the output. The descriptions in this chapter speak for themselves—kaleidoscopic, prism, blur, and diffract (in the Andromeda Photography plug-ins) and smoke, stone, wood, and puzzle (in Filters Unlimited). They appeal to home users and scrapbookers, but some packages like Still Effects from Mega-Graphic Digitals are aimed at the busy professional who wants to add pizzazz to wedding pictures. Whatever package you choose, generic eye candy is not inexpensive, with most collections costing in the range of $100–$300.

16

Sharpening Software

Many people who upgrade to a Digital Single Lens Reflex (DSLR) camera from a point-and-shoot camera are disappointed to find that the images appear less sharp. The reason for this phenomenon (the lack of sharpness, not the disappointment) is because point-and-shoot cameras impose a greater degree of sharpening as a matter of course. DSLRs give you a choice of whether to use the manufacturer's routines or carry out the process yourself on a computer. The latter is by far the better approach, especially with today's excellent choice of sharpening software.

What Is Sharpness?

In digital photography, sharpness is essentially a combination of acutance and resolution, the first being mainly a function of the lens and the second a function of the sensor. The two concepts are closely interlinked, but acutance relates to edge contrast—to the boundaries between areas of different tones or colors—whereas resolution relates to overall detail.

Pixel resolution is the overriding factor in sharpness, but contrast comes second, with uniform noise a distant third. Because the human visual system pays particular attention to the edges of objects, this is where we are most likely to notice any lack of sharpness in a photograph. Sharpening software concentrates on the edges, trying to make them absolutely distinct.

Methods

The classic method for improving edge definition has long been unsharp masking, which replicates a darkroom effect in which a negative is masked by a slightly out-of-focus (unsharp) duplicate. It creates a deliberate halo effect at edges by accentuating the intensities of adjacent pixels.

Most software now offers alternatives to the unsharp mask, mainly because an exaggerated halo effect can be unattractive, especially when applied right across the image. Two alternatives are edge masking, to isolate the edges before applying any sharpening routines, and the high-pass sharpening filter, which can be applied to a Photoshop layer.

Human error is the cause of much unsharpness in photographs: poor focusing, motion blur, and camera shake. To some extent, these can also be corrected with specialized processing, as proved by Focus Magic from Acclaim Software. Other packages provide RAW pre-sharpening, camera-specific settings, and even a different kind of sharpening routine for each stage of the workflow. It is all here, in the packages described in this chapter. See also the section entitled "Picture Cooler" in Chapter 17, "Noise Reduction".

CrispImage Pro

Vendor: SoftWhile

Purpose: Sharpening tool with six algorithms, including a proprietary method

Description

CrispImage Pro is sharpening software that offers six algorithms and improves on unsharp masking with "the CrispImage proprietary algorithm." The control panel gives you four slider controls: strength (affects the intensity of change in pixel values), threshold (sets level below which no change to a pixel is made), halo limit (controls halo size), and standard deviation (modifies the influence of surrounding pixels at varying distances).

As a Photoshop Action, CrispImage applies a standard sharpening process. When you open an image in it, you can then use the controls to modify the sharpening as you please.

There are three CrispImage editions: a basic plug-in for Windows, the Pro plug-in (discussed here), and a marginally more expensive Advanced plug-in with 16-bits-per-channel support in grayscale, RGB, Lab, and CMYK.

Comments

CrispImage Pro has been used by photo enthusiasts for several years and is now available in various editions at a range of prices. It is easy to use, creates crisp-looking output, and is definitely worth adding to Photoshop Elements. Typical comments from three users are: "[CrispImage Pro] makes natural looking images," "makes a big difference," and "[provides] good halo control."

Version: CrispImage Pro 1.1 (2007)

Plugs into: Photoshop 7 and above; Photoshop Elements

OS: Windows ME, 2000, XP, and Vista

RAM: 128MB

Supported file formats: Major formats

Price level: Standard version $25, Pro version $60, Advanced version $70 (all approx.)

Address: info@softwhile.com

www.softwhile.com

FixerBundle

Vendor: FixerLabs

Purpose: A bundle of four Photoshop plug-ins for fixing focus, shadow, noise, and blur issues

Description

FixerBundle is a collection of four pro-level plug-ins:

- FocusFixer, an image-sharpening tool that uses the vendor's LensFIT technology to restore detail and add clarity to the image. It can be used on specific parts of the image; it removes focus blur; and it works on both 8-bit (24-bit RGB) and 16-bit (48-bit RGB) images. The FocusFixer panel has Deblur (0 to 40 increments) and Threshold slider controls, together with pull-down menus to select the make and model of camera.

- ShadowFixer, for correcting exposure problems when there are very light and very dark areas of the image. The ShadowFixer panel has Radius (0 to 100 increments) and Amount (0% to 100%) slider controls. You can enhance a bounded area within an image, moving the sliders to find the "sweet spot" that gives the best result.

- NoiseFixer removes noise or "grain" from images, with separate algorithms for chrominance and luminance. The NoiseFixer panel has side-by-side before/after previews of both color and grayscale details.

- TrueBlur adds realistic softness to images, using Exif data to gain information about the make and model of camera. The TrueBlur panel has two controls: one to blur the image and one to add blending noise.

Comments

The FixerBundle plug-ins are advanced tools for serious photographers and they can make a real improvement to images that are already high quality. They are not intended for correcting common errors. All four plug-ins have been received very enthusiastically by the professional photographic press. The British referred to the "enormous improvement in image quality" achieved by FocusFixer. Much the same could (and has) been

said of the other plug-ins, especially ShadowFixer, which can illuminate deep shade more effectively than any adjustment in Photoshop.

Version: (Windows) FixerBundle 1.7, (Mac) FixerBundle 1.3 (as of 2008)

Plugs into: Photoshop and compatible editors, including (Windows version only) Paint Shop Pro; some host programs "work to some extent," others do not—see Website for details

OS: Windows 98, ME, 2000, NT, XP, and Vista; Mac OS X

RAM: 256MB

Supported file formats: TIFF and JPEG

Price level: Approx. $150

Address: FixerLabs, Watford, United Kingdom

www.fixerlabs.com

FocalBlade

Vendor: PhotoWiz

Purpose: Sharpening tool with many other effects, including blur and glow

Description

FocalBlade generates sharpening, soft-focus, blur, and glow effects, using automatic, semiautomatic, and manual tools. Unlike its rivals it does not use unsharp masking, the main reason for which, says the developer, is to avoid increasing color noise. It is around half the price of PhotoKit Sharpener, but has many similar features including slider controls for sharpening, setting radius, softening, fixing shadows, and highlights, plus several masking options. It lets you work at the sub-pixel level using radius values below 0.1 pixel. One particularly useful feature is its display of several split view modes so that you can compare original and sharpened versions side-by-side with variations of the current settings.

Comments

Very well received by the photographic media (typical remarks have called it "a gem" that "should be in every serious photographer's tool chest"), it has a reputation for excellent sharpening without introducing unwanted artifacts such as halo effects.

Version: Windows FocalBlade 1.04, Mac OS X 1.0 (2008)

Plugs into: Photoshop, Photoshop Elements, Paint Shop Pro, PhotoImpact, Photo-Paint, Fireworks, and so on (see vendor's compatibility list for full details)

OS: Windows 95, 98, NT, ME, 2000, XP, and Vista; Mac OS X

Supported file formats: 8-bit and 16-bit RGB and grayscale images

Price level: Approx. $50

Address: Nuremberg, Germany

www.photocorrection.com

Focus Magic

Vendor: Acclaim Software

Purpose: Photo sharpening editor to correct out-of-focus photos

Description

Focus Magic can help you fix images that are slightly out-of-focus or have been affected by camera shake. It is useful for restoring old photographs that exhibit these faults, but equally you can use it as a workflow option to correct recent errors.

Rather than use a simple unsharp mask for image sharpening, Focus Magic reverses the process by which the image became blurred in the first place. The vendor has made a study of all the different types of blur: motion blur, focus blur, camera shake, and so on, and has analyzed their different characteristics in order to create software to counteract them. The result is Focus Magic, a package that can be used forensically to recover detail, especially in images affected by unidirectional motion blur.

A despeckle filter and one for increasing the resolution of the image are included in the stand-alone version of Focus Magic.

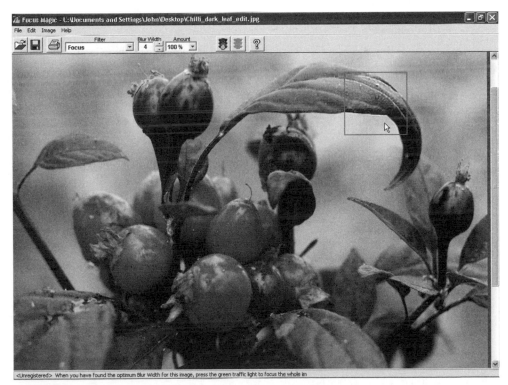

Figure 16.1

Focus Magic can correct for camera shake or when an image is slightly out of focus.

Comments

Focus Magic takes a sensible approach to image sharpening by finding the root cause of the blur. It really does work, as Keith Cooper of Northlight Images (www.northlight-images.co.uk) attests. Although the processing tends to be slow, it succeeds in reducing blur to the extent that images can be printed significantly larger than would otherwise be possible. The best policy is to avoid the error in the first place, but Focus Magic is an excellent emergency repair tool.

Version: Focus Magic 3.0 (2008)

Plugs into: Photoshop, Paint Shop Pro, Corel PhotoPaint, Ulead PhotoImpact, and others

OS: Windows 2000, XP, and Vista; Mac OS X

RAM: 512MB

Supported file formats: Stand-alone version JPEG; plug-in version as host

Price level: Approx. $45

Address: Acclaim Software Ltd., P.O. Box 51-722, Pakuranga, Auckland, New Zealand

www.focusmagic.com

Intellisharpen

Vendor: Fred Miranda

Purpose: Provides halo-less sharpening, edge sharpening, luminance sharpening, and mode sharpening

Description

Intellisharpen is sharpening software that offers a full set of sharpening tools, brought together within an intuitive interface. It promises halo-less sharpening, edge sharpening, luminance sharpening, and mode sharpening, among others, with options to sharpen fine detail. The vendor has done a lot of the hard work for you by providing 100 Intellisharpen intensity levels and 100 sharpen fine detail levels. You can select between high and low ISO settings, control halo size, and remove chroma noise.

Comments

Intellisharpen I was a first-rate sharpener, and Intellisharpen II (revised versions of which revert to Arabic numerals such as 2.5) is even better. Its output is demonstrably good, as you can see from the vendor's site and from before/after images submitted to forums. It has all the main features you would expect from a quality tool, plus some extras like the Intensity Tweak slider that lets you make last-minute adjustments to a selected intensity level. It is an excellent value.

Version: Intellisharpen 2.5 (2008)

Plugs into: Photoshop 6 and up; Photoshop Elements 1, 2, and 3

OS: Windows 2000, XP, and Vista; Mac OS X

RAM: 128MB

Supported file formats: JPEG and TIFF

Price level: Approx. $25

Address: San Clemente, California

www.fredmiranda.com

Nik Sharpener Pro

Vendor: Nik Software

Purpose: Specialist tool that takes account of image content, intended media, and other variables before sharpening

Description

Nik Sharpener Pro lets you sharpen 16-bit images without having to reduce them to 8 bits. It offers RAW pre-sharpening, followed by selective sharpening of specific areas, using a Wacom tablet if necessary, at the "creative" stage. It takes particular account of image detail and detail relationships; the intended print process, including resolution of the output device and substrate type/characteristics; and viewing characteristics, including intended display distance and the personal preferences of the artist creating the print.

Designed for professionals, Nik Sharpener Pro is substantially more expensive than some of its rivals, with a choice of a complete edition for all media or a (mainly) inkjet edition that also copes with Web and other electronic output. It has an easy-to-use interface, with simple slider controls to adjust parameters at the output stage such as viewing distance, paper type, and printer resolution.

Comments

Nik Sharpener Pro has been highly acclaimed in the photographic press. If you want to avoid inappropriate sharpening, over-sharpening, or ineffective sharpening, this is a product that can help. Developed by Nils Kokemohr (astrophysicist, painter, photographer, and cellist), it has many users completely hooked, such is the improvement it makes to the print quality of an image. The secret is in the fine-tuning, as Nik Sharpener Pro helps you optimize the image by taking into account the capabilities of the output device.

Version: Nik Sharpener Pro 2.0 (2008)

Plugs into: Adobe Photoshop 4 and up, Photoshop Elements, Corel Paint Shop Pro and Painter, Ulead PhotoImpact

OS: Windows 98 SE, ME, NT, 2000, XP, and Vista; Mac OS X 10.1.5 or later

RAM: 256MB recommended

Supported file formats: JPEG and TIFF

Price level: Approx. $400

Address: Nik Software, Inc., 7588 Metropolitan Drive, San Diego, CA 92108, United States

www.niksoftware.com

PhotoKit Sharpener

Vendor: PixelGenius

Purpose: A workflow tool that looks after sharpening from image capture to output

Description

PhotoKit Sharpener is more than just a set of sharpening tools. It is a workflow product that lets you take care of sharpening at each stage, from image capture to output. The developers have grouped its capabilities into three phases: "capture," "creative," and "output" sharpening. To avoid confusion, they also recommend that you let this plug-in handle all sharpening throughout the workflow. Processes are completely non-destructive, working on currently visible layers as the source for the effect.

Capture sharpening concentrates on the midtones, applying relatively little sharpening to highlights and shadows. Various sets of effects may be applied at this early stage, each set having SuperFine, Narrow, Medium, and Wide Edge Sharpen effects, suitable for a wide range of subjects.

Creative sharpening tools allow you to sharpen parts of the image selectively. You must vary the opacity and flow of the layer masks brush. Fog, diffusion, and smoothing brushes let you tone down the effect. Among the "heavy duty" sharpening effects are edge, luminance, and high-pass sharpen, plus super sharpener and super grain at five ISO levels.

PhotoKit's output sharpener caters for halftone, inkjet, and continuous tone (contone) printing, as well as for Web and multimedia output.

Comments

PhotoKit Sharpener is highly regarded by many professional photographers, if not quite as widely acclaimed as Nik Sharpener Pro. It has been created by a far-flung team of individuals (Jeff Schewe, Bruce Fraser, Andrew Rodney, Martin Evening, Seth Resnick, and Mike Skurski) who live and work in various parts of the United States or Britain. The product is well supported with detailed information about sharpening in general as well as how to use this particular tool; users should see the Website for sample workflows. Images treated with PhotoKit Sharpener do not look overdone, even when you add one of the "Super Grain" effects. It is a good value and gives pleasing results.

Version: PhotoKit Sharpener 1.2.6 (2008)

Plugs into: Photoshop 7.0 and up; does not run on Photoshop Elements; needs CS, CS2, and CS3 for 16-bit/channel RGB images

OS: Windows XP Home/Pro, and Vista; Mac OS X; earlier versions—Windows 98 and above and Mac 9.1 and above—will run Photoshop 7.0 plug-in

RAM: 256MB

Supported file formats: JPEG, TIFF, and Adobe PDS

Price level: Approx. $100

Address: PixelGenius, 624 West Willow Street, Chicago, IL, 60614, United States

www.pixelgenius.com

SharpiePRO

Vendor: Sean Puckett

Purpose: Sharpen/blur the image using "contrast enhancement," "luminance blur," and "pixel punch" filters

Description

Sharpie is a sharpen/blur plug-in for the RAW converter Bibble Pro, which, with Sean Puckett's numerous plug-ins, is rapidly becoming an image editor. Three Sharpie filters contribute "contrast enhancement," "luminance blur," and "pixel punch" to the image, improving pixel detail while reducing artifacts and noise.

The so-called pixel punch feature has been designed to enhance pixel-level "pop," the quality so admired by the gritty realist school of photography. It works only on full-sized images, not those destined for the Web. The Pro edition of the software also contains a Detail Filter, which combines the other filters into one slider. Using it has the effect of recovering fine detail in the image.

Comments

Many photographers found SharpiePRO to be an effective tool even before the major 2.0 update in 2007. With its additional features, it sharpens images with greater subtlety, especially those that are reasonably sharp already. Although there is a freeware edition, the Pro edition is essential and a very good value.

Version: SharpiePRO 1.2; (Pro edition) 2.0 (as of 2008)

Plugs into: Bibble Pro (upgrade when Bibble upgrades)

OS: As host

RAM: 128MB

Supported file formats: As host

Price level: Standard version free; Pro version $20

Address: seanmpuckett@gmail.com

www.nexi.com/178

Summary

Because the human visual system is so good at detecting the edges of objects, we are acutely aware of how sharp a photographic image appears to be when we scrutinize it.

Both the lens and the sensor play a role in determining sharpness. It is with those components that you first need to address the sharpness issue. In post-production, the use of sharpening software can improve good images and rescue poor ones. Specialist software like Focus Magic can help remove camera shake and motion blur, whereas mainstream sharpeners like Nik Sharpener Pro and PhotoKit Sharpener are widely used by professionals whose images rarely suffer from those faults. Good image editors also have sharpening facilities, but specialist software is among the best in this category.

17

Noise Reduction

In digital photography, noise is an unwanted pattern of pixels, usually a speckle pattern of random pixels, especially visible in images taken in low-light conditions at a high ISO setting. Camera manufacturers have been successful in keeping it to a minimum, especially Canon with its full-frame DSLRs. However, noise can still be obtrusive in images from cameras using smaller format sensors and often needs to be treated in post-processing.

Software typically begins by analyzing the individual image, creating a "noise profile" to indicate just what type of noise is affecting picture quality. For example, there is the standard "read-out" noise generated by the amplification of the signal, but there is also "thermal noise" caused by electrons leaking from the image sensor. Scanned images from film-based photographs may show "grain," which is often considered to be more attractive than digital noise but may still need to be eliminated from some pictures. Film grain shows up clearly in bright areas as well in shadows, but digital noise is more apparent in the dark parts of the image. Any degree of underexposure will make high-ISO noise worse in a digital picture.

Software Solutions

Clever software goes a long way toward banishing noise from digital images, although theoretically there is always a trade-off in using it. In practice, however, software such as Neat Image from ABSoft, Noise Ninja from PictureCode, and Image Doctor from Alien Skin can restore an otherwise unusable picture to publication quality.

Noise reduction software is not very expensive but it can make a dramatic improvement to the image. The best packages are "edge aware," meaning that they can detect and preserve the edges of objects depicted in the photograph. Every developer promises to "reduce noise while preserving fine detail," but some are more successful at this than

others. It is a competitive market, with claims and counter-claims, but all the major brands are effective whether they are wavelet-based or use alternative algorithms for finding and eliminating noise.

Different brands may be either plug-ins for Photoshop or stand-alone packages. Some, like Neat Image, are available in both versions. Photoshop itself has noise reduction capabilities, but research into this topic is ongoing in many companies—hence the appearance of new solutions from time to time.

Dfine

Vendor: Nik Software

Purpose: A set of tools for reducing noise and optimizing detail in digital images

Figure 17.1
Dfine is shown here denoising an image taken in poor light at ISO 800.

Description

The vendor makes noise reduction an easy-to-use, four-step process with Dfine, a package that lets you correct luminance noise, chrominance noise, and JPEG artifacts. It has fully professional features such as noise analysis, with optimization using camera-specific profiles. With these tools you can control the relationships between detail, noise, and color, thereby maximizing the quality of the image.

Dfine 2.0 allows you to apply noise reduction selectively, as it incorporates the vendor's ingenious U Point technology. With this technique you select control points on those objects you want to adjust, and then use the slider controls that are overlaid on the image. Automatic camera profiling is another feature of version 2.0, making it unnecessary to purchase camera profiles separately.

The 40-page User Guide is both comprehensive and useful. Among its good advice for keeping noise at bay, it mentions Four Golden Rules, as follows:

■ Turn off in-camera noise reduction

■ Turn off in-camera sharpening

■ Use flash in low light

■ Avoid above-average in-camera contrast settings

Comments

All software from Nik Software is highly regarded in the industry, especially Nik Sharpener Pro. This package provides some extremely powerful tools for dealing with noise, using the most efficient and up-to-date methods. It has been significantly improved in version 2.0 by the addition of U Point technology. There are one or two niggles with the interface: a less-than-perfect zoom tool that requires Ctrl> - to de-zoom, although it zooms to 100 percent and 300 percent with clicks on the image. But minor points aside, this is a superb tool for denoising those images that need it.

Version: Dfine 2.0 (2008)

Plugs into: Windows Photoshop 7 and up, Photoshop Elements 2–4, Corel Paint Shop Pro and Painter, Ulead PhotoImpact; Mac Photoshop CS2 and above

OS: Windows 2000, XP, and Vista; Mac OS X 10.4 and later

RAM: 256MB recommended

Supported file formats: As host

Price level: Approx. $100

Address: Nik Software, Inc., 7588 Metropolitan Drive, San Diego, CA 92108, United States www.niksoftware.com

Kodak DIGITAL GEM

Vendor: Eastman Kodak Company

Purpose: Reduces noise in both highlight and shadow areas without sacrificing image detail

Description

Kodak DIGITAL GEM (GEM stands for "Grain Equalization and Management") is part of a suite of image-enhancement plug-ins that are sold separately, the others being

DIGITAL SHO for fixing exposures, DIGITAL ROC to restore color balance, and the related DIGITAL GEM Airbrush Professional for removing skin blemishes. As well as noise reduction, DIGITAL GEM offers soft-focus effects and image sharpening, and lets you remove line-screening patterns from scanned images, and JPEG compression artifacts.

The professional version of DIGITAL GEM is twice as expensive but adds a new grain/noise reducing algorithm, 16-bit support, and an improved user interface with a bigger noise preview screen.

Comments

DIGITAL GEM was developed originally by Applied Science Fiction of Austin, Texas, which Kodak acquired in 2003. There is always a danger that a small product (or even a whole product line) might get lost in a multi-billion dollar company, and certainly the branding of this one reduces it to the standard Kodak style. It should be more distinctive, having won both the DIMA "Innovative Product and American Photo Editor's Choice Award" (Software) in 2003. Tests and reviews have shown it to be both effective and easy to use.

Version: Kodak DIGITAL GEM 2.0 (2008)

Plugs into: Photoshop 5.0 and up; Photoshop Elements 1.0 and up; Windows only—Paint Shop Pro 7 and up

OS: Windows 98 and up; Macintosh OS 8.6 and up

RAM: 256MB

Supported file formats: As host

Price level: Approx. $50, Pro edition $100

Address: Kodak's Austin Development Center (KADC), Austin, TX, United States
www.asf.com

Neat Image

Vendor: ABSoft

Purpose: Highly automated noise reduction software with device noise profiling

Description

Neat Image has some of the most advanced algorithms for noise reduction. The vendor claims it goes beyond even the relatively new wavelet-based methods offered by other vendors. The Neat Image software builds "device noise profiles," thereby adapting noise reduction to the specific imaging device such as a DSLR or a scanner. These noise profiles, not unlike the concept of color profiles, are now available for many different devices including cameras from Canon, Casio, Contax, Epson, Fujifilm, HP, Kodak, Kyocera, Leica, Konika-Minolta, Mamiya, Nikon, Olympus, Panasonic, Pentax, Ricoh, Samsung, Sanyo, Sigma, Sony, and Toshiba.

Neat Image comes both as a stand-alone program and as a plug-in for innur
image editors. For example, as a Photoshop plug-in it can apply noise reduct
sharpening in a layer, channel, or selection. There are three editions: Demo (freeware
edition with limited functionality), Home (with support for 24-bit images), and Pro
(with support for both 24- and 48-bit images). Both Home and Pro are also available
with the Photoshop-compatible plug-in.

Comments

Just a glance at the samples given on the ABSoft Website indicates how effective is Neat
Image, even without reading the endorsements by leading photographers. Neat Image
can even clean up captured TV frames, completely removing color banding and other
artifacts without destroying detail. Users have access to an extensive profile library where
other expert users have donated the profile sets they have created.

Version: Windows Neat Image 5.9 (2008); Mac 4.5 (2008)

Plugs into: Photoshop 7 and greater; Photoshop Elements 2 and greater; Ulead PhotoImpact;
Serif PhotoPlus; Corel Paint Shop Pro; Microsoft Digital Image Suite and other image editors

OS: Windows, all versions; Mac OS X

RAM: 160MB or more

Supported file formats: Stand-alone edition—TIFF, JPEG, and BMP; Photoshop plug-in—any
format that can be opened by the host software, including PSD, JPEG 2000, RAW, and DNG

Price level: Windows stand-alone Home version $30, with plug-in $50, Pro standalone $60, Pro
version with plug-in $75, Mac Home plug-in $35, Mac Pro plug-in $60

Address: info@neatimage.com

www.neatimage.com

Noise Ninja

Vendor: PictureCode

Purpose: Top-rated noise reduction software, with camera-specific profiles and a Noise brush

Description

Noise Ninja consistently rates as one of the best noise-reduction packages, and often
occupies the top spot in comparative reviews. It strikes a good balance between noise
suppression and detail preservation, which is one of the necessities of this software cat-
egory. Its tools include automatic and manual noise analysis, camera-specific profiles,
and a feature called the Noise brush, which lets you undo the global noise reduction of
specific parts of the image. You can therefore restore fine detail without letting the noise
creep back into the rest of the picture.

Based on new advances in wavelet theory, Noise Ninja can produce a two-stop gain in
image quality, allowing photographers to shoot at ISO levels they would not normally

consider. The new algorithms have largely overcome the tendency of conventional wavelets to create artifacts like halos, ringing, or color bleeding in high-contrast edges. Noise Ninja achieves smooth results, even in low-ISO images.

State-of-the-art noise reduction requires device profiling because noise differs from one device to another. Noise Ninja has all the necessary data to tell it how different cameras behave at various high-ISO levels, and it provides the correct filtering to counteract any tendency to accentuate noise at certain color frequencies. Equally, it provides separate control over color and luminance channels—another necessity for advanced noise reduction.

Noise Ninja is available in stand-alone and plug-in versions.

Figure 17.2
Noise Ninja uses wavelet technology to reduce digital noise.

Comments

With over 450 authorized resellers, PictureCode is the market leader in noise reduction, and deservedly so. Founded by computer scientist Dr. Jim Christian, it has specialized in this one aspect of image enhancement with demonstrably great results. Noise Ninja is used by most of the major newspapers and has found a market among both professional photographers and top amateurs.

Version: Stand-alone—Noise Ninja 2.1.1, plug-in—2.2.0 (2008)

Plugs into: Adobe Photoshop 7 and above; Photoshop Elements; compatible host applications

OS: Windows 98 SE, ME, 2000, and XP; Mac OS X (Intel and PowerPC); Linux x86

RAM: 512MB

Supported file formats: JPEG and TIFF: Uncompressed 8- and 16-bit channels (24/48-bit pixels), RGB/monochrome

Price level: Home stand-alone $35, Home bundle (plug-in) $45, Pro stand-alone $70, Pro bundle (plug-in) $80

Address: PictureCode LLC, 7610-B Highway 71 West, Austin, TX 78735, United States

www.picturecode.com

Noiseware

Vendor: Imagenomic

Purpose: Noise-reduction software with an intelligent batch-processing capability that learns as it processes

Description

The more you process images in Noiseware, the better it gets. This is because it has a learning capability that accustoms itself to the various types of picture taken by the photographer. Using Exif data it identifies image variables such as acquisition device parameters and shooting conditions, and then builds a noise profile that it constantly adjusts as it obtains further information from the images it processes. Over time, this self-learning feature significantly improves the quality of noise processing.

Noiseware comes in both plug-in and stand-alone editions, the latter in three versions—Community (free), Standard (low-cost), and Professional (full featured, sub-$50). All versions can open the formats listed here, and the Pro edition can also save in these formats.

Comments

Noiseware has been highly acclaimed by magazine editors for its ease of use, speed, and effectiveness. It succeeds in reducing visible noise without discarding image detail. For photojournalists on a tight deadline, its batch processing capability is ideal.

Version: Stand-alone Noiseware 2.0; plug-in v.4 (2008)

Plugs into: Adobe Photoshop 7.0 and above; Photoshop Elements 2.0 and 3.0; Paint Shop Pro 8.0 and 9.0; Ulead PhotoImpact 8.0, XL, and 10

OS: Windows 2000, XP, and Vista; Mac OS X

RAM: 256MB

Supported file formats: JPEG, PNG, BMP, and TIFF files, in both 24-bit and 48-bit color

Price level: Approx. $50, (Pro plug-in) $70

Address: Imagenomic, LLC, 309 Yoakum Parkway, Suite 1501, Alexandria, VA 22304 United States

www.imagenomic.com

Figure 17.3
Noiseware has the intelligence to improve as it gets to know your images.

Picture Cooler

Vendor: R. Kroonenberg

Purpose: Noise reduction, sharpening and "camera unshake" software with batch processing

Description

Picture Cooler not only reduces noise but also provides sharpening options such as deconvolution and high-pass sharpening, and can help to minimize the effect of camera shake. It is not quite competitive with top commercial software on features, but has a highly competitive price. Features include a large preview window, toggling between preview and original image, and facilities to apply different levels of noise reduction to various parts of the image. Besides noise reduction it offers image sharpening and a "camera unshake" feature to remove blur.

Comments

Ronnie Kroonenberg's Picture Cooler came in as the number five recommendation on Michael Almond's list of 22 noise reduction programs. This is quite an achievement, given the stiffness of the competition. The poor presentation of the product online (do they have English spell-checkers in the Netherlands?) completely belies the efficiency of its easy-to-use interface and the quality of its output. It takes only a minute or two to download, install, and try—and it comes ready-loaded with a trial picture.

Version: Picture Cooler 2.51 (2008)

OS: Windows 98 SE, ME, 2000, and XP

RAM: 256MB

Supported file formats: JPEG, BMP, and TIFF 8- and 16-bit

Price level: Approx. $20

Address: r.kroonenberg2@chello.nl

denoiser.shorturl.com

PureImage NR

Vendor: Mediachance

Purpose: Noise reduction that uses wavelet noise-reduction techniques, plus color matching and correction

Description

PureImage NR uses wavelet noise reduction to achieve a better result than you can get with older algorithms that were developed before digital cameras appeared. Its default mode lets you fine-tune the noise-reduction level and edge sharpness, but there are other, specialist modes for dealing with outdoor images, portraits, and very noisy images produced by high ISO settings. The program also works in scanner mode, removing moiré patterns from high-resolution scans. Its color matching and correction tools include adjustment for shadows and highlights, exposure compensation, color boost, and a color temperature filter.

Comments

If you are concerned about noise in your images, PureImage NR can deal with it. It adjusts its processing to each area of the image, applying stronger reduction to areas of smooth color (such as skies) than to textured areas (such as trees). The results are very good indeed. Used with the Portrait Mode preset, it can remove noise from portraits without giving the model a "face-lift" look.

Version: PureImage NR 1.6 (2008)

OS: Windows 98, 2000, XP, and Vista (all native); Mac requires BootCamp, VMware Fusion, or Parallels

RAM: 512MB (preferably more)

Supported file formats: RAW, JPEG, PNG, BMP, TIFF, and TGA

Price level: Approx. $35

Address: Ottawa, Canada

www.mediachance.com

Figure 17.4

PureImage NR lets you fine-tune the noise reduction level and edge sharpness.

Summary

A single pixel may represent either noise or essential detail. Determining which one of these two categories it belongs to is the primary task of noise-reduction algorithms. If it represents noise, they switch it to another value. If it represents important detail, such as the edge of an object, they leave it well alone. Most modern noise reduction software has very advanced algorithms with the intelligence to preserve detail. Noise Ninja is the benchmark, but some photographers prefer Noiseware for its learning capabilities, or PureImage NR for its wavelet technology.

Red-Eye Removal

When a flash is mounted close to the lens, light can reflect from retinas of the subject's eyes and show up as the "red-eye" effect in a photograph. Correcting for red-eye is one of the most common editing features, implemented directly in cameras as well as in most general purpose and "quick-fix" image editors. It is also a subject of scrutiny by researchers who are trying to find better ways of doing it. At its most advanced, modern software can locate the position of eyes automatically within the frame, and then replace the redness with a gray tone, and blend the edges to give an almost perfect fit. What it cannot do is guess what color the eyes should be (blue, green, black, or brown) or eliminate exaggerated examples of red-eye, sometimes called "demonic eye."

Tiny blood vessels in the retina are responsible for the redness of the red-eye effect in portraits of people. Animals have a different reflective layer behind the retina, called the "tapetum," which enhances night vision. In dogs, for example, it can make eyes look blue, green, yellow, or white, depending on the angle of the head in relation to the flash. There is even specialist software for this application: Pet Eye Pilot from Russian developer Two Pilots (www.colorpilot.com).

Red Eye Pilot

Vendor: Two Pilots Software

Purpose: Automatic red-eye removal software, with a choice of three methods

Description

Red Eye Pilot allows you to remove the red-eye from portraits with a high degree of automation. It provides three algorithms to determine the area of the eye that needs to be corrected, together with a control to change the brightness level of the substituted color. A Remove Border feature tidies up the edges.

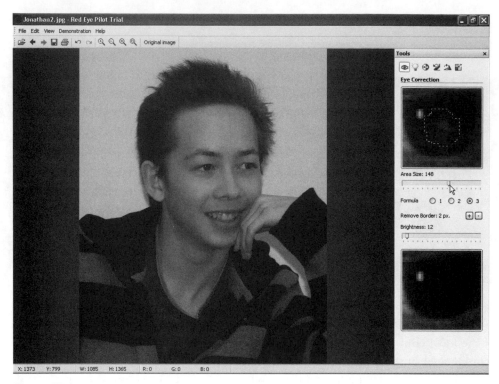

Figure 18.1
Red Eye Pilot lets you treat one eye at time with great accuracy.

The interface for Red Eye Pilot displays the image in a main panel, with panels to the right showing "source image" and "processed image" magnifications. Hot keys let you undo or redo the processing, whereas another feature lets you change the scale of the image by turning the mouse wheel.

Red Eye Pilot is available in English and Hungarian. Other editions include a Mac version and a plug-in version for Photoshop, Paint Shop Pro, Photo-Paint, and other editors.

Comments

Red Eye Pilot does not automatically locate the position of the eyes, as does, for example, STOIK RedEye Autofix. But it does a reasonable job of isolating the pupils and making corrections. It uses a three-step method to "zero-in" on each eye individually and has good fine-tuning facilities so that you can make a smooth repair. Development has greatly improved it since its first appearance, and it works beautifully on pictures of Red-Eyed Tree Frogs from Central America.

Red Eye Pilot is available in a stand-alone version for Windows and Macintosh and as a plug-in for Windows.

Version: Windows Red Eye Pilot 2.1, Mac 1.6 (2008)

Plugs into: Windows XP Photoshop; Photoshop Elements; Corel Paint Shop Pro Photo and Photo-Paint, Macromedia Fireworks MX

OS: Windows 98, NT, ME, 2000, XP, and Vista; Red Eye Pilot for the Mac—OS X

RAM: 64MB

Supported file formats: BMP, TIFF, JPEG, PNG, PCX, and PSD

Price level: Approx. $40

Address: ul. Serdlova 39, 2 Bol'sherech'ye, Omsk, 646670, Russia

www.colorpilot.com

RedEyePro

Vendor: Andromeda Software

Purpose: Red-eye removal with novice and professional capabilities

Description

RedEyePro offers professional-level red-eye removal (although you could argue that professional photographers should not be taking red-eye portraits in the first place). There is also a novice mode, and, most importantly, a pet mode to remove green-eye (and other colors) from images of pets.

RedEyePro works on both RGB and CMYK images and has selective Unapply and Unpaint tools. It can also fix non-circular red-eye, a particularly vexing problem that many so-called solutions fail to fix.

Comments

The two good things about RedEyePro are its speed, and, with a little extra effort from the user, its ability to preserve glints and other reflections in the eye. It is not perfect, despite its price, but red-eye software will always suffer from an inherent inability to guess the eye's original color.

Version: RedEyePro 1.11 (2008)

Plugs into: Windows and Mac Adobe Photoshop 5.5 and up; Photoshop Elements 1.0 and up; compatible editors

OS: Windows 98, 2000, ME, NT, and XP; Mac 9.x and OS X

RAM: 256MB

Supported file formats: RGB and CMYK formats

Price level: Approx. $40

Address: Andromeda Software, Inc., 699 Hampshire Rd Suite 109, Westlake Village, CA 91361, United States

www.andromeda.com

STOIK RedEye Autofix

Vendor: STOIK Imaging

Purpose: Fast and fully automatic red-eye removal for home photographers

Description

STOIK RedEye Autofix can fix red-eye problems in photographs with the click of a button. It automatically detects the eye positions, and then removes the red effect and replaces it with a realistic eye coloring. It lets you deal with photos one at a time, or in batches. To use it, you simply right-click on any photo (or a selection of multiple photos), click Remove Red Eye, and the program does the rest.

Comments

STOIK RedEye Autofix is a small, specialist utility, but it works well and is certainly very fast. It usually removes all the red from the eyes, but can sometimes leave a trace that needs touching up in another program. The program has been subjected to rigorous study by other researchers (at EPFL, Switzerland) and found to err only on small blemishes or when the eye is too small within the image, such as on background figures. It is available on a free trial period without the batch capabilities.

Version 3.0 of STOIK RedEye Autofix was launched without any intervening 2.0. The vendor says it has been completely rewritten to improve its detection rate, now said to be more than 80% with fewer than 5% false positives. A new manual mode allows you to eliminate all undetected red eyes.

Version: STOIK RedEye Autofix 3.0 (as of 2008)

OS: Windows 98 SE, ME, 2000, and XP

RAM: 128MB

Supported file formats: JPEG

Price level: Approx. $30

Address: STOIK Imaging, Ltd, P.O. Box 48, Moscow 119049, Russia

www.stoik.com

Summary

Designed to correct one of the most basic faults in flash photography, red-eye removal is now firmly embedded in most image editors and processors. Yet there are still one or two dedicated programs for carrying out this task. RedEyePro from Andromeda Software offers professional, novice, and pet modes, the last of which (pet mode) refers to the subject rather than the user. The eyes of animals can reflect colors other than red in the brilliant light of a flash.

<div style="text-align: right;">

19

</div>

Skin Tone Enhancement

Human beings are highly sensitive to face color, perhaps, in evolutionary terms, because it can give an indication of whether a person is ill and therefore likely to communicate a dangerous disease. In portrait photography, we notice the slightest variation in skin tones whenever there is a chance to compare shots side-by-side. Yet there is a lot more to this subject than the phrase "skin tone" implies. With a modern DSLR and a powerful lens you can resolve every mole, wrinkle, freckle, blemish, and dermatological disorder, much to the dismay of the subject. Having put them in, the photographer needs to take them out. Skin tone enhancement software does the job.

The software described in this category is mainly for professional use, but not exclusively. General-purpose image editors also have retouching tools suitable for dealing with occasional images that require skin tone adjustment, but if you make a living from portraiture you need all the help you can get from specialist software. Many photographers prefer to take precautionary measures at the capture stage, with subtle lighting and soft-focus lenses, but it is useful to have a second option as a backup. Developers have invested substantial research into improving both the speed and quality of this type of software. The results of their labors are as follows.

GinaPRO

Vendor: Sean Puckett

Purpose: Skin tone enhancement software to change skin color and saturation and add "glow"

Description

GinaPRO is a blotch-fixing, sharpening/blurring filter that specializes in making skin tones glow with health and vitality. Its interface has a stack of 18 slider controls arranged

in three groups: Blotch Fixer, Skin Selection, and Skin Adjustment. As with the developer's other products, you start at the top and work your way down the controls in a logical progression.

Skin tones occupy a narrow band of the color gamut, yet even the smallest changes can be apparent. GinaPRO gives you a high degree of control over colorcasts from reflections and lets you make very minor adjustments to the specific hues and tones of human skin.

Comments

GinaPRO has one significant drawback—being a plug-in to BibblePRO, it has no way of directly accessing mouse positions, hence you cannot simply point to an area of skin and make corrections. Any parts of the image that have similar coloration to that of skin can therefore be affected inadvertently. However, if you recognize this limitation, the plug-in works well on many images. It is not as effective as SkinTune, but is only a quarter of the price.

Version: GinaPRO 1.1 (2008)

Plugs into: Bibble Pro (upgrade when Bibble upgrades)

OS: As host (Windows, Linux, and Mac versions are in the same download)

RAM: 256MB

Supported file formats: As host

Price level: $20

Address: seanmpuckett@gmail.com

www.nexi.com

Kodak DIGITAL GEM Airbrush

Vendor: Eastman Kodak Company

Purpose: Software for correcting skin blemishes in portrait and wedding photography

Description

Kodak DIGITAL GEM Airbrush provides a quick way of smoothing skin without having to use complicated masking. It lets you control image detail at three levels: fine, medium, and coarse. It effectively preserves fine detail in the subject's face, such as eyelashes and eyebrows, although there is inevitably (and deliberately) some loss of other detail such as wrinkles and blemishes.

Designated as a "professional" plug-in, DIGITAL GEM Airbrush naturally works on both 8-bit and 16-bit images, like the professional editions of DIGITAL ROC, GEM, and SHO. You can record a procedure as a Photoshop action and use it for batch processing many subsequent images. Also available are pre-written action scripts designed to supplement the product. The Air Dimensional script helps to bring back the dimensionality of the image by adding shadows without affecting the plug-in's smoothing effects.

Comments

This tool is aimed chiefly at wedding and portrait photographers, but amateur users may also find it useful. It creates a flattering look, regardless of the age or complexion of the sitter.

Version: Kodak DIGITAL GEM Airbrush 2.0 (2008)

Plugs into: Photoshop 5.0 and up (full support for CS3); Photoshop Elements 1.0 and up; Windows only—Paint Shop Pro 7 and up

OS: Windows 98 and up; Mac OS 8.6 and up

RAM: 256MB

Supported file formats: As host

Price level: Approx. $100

Address: Kodak's Austin Development Center (KADC), Austin, TX, United States

www.asf.com

LookWow!

Vendor: LookWow, Inc.

Purpose: Online service for making portraits more flattering

Description

LookWow! is an online service (there is also a PC version) to which you can upload a nondescript portrait of yourself, however pallid or spotty, and get back a glamorized version—tanned and glowing with health. Its features are designed to make your features look good. For example, Enhance Lips will "brighten and plump your lips and define the mouth," as the vendor puts it. The skin-smoothing algorithms reduce unwanted marks—goodbye to moles, scars, and wrinkles. You can even add a touch of mood, using the Candlelight Effect to give the photo a soft, romantic light.

Other effects include flip, rotate, resize, remove red-eye, brighten smile, and whiten teeth. You can give an elegant, old-fashioned look to the image, make the whole picture broader (now who would want to do that?), or "thinnify" it, presumably to make yourself look thinner.

There is one other important feature: Add Text. The vendor does not say what sort of text, but probably not: "I certify this is a true likeness of..."

Comments

On the Internet, no one knows you are a dog until you try to get a date and need to post a picture of yourself to tempt prospective partners. Apparently this is one of the primary applications of LookWow! Pity the prospective partner! Here is an online service that takes portrait flattery to new levels of mendacity. Yes, it works well, although

red-eye removal is poorly implemented and the "suntan" effect gives a tan to the background as well as the person. But it requires no membership, no registration, and, being supported by advertising, is entirely "free."

Version: LookWow! 3.1 (2008)

OS: Multi-platform Java-based; PC version XP and Vista

RAM: 128MB

Supported file formats: JPEG

Price level: Free (advertising-supported)

Address: info@lookwow.com

www.lookwow.com

Portrait Professional

Vendor: Anthropics Technology

Purpose: Retouching software to fix blemishes, reshape faces, remove shiny highlights, and so on

Description

Portrait Professional is a package that allows photographers to make both subtle and dramatic changes to the sitter's appearance in a portrait. With it, you can fix skin blemishes, remove wrinkles, grease, sweat, and shiny highlights, adjust lighting to make it more flattering, and perform routine tasks like red-eye removal and teeth/eye whitening.

Built-in intelligence allows you to perform retouching operations without any special skills; the automatic airbrush "really does do all the hard work for you," according to the vendor. It has a slider control interface, each slider being dedicated to a separate task, such as "Imperfections," "Thin wrinkles," "Fine shadows," "Remove pores," and "Tan." Used to its full extent it will even make adjustments to a face's underlying bone structure.

There is a Max option in Portrait Professional that allows you to work directly with 16 bits per color in TIFF or RAW format, straight from the camera.

Comments

Based at London's Ealing Studios, the vendor of Portrait Professional is a commercial spin-off from the UK's National Film and Television School. Portrait Professional is one of its main products: a sophisticated retouching package that is a lot easier to use than the equivalent tools in Adobe Photoshop. Where speed is essential, Portrait Professional is a viable option, although the results you can achieve with slider controls might never quite match Photoshop precision.

Version: Portrait Professional 4.2 (2008)

OS: Windows 2000, Server 2003, XP, and Vista

RAM: 256MB

Supported file formats: Major RAW formats; JPEG and TIFF

Price level: Approx. $60, with Max option approx. $100

Address: Anthropics Technology Ltd., Unit 1a, Walpole Court, Ealing Studios, Ealing Green, London, W5 5ED, United Kingdom

www.portraitprofessional.com

Portraiture

Vendor: Imagenomic

Purpose: Intelligent smoothing for rapid retouching of portraits

Description

Portraiture is software for retouching portraits the easy way, using intelligent routines to eliminate selective masking. It removes imperfections but retains skin texture so that the portrait still looks very natural. It also gives you a high level of control over how it treats details, allowing you to adjust for sharpness, softness, warmth, brightness, and contrast.

The purpose of Portraiture is to achieve a great result as quickly as possible, hence it comes with predefined presets for one-click effects. Yet it is a fully professional tool in that it allows you to use custom presets that encapsulate your own actions. Its Auto-Mask feature lets you apply smoothing routines automatically and then fine-tune them with color tools and slider controls. Portraiture's auto feature can recognize all skin types that may be present in the image.

Comments

For the busy portrait studio that needs rapid retouching for hundreds of images, Portraiture is a powerful tool. Sitters will rarely complain that all their skin blemishes have magically disappeared. One reviewer thought it would be good for fashion photographers "working with aging models," but that may be going too far. Others have complained about the price, but for the intended market it seems to be a very good value.

Version: Windows Portraiture 1.0.1; Mac 1.0.2 (as of 2008)

Plugs into: Adobe CS and above; Photoshop Elements 3, 4, and 5

OS: Windows 2000, XP, and Vista; Mac OS X 10.3.x and 10.4.x

RAM: 256MB

Supported file formats: Those of host program

Price level: Approx. $170

Address: Imagenomic, LLC, 309 Yoakum Parkway, Suite 1501, Alexandria, VA 22304 United States

www.imagenomic.com

SkinTune

Vendor: onOne Software

Purpose: Specialist skin color correction software for wedding, portrait, and fashion photographers, developed by PhotoTune, acquired by onOne, and now part of onOne's PhotoTune package (see that entry in Chapter 9, "Quick-Fix Software").

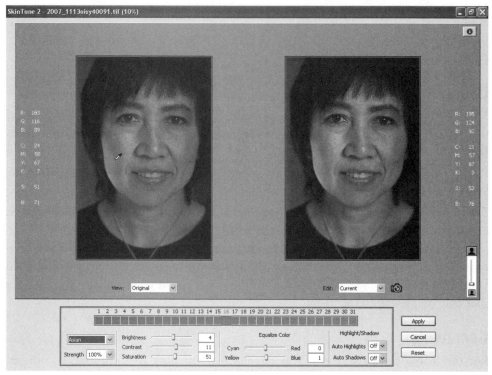

Figure 19.1
SkinTune technology is based on thousands of actual skin tone samples.

Summary

All aspects of photography are important to the person holding the camera, but to the person in front of the camera one aspect looms large: skin tone representation. Only those with a blemish-free skin are looking for complete accuracy in this respect, but skin color, too, is always noticeable and the slightest deviation will be apparent to many viewers. Many of the packages and plug-ins described in this chapter allow you to remove wrinkles and blemishes; some will accommodate even the most minor changes to skin color and saturation. Check out PhotoTune for its SkinTune technology, with its library of more than 125,000 skin colors (in Chapter 9, "Quick-Fix Software").

20

Photo Restoration

Photo restoration software predates the digital camera revolution, having been developed for scanner input long before CCD and CMOS sensors in cameras created a demand for similar retouching. It has the capability of making old photographs look as good as new.

Photoshop has comprehensive tools for retouching photographs, so why bother with other packages? As you will see, some of those listed in this chapter have facilities not found in any general-purpose image editor. The best known, Kodak DIGITAL ROC, is based on research into the problems surrounding the fading of color images. BlackMagic from NeuralTek uses neural net algorithms for automating the task of colorizing black and white images. PhotoFlair from TruView is based on Dr. Edwin Lang's Retinex theory and comes to the professional or amateur restorer courtesy of NASA.

Photo restoration has become a cottage industry with individuals offering to digitize, restore, enlarge, and print old or damaged pictures. It is a worthwhile task. If you, too, feel like rescuing the past, check out some of this software.

AKVIS Alchemy

Vendor: AKVIS LLC

Purpose: A software bundle of photo correction and restoration tools

Description

AKVIS Alchemy is a software bundle that consists of several individual plug-ins priced separately in the $50–$120 range. Purchased together, they are half-price.

The bundle includes Retoucher, Chameleon, Stamp, Enhancer, Coloriage, Noise Buster, Sketch, Decorator, and LightShop. Retoucher removes defects from damaged photos and reconstructs any missing parts by using information from the surrounding areas.

Chameleon is a tool for photo collage creation. It allows you to copy an object and insert it into another image, and then it automatically adjusts the object to its new background ("as chameleons do").

Stamp is good at removing unwanted objects and image flaws such as spots, stains and dust, as well as working on portrait enhancements, removing wrinkles, scars, and scratches. It automatically adjusts patches to the color range, texture, and brightness of the target background, blending patch and background for an absolutely natural look.

Enhancer brings out detail from underexposed, overexposed, and midtone areas by intensifying color transitions between adjacent pixels. Coloriage is a photo-colorizing program for adding color to black and white images or to hand sketch drawings. You can also use it to change the colors in existing color photos.

Noise Buster reduces both luminance and color noise, showing both "before" and "after" images for comparison.

Sketch converts photographic images into simulated pencil sketches and watercolor drawings. As well as working with still images, it lets you create comics from home videos.

Decorator is a texture-mapping tool for adding patterns and colors to objects in a picture.

LightShop is a specialist plug-in for creating light effects such as reflections, glows, and sparkle effects. You can add "the glow on smoldering wood in a fireplace" or "alien signs blazing in the night sky." Use presets or make your own effects.

ArtSuite lets you add decorative elements such as frames, textures, or color shades. You can experiment with ragged edges, scratched surfaces, and page curls, among many other effects.

SmartMask makes object selection easy by offering three selection modes (sharp, soft, and complex) depending on the nature of the object in question. For example, the soft mode lets you isolate areas depicting fluff, hair, or fur. Switch to the complex mode for touching up fine detail.

Comments

This developer is based in the Russian city of Perm (twinned culturally with Louisville, Kentucky, and Oxford, England) and has a Canadian office in Vancouver. The Enhancer and Noise Buster plug-ins are available as a Photo Correction Bundle, whereas Retoucher and Stamp can be purchased economically as the Restoration Bundle. AKVIS has some original ideas worth investigating. Its English language Website has screen-shots and output samples for every feature.

Version: Retoucher 2.9, Chameleon 5.0, Stamp 3.0, Enhancer 8.0, Coloriage 5.0, Noise Buster 5.0, Sketch 6.5, Decorator 1.5, LightShop 2.0, ArtSuite 3.0, SmartMask 1.2 (as of 2008)

Plugs into: Adobe Photoshop 5 and up, Photoshop Elements 1 and up, Ulead PhotoImpact 7 and up, Corel Photo-Paint 11 and up, Painter 9+ and up, Paint Shop Pro 6 and up, ACD FotoCanvas 3, Picture Publisher Pro, and Bodypaint 2 and up

OS: Windows 2000, XP, NT, and Vista; Mac OS X

RAM: 256MB

Supported file formats: Major file formats

Price level: Approx. $320

Address: AKVIS LLC, Malkova str, 20-36, Perm, 614087, Russian Federation

www.akvis.com

BlackMagic

Vendor: NeuralTek

Purpose: Colorize black and white, sepia, or infrared photos, or color-correct those with faded or inappropriate colors

Description

BlackMagic uses state-of-the-art neural net algorithms to bring further automation to the task of colorizing images. It allows you to select the "type of object" within the image to be colored, and then the software makes all the calculations to place realistic-looking color in place of the monochrome image.

Rendering tools included with BlackMagic are Selector, Eraser, Smart Paint-brush, Selection-paint, and Magic Touch-paint. It is available in three editions: Home, Business, and Professional. They all have the essential neural net capability, but the Home Edition supports a maximum processing resolution of one million pixels. The Business Edition goes to four megapixels and the Pro version supports processing at any resolution. The more expensive editions also have additional functionality, tools, and palettes.

Simple to use, BlackMagic is a Windows-only product.

Comments

Adding color to black and white photographs is an art in itself, once undertaken only by trained colorists who spent all their time tinting pictures with fine brushes and a steady hand. BlackMagic is genuine "expert software" in being able to make intelligent guesses about the correct way to colorize water, skies, faces, and so on, and to apply the color so that it looks reasonably natural. It is particularly good at imparting a "30s Hollywood" look to black and white portraits with fully saturated colors and lively hues.

Version: BlackMagic 2.85 (2008)

OS: Windows 95, 98, ME, 2000, XP, and Vista

RAM: 128MB

Supported file formats: JPEG and BMP

Price level: Home edition $40, Business edition $100, Professional edition $200

Address: NeuralTek, P.O. Box 582, North Ryde Business Ctr., NSW 1670, Australia

www.blackmagic-color.com

Image Doctor

Vendor: Alien Skin

Purpose: Image correction filter set to remove blemishes, scratches, stains, and compression artifacts

Description

Image Doctor is an image repair kit, with lots of tools for removing blemishes such as moles, birthmarks, acne, and scars; and others for restoring old photographs that have been scanned into digital form. It makes it easy to mend even badly damaged pictures with scratches, tears, and creases, while also taking out any unwanted text, time codes, and dust marks.

Among its tools are the following:

- Smart Fill covers up all traces of any object removed from the picture

- Scratch Remover repairs small defects

- Spot Lifter erases skin flaws, watermarks, or stains

- JPEG Repair lets you fix JPEGs that have been over-compressed

Comments

After using Image Doctor, one reviewer (a professional retoucher) wrote: "I think I'd better find another line of work." It is so simple to operate and achieve first-rate results that anyone can use it. It is aimed at both professional and amateur photographers, photo editors, archivists, and graphic and Web designers. Rendering speed and quality have been significantly improved in version 2.0, together with even more facilities for removing blemishes and wrinkles.

Version: Image Doctor 2.0 (2008)

Plugs into: Photoshop CS2 or later; Windows—Photoshop Elements 4.0.1 or later; Mac—Photoshop Elements 5.0 or later; Fireworks CS3 or later; Windows only—Paint Shop Pro Photo X2 or later

OS: Windows XP and Vista; Mac OS X 10.4.0 or later

RAM: 1024MB

Supported file formats: Those of host program

Price level: Approx. $200

Address: Alien Skin, 1111 Haynes Street, Suite 113, Raleigh, NC 27604, United States

www.alienskin.com

Kodak DIGITAL ROC

Vendor: Eastman Kodak Company

Purpose: Software designed to restore the color of faded photographic images

Description

Kodak DIGITAL ROC (ROC stands for "Restoration Of Colors") addresses the problem of color fading in photographs. Over time, both negatives and prints begin to acquire a distinct reddish or bluish tint, completely spoiling their aesthetic effect. After you have scanned the images into a computer, DIGITAL ROC can correct even extreme color fading, making them viewable again.

Another application of DIGITAL ROC is to correct colorcasts on images taken more recently under tungsten or fluorescent lights with daylight film. These have a yellow or whitish color that may need to be removed. Again, the software performs this specialist task very efficiently. It works with images from any digital source, but black and white images should be scanned in RGB mode. DIGITAL ROC can restore density and contrast to black and white pictures.

Comments

There are countless millions of faded color prints languishing in albums and picture frames all over the world. People should scan them and correct their color before it is too late. Kodak DIGITAL ROC is an excellent product for this purpose. It has a long and distinguished history, based on technology developed by Dr. Albert Edgar and his team at Applied Science Fiction before passing to Kodak.

Version: Kodak DIGITAL ROC 2.0 (2008)

Plugs into: Photoshop 5.0 and up; Photoshop Elements 1.0 and up; Windows only—Paint Shop Pro 7 and up

OS: Windows 98 and up; Macintosh OS 8.6 and up

RAM: 256MB

Supported file formats: As host

Price level: Approx. $50, (Pro edition $100)

Address: Kodak's Austin Development Center (KADC), Austin, Texas, United States

www.asf.com

PhotoFlair

Vendor: TruView Imaging Company

Purpose: Revolutionary photo enhancement software based on the Retinex algorithm

Figure 20.1
PhotoFlair uses the Retinex algorithm for instant improvement of poorly exposed images.

Description

PhotoFlair has the ability to improve incorrectly exposed photographs with a single click. If this sounds like hype, please read on, because this underrated product is the real thing: a technology based on the almost subversive insights of the late Dr. Edwin Lang, the inventor of Polaroid photography. He rightly supposed that color perception is a combination of the eye's retina ("retin-") and the brain's visual cortex ("-ex"), and he called his theory of two-channel processing the Retinex theory.

Many years passed before NASA developed retinex algorithms that simulated the effects of Dr. Land's experimental Retinex filters. These algorithms, which have been used to enhance space images, are now being marketed by a commercial firm as the PhotoFlair package. It is ideal for restoring detail in old photographs that have been digitally scanned. It also has forensic applications, enhancing images from surveillance tapes.

PhotoFlair's features in addition to Retinex include a levels dialog box for adjusting red, green, and blue channels and a composite channel, histogram equalization, gamma, sharpen, blur, despeckle, edge detection, three types of image resizing algorithm (pixel replication, gaussian, and cubic interpolation), cropping, grayscale conversion, and image rotation.

Comments

PhotoFlair is a specialist product, but an outstanding one. TruView's samples gallery is one of the most convincing demonstrations by a vendor of image enhancement software. Anybody who is in the business of restoring old photographs should definitely consider acquiring this software.

Version: Windows PhotoFlair 2.2.2; Mac 2.2.3 (2008)

Plugs into: Photoshop 5 and up; Photoshop Elements; Separate Windows-only edition, Premiere

OS: Windows 2000 and XP; Mac OS X (not Intel)

RAM: 128MB

Supported file formats: Reads and writes JPEG, TIFF, BMP, PPM, and PNG; in batch mode, PCD is also supported

Price level: Stand-alone version $70, Photoshop plug-in $40, Premiere plug-in $95

Address: TruView Imaging Co., 10 Basil Sawyer Drive, Hampton, VA 23666-1393, United States

www.truview.com

VueScan

Vendor: Hamrick Software

Purpose: World's most widely used scanning software, with restoration tools

Description

VueScan supports almost every scanner on the market and enables you to obtain scans that are demonstrably superior to those that can be obtained with the scanner's own software. It does not rely on TWAIN or any other third-party scanner extensions and it works independently of the normal scanner application. For people who are restoring faded slides or prints it has two automatic features—Restore Colors boosts RGB values, and Restore Fading compensates for the fade-to-red effect in slides and the tendency of color negatives to acquire a bluish cast over time.

VueScan can make images on badly scratched film appear as good as new by using a double-scan technique, first with a normal scan, second with infrared light to show up the imperfections. It combines the two images, producing a "nearly flawless" result. Other features include ICC and IT8 Target support, a RAW file save option for archiving, and batch scanning.

A wizard-driven interface means that VueScan is simple for the novice to operate, but there are also manual controls for the expert, making it one of the key weapons in the restorer's armory.

Comments

Over 5 million people have tried Ed Hamrick's VueScan, and 140,000 have bought it. Unsurprisingly, it has been given attention by dozens of reviewers, among whom there appears to be general agreement that it provides the greatest level of control of any scanner software you can buy. The developer readily admits that putting the full set of controls into the hands of a novice can lead to uncertain results, but the presets are there to allow beginners to achieve good results at the outset.

Versions: VueScan 8.4.64 (2008)

OS: Windows 95, 98, ME, NT, 2000, XP, Vista, and x64; Mac OS X 10.3.9 and 10.4 Intel and PowerPC; Linux

RAM: 256MB

Supported file formats: Major formats, including PDF output

Price level: Standard edition $40, Professional edition with unlimited free upgrades $80

Address: Hamrick Software, 4025 E. Chandler Blvd., Suite 70-F16, Phoenix, AZ 85048, United States

www.hamrick.com

Summary

To restore old photographs you first need to digitize them by scanning, and then use one of the software packages described in this chapter. Some of these packages have a history that goes back to before the digital camera revolution, to an era when scanning was more popular than it is today. The problem of color fading in early color photographs made such technology essential, otherwise millions of images would have been lost forever. There is still time to rescue those that remain, and Kodak DIGITAL ROC, developed for this purpose, is available for the task. You can clean up damaged or scratched images with VueScan, or use PhotoFlair, based on Dr. Edwin Lang's Retinex algorithm, to perform "quick-fix" style color corrections.

Part III

Blending, Stitching, and Optical Correction

This part covers the following topics:

21

High Dynamic Range

Dynamic range is the scale of values from the darkest dark to the brightest bright. All efforts to represent the real world, whether in painting, film, or digital photography, have to reduce the dynamic range to fit the capabilities of the medium. For example, reflective paper is bound to have a more limited dynamic range than a light-emitting screen, even if the manufacturer adds a lot of whitener to it. Most modern displays have a contrast ratio of around 1000:1 or 2000:1 (some are higher), but new displays developed by BrightSide Technology have a very high peak luminance (greater than 3,000 candela/m2) and a contrast ratio better than 200,000:1. A high dynamic range (HDR) image of a landscape on this type of screen looks as if you could step into it. It is that real.

In basic HDR photography, the photographer takes a series of shots of the same scene, using a tripod for absolute steadiness and exposing separately for the highlights and shadows. This can also be done automatically by bracketing if there is any movement in the scene. The next step is to use software to blend the images together in a process called *contrast blending*.

Where true HDR differs from normal digital photography, however, is in the way it encodes the greatly increased number of tonal levels. It uses a 32-bit file format to specify floating-point numbers that can represent millions of levels if called upon to do so. Digital cameras are not yet able to bracket a sufficient number of exposures to make full use of this enormous range and no output medium, except specialist displays like those mentioned previously, can represent HDR adequately. Hence the brightness levels have to be squeezed together by "tone mapping," available in HDR packages and in Photoshop CS2 and CS3.

Some people believe that HDR is the way forward for digital photography, a reasonable prediction because the representation of dynamic range is one of its few weaknesses. Like 3D or panoramic photography, it makes a great hobby and has the potential to make a great business. To get started, check out the products listed in this chapter.

Artizen HDR

Vendor: Supporting Computers

Purpose: All-in-one HDR and LDR solution for home and professional photographers

Description

Described by the vendor as "the first all-in-one HDR (High Dynamic Range) and LDR (Low Dynamic Range) solution for the home and professional photographer," Artizen HDR brings many editing facilities to HDR photography. It has a metadata editor for Exif, GPS, and IPTC; color-correction tool with more than 20 options; an image browser for over 40 formats; batch processor; icon creator; RAW image editor with support for 11 RAW file formats; Web gallery creator; Web page generator; artistic painter; and a panoramic fisheye creator.

Artizen HDR has the main functions you would expect of an HDR stand-alone program, including a merging tool with x,y alignment and masking support; a tone mapping application with 11 operators; and HDR x,y autoalignment. The image editor supports 8-bit (LDRi), 16-bit (LDRi), and 32-bit (HDRi) and has unlimited multi-processor support.

The vendor has also taken the tone mapping functions, which are included with the main stand-alone package, and incorporated them into a Photoshop HDR plug-in package called Photoshop Tone Mapping Operator plug-ins or "TMO Bundle." As an extra, the vendor has included the Orton artistic blending method that's popular among HDR enthusiasts, along with the other plug-ins.

Comments

Artizen HDR has so many normal editing functions in addition to its HDR features it is almost a general-purpose editor. These multiple features are popular with reviewers, but less popular are the heavy demands it makes on system resources. Tone mapping algorithms, which make the HDR image displayable on LDR devices, can be very slow, as you can imagine, given the huge numbers they manipulate. However, the tone mapping is non-destructive and the results are first-rate. The price is also extremely competitive, making the package an excellent value for photographers who want a complete HDR solution.

Version: Artizen HDR 2.5.29 (2008)

OS: Windows 2000 SP3, SP4, 2003, XP SP1&2, and Vista; Mac OSX in development

RAM: 512MB (3GB recommended)

Supported file formats: ATX (32–128 bit), BMP, DIB, EMF, GIF, HDR, ICB, ICO, JPG, JPE, JPEG, PBM, (Kodak Photo CD) PCD, PCX, PFM PGM, PNG, PPM, PSD (v4–CS2 with layers), PSP (v5–7 without layers), RLE, SGI, TGA, TIF, TIFF, VDA, VST, WBMP, and WMF; (export) ATX (32–128 bit), BMP, Wireless BMP, HDR, TIFF, Targa TGA, JPEG grayscale, JPEG low, JPEG mid, JPEG high quality, PFM, PNG 24 bit, and GIF Web safe colors.

Price level: Artizen HDR approx. $45, Tone Mapping Plug-ins for Photoshop approx. $35

Address: Supporting Computers, Inc., Toronto, Ontario, Canada

www.supportingcomputers.net

FDRTools

Vendor: Andreas Schömann

Purpose: Merge tools for combining differently exposed shots into a single high dynamic range (HDR) image

Description

FDRTools enables you to create high dynamic range images by merging several exposures into a single image, at the same time converting the result to tone-mapped output for display on conventional devices. Unlike other HDR merge tools, it brings merging and tone mapping closer together by allowing you to look at the final output in real time. It offers control of blackpoint and whitepoint, saturation and gamma, provides a histogram view of the HDR image, and eliminates noise as a by-product of the process.

FDRTools has an integrated RAW converter and comes in different editions: Basic and Advanced. The Advanced version has three tone-mapping methods instead of two and facilities for creating camera specific profiles for photogrammetric HDR images. Both versions have automatic compensation to correct slight camera vibrations. Also available is FDRCompressor, a Photoshop tone-mapping plug-in.

Comments

This is a good way to get started in HDR because FDRTools Basic is freeware, aimed at whetting your appetite so that you purchase the (low-cost) advanced package. Ferrell McCollough, in the *Complete Guide to High Dynamic Range Digital Photography* (Lark Photography, 2008), has rightly praised the high level of interactivity in FDRTools, noting that it effectively bridges the gap between merging and tone mapping. It allows you to edit the merging of source images in real time while making adjustments in the relative contribution of each image to the final result.

Version: FDRTools 2.1 (2008)

OS: Windows 98 and up; Mac OS X 10.3.9 and up

RAM: 512MB

Supported file formats: Imports RAW formats (nearly all), JPEG, 24-/48-bit TIFF (uncompressed, LZW, and ZIP), Radiance RGBE, and OpenEXR; exports Radiance RGBE, OpenEXR, 24-/48-bit TIFF, BMP, OS2, PPM, and TGA

Price level: Basic version is freeware, FDRTools Advanced approx. $75, FDRCompressor plug-in $45

Address: kontakt@andreas-schoemann.de

www.fdrtools.com

HDR Shop

Vendor: USC Institute for Creative Technologies

Purpose: Package for viewing and manipulating high dynamic range (HDR) images

Description

HDR Shop is a processing and manipulation package that allows you to import RAW data files or low dynamic range files and combine them to form HDR images. Rather than storing each pixel's on-screen color, HDR Shop uses floating point numbers to store the amount of red, green, and blue light that the pixel represents. The computations involved are necessarily more complex—instead of 0, 1, 2, 3...254, 255, the numbers can be something like 0.01534, 1.0500, or 1,356,035.0253. Note the huge range, because these numbers represent real light levels, however many times brighter the light from (say) an open window in an otherwise dark interior.

HDR Shop accepts plug-ins, including LightGen and Median-Cut (lightprobe sampling); and Reinhard Tone Mapping (converts HDR to low dynamic range images). Version 2.0 included many new features, including support for multi-threaded operations and the ability to assemble HDR direct from Canon RAW images.

Comments

If you want to become involved with HDR, HDR Shop's Internet home has many tutorials and is a good place to start. Version 2.0 is significantly faster than its predecessor, while offering several more features, not least of which is the ability to load and process digital camera RAW files. Although only Canon RAW is guaranteed to work fully, support for other formats is included. The software is not inexpensive and requires study of the tutorials to get the best results.

Version: HDR Shop 2.0 (2008)

OS: Windows only

Supported file formats: Radiance HDR format (RGBE), 16-bit or floating point TIFF, Portable Float Maps (PFM). With plug-in, supports OpenEXR HDR file format developed by Industrial Light and Magic

Price level: Approx. $400 (single user)

Address: info@hdrshop.com

www.hdrshop.com

Photomatix Pro

Vendor: HDRsoft SARL

Purpose: Merge tool for high dynamic range (HDR) image creation using bracketed exposures

Description

A stand-alone program for Mac and Windows, Photomatix Pro enables you to create images with a high dynamic range using a combination of auto-bracketing at different exposures and merging. Its features include automatic blending, unlimited stacking, easy comparison of results, and batch processing.

Photomatix can merge any number of bracketed photos, a process that also eliminates noise in the final image, adding further to image quality. The vendor also recommends it for creating panoramas, which are nearly always composed of high contrast scenes owing to the extra-wide angle of view, towards and away from the sun.

To reduce the extreme tonal range so that you can use conventional output such as prints, there is a tone mapping tool that's also available separately as a Photoshop CS2/3 plug-in.

Comments

The vendor illustrates Photomatix Pro's capabilities with images that are both beautiful and surreal. Low cost, effective, quite fast, but perhaps needing a better interface, this package is a very good introduction to HDR imaging. As with most HDR software, you must be prepared to examine the documentation and observe good practice by using a tripod, rather than rely on the program's image alignment facilities. If the right procedures are followed, the results should exceed those obtainable with Photoshop's "local adaptation" method.

Version: Photomatix Pro 3.0 (2008)

OS: Windows 98, ME, 2000, XP, or Vista; Mac OS 10.3.9 or higher

RAM: 256MB or more

Supported file formats: Opens and saves JPEG, TIFF (8-bit, 16-bit and Floating Point), Radiance RGBE, and OpenEXR; Reads only BMP, PNG (Mac OS X version only), and PSD

Price level: Approx. $100, Tone-mapping plug-in for CS2 and up $70, Bundle $120

Address: HDRsoft SARL, 10 av. du professeur Grasset, Bat. B, 34090 Montpellier, France

www.hdrsoft.com

Dynamic Photo HDR

Vendor: Mediachance

Purpose: HDR-style image creation, with pin-warping, anti-ghosting, and color-matching features

Figure 21.1
Dynamic Photo HDR can give your photos the HDR "look" without using multiple images.

Description

Dynamic Photo HDR (DPHDR) is a relatively new package for creating HDR-style images, offering an easy-to-use interface, but with plenty of features to create expressive work. One of its key features is pin warping, which corrects most types of misalignment, including camera roll, pitch, and yaw. Its anti-ghosting mask eliminates ghosting of moving objects. In addition it has various tone-mapping procedures for creating a whole range of images, from smooth photographic tone mapping to more extreme images that go well beyond natural appearances.

DPHDR works with most RAW camera formats; supports 360-degree panoramic images; has batch processing facilities that allow you to queue images and process them in one go; and has a live HDR preview that lets you see a tone-mapped preview before you create the master HDR file.

DPHDR gives you plenty of control over the effects of dramatic lighting, enabling precise adjustment by means of the Light Tuner feature that comes with its own real-time Light Tuner window. When accessed, it displays a light orb that shows the distribution

of light intensities and offers full control over their parameters. You can increase the strength and the light radius, with immediate effect. Too high a radius can make the image look less photographically believable, but even small changes can impart a dramatically different "feel" to the image.

Note: Also available is the ReDynaMix Adobe Photoshop plug-in, which uses the DPHDR Pseudo HDR algorithm (FITYMI) to create HDR-style images from a single JPEG file inside Photoshop.

Comments

In the right hands, Dynamic Photo HDR can be a very helpful tool because it comes with a host of filters including Black/White Heavy Sky, Black/White Hard Light, Orton Effect, Sepia, Vignette, and Mysterious Light, together with various non-photorealistic settings for producing graphic-style images. For example, the Manga filter simulates the way Manga is drawn, whereas a Comic filter simulates comic strips by creating detailed outlines and solid pattern fills. What do these have to do with high dynamic range? The vendor explains that "dramatic light" is necessary to enhance the details, making the graphic images more exciting visually. This is true, as the vendor's examples demonstrate, but not all potential users will think of looking at HDR packages for these effects.

Version: Dynamic Photo HDR 3.2 (2008)

OS: Windows 98, XP, 2000, and Vista; Mac via BootCamp, VMware Fusion, or Parallels

RAM: 256MB

Supported file formats: Major image formats

Price level: Approx. $55

Address: Ottawa, Canada

www.mediachance.com

Summary

In digital photography, dynamic range is the ratio between the brightest and darkest parts of a scene and the ability of a sensor to gather detail within these areas. Whereas monitors can display images with an extended dynamic range, sensors have difficulty in matching the same performance. Conventional paper output, too, is limited in its ability to reproduce it. Software developers have risen to these challenges, devising ways of combining several images to create a single image with high dynamic range. This can be displayed on special monitors or converted for printing by the process of tone mapping. Keen photographers can start with FDRTools before moving on to HDR Shop or another commercial package. It is worth bearing in mind that some HDR effects can appear unduly dramatic, like El Greco's "The View of Toledo," with its stormy clouds on an otherwise bright and sunny day.

22

Depth-of-Field Tools

Two types of depth-of-field tools are represented here: those that bring the entire scene into focus in a composite image and another that does the opposite in creating out-of-focus backgrounds in order to heighten the dimensionality of the subject.

There was a time when most photographers wanted everything to be in sharp focus, so tilt-shift lenses were invented to help achieve it. Later, the fashion changed, even in food and product photography, in favor of getting good *bokeh,* the blurred effect of an out-of-focus background complete with polygonal highlight flaring. Now, with powerful software, photographers have the option to do whatever they like, using an ordinary DSLR camera. It is quite feasible to get infinite depth-of-field by taking a series of shots, changing the focus each time, and then compositing the in-focus areas of each.

The products in this category are specialist tools, certainly not intended for home users. There are cheaper and less complicated methods of achieving reasonable depth-of-field, such as stopping down the lens or switching to wide-angle. When you tire of such mundane techniques, it's time to acquire some new tools. They can help you produce really stunning images.

Depth of Field Generator PRO

Vendor: Richard Rosenman

Purpose: Creates depth-of-field and bokeh effects as a post-process

Description

Depth of Field Generator PRO lets you add depth-of-field and bokeh (blur) effects, giving you full control over the whole process. It is available in two versions—1.5 with a limited set of features for photographers and digital artists who are working on single

…mes, and 3.0 for those who want greater control or need to work on images for animation, video, film, or print.

With Depth of Field Generator PRO, you can simulate all the different kinds of bokeh effect that are normally caused by the individual shape of a lens's aperture: pentagonal highlights from apertures with five blades and round highlights from those with seven or eight blades. It also provides depth-mapping tools so that you can create hand-made depth maps for photographic images, emulating a technique used in 3D computer graphics.

Comments

For creating out-of-focus effects, Depth of Field Generator PRO has no equal. It even lets you add different types of spherical aberration to your artificial bokeh and has an advanced pixel grain-rendering engine for simulating grain and noise in the defocused image areas. The plug-in, which is PC-only, is supported by online tutorials and a forum.

Version: Depth of Field Generator PRO 1.5 and 3.0 (2008)

Plugs into: Photoshop 4.0 or higher

OS: Windows 2000 and XP (no Mac compatibility)

RAM: 256MB (recommended)

Supported file formats: BMP, GIF, JPEG, PNG, TIFF, and TGA

Price level: Version 1.5 $30, version 3.0 $60

Address: richard@richardrosenman.com

www.dofpro.com

Focus Extender

Vendor: Reindeer Graphics

Purpose: Pro-level blending tool for combining images to create greater depth-of-field

Description

Focus Extender allows you to create images with extended depth-of-field (DoF). It lets you combine a series of photographs, selecting the in-focus area from each one. The result is a single in-focus image that can be used in science for analysis and measurement.

Focus Extender plugs into both Photoshop and Image-Pro Plus image processing and analysis software from Media Cybernetics. It is especially useful for close-up photography where DoF is limited. Actions are fully recordable so that you can treat other images in a similar fashion.

Comments

An expensive tool, Focus Extender justifies its price by being very accurate. Aimed primarily at scientists and engineers, it is not intended for the general photographic market.

Version: Focus Extender 1.0 (2008)

Plugs into: Photoshop 5, 6, 7, CS, or compatible; Image-Pro Plus 4.2 or later

OS: Windows 95, 98, ME, NT4, 2000, and XP; Mac 9.x and OS X 10.2 and up

RAM: 64MB (minimum)

Supported file formats: Major file formats

Price level: Approx. $500

Address: Reindeer Graphics, Inc., P. O. Box 2281, Asheville, NC 28802, United States

www.reindeergraphics.com

Helicon Focus

Vendor: Helicon Products

Purpose: Enables you to achieve infinite depth-of-field in macro- and micro-photography

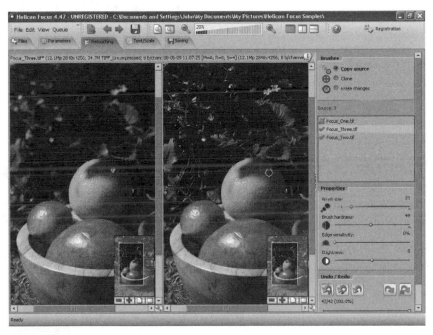

Figure 22.1
Helicon Focus can retouch individual images for perfect blending to create extended DoF.

Description

Helicon Focus allows you to achieve infinite focus throughout the whole picture by using a series of images with overlapping focal ranges. Especially suited to macro photography where DoF is often very limited, it can produce some stunning images. The only drawbacks are the extra time involved in capturing the initial images and the difficulty of dealing with any movement that takes place within the image from one frame to the next.

Helicon Focus is highly automated. It automatically adjusts/resizes images, places no limitation on image resolution, and processes an unlimited number of images in the stack. It also supports dust mapping to remove black marks from the resulting images.

There are three editions: Helicon Focus Lite, Pro, and Multiprocessor, the Pro version having additional retouching functions. Lite is available as a 30-day evaluation.

Comments

Depth-of-field is often severely limited in close-up photography, creating a genuine need for this type of software. Using it is extremely easy, but taking the pictures can be more demanding. Special equipment such as the Manfrotto macro rail can help you advance the camera by tiny increments (1.25mm for every full turn of the crank).

However, you do not have to restrict yourself to macro- or micro-photography in order to get benefits from using Helicon Focus. It is superbly designed, with an interface that is highly sympathetic to its users. For example, it allows you to add images at any time to the stack and lets you switch individual images on or off to see if the overall effect can improved. One of its best features is the provision of retouching tools that enable you to remove unwanted artifacts that can occur when there is shadow movement from one image to the next (see Figure 22.1). Above all, it is great fun to use and the results can be outstanding.

Uniquely, the vendor offers a free license if you send an instructive tutorial with tips on how to use the product; this means that many helpful tutorials are available.

Version: Windows Helicon Focus 4.46, Mac 3.79 (2008)

OS: Windows 2000, XP, Vista, and Vista64; Mac OS X 10.3

RAM: 256MB

Supported file formats: Reads RAW, 8-bit and 16-bit TIFFs, JPEG, JPEG 2000, and BMP; writes 8-bit and 16-bit TIFFs, JPEG, JPEG 2000, and BMP

Price level: In the range of $30–$250

Address: Helicon Soft Ltd., per. Mekhanichesky 4, 61068 Kharkov, Ukraine

www.heliconfilter.com

Summary

Like high dynamic range (HDR), depth-of-field tools use the technique of combining multiple images into a single image. The objective in this case is to extend the depth-of-field beyond the capabilities of the camera/lens combination. In close-up photography especially, depth-of-field is often very limited, making it impossible to capture the width of a blow-fly or the length of a wasp in a single shot. Using software like Helicon Focus enables you to achieve stunningly sharp results in macro- and micro-photography, whereas other software like Depth of Field Generator PRO lets you move in the opposite direction and create selective bokeh (out-of-focus) effects.

23

Lens Distortion Correction

Lens and perspective distortion are among the most common "errors" in photography. In one sense they are not really errors at all because they are almost impossible to avoid completely. Tilt the camera up and you get parallel lines converging toward the top of the image, tilt it down and you get keystone distortion. If you fit a wide-angle lens, especially on a full frame DSLR, you will undoubtedly see some barrel distortion at the edges. Lens manufacturers make corrections to barreling and its opposite pincushion effect using aspherical elements, but sometimes this results in a double-whammy, in so-called "complex distortion," which can create a wavy image not unlike the shape of Sir Arthur Conan Doyle's moustache.

The most extreme distortion comes from the use of ultra-wide-angle or fisheye lenses. For these 14mm and smaller focal length lenses, manufacturers have dropped any pretense of eradicating the distortion and so it becomes an integral part of the image. At least, in pre-computer days, that is how it was treated—as a dramatic effect to show (for example) the supposedly gigantic pair of feet of someone lying down, head away from the camera. But now that the computer can unwrap the image to give it a true perspective, the use of ultra-wide and fisheye lenses has changed completely. You can photograph an interior with a fisheye and make it suitable for the human eye in, almost, the blink of an eye.

For very rapid results, the software ideally needs access to specific data about the lens/camera combination used for taking the image. Armed with this information, it can easily make corrections by running the right set of numbers. Without it, you have to start using slider controls while judging the results in real-time.

Correcting geometric errors can make an improvement to the image equal to that of exposure correction or white balance. It is so important it should not be left to the standard tools of an image editor although good facilities are available in Photoshop CS2 to CS4 and Paint Shop Pro. Specialist packages are listed in this chapter. You will also

find distortion correction tools in kits that are listed under other categories, such as PowerRetouche Lens Correction, 55mm Lens Correction, and The Imaging Factory Debarrelizer. See also Acolens, from Nurizon Software (in Chapter 37, "Analysis and Diagnostics").

DxO Optics Pro

Vendor: DxO Labs

Purpose: Geometry correction and image enhancement for advanced amateur and professional photographers

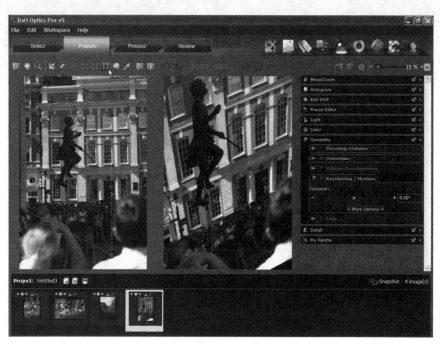

Figure 23.1
DxO Optics Pro provides total control over geometric distortion.

Description

DxO Optics Pro is one of the most powerful packages for correcting errors due to lens distortion, vignetting, lens softness, keystoning, horizon leveling, and chromatic aberration. Now in its third generation, its core routines are based on sophisticated models of camera and lens performance. Many other features have been added, making the software an all-round image-enhancement package, capable of performing RAW conversion and color conversions that exploit the full range of available color space for RAW or JPEG files. It also has many lighting and denoising techniques.

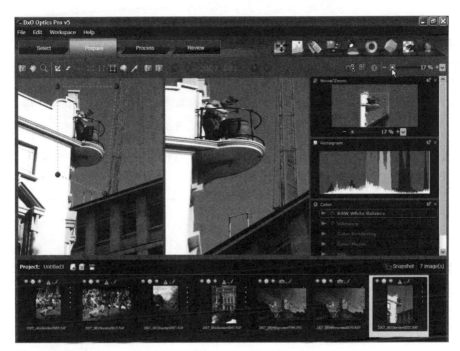

Figure 23.2
You can use DxO Optics Pro correctively or creatively.

Adding DxO FilmPack, a plug-in for Adobe Photoshop and DxO Optics Pro, brings a capability to achieve the look of famous silver halide films such as Velvia, Ektachrome, and Kodachrome, together with many more Fuji, Kodak, and Ilford black and white films.

Comments

Although it requires substantial system resources and takes a long time to download and install, DxO Optics Pro is a brilliant application, well worth the wait. It is also surprisingly easy to use, at least for making basic viewing angle corrections. It gives you complete control over the projection of the image on a two-dimensional surface. All kinds of creative effects are possible if you use the tools provided to generate rather than eliminate distortion.

DxO Labs hit the ground running in 2002 as a spin-off from the computer vision company Vision IQ. Backed by substantial funding, it employs around 60 people at its headquarters. Not surprisingly, product development is brisk, with emphasis being placed consistently on image quality. New features in version 5.0 include an improved RAW converter, noise removal technology for RAW images, a dust removal tool, and a new user interface. DxO Optics Pro is a great product to serve as a flagship, but many others will follow it from the same team. Watch this space.

Version: DxO Optics Pro 5.0 (2008)

OS: Windows XP SP2, Vista; Mac OS X 10.4.x and later

RAM: Standard 1GB, Elite 2GB

Supported file formats: Nearly all RAW nearly all formats and JPEG

Price level: Standard edition approx. $170, Elite edition approx. $300, FilmPack approx. $100

Address: DxO Labs, 3, rue Nationale, 92100 Boulogne, France

www.dxo.com

Lens Corrector PRO

Vendor: Richard Rosenman

Purpose: Lens distortion correction

Description

Lens Corrector PRO is a versatile lens correction plug-in that not only corrects common lens distortions such as barrel and pincushion effects, but also can scale, skew, taper, shift, flip, and rotate an image and make precise perspective adjustments.

Comments

With excellent lens correction facilities in Photoshop and being overshadowed by specialist package DxO Optics Pro, Lens Corrector PRO has never obtained a large market share. Yet it has many facilities; users have commented favorably on it in forums. There were a mass of improvements in version 1.1, including automatic fitting of corrected images to window size; sub-pixel filtering for sharper rendering; new presets for common camera lenses and their correction settings; image rotation; and horizontal and vertical precision image scaling, shearing, curved tapering, perspective adjustment, and shifting.

Version: Lens Corrector PRO 1.2 (2008)

Plugs into: Photoshop 4.0 or higher

OS: Windows 2000 and XP (no Mac compatibility)

RAM: 256MB (recommended)

Supported file formats: RGB formats only

Price level: $30

Address: richard@richardrosenman.com

www.richardrosenman.com

LensDoc

Vendor: Andromeda Software

Purpose: Corrects barrel, pincushion, rotation, and perspective distortions

Description

LensDoc is a plug-in that corrects barreling and pincushioning distortions produced by many zoom and wide-angle lenses. It is very easy to use: you simply identify two lines that are meant to be straight, place target points as guides, and then let the software do the rest.

Generic lens correction curves are supplied with the software, but there are also facilities for users to create their own. It is particularly good at correcting images that are "just a little off," with the use of its Make Rectangle feature.

Sixteen-bits-per-channel output is available for high-quality results.

Comments

Nothing spoils an image more than small but highly unpleasant lens distortions, especially those that bend verticals very slightly. Andromeda LensDoc is more than a match for this kind of problem. It has a step-by-step interface for novice users, but also an expert mode with generic correction options and slider bar adjustment. Several reviewers have looked at it in depth. The editors of *Imaging Resource* (www.imaging-resource.com), for example, found it to be one of the most valuable editing tools.

Version: LensDoc Plug-In 3.1 (2008)

Plugs into: Photoshop 7.0 and later

OS: Windows XP and Vista; Mac OS X 9.x

RAM: 256MB

Supported file formats: As host

Price level: Approx. $120

Address: Andromeda Software, Inc., 699 Hampshire Rd. Suite 109, Westlake Village, CA 91361, United States

www.andromeda.com

PTLens

Vendor: ePaperPress

Purpose: Corrects lens pincushion/barrel distortion, vignetting, chromatic aberration, and perspective

Description

PTLens is a low-cost utility that corrects most kinds of lens distortion for images taken with point-and-shoot (P&S) cameras for which lens profiles are available. It makes excellent corrections to the three main types of distortion: barrel distortion, pincushion distortion, and complex distortion.

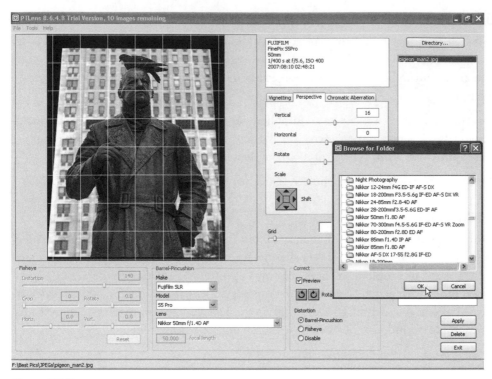

Figure 23.3
PTLens has tools to deal with vignetting, perspective distortion, and chromatic aberration.

Complex distortion is a combination of the other two main types and is normally hard to correct. PTLens makes a better job of it than most image editors, providing one slider control to correct barrel distortion at the center of an image and another to correct pincushion problems at the edges.

PTLens comes in stand-alone and plug-in editions, the latter having 16-bit and TIFF and RAW support.

Comments

Many amateur photographers with P&S cameras will find this is all they need to make dramatic improvements to their photographs. Although it lacks many of the features of DxO Optics Pro, it comes at a fraction of the price. However, for DSLRs with their detachable lenses the DxO product is more accurate.

Version: PTLens 8.6.4.8 (2008)

Plugs into: Windows and Mac—Photoshop 6 and above, Photoshop Elements, and the German FixFoto; Mac only—Aperture 2.1 or later, Lightroom 2.0 or later

OS: Windows 2000, XP, and Vista; Mac OS X 10.5.2 or later

RAM: 128MB

Supported file formats: JPEG; plug-in edition also TIFF and RAW

Price level: Approx. $15

Address: Tom Niemann, Portland, Oregon, United States (form contact only)

www.epaperpress.com

LensFix CI

Vendor: Kekus Digital

Purpose: Makes individual image distortion corrections for Mac users

Description

LensFix CI is an automatic image correction package that contains a database of correction settings for over 500 popular cameras and lenses. In manual mode, it also allows you to fix chromatic aberrations and vignetting, and to alter the image perspective. It is available as both a stand-alone program for use with Adobe Lightroom and Apple's Aperture and as a plug-in for Adobe Photoshop.

Perspective controls allow you to change the viewing angle of the image with ease. Its extensive range of camera settings is supplemented by those in the PTLens database from epaperpress.com, which is supplied under license. Being a universal binary, LensFix CI runs natively on Power PC and Intel Macs.

Comments

Described as "simple but powerful" by one reviewer on the Mac community Website MacUpdate, LensFix CI is an improved version of the earlier LensFix software. It has been widely tested and enjoyed by many enthusiasts, who report good results from it. It is fast, as it uses the video card for processing when supported by the host computer, and the plug-in version has full 16-bit support. Since LensFix was first introduced a few years ago, distortion correction has become commonplace, but the software is still useful if you need to make a lot of corrections on images taken by the camera/lens combinations held in the databases supplied with it.

Version: LensFix CI 4.0 (2008)

OS: Mac OS X 10.4 and later

RAM: 256MB

Supported file formats: As host; stand-alone version JPEG, many common RAW formats

Price level: Approx. $30

Address: help@kekus.com

www.kekus.com

Rectilinear Panorama

Vendor: Altostorm Software

Purpose: Corrects any geometric image distortion and restores the natural look of images

Description

Rectilinear Panorama corrects geometric distortions in both panoramic and conventional images. It makes multiple transformations of the image in a single pass; hence it does not unnecessarily degrade picture quality. It corrects for barreling and pincushioning, perspective shift and image skewing, image rotation, panorama distortion, and curved horizons.

Rectilinear Panorama has an easy-to-use wizard interface that takes you through four steps:

- Identify distorted lines in the image
- Choose what will happen to them after processing
- Define parameters to compensate for the change in object size
- Define the cropping area of the finished image

The Professional edition of the product supports both 8- and 16-bit images in RGB, CMYK, Lab, and grayscale (Home edition is 8-bit only).

Comments

Reviewers have found Rectilinear Panorama easy to learn and use, although the manual has been criticized for not being sufficiently explicit. It makes an excellent job of correcting for tilt and keystoning, but does not use lens data for automatic correction of lens distortion.

Version: Rectilinear Panorama 1.2.2 (2008)

Plugs into: Photoshop 4 and later, Photoshop Elements 2-5, and many other editors, tested for compatibility, including ImageReady, Corel Photo-Paint, Photo-Impact, Painter, and Paint Shop Pro, Fireworks MX, PhotoLine 32, Microsoft Digital Image, and Xara Xtreme

OS: Windows 2000, XP, and Vista

RAM: 128MB (512MB recommended)

Supported file formats: Major image formats

Price level: Home edition $70, Pro edition $180

Address: Altostorm Software, Simonova st., 34-115, Volgograd 400137, Russian Federation

Pacific Business Centre, c/o Altostorm Software, #101 - 1001 W. Broadway, Suite 381, Vancouver, BC V6H 4E4, Canada

www.altostorm.com

Summary

No lens is perfect, but even a perfect lens would project perspective distortion if you were to point it up toward the top of a tall building. Special software exists for correcting all kinds of lens distortions, from chromatic aberration and vignetting to the perspective effects mentioned in this chapter. DxO Optics Pro is the leading package for geometry enhancement, but make sure your lenses are profiled in its database. It is a dream to use, and excellent value, but if all you need is a low-cost utility, consider PTLens at a fraction of the price.

Panorama Software: Photo Stitching and Virtual Tours

The market for photo stitching and panoramic software has polarized between two extremes. At one end, the main users are real estate agents and their suppliers who want a quick and convenient way of creating virtual tours of houses and property developments; at the other end are experimental photographers who want to show the world in a new way. Quite a few companies and their panoramic products fell through the gap in the middle when these two extremes suddenly drifted apart.

Special Equipment

Although some of the software described here can make a reasonable job of stitching hand-held photographs, the technique really requires the use of a special *pano head* on a firm tripod. The head makes the camera pivot around a point within the lens in such a way that all the images appear to have been taken from the same location. Even the slightest error can cause ripples in the finished panorama.

A pano head costs a few hundred dollars and is something that only the enthusiast or professional tends to buy. With it you can take dozens of pictures for a single composite image, using a standard or even a telephoto lens. The resulting panorama does not have to be 360 degrees, but can be simply a large planar image at extremely high resolution. Photo stitching is a good way of turning a relatively low-res camera into an ultra-high-res tool.

Stitching dozens of overlapping pictures together can be time-consuming unless the stitching software can do much of the work automatically. This is something that computers are very good at—detecting unique groups of pixels and identifying them as control points. It is much easier for a computer than for the human eye, so you should ensure that the software has an excellent auto-stitching mode before committing to it.

Commercial software for real estate suppliers cannot normally have the luxury of using too many images for each panorama. It would take far too long to acquire the input. Hardware companies have invented other ways of solving this problem: for example by "one-shot" camera systems that use a 360-degree mirror to capture the entire scene in a single take. More common is the use of fisheye lenses to take either two or three (three is better) hemispherical shots that can be stitched together to make a complete panorama. The fewer images you have to input to the software, the faster it will generate the output.

Virtual Tours

For creating virtual tours, software requires many additional features. It links together panoramas of (for example) individual rooms to give the impression that the viewer is taking a walk around the building. It may also add other information, in text or video, plus a soundtrack. There is really no limit to the degree of complexity you can introduce into a full multimedia presentation. Most companies package their stitching software separately from their virtual tour features, often making both available as a suite at a slightly reduced price.

Display Options

The two main methods of displaying panoramas, and indeed virtual tours, are Apple's QuickTime VR (QTVR) and its variations, or the use of a Java player. Both options give very good results, QTVR being especially suited to displaying virtual reality (VR) with a cubic projection. Developers have performed miracles with Java code, enabling panoramic images to be displayed instantly in full-screen mode on practically any computer. Some of the latest and most exciting developments involve the display of special effects within a basic panoramic image, such as moving an object independently of the pan. Another is the use of Adaptive Dynamic Range (ADR) to solve one of the key panoramic problems: how to cope with the extreme exposure range encountered in 360 degrees with fields of view both towards and away from the light source. (See the section "SPi-V," later in this chapter).

3DVista Stitcher

Vendor: 3DVista España

Purpose: Image-stitching software for creating large images or panoramas

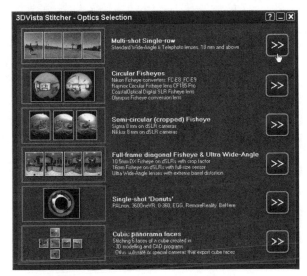

Figure 24.1
3DVista Stitcher's Optics Selection panel offers a full range of projections.

Description

3DVista Stitcher is the stitching package in a suite of photographic VR software that includes 3DVista Publisher and 3DVista SHOW. The vendor also offers Skin Editor, for customizing the "skin" of a virtual tour; and Floorplan Maker to design how a tour fits together.

3DVista Stitcher, the essential workhorse of the suite, can be purchased separately. It copes very well with standard images and "one-shot" lens images (from special mirrored devices), and it also handles several types of image from fisheye lenses, including rectangular, hemispheric (360×180 degrees) and near-hemispheric (360×150 degrees). Its cubic stitching (360×180 degrees with flat projections) is first rate.

- 3DVista Publisher lets you go on to create virtual tours with output to Flash, Java, Apple QTVR, or high-quality 3Dvista ActiveX.

- 3DVista SHOW has a greatly extended range of effects for tour creation, including streaming audio and video.

- 3DVista Real Estate is an all-in-one property presentation and management tool for realtors. It includes the Stitcher module, slideshow, and video clip facilities; Web page template online map locator; and a hosting service.

Comments

Started by a group of amateur photographers, 3DVista España hired in programmers to produce Stitcher and the other programs mentioned here. They are gradually putting them all together as integrated packages, the configuration of which is subject to change. Independent users have reported good results from 3DVista Stitcher, praising the support for many different kinds of optics. It stitches quickly, has a clean interface, and is packed with features including image-enhancement tools.

Version: 3DVista Stitcher 3.0 (2008)

OS: Windows 2000, 2003, and XP

RAM: 256MB

Supported file formats: Saves to JPEG, BMP, and PSD

Price level: Approx. $200

Address: 3DVista España S.L., Granada, Spain

www.3dvista.com

ArcSoft Panorama Maker

Vendor: ArcSoft

Purpose: Pro-quality photostitching with extensive RAW support

Description

ArcSoft Panorama Maker is an automatic image stitcher that allows you to create horizontal, vertical, 360 degree, and tile (4×4) panorama pictures. It has additional manual controls for aligning the stitching points and adjusting the stitching path. It provides brightness and contrast controls, tools for cropping and straightening, and it lets you add frame, title, and copyright information to the finished image.

Among ArcSoft Panorama Maker's pro features is support for major RAW formats and printing on multiple sheets using borderless banner paper.

Comments

Most reviewers have found ArcSoft Panorama Maker quick and intuitive to use, with good color matching and accurate fine-tuning of image alignment. However, the source images need to be free from too much parallax error, preferably taken with the use of a tripod and a proper pano head. If you follow some basic rules during shooting (such as keeping the camera level, avoiding changes to focus and white balance, and overlapping images by at least 30 percent), you should get excellent results. Ongoing development has greatly improved this product, bringing it up to standard for many professional applications.

Version: ArcSoft Panorama Maker 4 Pro (2008)

OS: Windows 2000, XP, and Vista; Mac OS X 10.3 and 10.4

RAM: Windows 128MB (768MB recommended); Mac 512MB (768MB recommended)

Supported file formats: Major RAW formats, JPEG, and TIFF; outputs JPEG and TIFF; BMP, TGA, MOV, PTViewer HTML, and Flash HTML

Price level: Approx. $80

Address: ArcSoft Corporate Headquarters, 46601 Fremont Blvd., Fremont, CA 94538, United States

www.arcsoft.com

Autopano Pro

Vendor: Kolor

Purpose: Creates panoramas automatically, and even selects the right pictures from folder

Figure 24.2
Autopano Pro's Render dialog box.

Figure 24.3
Autopano Pro's Settings dialog box.

Description

Autopano Pro brings a high degree of automation to the process of creating panoramas. It begins by selecting the appropriate pictures from a folder, ignoring any that do not contribute to the scene. You just select Detect Panorama and the program does the rest. You can fine-tune the result using a Vertical tool and an Auto Leveling tool. Other key features include color correction and full HDR stitching.

Autopano Pro uses a proprietary and patented algorithm called SIFT, which detects matching areas automatically—far better, says the vendor, than the human eye. It also has integrated "Smartblend" technology to remove ghosting effects. Another exclusive feature is the color-correction scheme, which equalizes the color and exposure of the component images.

Comments

One of the newest panoramic stitchers, Autopano Pro takes automation a step further with its ability to select the component images as well as stitch them. Panoramic photography is popular in France, where Autopano Pro is under intensive development. One of its most remarkable abilities is its "unlimited" capacity for component images. The vendor mentions that one panorama has been created with 300 pictures "without any issue." You can even create a 90-gigapixel panorama without needing a huge amount of RAM (just a large hard drive). Autopano Pro is extensively documented, with its own Wiki.

Version: Autopano Pro 1.4 (2008)

OS: Windows 2000, XP, and Vista; Mac OS X 10.4 and 10.5; Linux kernel 2.4 or higher

RAM: 512MB

Supported file formats: Hundreds of formats; exports JPG, TIFF, PNG, HDR, Adobe Photoshop PSD, and PSB

Price level: Approx. $120 (includes free updates for one year)

Address: Kolor, 204, Avenue du parc, 73190 Challes les eaux, France

www.autopano.net

ImageAssembler

Vendor: PanaVue

Purpose: Image-stitching software for creating panoramas, with fisheye lens support

Description

ImageAssembler is image-stitching software for joining separate, overlapping images into multi-row mosaics or panoramas. It comes in three editions: Standard, with basic tools for the enthusiast; Professional, with the power to make really large images; and Enterprise, with batch processing facilities.

With ImageAssembler, you can easily create a montage from aerial and satellite photos, as well as landscape panoramas, maps, medical imagery, or large composite images from multiple photos of a painting. Its interface allows you to position little flags or markers to indicate stitching points—a precise method that allows you to tilt the camera and get away with it. It can warp and blend images as well as adjust their color. There is also an automatic mode that positions all the images without manual intervention.

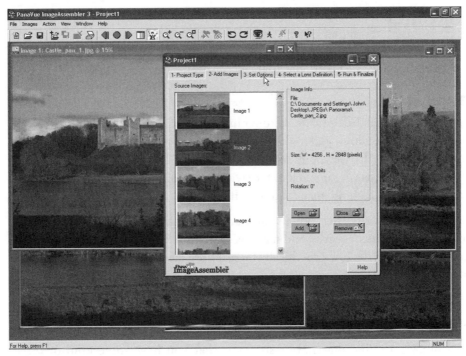

Figure 24.4
PanaVue ImageAssembler provides a five-tab Project wizard for easy pans.

ImageAssembler adjusts itself to lenses of different focal length, including very wide angle or fisheye lenses with a focal length above 10.4mm.

Comments

PanaVue ImageAssembler is a popular product, much admired for its efficient automatic stitching and ability to compensate for lens distortion. Although it does not stitch full spherical panoramas, it deals effectively with 360-degree versions. The Pro version has a maximum side length limitation of 100,000 pixels, big enough for most applications.

Version: ImageAssembler 3 (2008)

OS: Windows 2000, XP, Server 2003, Vista, and Vista x64

RAM: 256MB

Supported file formats: BMP, JPEG, uncompressed TIFF, TGA, PCX, PSD, PICT, PhotoCD, and FlashPix

Price level: Standard edition approx. $65, Pro edition approx. $130, Enterprise edition approx. $200

Address: PanaVue, 616 boul. René-Lévesque Ouest, QC, Canada G1S 1S8

www.panavue.com

PanoPrinter

Vendor: ImmerVision

Purpose: Dedicated software for printing panoramic images

Description

PanoPrinter is a tool for editing, retouching, and printing all photographs and panoramic images. It allows you to fit a panorama to the page, adjust color, brightness and contrast, change the viewpoint, and crop the image. It supports extra-large prints of up to 15 meters, making it suitable for creating stunning wall decorations. Special effects include sepia, etching, paint, and lens flare.

PanoPrinter supports all paper formats and can print out assembly information such as page numbers, alignment marks, and margins so that multi-page printouts can be easily reconstructed. It is designed specifically for print use, not for creating the sort of Web panoramas you often see on real estate sites. You can use a standard inkjet printer to produce the output.

Comments

Printing out panoramic material presupposes that you have some kind of three-dimensional structure on which to fix it, otherwise the projection distorts the image so dramatically it makes very little sense. PanoPrinter tiles the image so that it gets printed on multiple sheets of paper that can be fitted to a curved wall. At the time of writing, this package is the only one dedicated to panoramic printing. The vendor is primarily a supplier of panomorph lenses, CCTV equipment, and plug-ins for 360-degree video/IP surveillance.

Version: PanoPrinter 1.1 (2008)

OS: Windows 98 SE, ME, 2000, and XP

RAM: 128MB

Supported file formats: IVP (ImmerVision panoramas file format) and standard image formats

Price level: Approx. $50

Address: ImmerVision Inc., 2020 University, Suite 2420, H3A 2A5 Montréal, QC, Canada

www.immervision.com

PanoStitcher

Vendor: Pixtra Corp

Purpose: Create a 360-degree panorama from a row of images, with or without a tripod

Description

PanoStitcher lets you create 360-degree panorama from overlapping photos taken from the same fixed location, with or without a tripod. It offers both manual and automatic stitching; allows you to add or remove component images at any time; can stitch images that have been zoomed to different lengths; automatically balances brightness levels between images; and can output the final image for the Web or for print.

The PanoStitcher online tutorials (five of them) are very helpful in explaining the whole procedure of creating a panorama, step-by-step. The vendor also supplies a long list of advanced topics, with in-depth discussion of each. By going through this material, you will come across all the issues that face the panoramic photographer, from straightening the horizon to coping with the movements of people within the scene.

Note: In "minimum requirements," the developer lists a tiny amount of necessary RAM, quite inadequate for dealing with large images (as actually explained in Advanced Topic 10).

Comments

PanoStitcher is a very competent, highly forgiving image-stitching package. The automatic stitching facility is not foolproof, but is not markedly worse than the same facility in other stitching software. It gives a choice of manual stitching methods to compensate for any errors that occur automatically. Version 1.5 includes a free virtual tour authoring feature powered by a Java applet called PixtraTour. If you are looking for a low-cost entry level package for stitching large images (not necessarily panoramic ones), PanoStitcher is well worth trying.

If you are more ambitious and want to move beyond 360-degree panoramas to 360×360 "omnirama" images, you will need the vendor's alternative product OmniStitcher. This will allow you to stitch full spherical panoramas from images taken by regular cameras.

Version: PanoStitcher 1.5 (2008)

OS: Windows 95, 98, NT, ME, XP, and Vista

RAM: 16MB (see note)

Supported file formats: Inputs JPEG, BMP, and TIFF; outputs JPEG, TIFF, and QuickTime

Price level: Approx. $30

Address: info@pixtra.com

www.pixtra.com

Panoweaver

Vendor: Easypano

Purpose: Pro-level stitching software to combine two hemispherical fisheye images into a 360-degree spherical panorama

Description

Panoweaver takes around three minutes to stitch two hemispherical fisheye images into a 360-degree spherical panorama. It is aimed at photographers, Web designers, realtors, and project managers who have a busy workflow. The vendor has related products, including Tourweaver to link the images from Panoweaver together to create virtual tours, and Easypano Studio, which bundles the two packages together.

Panoweaver is limited to stitching fisheye images, but can deal with three types: drum images (120×180 degrees), full frame (rectangular) images, and full circular images. Typical equipment needed is a good quality pano head on a tripod and a DSLR equipped with a fisheye lens such as the Sigma 8mm.

Comments

All the Easypano packages are easy to use (as the brand name suggests), but they are priced at a professional level and demand the use of proper equipment to take the original images. There is little leeway for error when you are working with only two images and need to make them match perfectly to create a sphere. A better result is achieved with three full circular images. Drum and full frame stitching require several more shots and take longer to stitch.

Panoweaver 5.0 supports the creation of high dynamic range (HDR) images and converting them to LDR, a feature that overcomes the flare problem, which tends to affect many panoramic images.

Version: Panoweaver 5.0 (2008)

OS: Window 98 ME, NT4.0, 2000, XP, and Vista; Mac OS X 10.2 or later

RAM: 512MB (1GB RAM or more is recommended for pans over 6,000×3,000 pixels)

Supported file formats: Major image formats and QTVR

Price level: Approx. $600

Address: Easypano Holdings Inc., Room 21204, 498 Guo Shoujing Road, Pudong New Area, Shanghai, 201203 China

www.easypano.com

Photovista Panorama

Vendor: iseemedia

Purpose: Popular 360-degree panorama software for real estate tours and other uses

Description

Photovista Panorama is a widely used package for creating 360-degree panoramas and real estate tours. It has dozens of features, including automatic lens detection, 2D vertical stitching, and a Java viewing tool with full customization.

Photovista Panorama comes in several editions—Home, Pro, and International—all with broadly similar features. The International edition is available in French, Italian, German, and Spanish. It also forms part of the Reality Studio professional multimedia toolkit, which includes the vendor's Photovista 3D Objects software for creating detailed photo-realistic 3D image objects.

Comments

Virtual tours are a popular way of presenting properties on the Internet, a market where iseemedia has a significant share. With automatic warping, aligning, and blending, it is a very capable package that anyone can use. Enthusiasts will not find it very challenging, but it aims to be a low-cost solution for the use of realtors.

Version: Photovista Panorama (Windows) 3.5, (Mac) 3.0 (2008)

OS: Windows ME and XP; Mac OS 9.1 and OS X 10.2

RAM: 16MB (32MB recommended)

Supported file formats: GIF, JPEG, BMP, and FPX

Price level: Approx. $100, Professional edition $200

Address: Iseemedia, Inc., 180 Jardin Drive, Suite 6, Concord, Ontario, L4K 1X8, Canada

www.iseephotovista.com

PTGui

Vendor: New House Internet Services

Purpose: A graphical front-end for PanoTools, to stitch planar images, cylinders, spheres, and cubes

Description

PTGui stands for "graphical user interface for panorama tools," the latter being the early set of stitching tools created by Helmut Dersch. Although Dersch's tools were capable of handling most lens types and could cope with many different formats and projections, they were difficult to use without an additional interface. Dutch developer Joost Nieuwenhuijse wrote PTGui as a graphical front-end that would enable anyone to use the tools, including those for correcting lens distortion.

PTGui can stitch planar images, cylinders, spheres, and cubes. It supports both rectilinear and fisheye lenses and several image file formats. It obtains lens details by reading Exif information. In earlier versions, it required you to insert control points (called "flags") manually in order to align the images, but it is now completely automatic, with manual fine-tuning. Once alignment has been done, it quickly stitches the images together ready for output to many additional formats. PTGui Pro has exposure correction, automatic vignetting and white balance correction, HDR support, plus many other features.

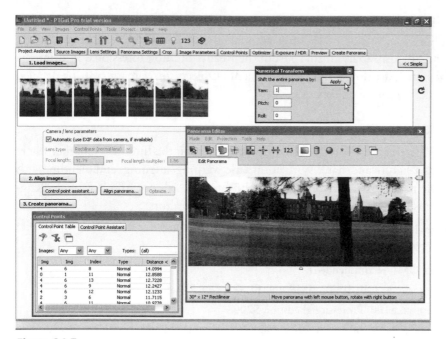

Figure 24.5
PTGui makes easy work of stitching even hand-held images.

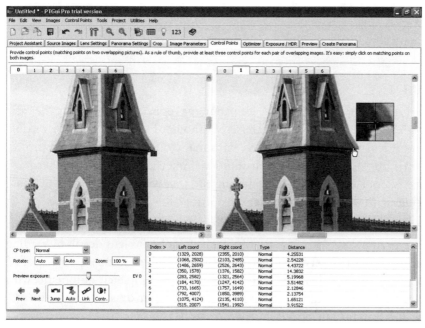

Figure 24.6
PTGui sets control points automatically, with close-up inspection on demand.

Comments

Over a period of several years, Joost Nieuwenhuijse has developed and refined PTGui to make it what it is today:—a stable, reliable product with very good image quality and enough features to keep most photographers happy. It will not yet help you create virtual tours, but it allows you to save settings to a template so that you can batch process subsequent images.

PTGui is wonderfully accommodating, making it easy to create high-res composite images or panoramas without compelling you to buy a specialized "pano head" for the tripod. If alignment is not quite up to scratch, it tells you so. It also blends the final image so that any inconsistencies are seamlessly smoothed. Well documented and supported by vigorous ongoing development, for the keen photographer PTGui is one of the most rewarding products to use among all those discussed in this book.

Version: PTGui Pro 7.8 (2008)

OS: Windows 98, XP, and Vista; Mac OS X 10.4 and up

RAM: 256MB

Supported file formats: Inputs JPEG, BMP, PNG, and TIFF; outputs BMP, JPEG, PNG, TIFF, VRML, PSD (layers or merged), iMove PAN, and IVR

Price level: (PTGui) approx. $100, (PTGui Pro) approx. $225

Address: New House Internet Services B.V., Rotterdam, The Netherlands

www.ptgui.com

Pure Starter Toolkit

Vendor: ImmerVision

Purpose: A toolkit that has everything to get you started in panoramic image publishing

Description

Pure Starter Toolkit has all the basic tools you need for editing and publishing panoramic images. It has five modules:

- Panorama Image Extractor, which extracts panoramic images created in formats such as IMP, ImmerVision IVP, and QTVR JPEG.

- Panorama FileMaker, which generates IVP and QTVR file formats from images in cubical, cylindrical, or spherical formats.

- Lensflare Creator, which creates lensflare effects for enhancing panoramas created with Panorama FileMaker.

- Package Maker, which creates convenient IVP file bundles for easy publishing.

- Package Crypter, which encrypts IVP file packages with security codes.

Designed with the objective of making panoramic publishing easier and quicker, Pure Starter Toolkit creates files that are compatible with the vendor's Java-based PURE Players and QTVR. Panorama FileMaker accepts spherical, cylindrical, and cubical projection JPEGs and TIFFs as well as QuickTime VR JPEGs (cylindrical and cubical). Its editing functions allow you to calibrate the angle limits of the projection, define an entry point and the panorama's field of view (FOV) limits, create an automatic horizontal movement, block the nadir and zenith, and add metadata with author, copyright, and licensing information.

The Lensflare module adds drama by creating flare effects when a light source appears in the camera's field of view. It has 16 customizable halo effects. Package Maker puts the files together so that they are compatible with the vendor's PURE Player viewing software, optimizing them for the fastest possible downloads over the Web. Package Crypter protects the files with simple, localized, or temporal encryption.

Comments

With its five modules, the Pure Starter Toolkit is an exceptional value. Java-based VR gives the smoothest and most rewarding viewing experience. Download times are very reasonable, especially now that most people have broadband connections. Note: This is a publishing toolkit, not an image creation kit. It prepares immersive VR images for display, and does it very well.

Version: Pure Starter Toolkit 1.0 (2008)

OS: Windows 2000 and XP; Mac OS X 10.2–10.5

RAM: 256MB

Supported file formats: Extracts from ImmerVision packages (IVP, IVL, IVU, and IVI), IMP, and QTVR with JPEG compression, plus formats that integrate images using JPEG, GIF, TIFF, and PNG

Price level: Approx. $35

Address: ImmerVision Inc., 2020 University, Suite 2420, H3A 2A5 Montréal, QC, Canada
www.immervision.com

Autodesk Stitcher

Vendor: REALVIZ (now part of Autodesk)

Purpose: Image stitching and 360-degree panorama creation software

Description

The Autodesk Stitcher product range represents a comprehensive approach to panoramic imaging, including the production of high-quality panoramas for the Web, film, print, and 3D. Whether you want to produce large format prints or create a virtual tour for an estate agent, this software has the answer.

It comes in two editions:

- Stitcher Express
- Stitcher Unlimited

Stitcher Express has many of the features of the more expensive Stitcher Unlimited, including automatic stitching of photos of any resolution, a full 3D interface with drag-and-drop operation, vignette removal, light equalization, and real-time preview. It is aimed at the hobbyist, but professional photographers will find this is a good package with which to start.

When you get serious about panoramas it is time to move up to Stitcher Unlimited with 16-bit support, which produces output ready to be printed on professional printers. It will also package 360-degree panoramas for virtual tour businesses.

With Stitcher Unlimited you move beyond QuickTime VR to publishing for Java-based and Shockwave-based viewers. This is the package for businesses that produce a lot of high-quality panoramic images and provide specialist virtual tours with hot spots (embedded information).

Comments

Stitcher Unlimited won a maximum six stars from James Rigg, who specializes in reviewing and explaining panoramic technology on his Panoguide Website (www.panoguide.com). In fact, it is hard to think of anything that is obviously missing in this top-of the-range package. Its core features are shared by the other, cheaper editions, but if you want support for fisheye lenses, cubic image output, and publishing facilities for ImmerVision's Java-based PURE Players, you need Unlimited.

Belgian photographer Tito Dupret has used (what is now called) Autodesk Stitcher to great effect since 2001, as is demonstrated in his shots of the 80 new World Heritage sites depicted on WHTour.org (www.world-heritage-tour.org).

Autodesk, the world leader in 2D and 3D design software, acquired REALVIZ in 2008 with the objective of adding the French company's technology to Autodesk's modeling, visual effects, and animation products. As a result, the Stitcher line has been rationalized to the two products described here. An intermediate Pro version has been dropped, as has a Student version, but an Education version is still available at the time of writing.

Version: Stitcher Express 2.5, Unlimited 5.7 (2008)

OS: Windows XP; Mac OS X 10.4

RAM: 256MB (512MB recommended)

Supported file formats: Inputs Cineon, JPEG, Maya, PNG, Portable Pixelmap, SGI, Softimage, TIFF, TGA, and BMP; outputs PSD, Maya, PNG, Portable Pixelmap, SGI, QuickTime, TIFF, TGA, Shockwave, and VRML

Price level: Express version $80, Unlimited version $350

Address: AutoDesk, Arep Center, 1 Traverse des Brucs, 06560 Sophia Antipolis, France

www.stitcher.realviz.com

Serif PanoramaPlus

Vendor: Serif

Purpose: Image-stitching and panorama-creation software, in three easy steps

Description

Serif PanoramaPlus lets you create panoramas in three easy steps: import, edit, and export. The import procedure allows you to bring in movie frames as well as standard images, preview them, and then stitch them automatically. Edit functions permit adjustment of the horizon line, autocropping, and rotation. You can dip in and out of Serif PhotoPlus, the vendor's image editor, for further modifications. The transparency option allows you to place the panorama against any background. Export can be high quality for print, or compact size for the Web. There is a QuickTime VR option for 360-degree panoramas, and you can even save to PDF, a great format for printing.

Comments

PanoramaPlus is a very competent image stitcher from a long-established software company that has loads of experience in the graphic arts. It is highly automated and can cope with component images that other stitchers find hard to handle. The vendor provides a demo version that works well, but the reduced output quality makes it hard to evaluate the purchased product.

For the image editor, you can buy the latest version (PhotoPlusX2) on the main Serif site, or an earlier, free version at www.freeserifsoftware.com.

Version: PanoramaPlus 3 (2008)

OS: Windows 98, ME, NT, 2000, XP, and Vista

RAM: 128MB (256MB recommended)

Supported file formats: Standard formats including JPEG, TIFF, and GIF

Price level: Approx. $50

Address: Serif, Inc., 13 Columbia Drive, Suite 5, Amherst, NH 03031, United States

Serif (Europe) Ltd., The Software Centre, Unit 12, Wilford Industrial Estate, Nottingham, NG11 7EP, United Kingdom

www.serif.com

SPi-V

Vendor: fieldOfView

Purpose: Hardware-accelerated panoramic viewing engine, built on Shockwave 3D

Description

SPi-V (pronounced "spiffy," and short for Shockwave panorama viewer) is a panoramic viewing engine that requires an up-to-date video card with plenty of RAM and the Adobe Shockwave plug-in. Its purpose is to provide the smoothest and best VR viewing experience, but it does more than that. The SPi-V viewer is configured through XML files so that it can display special effects in addition to the normal panning and zooming of a panoramic image.

For example, SPi-V can show animated time-lapse photography combined with panoramic viewing: most of the image remains static, but a figure in it can move. Even more impressive is its implementation of Adaptive Dynamic Range (ADR), a technology that adapts the tonal levels according to the part of the image currently displayed. (Pan to an open window and the displayed image stops itself down automatically.) In another technique, Focal Blur, panning the image makes the edges go out of focus but sharpens the central field of view, giving a strangely realistic simulation of how we actually see the world around us. These and other effects make SPi-V the most capable of all VR viewers currently available.

Comments

Available for licensing to panoramic photographers and Website developers, SPi-V was made originally for the vendor's own customers. The images it displays are among the most innovative of all those on the Web, but to appreciate them you need to view them online rather than in print. SPi-V for Flickr is a useful tool for placing the images onto the Flickr photo-sharing site. At the time of writing SPi-V is still in development, but promises to be a revolutionary means of viewing photographs on a computer.

Version: SPi-V 1.4.6 (2008)

OS: Windows 98 and up; Mac OS 9.x and OS X

RAM: Hardware-accelerated 3D card with 32MB RAM

Supported file formats: XML plus standard graphics formats

Price level: With fieldOfView branding free, without branding approx. $50

Address: Aldo Hoeben/fieldOfView, Lange Nieuwstraat 23 b1, 3111 AC Schiedam, The Netherlands

www.fieldofview.com

STOIK PanoramaMaker

Vendor: STOIK Imaging

Purpose: Photo panorama software based on advanced mathematical techniques for image matching

Description

STOIK PanoramaMaker can turn any group of overlapping images into a high-quality panorama. It uses the most advanced type of image matching, a technique that looks for approximate correspondences in high dimensions, in what mathematicians call 128-D features space. For the user it provides a step-by-step procedure for creating the final image, and can be operated in automatic or manual mode.

STOIK PanoramaMaker can correct minor differences between component images of the panorama, in brightness, color balance, and camera tilt angle. As a result, says the vendor, many stitching defects that are typical of other panorama stitching applications are either minimized or avoided altogether. The software also offers various printing options, such as printing across multiple sheets of paper, borderless printing, banner printing, and printing with overlap for easy assembly.

Comments

Any new product from STOIK Imaging is worth noting, as this award-winning company often works on an OEM basis for other firms. PanoramaMaker joins a growing list of auto-stitching software and brings the latest techniques to it.

Version 2.0 has a new algorithm to make tiled panoramas by stitching multiple rows of photos, including images taken with different levels of zoom. Other new features include viewpoint correction, with Elevation, Azimuth, and Tilt controls to change viewpoint and compensate for geometrical distortions.

Version: STOIK PanoramaMaker 2.0 (2008)

OS: Windows 98 SE, 2000, XP, and Vista

RAM: 256MB (recommended)

Supported file formats: JPEG, TIFF, BMP, PNG, and JPEG 2000

Price level: Approx. $40

Address: STOIK Imaging, Ltd, P.O. Box 48, Moscow 119049, Russia

www.stoik.com

The Panorama Factory

Vendor: Smoky City Design

Purpose: Creates high-quality panoramas from a set of overlapping digital images

Description

The Panorama Factory lets you stitch overlapping images to create full 360-degree panoramas. Its rich feature set includes a wizard interface, automatic detection of focal length, detection of camera rotation and tilt, easy rotation of imported images, and automatic and manual correction for barrel distortion, brightness falloff, and ghosting.

The Panorama Factory accepts 24-bit and 45-bit color images (15 bits each for red, green, and blue), has a library of over 800 digital camera models including DSLRs, exports to layered Photoshop image format, and includes 64-bit processor support.

Comments

The fact that The Panorama Factory is available in English, French, Italian, German, Spanish, Catalan, Dutch, Hungarian, Polish, Czech, Chinese, Slovak, and Russian is a sure sign that users have rallied around the product. Developed by recumbent biker John Strait, it started out as freeware—and look at it now! People love the way it joins images automatically and blends them seamlessly together. It lets you create autopanning virtual tours, with hotspots and Web page creation. Version 5 brought the product to the Macintosh platform, complete with Cubic QTVR import and export. Professional users can now enjoy a color-managed workflow, with read/write of embedded color profiles and ColorSync (Mac) or Image Color Management (Windows) to control color in printing and display.

Version: The Panorama Factory 5.1 (2008)

OS: Windows 98 or newer; Mac OS X 10.3.9 or newer

RAM: 512MB

Supported file formats: Reads/writes BMP, JPEG, TIFF, and PNG; outputs QTVR, IVR, PTViewer, and HTML image map format

Price level: Approx. $80

Address: Smoky City Design, 1017 N. Sheridan Ave., Pittsburgh, PA 15206-1718, United States

www.panoramafactory.com

Summary

Creating panoramas has become almost a subset of digital photography, with specialist hardware such as "pano heads" plus a whole range of software aimed at different sectors of the market. This chapter described packages for making high quality, artistic panoramas, together with others that address the needs of real estate agents and holiday companies who want to offer virtual tours of their properties online. Photographers wanting to experiment with these techniques can start with PTGui and stitch images together from a standard camera/tripod combination. The best results, however, will be obtained by using the right hardware and an advanced package like Autodesk Stitcher Unlimited.

Before investing any money, check out what other people are achieving in this field. See, for example, Eric Rougier's FromParis.com, a truly outstanding collection of images, with plenty of technical information.

Part IV

Presenting
Your Images

This part covers the following topics:

25

Digital Scrapbooking

In the United States, scrapbooking is more popular than golf. This is a fact, established in a survey by *Creating Keepsakes* magazine. Whereas 28.5 million people over the age of 18 play golf, scrapbooking is enjoyed by 32.1 million, or by someone in 1 in 4 American households, as opposed to 1 in 5 households for golf. Apparently, three-quarters of scrapbookers actually set aside part of the home as a place where they can perform their hobby without interference. Novice, intermediate, and dedicated scrapbookers spend $1,000, $1,700, and $2,300 respectively every year on their hobby, which, as software developers cannot have failed to notice, is becoming increasingly mechanized with the use of computer software.

Make no mistake: this is a very important category of photographic software, commercially perhaps the most important in this entire book. It seems to attract large corporate developers, companies with parent companies—always sign of success. It also makes it more difficult for smaller firms to break into the market, because, as you will see, the large companies have a tendency to blitz the customer with thousands of designs, clipart, templates, and fonts. If one of them offers 40,000 graphics, another will respond with 55,000. They make you an offer you can scarcely refuse, but is the simple three-step scrapbooking program really what people want? Some scrapbooking magazines go the opposite extreme and publish how-to articles based on using the full version of Photoshop. Other approaches are pitched sensibly somewhere between these two extremes of user ability.

Two of the most popular software packages for scrapbooking are discussed elsewhere in this book: Adobe Photoshop Elements and Corel Paint Shop Pro Photo. It is the liveliness of the scrapbooking market that has changed Photoshop Elements into what it is today, not a cut-down version of Photoshop but a program designed to appeal to people

who want to create scrapbooks and albums. Even so, it must surely appeal more to the dedicated scrapbooker than to the novice. Not everyone wants to make the transition between paper and scissors to keyboard and monitor, and for many people the jump from the physical to the virtual method is simply too great when the program has the flexibility and versatility of Photoshop Elements. Nowhere is the trade-off between ease-of-use and number of features better demonstrated than here, among the different types of scrapbooking software.

There is one online service listed here (Smilebox), plus one multimedia kit (MemoryMixer) for creating digital slide shows. MemoryMixer is included because it is aimed specifically at the scrapbooking sector, whereas other slide show software has a broader appeal. If you want to turn scrapbooking into a multimedia experience, you should certainly look at some of the products described in the slide show category.

The trend towards "openness," seen in photographic software generally, is one that is likely to gather steam in scrapbooking. After all, no one wants to have personal choice restricted by someone else's idea of his or her chosen art form. Even when there are thousands of graphics available, it is little comfort if they all look vaguely the same. It is much better to have a program that will take input from many suppliers, allowing you to choose from a wider range of styles and approaches. One indication of openness is the number of alliances, partnerships, and affiliations that are formed in the scrapbooking industry. For example, 30 independent retailers in Southern California have formed the Southern California Scrapbook Retailers Association, and similar link-ups have been spearheaded by software companies like Lumapix. Whether these will lead to improved usability and better-quality graphics remains to be seen. Watch this space (or, conversely, drag-and-drop an Easter bunny into it).

Art Explosion Scrapbook Factory Deluxe

Vendor: Nova Development
Purpose: Drag-and-drop scrapbook creation with thousands of templates, fonts, and clipart

Description

Art Explosion Scrapbook Factory Deluxe (AESFD) could scarcely be easier to use: from a selected category you choose an event, occasion, or theme from 6,000 designs; you personalize it with your own photos, captions, and embellishments; and finally you print it on any printer. Another output option is to convert the page to PDF for sending to friends and family.

The key selling point of AESFD is the bewildering quantity of templates, graphics, and fonts that come with the software. There are 60,000 graphics, consisting of watercolors, illustrations, vector drawings, fine art, and other styles, any of which you can use in your scrapbooks. 6,000 projects are categorized into Special Occasions, Family and

Friends, Journals, Holidays (no concessions to UK users: Holidays are Halloween, Christmas, and so on, nothing to do with the beach), Vacations (that's the beach), Albums and Bragbooks, Paper Crafts, Iron-On Projects, Photo Frames and Calendars, and the intriguingly named Spectacular Scrapbook Additions. And Much More.

If all this is not enough, the vendor has thrown in another 5,000 "photorealistic embellishments" consisting of buttons and bows, alphabets, tags, charms, and other decorations. There is also a built-in digital photo editor and support for traditional 12"×12" paper.

Comments

Art Explosion Scrapbook Factory Deluxe took top honors in an online comparative review of the top ten scrapbooking software packages organized by TopTenREVIEWS. There is no doubt that loading the user with lots of templates and fonts is often going to win against better photo enhancement or superior layout facilities. In this case, the vendor can be excused as it also offers an image editor called Photo Explosion Deluxe to take care of picture quality, cropping, and so on. AESFD tends to do whatever it thinks is best for the user, such as compressing JPEGs automatically to a mid-range value when saving—but there is an override to maximize quality (if you know about it). The program and its truckload of artwork will keep scrapbookers happy for hours and is a lot easier to use than Photoshop.

Version: Scrapbook Factory Deluxe 4.0 (2008)

OS: Windows XP and Vista

RAM: 128MB

Supported file formats: JPEG, PDF, and five other major formats

Price level: Approx. $40

Address: Nova Development Corporation, 23801 Calabasas Road, Suite 2005, Calabasas, CA 91302-1547, United States

www.novadevelopment.com

Creating Keepsakes Scrapbook Designer

Vendor: Encore

Purpose: Three-step scrapbook creation in different editions with up to 55,000 images

Description

Like Art Explosion Scrapbook Factory Deluxe, which it much resembles, Creating Keepsakes Scrapbook Designer offers a three-step process for creating scrapbooks—you select a design, personalize it by importing photos and graphics, and then save it as a PDF file to send to friends, print it, or burn it to CD for safekeeping.

It comes in two editions:

- Scrapbook Designer Deluxe v.2—Contains 7,500 professionally designed pages and 500 layouts from *Creating Keepsakes* magazine
- Scrapbook Designer Platinum—Contains 5,000 project designs, 55,000 "irresistible" images, and over 1,200 fonts

Creating Keepsakes Scrapbook Designer is developed by Broderbund (a trademark of Riverdeep Interactive Learning Limited) for PRIMEDIA Special Interest Publications, the publisher of *Creating Keepsakes* magazine.

Comments

With so many images, it can be difficult to find what you are looking for, so there must surely come a point when the "pile 'em high" policy starts to have a negative effect. Nonetheless, this is a very popular range, with (arguably) superior graphics to Art Explosion and the same ease-of-use. Most users report good results with it, apart from one or two minor niggles like having to rotate images manually before inserting them into tilted frames. Fortunately, the pros outweigh the cons in what is a very strong brand, with enough features to make anyone feel creative. Creating Keepsakes has its own Website and online community at www.creatingkeepsakes.com.

Version: Creating Keepsakes Scrapbook Designer Deluxe Version 3 (2008)

OS: Windows 98SE, ME, 2000 SP4, and XP (Home and Pro) SP1

RAM: 128MB

Supported file formats: JPEG and PDF

Price level: Scrapbook Designer Deluxe v.3 approx. $20, Scrapbook Designer Platinum approx. $40

Address: Riverdeep, Inc., 71 Stevenson Street, 4th Floor, San Francisco, CA 94105, United States

www.broderbund.com

FotoFinish

Vendor: SmartDraw.com

Purpose: Edit digital images, create collages and scrapbooks, and print the results

Description

FotoFinish is an image editing, designing, and printing application that is packaged as three editions.

- FotoFinish BASIC, for either printing or emailing images, but without editing or design features

- FotoFinish STUDIO, which adds editing facilities such as crop, resize, and rotate; plus borders, floating text, and special effects

- FotoFinish SUITE, not only printing and editing, but also design and layout

The top edition of FotoFinish, which offers facilities for designing cards, invitations, even business brochures, is especially popular with users who create collages and scrapbooks. Both the Studio and Suite editions have extensive editing capabilities, with color control, exposure adjustment, and retouching tools. Everything is implemented in an easy-to-use way.

Comments

FotoFinish comes from a top vendor of business graphics software, a company that deliberately applies a "keep-it-simple" philosophy to its products. Of the three editions, FotoFinish SUITE is surely the best value with its layout facilities, professionally designed templates and royalty-free graphics. Reviewers have given it full marks for its photo-sharing options, but have found the editing facilities somewhat limited. This is true, but it has enough tools for its intended market, and, by all accounts, the help and support are terrific. The vendor offers discounts to students and academic institutions.

Versions: FotoFinish1.0 (2008)

OS: Windows 98, ME, NT, 2000, and XP

Supported file formats: SPH (FotoFinish), JPEG, GIF, TIFF, BMP, PNG, and PSD

Price level: Basic edition $70, Studio edition $ 100, Suite $130

Address: SmartDraw.com, 9909 Mira Mesa Blvd., Suite 300, San Diego, CA 92131, United States

www.fotofinish.com

LumaPix FotoFusion

Vendor: LumaPix

Purpose: Collage creation, with automatic layout and fine-tuning

Description

LumaPix FotoFusion is a fast tool that lets you create collages in any style rather than constraining you with templates, although templates are available if you need them. It comes in three variants—Essentials, Enhanced, and Extreme (formerly called Standard, Pro, and Studio)—with significantly different levels of functionality from one to the other. Only the Extreme edition offers multi-page support for composition and printing.

FotoFusion has useful photo organizing and grouping facilities that allow you to prepare a selection of pictures for your project. Autocollaging has been improved in version 4.0, with ordering (arranging) by filename, file date, Exif date, or in random order.

You can make an image fill a page (a great advantage over other, more restrictive scrap-booking programs that squeeze photos into tiny spaces) and ensure that it retains its proper aspect ratio.

Color-editing features are available in the Enhanced and Extreme editions, but are very limited in the Essentials program. Notably absent are the thousands of clipart images, embellishments, and fonts that are common in many scrapbooking programs. Arguably these are two-a-penny, with many available free online, and there is nothing to stop you adding any image in JPEG format to your FotoFusion pages.

Comments

Although LumaPix FotoFusion Essentials does not go far beyond making collages, it is a true scrapbooking tool that has become the focus of an industry consortium called the dotScrap Alliance (www.dotScrap.com). This imaginative business venture ties in physical scrapbooking tools and materials with digital creation, under the banner "All the Fun, None of the Fuss." Participating companies, besides Lumapix, are All My Memories, Autumn Leaves, Creative Imaginations, Daisy D's, DMD, K & Company, KI Memories, L'il Davis Designs, LineCo, Rastar, Scrapbook.com, Scrapjazz.com, SEI, and Westrim. None of this would have been possible if FotoFusion was not a first-rate tool, able to produce original and satisfying layouts with great ease of use.

At the time of writing there is no Macintosh version of LumaPix FotoFusion, although it runs in VMWare and Parallels mode on Intel Macs. Nonetheless, the Extreme version is the only product in this chapter that is highly rated by professionals. For example, top wedding photographer David A. Ziser (www.davidziser.com), who teaches digital mas-ter classes in Ohio, tells me informally that it's "the best design software on the planet Earth." A subjective judgment? Possibly. But it clearly helps him get the job done.

Version: FotoFusion 4.2 (2008)

OS: Windows 2000, XP, and Vista

RAM: 256MB

Supported file formats: JPEG, BMP, TIFF, PNG, GIF, PSD, and PDF

Price level: Essentials version $40, Enhanced version $120, Extreme version $300

Address: LumaPix, 195 Louis-Lalande, Boucherville, QC, J4B 6P6, Canada

www.lumapix.com

Hallmark Scrapbook Studio

Vendor: Creative Home

Purpose: Scrapbooking software with templates, graphics, fonts, and a photo editor

Description

Hallmark Scrapbook Studio is another easy-to-use scrapbooking utility with more than 1,200 templates, over 7,000 graphics, over 500 fonts, over 1,000 embellishments, and a built-in digital photo editor. Like its competitors Art Explosion and Creating Keepsakes, it provides a three-step process for putting scrapbooks together—you can start from scratch or use a Hallmark template; add your own photos and personalize the pages with words and graphics; and then preview and print on any printer. The difference is in the graphics. If you like the Hallmark style, go with this one.

Photo editing includes red-eye removal, correction for brightness, contrast, and color, and resize, rotate, and crop facilities. The templates are professionally designed, with a layout for every occasion. Graphics are invariably cute to give a cheerful accompaniment to your pictures. There are plenty of frames to choose from, plus journals, family trees, and photo cards. One special feature is hundreds of paper doll accessories, but there are many others, all designed to delight the avid scrapbooker.

Hallmark Scrapbook Studio is sold through resellers such as Wal-Mart, Staples, and Amazon.com, and online at the Hallmark Software store.

Comments

The Hallmark product is particularly strong on special effects, offers hundreds of designs with a wide choice of themes, and provides good photo-editing facilities with PhotoLab. Some reviewers have complained that it is "complex and challenging" to use, but this is a standard comment for any program that offers even basic image-adjustment features. Photo editing is essential: grandchildren should have red eyes only if they happen to be a particular species of lemur or tree frog. Hallmark's software developer has done a fine job of putting together a sensible and fun-to-use package.

Version: Hallmark Scrapbook Studio Deluxe 3.0 (2008)

OS: Windows 98, ME, 2000, XP, and Vista

RAM: 64MB

Supported file formats: Imports major image formats; exports proprietary format only

Price level: Approx. $30

Address: Creative Home, 23801 Calabasas Road, Suite 1018, Calabasas, CA 91302-1547, United States

www.hallmarksoftware.com

MemoryMixer

Vendor: Lasting Impressions

Purpose: Create a multimedia digital scrapbook, with images, video, and sounds

Description

MemoryMixer adds a few levels of sophistication to the concept of family slide show software by adding video overlay on top of your slides and include voice narration that can interrupt any background audio. All of these features are wrapped up with "Embellishments & Backgrounds," with ribbons and bows and textures.

It comes in two editions—MemoryMixer Lite, with 100 backgrounds and more than 375 embellishments; and MemoryMixer, with 400 backgrounds and more than 1,200 embellishments.

You can also create printed albums with this product as it ships with more than 30 professionally designed albums and many more are available from professional designers. The vendor has a photo-processing service with delivery to the door.

Comments

MemoryMixer has been vigorously promoted to become one of the leading brands in this sector. It is sold in the online Apple shop, which gives it a kind of official seal of approval, but it remains a basic program that places a lot of emphasis on decoration, but comparatively little on photographic quality. However, that is par for the course with most scrapbooking provision and MemoryMixer is no worse in that respect.

To use MemoryMixer you have a choice of three modes—InstaMix, which allows you to select background and photos and then the program automatically puts the pages together; QuickMix, where you start with a professionally designed album into which you insert your photos individually; and From Scratch, with which you can customize the various elements. This is a good approach as it caters for all levels of expertise. The vendor also offers a photo-processing service for printing album pages to the size you want.

Versions: MemoryMixer 2.0 (2008)

OS: Windows 2000 and XP; Mac OS X

RAM: 256MB (512 or more MB recommended)

Supported file formats: Major image, video, and sound formats

Price level: Lite version $35, Full version $80

Address: Lasting Impressions for Paper, Inc., 2441 South 1560 West, Woods Cross, UT 84087, United States

www.memorymixer.com

PhotoELF

Vendor: Landofcom Software

Purpose: Photo printing and editing software, with organizing and batch facilities

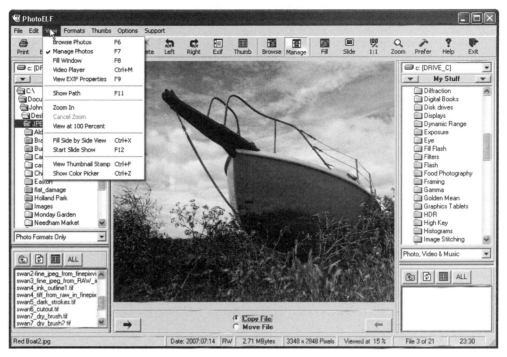

Figure 25.1
PhotoELF lets you browse and manage images as well as make slide shows and albums.

Description

Having the tagline "The Digital Camera Companion," PhotoELF is a versatile tool that works as an image organizer, editor, and print utility. Its appeal is primarily to home users who want to improve family photographs and create albums, slide shows, and cards for Christmas and birthdays. However, it also has extensive batch facilities for such tasks as renaming, resizing, rotation, and compression—which tends to place it in a slightly different category. For example, it would appeal to anyone who has responsibility for editing and distributing community sports images.

As a print utility, PhotoELF offers many features, such as printing up to 64 photos on the same page, printing to specific sizes such as 8"×10", 5"×7", 4"×6", and 3"×4", borderless printing, duplicates, template creation, add-text, add-captions, and large-size poster printing. It also allows you to create browser-based photo albums to which you can add music in the form of MP3 and WAV files. It has sequential and random slide show options, plus a feature that allows you to publish albums direct to the Web or burn them to CD-ROM.

PhotoELF works with all printers, including Olympus P400, Hewlett Packard, Epson, Canon, Lexmark, Compaq, and Xerox.

Comments

PhotoELF is not aimed specifically at the scrapbooking market. Far from it: the vendor mentions possible use by insurance and real estate agents. Yet it has most of the facilities that scrapbookers demand, apart from clipart (which is readily available elsewhere). Reasonably priced, it offers image adjustment as well as editing, while being strongly oriented towards output with its multiple print options. If you are tired of decorating your work with cute rabbits, PhotoELF can conjure up a slick layout in no time at all.

Version: PhotoELF 4.0 (2008)

OS: Windows 95, 98, ME, NT, 2000, XP, and Vista

RAM: 32MB

Supported file formats: Saves to 60 formats; views 17 formats: BMP, CLP, CUR, EMF, FPX, ICO, IFF, JPEG, PCT, PCX, PNG, PSD, RAS, SGI, TGA, TIFF, and WMF

Price level: CD version approx. $40

Address: Landofcom Software, 17845 211th Ave., Big Lake, MN 55309, United States

www.photoelf.com

PhotoMix

Vendor: fCoder Group

Purpose: Digital scrapbook and collages software, with monthly add-ins

Description

PhotoMix lets you take either scanned photos or images direct from a digital camera and then create scrapbooks and collages using themed "graphic kits" or templates. When completed you can print the pages on glossy paper or surround them with virtual frames and add them to your digital scrapbook collection.

Creation of scrapbook pages with PhotoMix is a simple drag-and-drop affair. You can zoom into any of the images, add text and graphics, and finally email, print, or store the result. The vendor makes great play of the program's simplicity, saying that the learning curve is "not a curve but rather a short straight line."

There are both free and commercial add-ins (additional graphics kits), with seasonal and special interest themes. They include a military add-in designed especially "for military people and patriots." There are also dozens of Amy Teets designs of a general nature with titles like "Sophisticated," "Extraordinary," "Showdown," and "Sublime."

Comments

Attractive templates, easy operation, plenty of updated graphics, and useful tutorials help to make PhotoMix an above-average, even classy, scrapbooking option. It lacks proper photo-editing tools, but maybe editing is a task that is best done in a specialist program.

In fact, it is quite likely that a different family member will process the images and then pass them to the scrapbooker for layout and text. Unlike photo editing, PhotoMix needs no computer literacy skills, yet good results can be achieved if you work with well-adjusted images.

Version: PhotoMix 5.3 (2008)

OS: Windows 98, ME, 2000, XP, and Vista

RAM: 128MB

Supported file formats: Imports and exports major graphics formats

Price level: Approx. $30, add-ins are $5 each

Address: fCoder Group, Inc., Pacific Business Centre, #101 - 1001 W. Broadway, Suite 381, Vancouver, BC V6H 4E4, Canada

www.photomix.com

Smilebox

Vendor: Smilebox, Inc.

Purpose: Online scrapbooking application—download a design, personalize it, email it

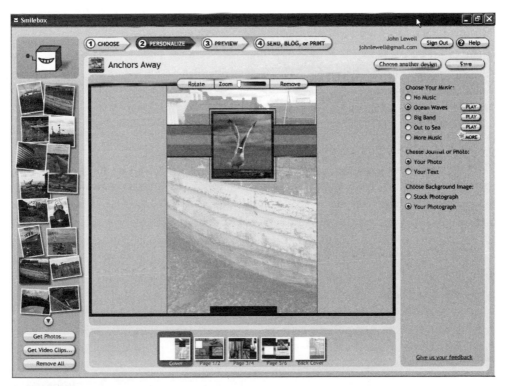

Figure 25.2
Smilebox puts the whole process of slide show creation online.

Description

Smilebox is an online service that lets you create animated scrapbooks, photobooks, slide shows, postcards, and greetings. To use it, you download a design, personalize it for the occasion you have in mind by adding images, video, music and captions, and then email it to the recipient.

There are three levels of service: a basic, free design; a premium design; and a club subscription.

Comments

Smilebox may very well appeal to scrapbookers. It has a huge number of cheerful designs with a seasonal emphasis that changes as the year progresses. Unfortunately, it does not give you enough control and tends to put your scrapbook together as it thinks best, loading pictures automatically from your Windows folders. It needs a fast broadband connection as it sends you a substantial amount of images and code. There is an initial wait even with a 8Mbps connection.

Versions: 1.0 (2008)

OS: Windows XP

RAM: 256MB

Supported file formats: Limited formats

Price level: Premium designs $2 each, subscription $5/month or $40/year

Address: Smilebox, Inc., 8201 164th Ave NE, Suite 305, Redmond, WA 98052, United States

www.smilebox.com

Summary

More than a hobby, scrapbooking is an activity that celebrates family life, preserving its special moments for later enjoyment. Its modern version is digital scrapbooking, either in virtual form for sharing online or else as a design tool for printing physical scrapbooks, often in their traditional square format. Most scrapbooking software contains vast quantities of clipart, mainly because developers believe this is what the market demands. Not all of it would pass muster in a design contest, but the homespun nature of scrapbooking makes it readily accepted. Developers have kept layout and image manipulation as easy-to-use as possible, but dedicated scrapbookers always have the option of moving up-market to Photoshop Elements or Corel Paint Shop Pro Photo. Another option is to use an online service such as Smilebox, but ultimately there is no substitute for using good photographic skills at the point of origination.

26

Photo Album Creation

Album software often forms part of a larger program, a good example being Apple's Aperture, which gives Mac users all the tools they need to create digital albums. You should therefore also check out some of the image editors and image viewers for programs like Adobe Photoshop Elements or Google Picasa, which are renowned for their photo album capabilities. This chapter covers several other packages that are dedicated to helping you prepare images for showing on the Web. Most come with an integral FTP client to save you the trouble of acquiring CoffeeCup, CuteFTP, or other specialist uploading software, and several have basic editing features like cropping and rotation. Some provide layouts that are also suitable for printing: the pages forming a real album when bound together. That said, most of them are fairly basic in what they have to offer.

Photo album software is generally less fussy than digital scrapbooks in its approach to displaying images. Whereas scrapbooks place emphasis on decorative graphics, album software tries harder to show your images to their best advantage. This is not to say that album software never ventures into the realms of storytelling or special effects. It does. But its primary objective is to get your pictures organized on the page for browsing online. A good argument can be made in favor of the simple approach: the simpler the better.

Two packages that exemplify the simple approach are Quixhibit from WilyBeagle Software and Diji Album from Xequte Software. Either one is capable of creating a photo gallery that will display your images with clear navigation and acceptable layout. Often using Flash, far too many photographers attempt to create elaborate Websites that are slow to respond and challenging to navigate. The advantage of Flash lies in the extra protection it gives to your images, making it difficult for people to save them to their computers. Album Creator is a viable option if you really want to use Flash.

From among the larger corporations, Serif's AlbumPlus is one of the easiest packages to use, but you may need one of the vendor's other programs for editing. From the biggest company of all, there is Kodak EasyShare, part of an extensive system composed of camera, dock, online gallery, and print service.

It is logical to combine album creation software with online services, and the Kodak offering is comprehensive. It may be too consumer-oriented for some tastes, but a good level of print quality is always maintained. An alternative for those who simply want a convenient online presence is SendPhotos, a two-in-one software/service solution that comes with free Web space. With the vendor's ongoing development, you can load pictures direct from your mobile phone as well as from your PC.

Album Creator

Vendor: FirmTools

Purpose: Generates professional-looking Flash and HTML image galleries

Description

Album Creator lets you create online albums in Flash or HTML, using specially designed templates to give the pages a professional look. It gives you the flexibility to customize the templates, plus the option of designing your own.

Additional, themed templates are available for download, several new ones being released every month. For example, "Dotted Frames" has a dark gray color scheme and a new font (Candara), and is ideal for showing images to their best advantage. Another, "Paper Album," has a page-turning, corner-dragging feature with the option of setting your own texture image for the pages or the album cover.

As well as album creation, the software has editing tools to enhance photos, remove red-eye, adjust colors, and apply watermarks. It has support for Exif and IPTC metadata and includes FTP facilities for uploading to a Website.

Album Creator comes in three editions: Lite, Basic, and Pro.

Comments

Well presented and carefully explained, Album Creator has the look and feel of a main-stream product, despite its relatively low cost. Since it was launched in 2003, its templates have become increasingly well designed, some of the latest being outstanding. If you prefer to place albums on your own Website rather use Flickr or another online service, Album Creator is an effective tool that gives you plenty of creative freedom. The developers are enthusiastic users of digital cameras—and they have put their experience to good use in this product.

Version: Album Creator 3.5 (2008)

OS: Windows 98, ME, NT, 2000, XP, and 2003 Server

RAM: 64MB (128MB or greater recommended)

Supported file formats: JPEG, TIFF, PSD, BMP, GIF, PNG, ICO, WMF, EMF, and EMF+

Price level: Lite version $15, Basic version $25, Pro version $40

Address: FirmTools, 46 Tkatskaya Street, Suite 25, Moscow, 105187, Russian Federation

www.firmtools.com

AlbumPlus

Vendor: Serif

Purpose: Digital media manager to organize, browse, search, and locate photos, movies, and sounds

Description

AlbumPlus is a comprehensive package for creating digital photo albums, with features that allow you to organize, browse, search, and locate your images and other multimedia files. Having found the right images you can go on to create screensavers, personalized calendars, greetings cards, multimedia slide shows, and, obviously (given the name) albums.

AlbumPlus lets you create an unlimited number of tag categories which you can then use to tag your images with keywords. It also has plenty of alternative search options, including "my projects," star rating, import history, and text searching. It allows you to edit Exif, XMP, and IPTC metadata—a feature that many people missed in earlier versions.

Photo enhancement options include rotate, crop, sharpen, red-eye removal, and adjustment of lightness, darkness, brightness, contrast, and color. If you need more advanced tools, you can link directly to the vendor's PhotoPlus software.

Comments

Reviewers have given AlbumPlus full marks for ease-of-use but have tended to be critical of its price after comparing it with free offerings from Google (Picasa) and Kodak (EasyShare). There is some truth to this observation, although AlbumPlus does have a unique personality of its own. It has been put together very professionally with a full set of output options that includes the ability to send images to mobile phones. Its search facilities are especially strong and it is very well supported with guides, updates, and free user forums.

Version: AlbumPlus X2 (2008)

OS: Windows 2000, XP, or Vista (certified)

RAM: 128MB (512 recommended)

Supported file formats: Major image formats

Price level: Approx. $50

Address: Serif, Inc., 13 Columbia Drive, Suite 5, Amherst, NH 03031, United States

www.serif.com

Biromsoft WebAlbum

Vendor: Biromsoft

Purpose: To create professional-looking online photo albums with thumbnail galleries

Description

WebAlbum lets you create fully customizable Web albums without any knowledge of HTML or programming techniques. A wizard-like interface guides you through the process, allowing you to play with different themes, such as birthday, Christmas, and office-related themes, games, kid themes, leisure-related themes, military themes, nature themes, science themes, sports, travel, and wedding themes, while also providing the option to create some themes of your own.

Once you have created them, you can serve the albums from any Web server, local hard disk, or writable CD. A built-in FTP client then makes it easy to upload albums to the Web.

Comments

All the emphasis is placed on ease-of-use in Biromsoft WebAlbum (not to be confused with Mac software of the same name). Nonetheless, an advanced user can edit page layouts and style sheets and produce a slightly more individual look to the finished result. The vendor has created a clean interface with large tabs to make the "next step" fairly obvious. It is ideal for beginners, but lacks features for other users. The same product is sold by Sarm Software as "WebAlbum."

Version: Biromsoft WebAlbum 4.0 (2008)

OS: Windows 95, 98, NT4, ME, 2000, and XP

RAM: 128MB

Supported file formats: Major formats such as JPEG, GIF, TIFF, BMP, TIF, and PNG

Price level: Approx. $30

Address: Biromsoft, 555 8th Ave #1001., New York, NY 10018, United States

www.biromsoft.com

InAlbum

Vendor: IncrediTools

Purpose: Turns digital photos and videos into photo albums, with 100 or more ready-to-use templates

Description

InAlbum is template-based software that lets you turn your digital photos and videos into albums for printing or online hosting. You choose a template from over 100 designs, and then combine, mix, and match background animations, buttons, photo frames, fonts, and transition effects to create a complete presentation. You can add videos and apply video effects such as motion blur, emboss, sepia, "mozaik," and oil painting. There are also facilities for voice recording (and converting your voice using various effects such as "ghost," "girly sound effect," and so on), plus animated clipart for decoration, and clickable speech bubbles.

Comments

Designed to be fun to use, InAlbum has plenty of features to keep the most active user interested, including one that will "morph your friend's face into apes, aliens, birds, and a lot more!" If this sounds a little gimmicky, it is, but the examples given are skillfully done and very amusing. Version 3.0 added CD/DVD burning, playable on TVs, helping to combat the criticism of reviewers that it did not have enough features. In fact, it is now very capable, easy-to-use, and has excellent picture quality. It could have been included in Chapter 27, "Slide Show Creation."

Version: InAlbum 3.0 Deluxe (2008)

OS: Windows 98, ME, XP, and 2000

RAM: 512MB

Supported file formats: JPEG and PNG; Imports Windows video files (AVI, WMV, and ASF); MPEG video files (MPEG, MPG, and MPV); QuickTime video files (QT and MOV); exports Flash, HTML, and AVI movie files

Price level: Approx. $55

Address: IncrediTools

www.inalbum.com

Dg Foto Art

Vendor: PXL Soft

Purpose: Pro-level digital album creation tool with more than 1,000 ready-to-use templates

Description

With two editions and a huge template collection, Dg Foto Art is a comprehensive solution for creating photo albums of all kinds, especially for weddings and special occasions. The editions are:

- Essentia, for quick album creation
- Gold, with all the tools

Brightness, contrast, gamma, and sharpness controls are included in both editions, along with resizing and cropping. Only the Gold edition has rotation, curves, and color correction. You can resize the pages inside an Album, but not in the Essentia edition, and swap photos instantly (but only in Gold). By far the best results are achievable with the significantly more expensive Gold edition, which includes guidelines for accurate composing together with automatic color and contrast adjustment. An intermediate, Classic edition has been discontinued but is still supported.

Comments

Dg Foto Art comes from a respected team of developers in India, the company having been founded by Viren Satra, the father of videography in the subcontinent. As a result, many of its designs lean towards Bollywood taste, with clashing colors and lively layouts. Among its best designs are some superb Indian wedding templates, which require separate purchase from the Dg Foto Galleria collection but are very tasteful by comparison. Dg Foto Art would be a natural choice for anyone making albums for an Indian wedding. The product is widely available—dealers in the U.S. include Alkit (www.alkit.com) and B&H (www.bhphotovideo.com). It comes with a USB dongle to combat software piracy.

Versions: Dg Foto Art 5.2 (2008)

OS: Windows 2000 and XP with SP2; Mac OS X 10.4.x and above

RAM: 512MB

Supported file formats: Major graphic formats, such as JPEG, BMP, TIFF, GIF, PNG, MGF, and TGA

Price level: Essentia $150, Gold $650, Dg Foto Galleria templates $5 each

Address: PXL Soft LLC., B-204, Master Mind III, Royal Palms, Aarey Milk Colony, Goregaon (East), Mumbai-400065, India

www.pxlsoft.com

Diji Album

Vendor: Xequte Software

Purpose: Wizard-based creation of albums with images, rich text, and multimedia

Description

Diji Album lets you create electronic photo albums that look like real albums, right down to the optional photo corners. Its tools give you complete control over layout, using multiple images, headings, rich text, and multimedia. It lets you paste text and images from editing applications or drag and drop them from Explorer. One key feature is full text searching within your album, enabling you to locate specific pages.

Figure 26.1
Diji Album lets you place images and text with precision.

Common image-editing functions include rotation, cropping, and red-eye removal. You can send a Diji Album to friends as a self-extracting file, distribute it on self-booting CD-ROMs, or post it to a Website using exported HTML. There is also the option to display the album as a slide show, complete with background music, page flips, and other effects.

Comments

A rave review for Diji Album on *Great Canadian Reviews* said it "should be triple the price," and other reviewers have also written warmly about the product. It even won five stars in the UK *Sunday Times*. They are right. Although it is not a "designer product" with slick graphics and an ultracool interface, it gets the job done in a straightforward way, without clutter or too many options. The end result is very acceptable and should appeal to a very wide market.

Version: Diji Album 7.0 (2008)

OS: Windows 95, 98, ME, NT, 2000, XP, and Vista

RAM: 32MB

Supported file formats: JPEG, PNG, GIF, BMP, WMF, AVI, MPEG; MP3, WMA, WAV, and HTML

Price level: Approx. $40

Address: Xequte Software, PO Box 83-087, Johnsonville 6440, New Zealand

www.xequte.com

JAlbum

Vendor: JAlbum

Purpose: Free gallery software for publishing images to any Web page or sharing directly from your computer

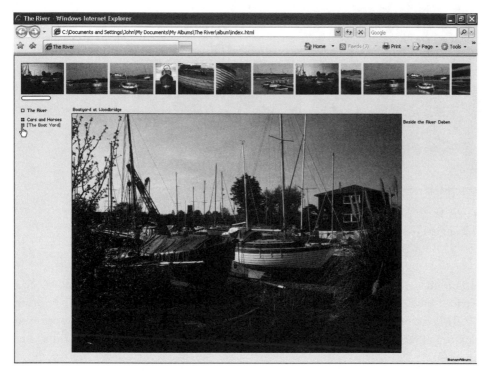

Figure 26.2
JAlbum offers an instant preview of your virtual gallery.

Description

JAlbum is a popular program for creating online galleries that you can post to any Website, together with text and comments. It lets you choose color themes, layouts, picture and thumbnail sizes, music, and method of navigation. A freshly designed interface makes it easy to find your images and then place them using drag-and-drop tools. You can also edit comments, rotate images, and run slide shows directly from your local hard disk.

To the albums you can add any file type, not just images, together with icons to link to the appropriate resource on the user's computer (such as a PDF reader for PDF files). It also lets you plug in image filters to add watermarks and logos; Exif and IPTC support are standard.

Comments

After two million downloads, it is clear that the developer is doing something right. The fact that JAlbum is free may account for some of its popularity, but not all of it. Users particularly like the way it allows you to make your own "skins" (everything that frames the image). It is easy to learn, looks better on a PC than on the Mac, and has templates that were considered by some to be better than its interface until the 2008 redesign.

The vendor gives many good examples of creative uses for outstanding snaps, showing how easy it is to make a printed-and-bound book from your album pictures by following the links to the appropriate supplier. Likewise, from partner bagsnatcher.com, there are cushions, bags, placemats, wallets, and pillowcases to be had. Clearly, JAlbum does not mean "just albums" (the J, of course, being Java—a language that enables the vendor to keep the service always up-to-date).

Version: JAlbum 8.0 (2008)

OS: Any platform that supports Java 1.4, such as Windows, Mac OS X, Linux, Solaris, AIX, and OS/2

RAM: 128MB

Supported file formats: JPEG, GIF, and PNG

Price level: Free

Address: JAlbum AB, Solna strandväg 96, S-171 54 Solna, Sweden

www.jalbum.net

Kodak EasyShare

Vendor: Eastman Kodak

Purpose: Software component of system that includes camera, dock, online gallery, and print service

Description

Kodak EasyShare (or EASYSHARE, as the vendor insists on shouting) is free software that lets you prepare your images for printing or sharing online. It is part of a larger system that consists of a choice of Kodak digital cameras, a docking station, an online gallery (www.kodakgallery.com—formerly Ofoto), greeting card software, and a comprehensive printing service that offers an excellent range of real photo albums.

If you use the EasyShare dock, your pictures are transferred to your computer automatically. There, the EasyShare software takes over and lets you organize your photos by date, caption, or favorites. You can use the Creative Projects tab to personalize photo cards, books, and gifts. Editing includes enhancement, cropping, and red-eye reduction with a single click.

For output you can use Quick Print for one-click printing or share your pictures with others on the EasyShare gallery. At the gallery there is an extensive shop where you can purchase albums, clothes, calendars, frames, prints, and more, much more.

Comments

Somehow, it all fits together, although Kodak's online explanation is a triumph of market-speak over useful information. The Kodak EasyShare gallery is said to contain over two billion images (or does that include other parts of the organization? Again, the information is unclear). The registration page has a picture of a mug with a dog on it—and that is really all you need to know. Give it a try. The printing is fine and you get free prints when you join.

Version: Kodak EasyShare 7 (2008)

OS: Windows XP and Vista; Mac OS X 10.3 and up

RAM: 128MB (256MB recommended)

Supported file formats: JPEG, TIFF, BMP, Flashpix, GIF, JFIF, PICT, PNG, Photoshop (with layers), SCI, Targa, MacPaint, RAW (.KDC), MOV, and AVI

Price level: Free

Address: Kodak Imaging Network, 1480 64th St., Suite 300, Emeryville, CA 94608, United States

www.kodak.com

Quixhibit

Vendor: WilyBeagle Software

Purpose: Image gallery building in minutes with "Quick Exhibit" tools

Description

Quixhibit allows you to download images to your computer, arrange them into photo galleries, and then upload them to the Web. Its name elides "quick" and "exhibit," emphasizing that this is a speedy way to put images online.

Among Quixhibit's growing number of features are styling tools that enable you to choose a basic text index, a "contact sheet" of rows/columns, or scrolling navigation bars. You can choose font, background color, background image, page layout, and drop-shadows to add to the basic style. The optional captioning facility includes spell checking, whereas other features include cropping, rotation, and sorting. There is an integrated FTP client for uploading the gallery, plus context-sensitive help to guide users through the whole process.

Comments

Although this is (currently) a very basic program, it produces a clean, effective result that is likely to appeal to photo enthusiasts. After all, a gallery needs only to have sensibly arranged thumbnails, a large central display area, and good navigation. Using Quixhibit, you can create a scrolling navigation bar along the top of the frame and see the images displayed below—just like the layout on DPReview.com. Check it out; it may be all you need.

Version: Quixhibit 3.2.12.85 (2008)

OS: Windows XP

RAM: 256MB

Supported file formats: Major formats

Price level: Approx. $20

Address: WilyBeagle Software, 100 Beagle Way, Raleigh, NC 27613, United States

www.quixhibit.com

SendPhotos

Vendor: Avanquest Software

Purpose: Organizes pictures on your PC; comes with Web space for uploading

Description

This is a two-in-one solution: PC software that lets you create albums on your PC, but with the purchase comes some Web space to which the software can upload the albums. What is more, friends and family can view your online photos as well as add their own.

Among SendPhotos' many features are over 200 theme templates, a wide choice of frames, colors, and caption styles, and various design tools with drag-and-drop placement of images. One key feature is the facility to create online photo stories, with text and images, along the lines of "Hi, Grandpa! Look what I've been doing..."

SendPhotos can synchronize your PC albums with those online, while also scheduling automatic uploads so that photos are always backed up online and on the PC. Printing options include six formats, enabling you to print one large picture or several small ones on each page.

Comments

The combination of desktop software and online service is a winner for many users. SendPhotos does it very well and has earned the plaudits of reviewers and users alike. Avanquest is a large, international software company that has big plans for this product, including integration with a new mobile phone application called SendPhotos

Mobile (shortly to be released at the time of writing). With this new product, you can browse your galleries and upload pictures from your mobile phone directly to your online locker.

Version: SendPhotos 5 (2008)

OS: Windows 2000 or XP

RAM: 128MB

Supported file formats: Major formats

Price level: Includes 2GB online storage, approx. $30

Address: Avanquest Software USA, 1333 West 120th Ave., Suite 314, Westminster, CO 80234, United States

www.sendphotos.com

Virtual Album

Vendor: Radar Software

Purpose: Organize, protect, and share your photographs

Description

Virtual Album lets you create albums from images direct from a digital camera or scanned into your computer. It has an option for presenting full-screen slide shows complete with descriptions, while making it easy to add the descriptions with simple mouse clicks. One unusual feature is "Point a Person," which allows you to list people's names in your photos and point each person out.

Easy to use, Virtual Album lets you create an unlimited number of sub-albums, attach background music, and perform image transformation using photo-optic tools. Output can be to the Web or you can burn your exported albums to CD. It also gives you the option of printing 1, 4, or 24 photos per page.

Comments

From a design point of view, Virtual Album looks a little homespun, although some users actually like their software to have a friendly and non-threatening appearance. For example, the "Point a Person" feature is a good idea, but the lists of names take up almost as much room as the images. The vendor aims the product at the home user and also sells useful hardware to connect a PC to a TV so that you can see your albums in a family viewing area.

Version: Virtual Album 3.0 (2008)

OS: Windows 95, 98, NT, 2000, ME, and XP

RAM: 128MB

Supported file formats: Major image formats

Price level: Approx. $30

Address: Radar Software, Inc., 7027 W. Broward Blvd. #400, Plantation FL 33317, United States

www.albumsoftware.com

Summary

Photo album packages are essentially digital scrapbooks minus the Easter bunnies and all the other clutter that interferes with the clean presentation of images. At their best they help you produce stunning books of images, organized with attractive layouts, tasteful borders, and discreet captions. Alternatively, your book can be a virtual album that exists only online or in the computer. Page turning can be perfectly simulated, so there is really no need to chop down a forest for physical materials. It is a very popular category of software, hence only a selection has been described in this chapter. Examples range from the free Swedish product JAlbum to the wizard-based Diji Album from New Zealand. Millions of people use Google's Picasa (see Chapter 2, "Image Viewers") and Kodak's EasyShare, whereas Apple's Aperture also has excellent album creation facilities (see Chapter 38, "Two Featured Products").

Slide Show Creation

What passes for slide show creation in most image viewers and editors is little more than the automatic cycling of images with a brief dissolve in between them. This may be acceptable on some occasions, but it is scarcely the kind of show we remember from the great days of audio/visual presentation using real slides on computer-controlled banks of Kodak Carousel projectors. Even in the Victorian era, traveling showmen put on great entertainment with magic lanterns that took slides with moveable picture elements. The visual effects they created were more complex than those in the first edition of Adobe Lightroom's slide show module. Did you ever see the one of a man swallowing a rat?

Specialized slide show software goes a long way beyond what is offered in standard image editors. For a start, it needs to accommodate a synchronized soundtrack, the one element that is most likely to create a memorable experience, apart from the images themselves. Second, it needs to have the ability to pan and zoom the images and record these effects for automatic playback. Plenty of transition effects is a given—and here some developers go way over the top in providing visually irritating transitions along with the good ones. Finally, it needs to have an interface that makes it easy for you to organize images and set timings, and synchronize transitions to the soundtrack. Surprisingly, very few software packages meet these criteria.

Unlike some of the other categories in this book, the slide show software listed in this chapter is a rag-bag collection of packages with very different personalities. They range from the no-nonsense Soundslides, favored by journalists, right up to ProShow Producer for making professional shows. In a determined effort to mix media as much as possible, Slideroll lets you create a slide show online, download it as a QuickTime movie, and then email it to your friends. If it can be done, you know there is a developer out there who will attempt to do it.

ImageMatics StillMotion Professional

Vendor: Net<X>Corporation

Purpose: Professional pan and zoom animation tool for "Ken Burns" effects

Description

ImageMatics StillMotion lets you create sophisticated slide shows in Flash or video by zooming and panning within high-res images, in the style of American documentary filmmaker Ken Burns. Most documentary films now use this technique, but Ken Burns made it popular in such films as *The Civil War* (1990) and *Baseball* (1994). By introducing motion to still images—for example, by zooming in to one particular face in a group shot—he showed how you could hold the audience's attention and create compelling footage.

You can use ImageMatics StillMotion for creating virtual tour segments or still image animation for commercials, news, documentaries, wedding and event videos, and many other applications. Saved in the Flash format as SWF (pronounced "swiff") files, the animations take up very little bandwidth online. In fact, a full minute of animation requires only 600 bytes in addition to those needed to show the original image. As the vendor points out, 98% of all browsers in current use can support Flash.

ImageMatics StillMotion comes in two editions: StillMotion Personal Edition-II and StillMotion Professional. Personal Edition-II supports single-click publishing output such as auto-play CD-ROM, video for DVD and YouTube, Web pages, SWF files, and self-extracting movies. The Pro edition adds facilities for Web page navigation, thus enabling you to create linked content.

Comments

The vendor describes this product as "an essential tool for any digital photographer," and it is hard to disagree. Yes, it removes a vital quality (the "stillness" of still photography), but in doing so it brings movement, which is essential if you are using your images to tell a story, create a slide show, or form an insert to a video. The history of the product dates back to founder Bill Strum's long-term relationship with StageTools (www.stagetools.com), a creator of professional film animation software. By bringing this technology to a wider market, ImageMatics made a serious contribution to the art of digital photography. It should be noted that other slide show software (such as Canopus Imaginate) now offers panning and zooming as standard effects. StageTools itself also markets these techniques to the prosumer as a plug-in to Adobe Premiere, After Effects, and other multimedia software.

Version: ImageMatics StillMotion Professional (2008)

OS: Windows 95, 98, 2000, XP, and Vista

RAM: 64MB

Supported file formats: JPEG, TIFF, TGA, and BMP (see description)

Price level: Personal Edition-II (PE) $50, Professional (Pro) $100

Address: Net<X>Corporation, 5405 Tuckerman Lane, #407, North Bethesda, MD 20852, United States

www.imagematics.com

DVD Slideshow Builder

Vendor: Wondershare Software Co.

Purpose: Creates professional DVD slide shows and home movies using digital photos and videos

Description

DVD Slideshow Builder is a versatile package for creating slide shows on DVD, using either your digital stills images or videos. It is very up to date, with support for the latest HD formats, and enjoys ongoing development by the vendor. It lets you add background music, transition effects, captions, and DVD menus, and allows you to crop or edit your photos/videos, and add text, effects, and clipart. It is ideal if you want to export the result to a mobile device, such as an iPod, iPhone, Zune, or cell phone.

Comments

Easy to set up and use, DVD Slideshow Builder has most of the features needed for creating basic slide shows on DVD. It lacks voice recording facilities, but this will almost certainly be added in later versions. It boasts a storyboard and a timeline, with editing tools to make your slides match the music. There are plenty of transition effects and timing controls, all of which are easy and intuitive to use. Themes include baby, nature, occasions, sport, travel, wedding, and professional. It is hard to think of a better toe-in-the-water introduction to multimedia authoring; it's simple but effective.

Version: DVD Slideshow Builder 4.1 (2008)

OS: Windows 2000, 2003, XP, and Vista

RAM: 256MB (512MB recommended)

Supported file formats: Inputs TIF, TIFF, FAX, G3N, G3F, JPG, JPE, PCX, BMP, DIB, RLE, ICO, CUR, PNG, WMF, EMF, TGA, TARGA, VDA, ICB, VST, PIX, PXM, PPM, PGM, PBM, JP2, J2K, JPC, and J2C; audio formats are WAV, MP3, and OGG; video formats are AVI, MPG, MEPG, and QuickTime; outputs disc export (VCD, SVCD, DVD, Blu-ray discs, and HD-DVD) and video export (AVI, WMV (Zune), MPEG1, MPEG2, and MPEG4 (iPod))

Price level: Approx. $40

Address: Wondershare Software Co. Ltd., 3/F, Fucheng Hi-Tech Building, Gaoxin Ave.1.S., Nanshan District, Shenzhen, Guangdong, PR China 518057

www.wondershare.com

Imaginate

Vendor: Canopus

Purpose: Creates animation from still images by zooming, panning, rotating, and skewing

Description

Imaginate creates slide shows that look like movies, using still images and "virtual camera" movements. You can pan, zoom, rotate, or skew an image in order to get movement into the show. It has a Scene Wizard and Storyboard mode for putting the show together quickly, complete with synchronized music and real-time preview. For fine-tuning the timings and transitions, there are keyframing options, making it possible to create complex productions. You can make intricate motion sequences using the Anchor and Spline controls for precise camera positioning.

On completion, an Imaginate show can be exported to video formats for editing and to VideoCD/DVD for storage and distribution. It works as a stand-alone product and as a plug-in for various video editors.

Comments

Reviewers found Imaginate to be suitable for both hobbyists and professionals, the latter including event and corporate videographers who need to include still image content in their productions. EMediaLive (www.emedialive.com) definitely considered it to be "powerful enough for pros" on account of its 3D controls, spline editor, and customization options. Also worth noting is the excellent quality of rendered output, if you work with medium- or high-res images.

Version: Imaginate 2.0 (2008)

Plugs into: Grass Valley EDIUS Pro, Canopus Edit, Canopus Let's EDIT 2, and Adobe Premiere Pro 1.x

OS: Windows 2000 Professional and XP Home or Professional

RAM: 256MB

Supported file formats: BMP, JPEG, TGA, PSD, JNG, PNG, TIFF, IFF, MNG, PCD, PCX, WAV, MP3, WMA, WMV, AIFF, AVI, MPEG, MPEG-2, and ASF; video formats include uncompressed RGB AVI (PAL/NTSC, 16:9/4:3), Microsoft DV (PAL/NTSC, 16:9/4:3), and DirectShow AVI codecs

Price level: Approx. $200

Address: Canopus Corporation, 711 Charcot Ave., San Jose, CA 95131, United States

www.canopus.com

MAGIX Xtreme PhotoStory on CD & DVD 6

Vendor: MAGIX

Purpose: Turns digital images into slide shows with a soundtrack, for TV display

Description

MAGIX Xtreme PhotoStory on CD & DVD 6 lets you turn digital images into a slide show, complete with a soundtrack, for burning to disk and displaying on all types of monitors, including 16:9 widescreen TVs.

The software puts a collection of images together as a slide show almost instantly, but you have to add text, fades, and zooms in the appropriate places. Beyond that, it offers a wide range of features, with editing functions that include auto-exposure/color, red-eye correction, and white balance. A key feature is the capacity to add a recorded commentary synchronized to the pictures.

Dozens of special effects are inevitable in good slide show software and PhotoStory does not disappoint in this department, with dozens of transitions, including a 3D page turner, morphing, and picture-in-picture effects. It can simulate video camera movements with zooms and pans. Neither does it lack "fun elements" like speech bubbles and cartoons. Output is to CD or DVD, or to the MAGIX Online Album, a free Website for online slide shows and streaming videos. It creates CDs with SCSI or IDE CD-R(W) burners and DVDs with DVD+/-R(W) burners.

Comments

One line of the vendor's advertising reads: "Never have boring slide show evenings ever again!" The problem is that unless the photographs are so good they speak for themselves, no one will ever create an interesting slide show without considerable effort. Transitions require a sense of timing; soundtracks a sense of theater. However, if you are a good photographer with a flair for drama and time on your hands, MAGIX Xtreme PhotoStory on CD & DVD 6 is a great product. Latest features include the ability to enhance portrait pictures with creative effects, use animated Web graphics as decorative elements, and add Flash movies to HTML Websites.

Version: MAGIX Xtreme PhotoStory on CD & DVD 6 (2008)

OS: Windows 2000, XP, and Vista

RAM: 256MB

Supported file formats: JPEG, BMP, GIF, TIFF, and PSD

Price level: Download approx. $20, box approx. $25

Address: MAGIX AG, Friedrichstraße 200, 10117 Berlin, Germany

www.site.magix.net

ProShow Producer

Vendor: Photodex Corporation

Purpose: Professional slide show creation software

Description

ProShow Producer is a professional-grade package for making slide shows. Unlike simpler, consumer-grade software, it offers a very full feature set and handles over a hundred file types, including video formats. It lets you add any number of layers to any slide, with full masking capability so that you can reveal underlying layers. There is a full range of transition effects between layers and between slides. You can also use interactive slide actions to launch PDFs, spreadsheets, and Web pages at any point in the presentation.

Editing and captioning features are equally extensive. You can adjust the color and opacity of a shadow on any layer, and crop and rotate the images (and indeed the videos) with precision. A new feature in the latest version lets you animate captions and create multiple caption motion effects on a single slide. The soundtrack has not been neglected, either, as it often is in less sophisticated slide show software. ProShow Producer provides an Audio Trimmer to crop the audio and set fades, and there is now a built-in soundtrack waveform in the slide list.

Besides ProShow Producer there is also ProShow Gold ("for enthusiasts") and ProShow Standard ("for beginners"), but these versions have reduced functionality.

Comments

The average middle manager with a busy job may find ProShow Producer a challenge after using PowerPoint, but this is a professional tool aimed at those who have the time, knowledge, and skill to create great presentations. However, there are very extensive training materials available, including videos, "how-to" guides, and a tips library, all of which make it possible for anyone to learn to use it. Slide show templates get you up and running quickly and boost productivity. Finally, there is a whole gallery of other people's work that you can eyeball enviously. Make no mistake—this is the top slide show creation package. In 2008, it won its second "Hot One" award from the Professional Photographers of America, in the Presentation Software category.

Version: ProShow Producer 3.2 (2008)

OS: Windows 2000, XP, and Vista

RAM: 1GB

Supported file formats: More than 100 file types, including RAW

Price level: Producer edition approx. $250, Gold edition approx. $70, Standard edition approx. $30

Address: Photodex Corporation, 925 Westbank Drive, Austin, TX 78746, United States

www.photodex.com

Soundslides

Vendor: Soundslides, LLC

Purpose: Production tool for still image and audio Web presentations, favored by journalists

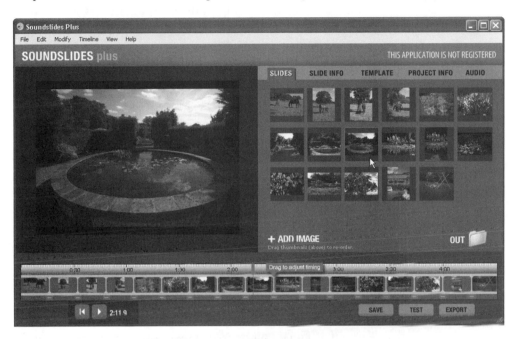

Figure 27.1
Soundslides is a basic but effective tool for creating slide shows rapidly.

Description

If you need a really quick tool for putting together a slide show of photojournalistic images and voiceover, Soundslides is the ideal solution. It makes SWF (Flash) files, together with the HTML needed to display them. It does not come with any Web hosting services but conveniently exports a folder so that you can upload the show to your server without additional work. Although it is optimized to work with fewer than 200 images, there is no fixed upper limit.

A new professional version called Soundslides Plus introduces image movement in the form of panning and zooming. It also includes image-only click-through slide shows, individual transitions, built-in lower-third subtitles, and built-in thumbnail menus.

Comments

Soundslides is a basic utility, without any editing facilities for audio, but it produces clean and attractive results very quickly. That is probably why journalists like it so much.

It is essential to perform pre-prep on the slides before loading them into Soundslides and to create and edit a soundtrack. A typical journalist's workflow is to tone, crop, and caption the images in Photoshop; convert them to generic RGB with a longest dimension of 1,000 pixels; sharpen the images; save them as JPEG on 12 or Maximum (top quality/lowest compression); and then finally import them to Soundslides. At the vendor's Website there is a lively forum where you can see many great shows made with the software, plus get help and search the knowledge base.

Version: Soundslides 1.8 and Soundslides Plus 1.2 (2008)

OS: Windows 2000, XP, and Vista; Mac OS X 10.3

RAM: 256MB

Supported file formats: JPEG and MP3 audio

Price level: Approx. $40, Soundslides Plus $70

Address: Soundslides, LLC

www.soundslides.com

Slideroll

Vendor: Geoffrey P. Gaudreault

Purpose: Slide show creation/publishing online service, with Flickr import

Description

Slideroll is an online service that allows you to upload images or import them directly from a Flickr account, and then create and display a slide show. It has several features that you would expect from specialist desktop software, with pan and zoom, text overlay, and a recently added capability for a soundtrack.

There are two editions: Basic, limited to 100 uploads/10 slide shows, and Pro, with 5,000 uploads (may be increased in the future) and unlimited slide shows.

Comments

Once you have created a slide show online, you can download it as a QuickTime movie, post it to your Website, put it on MySpace or YouTube, or email it to friends. It is all good fun, although the end result may have limited entertainment value unless you are exceptionally gifted at packing a punch in a tiny format. In fact, this software was created by an accomplished interactive designer whose work sets an excellent example. Putting a show on to Slideroll would make a good class exercise for first-year media students.

Version: N/A (online application)

OS: Browser-based access

RAM: N/A

Supported file formats: JPEG

Price level: Basic edition free, Pro edition by subscription

Address: Geoff Gaudreault, www.gaudreault.org

www.slideroll.com

Slide.com

Vendor: Slide, Inc.

Purpose: A set of online services for making and publishing slide shows

Description

Slide.com is the top online service for making and sharing slide shows. It comprises more than one product. It includes Slideshows, FunWall, and SuperPoke!, which are all popular widgets used on social networking and blog platforms such as MySpace, Facebook, Bebo, Hi5, Friendster, Tagged, and Blogger. Itself dubbed the "$500 Million Widget" by *BusinessWeek* on account of its spectacular growth, Slide.com has leveraged the success of these sites, adding animation and decorative elements to make ordinary images look more fun.

Slide show creation is available in German, Spanish, Portuguese, Simplified and Traditional Chinese, Japanese, Thai, and Korean. Once you have uploaded images you can select from Styles, Skins, Themes, Music/Video, Background, Effects, Size, and Privacy (public or private viewing permission). The video selector lets you play a popular music video as a thumbnail in a corner of the show.

Among Slide.com's other applications, FunPix allows you to personalize images with stickers, graffiti, thought bubbles, and so on. SkinFlix lets you frame YouTube videos with skins such as diamonds or a plasma TV.

Comments

A business created by PayPal co-founder Max Levchin, Slide.com has created a new breed of online applications that offers few instructions; it just lets you upload images and click some buttons to add the effects. The Slide.com widgets are not intended to exist independently of the social networking sites to which they add substantial functionality and value. However, you can go directly to the Slide.com site and make a slide show, adding images from any of the previously mentioned sites as well as Flickr, PhotoBucket, or any other site.

Version: N/A (online application)

OS: N/A

RAM: N/A

Supported file formats: JPEG

Price level: Free (advertising supported)

Address: Slide, Inc., 612 Howard Street, Suite 400, San Francisco, CA 94105, United States

www.slide.com

Animoto

Vendor: Animoto Productions

Purpose: Automatic, online slide show creation utility; makes videos from uploaded images

Description

Animoto generates synchronized slide-sound videos from uploaded images, entirely automatically. It lets you choose or upload music of your choice, and then analyzes both the images and the music before rendering a slick video presentation. Simple to use, it has proven to be a great hit on the Internet, enabling many thousands of users to make slide shows from their images stored on Flickr (or other photo-sharing sites), and then upload them to YouTube with a click of a button.

For successful results, you need to "tell a story" with your images, not least by taking plenty of them. Instead of trying to capture individual moments, you should aim at capturing a whole experience, whether it be a trip to the coast, a walk in the park, or a visit to Disneyland. The developers refer to the "brains" behind Animoto as "Cinematic Artificial Intelligence technology," an expert system that takes into account of the structure, rhythm, instrumentation, and other qualities of the song or instrumental music chosen to accompany the images. It uses dozens of neat editing tricks, like duplication of images, on-screen displacement, and cuts and fades, to match the mood and pace of the soundtrack.

The end result is a professional-looking music video, no two of which are ever the same. In fact, you can use a different choice of music with the same set of images to create videos that are entirely dissimilar in their impact.

Comments

Often cited as a classic "Web 2.0" application that maximizes the use of "cloud computing" resources, Animoto was created by TV/film producers who had made professional videos for MTV, Comedy Central, and ABC. A little bit of lateral thinking led them to encapsulate their skills in software that is both time-saving and fun to use. Its outstanding success as a Web service owes much to its efficient use of Internet infrastructure, enabling it to accept 20,000 new users per hour following its appearance as a Facebook application. As its developers point out, it opens up YouTube as a potential showcase for people who prefer to take only digital stills rather than movies. Animoto was the winner of the Film/TV category at the 2008 SXSW Interactive Festival (2008.sxsw.com).

Version: N/A (Web application)

OS: N/A

RAM: N/A

Supported file formats: JPEG or GIF (smaller than 3MB); MP3

Price level: Free to users

Address: New York, NY, United States

www.animoto.com

> **Note**
>
> It is essential to reduce the size of your images to 3MB or smaller before attempting to use Animoto. For Macintosh users, the developers recommend the free DroPic! utility (www.kreynet.de/dropic/). Windows users can use VSO Image Resizer (www.vso-software.fr). However, there are many other, similar utilities that perform the same task.

SWF 'n Slide

Vendor: Vertical Moon

Purpose: Create photo slide shows in Flash with your digital images and audio

Description

SWF 'n Slide is a program that lets you put your slides and some music together into a professional-looking slide show in Adobe's Flash file format. It will also output HTML so that you can create a Web page on which you can place the show.

SWF 'n Slide comes in two editions—Standard and Professional. The Professional edition has a WYSIWYG workspace and more viewing types including scrolling thumbnails and a 3D Album (a page-turning simulation). The program lets you add sound effects, narration, or background music, together with playback control buttons so that the viewer can pause or play the slide show. There are over 150 transition effects, special effects such as fireworks, falling snow, and hearts that can be superimposed on the slides, pan and zoom camera effects, plus resize, crop, rotate, and flip. You can even add a preloader to enable smooth playback over the Internet.

Comments

Created by Flash specialists who know what they are doing technically, SWF 'n Slide is a versatile and reliable application that is great fun to use. Reviews have been highly favorable, mentioning that it is well laid-out, easy-to-use, and has excellent file handling facilities. So far, so good—but the name? The vendor points out that 97% of browsers have Flash playback facilities. This is true, but what percentage of users knows that SWF, the Flash file format, is pronounced "swiff"?

Version: SWF 'n Slide Pro/Win 1.024, Pro/Mac 1.026 (2008)

OS: Windows 98, ME, 2000, and XP; Mac OS X (recommended, essential for Pro edition) or later

RAM: 64MB (128MB recommended)

Supported file formats: Imports BMP, GIF, JPEG, PDF, PSD, PICT, PNG, TGA, TIFF, AIFF, MP3, System 7 Sound (Mac only), WVA, TXO (Text-Osterone text effects), and LKL; exports Flash SWF, Macintosh Flash Projector, Windows Flash Projector, QuickTime .mov, Screen Saver, and HTML

Price level: Approx. $90, Pro approx. $110

Address: Vertical Moon, PO Box 9881, Brea, CA 92822, United States

www.verticalmoon.com

Summary

Slide show creation is one of the most demanding branches of media, desperately dull when misconceived or poorly executed, but utterly inspiring when somebody does it correctly. The three main elements are images, words, and music, all of which need to be synchronized if the show is to make any sense. Several compelling art films have been essentially slide shows transferred to continuous celluloid, like Chris Marker's memorable 1962 movie *La Jetté,* or, more recently, Patryk Rebisz's prize-winning 2005 short film *Between You and Me,* shot entirely with a Canon DSLR. Among the software described in this chapter, ProShow Producer is the professional-grade package for making the most sophisticated shows, but photojournalists love Soundslides for its simplicity and speed.

Part V
Preparation for Printing

This part covers the following topics:

28

Image Rescalers

After their first experience of sending a digital image to a print shop for enlargement and printing, many people express astonishment at the high image quality obtained by a professional service. The original image may have been only 8 megapixels, but when it comes back it looks like 16 megapixels or more. How did the extra resolution come to be there? The answer is through *interpolation*. This process runs complex routines that place additional pixels in between the existing ones, at the same time taking into account the existence of edges and fine detail. This process is called, colloquially, *up-rezzing*.

Image rescaling (to give it a more formal name) is a lucrative market for software developers because so many companies and individuals need to print high-quality digital images. There has been intense competition to create the best possible method, using interpolation routines with exotic names like "bilinear," "bicubic," "B-spline," "sinc," or "Lanczos." Broadly, rescaling algorithms fall into "non-adaptive" types, like those just mentioned, and "adaptive" types, which are much smarter because they give special attention to edge-defining pixels. If a developer wants to make an impression with a new brand of rescaling software, it has to be based on a very fancy adaptive algorithm. A good example is the adaptive S-Spline XL algorithm in BenVista's PhotoZoom Pro, but others produce comparable results, depending on the required magnification.

The price range for image rescaling software is relatively high: $150–$450. Photoshop and other editors have rescaling facilities, so is an alternative method worth the extra expense? The answer is absolutely, if you want to print enlargements beyond 8"×10". All the packages listed in this chapter will make significant improvements.

BlowUp

Vendor: Alien Skin

Purpose: Image rescaling to 3,600 percent (six times) with no noticeable artifacts

Description

BlowUp is an "up-rezzer" that enlarges digital images in preparation for printing. It is effective at enlarging images containing clear outlines, such as those taken by a fast lens to blur the background and isolate the subject. BlowUp detects these edges and then scales the areas bounded by them using vector-style techniques, eliminating jagged artifacts in 6x enlargements.

The vendor is so confident about BlowUp's capabilities, it claims that graphic designers can scale Web graphics up to print resolution. BlowUp has a 30,000-pixel size limitation, which fortunately is not total pixels but refers to the maximum number of pixels in width or height (billboards and buses are out). Features include photo grain controls, enlargement-specific sharpening, and support for several image modes, including CMYK.

Comments

Alien Skin maintains its reputation for great plug-ins with BlowUp; all reviewers find it the winner in comparative tests with standard Photoshop techniques. However, it is hard to say whether output is better or worse than that of its great rival Genuine Fractals because subjective taste is a factor. Images upscaled in Genuine Fractals tend to have sharper outlines but more geometric artifacts in areas of color. Take a look at samples from both packages before purchasing.

Version: BlowUp 1.1.1 (2008)

Plugs into: Windows Photoshop CS or later and Photoshop Elements 3 or later, Mac CS2 9.0.2 or later and Photoshop Elements 4.0.1 or later

OS: Windows 2000, XP, and Vista; Mac OS X 10.4.0 or later

RAM: 512MB

Supported file formats: Those of host program

Price level: Approx. $200

Address: Alien Skin, 1111 Haynes Street, Suite 113, Raleigh, NC 27604, United States
www.alienskin.com

Genuine Fractals

Vendor: onOne Software

Purpose: Image rescaler for creating high-quality, print-ready enlargements

Description

Genuine Fractals lets you make images many times bigger without noticeable loss of quality. By analyzing the image prior to scaling it, Genuine Fractals can make sure that the color values of newly created pixels are appropriate to the image. In early versions of the software, you had first to save your files in the .STN ("sting") format, but now files opened in Photoshop can be scaled in a single step. The improved sharpness and overall quality of the "rezzed up" image achieved by using fractal techniques is demonstrable, especially for natural forms.

Genuine Fractals generates a scalable, resolution independent format to which any image may be converted. It lets you scale your images by up to 1,000 percent. The vendor suggests a number of other ways in which it can be used. For example, you can save time and money if you scan images at a lower resolution, and then scale them later with the fractal software. You can also save storage space by up to 50 percent if you use the Visually Lossless encoding option.

Those who work in a strict CMYK color workflow will need Genuine Fractals Print Pro, which adds support for scaling CMYK images as well as RGB and grayscale. However, if you are using inkjet printers and work in sRGB, Adobe RGB, or the Pro Photo color workspaces, the Standard edition is completely adequate to your needs.

Comments

However much you magnify a true fractal pattern, it always seems to have the same shape. It was therefore only a matter of time before someone harnessed this mathematical phenomenon and hitched it to the cause of enlarging photographs. Genuine Fractals has a colorful history, having been developed by Altamira, sold to LizardTech, developed up to version 4.0 in 2005, and then sold again by LizardTech's parent company Celartem to onOne. When it first appeared, some reviewers were so enthusiastic about it they were accused of bias, but this was not the case. Genuine Fractals is a genuinely effective product, a massive step beyond traditional bicubic interpolation.

Version: Genuine Fractals 5

Plugs into: Photoshop CS2 9.0.2 and CS3 and Photoshop Elements 4 or later

OS: Windows XP SP2 and Vista; Mac OS X 10.4.8 or later

RAM: 512MB

Supported file formats: Those of host program

Price level: Approx. $160, Pro version $300

Address: onOne Software, 15350 SW Sequoia Pkwy., Suite 190, Portland, OR 97224, United States

www.ononesoftware.com

PhotoZoom Pro

Vendor: BenVista

Purpose: Image magnification for printing using an adaptive S-Spline XL algorithm

Description

PhotoZoom Pro is an image-magnification package that uses an adaptive S-Spline XL algorithm (another spline variant) to achieve high-quality interpolation. In this technique, the algorithm deals with actual pixel values—not just their position in the image—to derive different weights for calculating new pixels. The image remains sharp and focused but avoids jagged edges and the slightly artificial look associated with some forms of enlargement. PhotoZoom Pro supports 48- and 64-bit images and contains some fine-tuning tools to maximize the quality of the upsized image.

Comments

The developer, Rogier Eijkelhof, is sufficiently confident to allow you to flip between images processed by PhotoZoom and other packages and to examine the results in close-up. Reviews have been very positive, several of them saying this is the best image rescaler available. That may be going too far, given the quality of the competition, although the results are clearly very pleasing. The product is marketed by Shortcut Software (www.shortcutinc.com) in the United States.

Version: PhotoZoom Pro 2.3.2 (2008)

Plugs into: Windows Photoshop 6 or higher, Corel Paint Shop Pro and Photo-PAINT; Mac CS2/CS3

OS: Windows 98, ME, NT4, 95, 2000, XP, and Vista; Mac OS X 10.3, 10.4, and 10.5

RAM: Windows 64MB; Mac 128MB

Supported file formats: As host

Price level: Approx. $150

Address: Shortcut Software Europe Ltd., Meander 251, 6825 MC Arnhem, The Netherlands

www.benvista.com

Liquid Resize

Vendor: onOne Software

Purpose: Content-aware image resizing plug-in that minimizes geometric distortion when the aspect ratio changes

Description

Liquid Resize is a "content-aware" image-resizing application that allows you to change the aspect ratio of an image without distorting the contents. At the time of writing it is still in early development, but the vendor has made a preview version available to anyone

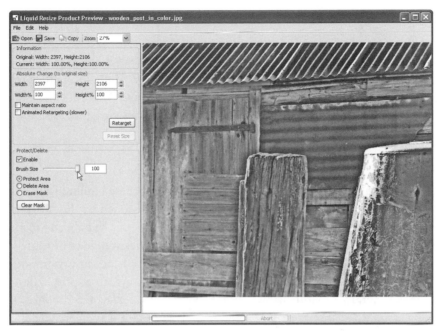

Figure 28.1
Liquid Resize can shrink the background while leaving one or more objects untouched.

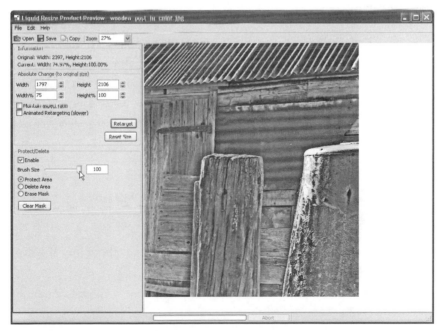

Figure 28.2
Note how the pillar in the center is unaffected by squeezing the image horizontally.

who wants to try it. It is intended to become a Photoshop plug-in, but until then it is being offered for trial as a stand-alone application.

Not a conventional rescaling or interpolation product (for that, the vendor recommends its Genuine Fractals software), Liquid Resize lets you mask areas of the image for protection or deletion, while providing two key controls for height and width. If you check the "animated retargeting" box, you can see the resizing take place in real time, although this slows the process on all but the fastest machines.

Comments

Always on the lookout for great new ideas, onOne Software purchased Liquid Resize in early 2008 with a view to making it a Photoshop plug-in. Developed by the Austrian husband-wife team of Ramin Sabet and Irmgard Sabet-Wasinger, it had already made a big impact at SIGGRAPH 2007, where its unique capabilities were demonstrated. However, it is not yet clear whether there will be a big demand for it, because most photographers and layout designers are quite capable of preserving correct proportions within the image, when they put their minds to it. For lazy Web designers, obliged to squeeze images into odd shapes, it may be a blessing. It is certainly a remarkable and intelligent tool, with an uncanny ability to preserve the proportions of individual objects, whatever the shape of the frame.

Version: Liquid Resize Product Preview (2008)

OS: Windows XP SP2 and Vista; Mac OS X 10.4.10 or 10.5

RAM: 256MB recommended

Supported file formats: 8-bit JPEG (final version will support all major image formats)

Price level: Free public beta

Address: onOne Software, 15350 SW Sequoia Pkwy., Suite 190, Portland, OR 97224, United States

www.ononesoftware.com

SizeFixer

Vendor: FixerLabs

Purpose: Image rescaling without loss of sharpness; also available as a Web service

Description

SizeFixer is an image rescaler that can enlarge images for printing without loss of sharpness. It comes in three main editions:

- SizeFixer Home, for quadrupling the number of pixels from a digital camera or camera phone.

- SizeFixer SLR, for enlarging images up to 68 megapixels.

- SizeFixer XL, for enlarging to 500 megapixels and beyond.

SizeFixer works on both 8-bit (24-bit RGB) and 16-bit (48-bit RGB) images and uses what the vendor calls "Super-Resolution Technology" to enlarge while preserving fine detail.

To introduce SizeFixer to the photographic world, the vendor originally offered it as an online service as well as a software application. But now the software has become established, the service has been dropped. Enlargement is to A0 (33"×46") size or larger. It requires an uncompressed, unsharpened TIFF image from a quality camera, complete with attached Exif data. The software uses information in the Exif data to optimize the image.

Comments

SizeFixer is the vendor's flagship product: stand-alone software that "up-rezzes" for printing more effectively than any standard image editor, including CS3. It is certainly one of the most effective rescalers currently available. Macworld mentioned its relative slowness (it is now five times faster on an Intel Mac) but gave it a glowing review for the quality of its output. SizeFixer uses the LensFIT technology that is also available in the vendor's plug-ins (FixerBundle) to customize sharpening for the particular camera used for taking the original. It preserves an exceptional level of detail, making it ideal for anyone preparing exhibition-quality prints.

Version: SizeFixer SLR 1.3.0r9, SizeFixer XL 1.3.3r9 (2008)

OS: Windows 2000, XP, and Vista; Mac OS X (Mac version of Home product in development)

RAM: 512MB

Supported file formats: RGB, TIFF, and JPEG

Price level: Home version $60, SLR version $120, XL version $200 (all approx.)

Address: FixerLabs, Watford, United Kingdom

www.fixerlabs.com

Summary

Image rescaling (or *up-rezzing*) is a process that increases the number of pixels used for representing an image, prior to printing. Without rescaling, the pixels themselves can become visible to the eye, but the process ensures this does not happen. Many different and competing algorithms have been developed for this purpose, the most popular of which are now the intelligent, "adaptive" algorithms. These adaptive algorithms can detect the edges of objects and treat them differently from the rest of the image. Professional print shops use products such as Genuine Fractals or BlowUp to rescale images when making poster-sized prints.

29

Color Management

Whenever an artist in ancient Rome wanted to represent the color of clotted blood, he reached for his jar of Tyrian purple, made from the secretions of a marine snail. This is an early example of color management. We have come a long way since then, but the example certainly illustrates that the concept is not new. In Roman times, color management was "pigment dependent," hence somewhat limited. In our times, until very recently, it was "device dependent," meaning that you could control the color of the end product providing you used equipment designed specifically to work together. But now, color management has taken a giant leap forward. The human perception of color has been codified in such a way that each stage of color reproduction, from capture to print, can be done "to the numbers." You can use any camera, monitor, or printer, as long as each one has a color profile that can be passed across to the other devices. After starting at a snail's pace two thousand years ago, color management has finally arrived.

Overseeing the growth of color management is the International Color Consortium (ICC), a body formed in 1993 by a small group of manufacturers, including Apple, Adobe, and Eastman Kodak. Their aim from the outset was to create an open architecture based on international color standards that would allow color-management systems to work with all devices, even those that, at the time of image input, have not yet been chosen for the output. The work of the ICC, now a body with more than 70 members, has been outstandingly successful and its profile specification (V4 at the time of writing) has been approved as an International Standard, ISO 15076.

ICC Profiles

A color profile is a description of the color characteristics of the device in question. In structure, it consists of matrices, tone curves and lookup tables (LUTs) that describe characteristics such as "blackest black" or "most saturated blue" in their respective color spaces. Profiles can be passed in both directions of the workflow. For example, you can obtain the ICC profile of an intended printer and use it to adjust the printer input.

Calibration

If color management is to work properly, every device in the chain needs to be calibrated regularly, especially the monitors and printers. Color management software usually comes with a color-measuring device for this purpose. Monitors require a colorimeter to measure the color of emitted light; printer output needs a slightly more expensive spectrophotometer to measure reflective light. Once used exclusively by professionals, this type of hardware is now within reach of the amateur—a sure indication that color management has come of age.

Software

Listed in this chapter is a selection of color management software, chiefly from the two manufacturers, X-Rite and Datacolor, which dominate the market. X-Rite in particular has a huge, and some would say, bewildering range of solutions that has undergone re-naming and reorganization following the acquisition of Monaco, GretagMacbeth, and Pantone. Not listed here are any of the consultancies that have sprung up to help companies implement color management, a discipline that is not as hard as it seems on first acquaintance. Although the color science underpinning the software requires lengthy study to be fully understood, using the software is relatively easy. No one should be put off using it because of its supposed difficulty.

PANTONE huey

Vendor: Pantone, Inc.

Purpose: Monitor calibration system, with colorimeter and software

Description

PANTONE huey is a popular monitor-calibration system that comes in a package containing a slim colorimeter and accompanying software. It is used for calibrating all types of monitors: CRTs, LCDs and laptop screens. When it's not being used for this purpose the colorimeter sits in a stand, measures ambient light, and adjusts the monitor accordingly. It is aimed chiefly at consumers and photo enthusiasts.

Figure 29.1
PANTONE huey comes with monitor-calibration software and a compact colorimeter.

PANTONE huey reminds you every two weeks that it is time to recalibrate the monitor. Having a wizard-driven interface, it requires no formal understanding of color management. You just follow the step-by-step procedure. It takes five minutes to calibrate a monitor, ensuring accurate color to ICC standards.

Comments

Every so often a product comes along that captures people's imaginations, and PANTONE huey is such a product. The physical shape of the colorimeter, its dual purpose, and the ease of operation all combine to make this a winner. Most reviewers have commented on its ease of use and most have confirmed that you get a distinct improvement in display quality as a result of using it. Other reviewers have warned that this is strictly a consumer product and should not be used by professionals trying to cut costs. Pro photographers need the marginally more expensive PANTONE hueyPRO, which offers better control over calibration and output matching. User-defined white point and gamma combinations, plus higher-grade optical sensors, make the Pro version the better investment of the two products.

Versions: PANTONE huey 1.0.5 and PANTONE hueyPRO 1.5 (2008)

OS: Windows 2000, XP, and Vista; Mac OS X 10.3 or higher

RAM: 128MB

Supported file formats: N/A

Price level: huey approx. $90, hueyPRO approx. $130

Address: Pantone, Inc., World Headquarters, 590 Commerce Blvd., Carlstadt, NJ 07072-3098, United States

www.pantone.com

Kodak Profile Wizard Mio

Vendor: Kodak's Graphic Communications Group

Purpose: Create and manage monitor, input, output, and DeviceLink ICC profiles

Description

With Profile Wizard from Kodak you can create and manage device and DeviceLink ICC profiles for three to seven color devices. It also has comprehensive ICC profile editing capabilities with control over gradation, luminance/saturation, gray balance, black hue, white point, and color correction. It supports a large variety of spectrophotometers and spot color matching. It can also preserve black channel separation across the entire color space.

As its name suggests, Profile Wizard has a wizard interface that makes the whole process of creating ICC profiles relatively easy. With its comprehensive set of ICC profile editing features, you can interactively preview and edit destination and DeviceLink profiles in HLS, CMYK, and CIE L*a*b modes.

Version 4.0 of Kodak Profile Wizard Mio generates monitor profiles in ICC 4.0, input profiles in ICC 2.0, output files in ICC 2.0 and 4.0 according to the selected option, and DeviceLink profiles in ICC 2.0 and 4.0.

Kodak Profile Wizard Mio is aimed at the commercial, newspaper, packaging, digital print, and creative markets. There are other editions of the software for specialist applications such as document printing with Xerox DocuColor presses.

Comments

Print providers can improve the predictability of their print jobs with Kodak Profile Wizard Mio. This product is designed to increase productivity by minimizing the time spent on redoing the work, while at the same time keeping costs down by saving on materials.

Version: Kodak Profile Wizard Mio 4.0 (2008)

OS: Windows 2000 and XP; Mac OS X 10.3

RAM: 512MB

Supported file formats: Works in LCH, CMYK, and CIE L*a*b* modes

Price level: On application

Address: Kodak's Graphic Communications Group, 343 State Street, Rochester, NY 14650, United States

www.graphics.kodak.com

ColorMunki Photo

Vendor: X-Rite

Purpose: Professional color-management solution for photographers

Description

Aimed primarily at wedding and event photographers who need precise control over color all the way from screen to print, ColorMunki Photo is an integrated hardware/software kit that consists of a spectrophotometer, the ColorMunki profiling software, plus color creation and communication tools. Among the latter is DigitalPouch, a tool for ensuring that the client sees exactly the same colors, regardless of the device that reproduces them.

ColorMunki's Swiss-engineered spectrophotometer serves multiple purposes, calibrating not only monitors but also projectors and printers. It measures and compensates for ambient light, while also offering spot color measurements when you need to build palettes or color schemes. The accompanying software takes you step-by-step through each process, prompting with simple selection choices such as "match my printer to my display." There are also advanced modes that give experienced users greater control.

ColorMunki's printer profiling technology lets you work in RGB or CMYK, and it also has the ability to optimize specific colors, black and white shades, and flesh tones. The kit handles printer profiling with ease, rapidly scanning test charts in less than a minute, saving you the chore of reading individual color patches. It all comes with the necessary power cord, start guide, and protective bag that doubles as an integrated monitor holder.

There are other ColorMunki solutions aimed at designers, including the low-cost ColorMunki Create, which offers palette software and display profiling, but lacks the printer profiling and communication facilities of ColorMunki Photo.

Comments

Extremely well thought-out, the key item in this kit is the all-in-one spectrophotometer, which represents a significant advance over earlier instruments. Everything about it says "precision." If you want to make a spot color measurement of a real-world object, you can release a guide, which flips down to ensure correct positioning. With the included Photo Color Picker you can then create custom palettes that will exactly match the setup you are shooting. The software alerts you if colors are outside gamut and unlikely to print correctly. Another included application is Digital Pouch, which acts as a "digital wrapper" when you send images to a client. This is a self-executable application that

checks for appropriate viewing conditions at the receiver side, enabling the receiver to view the images without the full ColorMunki software. The whole product is definitely a step beyond huey, which X-Rite has now consigned to its Pantone subsidiary.

Version: ColorMunki Photo 1.0 (2008)

OS: Windows XP and Vista; Mac OS X 10.4 and later

RAM: 512MB

Supported file formats: N/A

Price level: Approx. $500

Address: X-Rite Incorporated, 4300 44th Street SE, Grand Rapids, MI 49512, United States www.colormunki.com

EZcolor with i1Display 2

Vendor: X-Rite

Purpose: Entry-level color-management kit for making color profiles, with supplied IT8 target

Description

This is a bundle that contains three color-management essentials—a versatile colorimeter for calibrating displays, scanner-based color-management software to ensure correct color printing, and a scanner target. The colorimeter is i1Display 2 (formerly Eye-One Display 2); the software is EZcolor (formerly MonacoEZcolor); the IT8 scanner target completes the bundle, which is aimed at photographers, creative directors, publishers, and designers who need "reliable and affordable color."

The USB-powered i1Display 2 is a compact tool for taking measurements on emissive LCD, CRT, and laptop displays. It has a detachable ambient light head that doubles as a dust protector. A built-in counterweight makes it easy to attach to the monitor. Its push-button method of calibration is easy to use and requires no special expertise.

Creating printer profiles can be time-consuming if you have to scan in thousands of patches using a spectrophotometer. EZcolor, however, provides a shortcut in allowing you to use a flatbed scanner into which you input both the test target and the printed version at the same time. You still need to create a separate profile for each combination of media (paper), resolution, and printer settings you intend to use.

EZcolor software can be purchased separately, but is normally acquired as part of a bundle with the colorimeter. Color management then becomes a simple three-step procedure. The first step is to profile the monitor, calibrating luminance, gamma, and white point to match standard viewing conditions. Next, you go on to create custom profiles for your scanners and printers, using the included IT8 scanner target. Then, in the final step, you apply the results, using the color profiles to generate accurate prints or to display "soft proofs" on the screen.

Comments

The key to accurate color is the relationship between monitor and printer. If you get this right, 90 percent of the task completed. EZcolor helps you do this very accurately, to a tolerance of 0.003 chromaticity using the supplied OPTIX colorimeter. The software has basic profile editing and makes a first-rate printer profile that will satisfy most users. However, many professional photographers will still find they need a spectrophotometer-based package—and that means spending quite a lot more money.

Version: EZcolor 2.6 (2008)

OS: Windows XP and Vista; Mac OS X 10.2 or later

RAM: 128MB

Supported file formats: TIFF

Price level: EZcolor with i1Display 2 Bundle approx. $520

Address: X-Rite Incorporated, 4300 44th Street SE, Grand Rapids, MI 49512, United States

www.xrite.com

i1 Solutions

Vendor: X-Rite

Purpose: Comprehensive range of color-management solutions

Description

Photographers, designers, and printers have varying degrees of need for color management, ranging from basic reliance on the controls provided by device manufacturers, all the way up to full-blown ICC profiling of every device in the chain. X-Rite's i1 Solutions (pronounced "Eye One") comprise a comprehensive range, aimed at satisfying the color-management needs of all professionals in the graphic arts industry. To understand this complex range, you need first to see how it all fits together, from simple calibration of monitors (i1Display LT) to the all-singing-dancing i1XT, a solution that contains all the available modules.

There is a hardware component to each solution: the i1Display 2 color measurement device for monitors or the accelerated i1Pro spectrophotometer, which measures not just monitors but many other devices.

Common to all the solutions is i1Match software, only part of which is made available at the lower end of the range. When you pay for an upgrade to add functionality, the vendor sends you a code to unlock the additional functions. i1Share freeware also comes with every solution, enabling you to measure ambient light and spot colors, plus access to the full Pantone library.

The solutions are as follows, beginning with the most basic:

- i1Display LT: Compact monitor profiling solution. For photographers, creative directors, publishers, and designers.

- i1Display 2: The i1Display LT, with additional capabilities such as workgroup match and RGB controls.

- i1Design LT: For freelance designers, small creative firms, and print shops.

- i1Photo: RGB workflow solution from camera to printer. Includes i1Editor. For photographic professionals.

- i1Photo SG: As i1Photo, plus the Digital ColorChecker SG. For photographic professionals.

- i1Proof: CMYK output profiling. Ensures accurate color from scan to monitor to proof and final print. For print shops and design firms.

- i1XT: The bundle "for those who want it all." Covers scanners, cameras, displays, RGB and CMYK printers, projectors, and profile editing and measurement of light, spot, and Pantone colors.

Comments

It is hoped that the summary provided here will help potential users cut through the complexity of X-Rite's more detailed explanations. One or two distributors, such as UK-based Colour Confidence (www.colorconfidence.com), have succeeded in describing the range in intelligible terms. In professional studios around the world, i1 Solutions have become a standard for photographers seeking color management. The vendor's entry-level product i1Photo LT has been replaced by ColorMunki Photo, coming in at a lower price point. The product lineup is subject to frequent changes, with some products still being available from dealers long after the vendor has upgraded them. At the time of writing (mid-2008), i1Photo and i1Photo SG are still officially listed, but who knows? Changes are inevitable when companies merge. There is copious documentation on the vendor's Website, and if it all seems too much, you can take up the offer of a personalized one-hour remote session with an X-Rite Personal Color Trainer (PCT).

Version: i1Match 3.6.2; i1Share freeware 1.4 (2008)

OS: Windows 2000, XP, and Vista; Mac OS X 10.2 or higher

RAM: 128MB

Supported file formats: N/A

Price level: i1Display LT $180, EZcolor with i1Display 2 Bundle $500, i1Design LT $1,200, i1Photo $1,700, i1Photo SG $1,900, i1Proof $1,650, i1XT $1,700 (all approx.)

Address: X-Rite Incorporated, 4300 44th Street SE, Grand Rapids, MI 49512, United States

www.xrite.com

MonacoPROFILER

Vendor: X-Rite

Purpose: Color profile creation and editing for photo labs, repro shops, and high-end commercial photographers

Description

MonacoPROFILER from the market leader in color management is the most comprehensive software bundle for creating ICC profiles, not only for monitors, scanners, and printers, but also for digital cameras (Platinum edition). It is supported by a good deal of literature, help, tutorials, and events.

The latest version of MonacoPROFILER includes options for multi-ink profiles and calibration for LCD monitors. It also supports X-Rite's IntelliTrax auto-scanning system, which helps when you have to scan up to 3,000 patches while building a profile. Among the editing options are manipulation of lightness, saturation, and output curves, plus the ability to make selective color adjustments. In common with industry practice it lets you relinearize an output device such as a printer without having to make fundamental measurements each time.

Comments

Overkill for most photographers, MonacoPROFILER is the software used by most newspapers and large print suppliers. The top, Platinum edition supports true hexachrome and spot-color palettes. More powerful than the i1 solutions, MonacoPROFILER is compatible with instruments used in that range, such as the i1Pro spectrophotometer and the i1iO automated scanning table.

Version: 4.8 (2008)

OS: Windows XP and Vista; Mac OS X.10.2

RAM: 512MB

Supported file formats: TIFF

Price level: Gold approx. $3,000, Platinum approx. $4,400

Address: X-Rite Inc., Kentwood, Michigan, United States

www.xrite.com

PictoColor inCamera

Vendor: PictoColor Corporation

Purpose: A quick, easy way to create ICC profiles for digital cameras and scanners

Description

PictoColor inCamera is a "no-nonsense" tool that provides a quick way to achieve consistent, predictable color in a photographic workflow. It works with standard charts like X-Rite GretagMacbeth ColorChecker, or Digital ColorChecker SG, but these are not included. Using it is a simple five-step process:

1. Open an image that includes one of the supported charts.

2. Select inCamera from Photoshop's Filters menu.

3. Align a flexible template over the chart in the image.

4. Click OK to save the profile.

5. In Photoshop, assign this profile to all other images taken under the same lighting conditions.

Comments

PictoColor specializes in easy-to-use software (like iCorrect EditLab), and this could scarcely be easier. It is robust and has a "check capture" feature to analyze the quality of the original image. Reviewers have found it flexible and accurate, one of them admiring its ability to avoid being confused by the glossy parts of a test card. The key to using it is to calibrate the camera under the same lighting conditions that you intend to use for your shots. It is not a one-time-only process.

Version: PictoColor inCamera 4.5 (2008)

Plugs into: Photoshop CS, CS2, and CS3

OS: Windows 2000, XP, and Vista; Mac OS X 10.2.8 through 10.4.8

RAM: 512MB

Supported file formats: BMP, JPEG, and TIFF

Price level: Approx. $200

Address: PictoColor Corporation, 151 West Burnsville Parkway, Suite 200, Burnsville, MN 55337, United States

www.pictocolor.com

Spyder3Studio

Vendor: Datacolor

Purpose: Complete color-management system for professional photographers and studios

Description

A complete color-management system from screen to print, Spyder3Studio consist of the vendor's top-rated monitor calibration solution Spyder3Elite with the Spyder3 colorimeter, and the Spyder3Print solution with the Datacolor 1005 spectrocolorimeter.

Their combined capabilities offer a powerful set of features, more than ample for the most demanding studio, including fine art photographers.

Spyder3Elite and Spyder3Print are each discussed separately here (see those entries).

Comments

The new user interface for the Spyder3 generation of software has been designed, says the vendor, from the photographer's point of view. This appears to be true, and it is very welcome. Over recent years too much photographic software has been created from a graphic designer's point of view, or worse, from a computer programmer's POV. Spyder3Studio deals in a pictorial way with gamma and color temperature control, showing actual images for evaluation by eye. This is also a logical approach, because the product's whole purpose is to create interchangeability between devices—so that we can trust our eyes once again.

Aimed at all kinds of professional users of photography, Spyder3Studio proves that there does not have to be a trade-off between precision and speed, as well as showing that these benefits can be obtained at reasonable cost in a complete color-management system.

Version: Spyder3Studio (2008)

OS: Windows 2000, XP 32/64, and Vista 32/64; Mac OS X 10.3 or higher

RAM: 128MB

Supported file formats: N/A

Price level: Approx. $600

Address: Datacolor, Digital Color Solutions, 5 Princess Road, Lawrenceville, NJ 08648, United States

spyder.datacolor.com

www.spyder3.com

Spyder3Print

Vendor: Datacolor

Purpose: Printer profiling system for any combination of printer, paper, and ink

Description

Also part of the Spyder3Studio bundle, Spyder3Print is a printer profiling solution that comes with a Datacolor 1005 spectrocolorimeter and base. It lets you create custom profiles and produce prints to the highest quality without needing to use trial-and-error methods. Using standard targets it takes less than five minutes to create a profile for any combination of printer, paper, and ink. The measuring device plugs into the computer just like a digital camera, using the same type of USB mini-connector cable. The rest of the procedure is equally straightforward.

A wizard interface takes you through each stage of the process. One feature allows you to check for clogged or empty ink channels or any other colorant problems before going any further. What the vendor calls "Ambient PreciseLight Viewing Controls" allow you to select the type of viewing conditions expected to prevail when the print is placed on display. Preview output is to a single sheet of paper, enabling you to compare different rendering intents and profile adjustments. Spyder3Print also supports both standard 8-bit and high-resolution 16-bit profiles.

Very "high spec," the software gives you unlimited gamma and color temperature choices, three levels of color targets, gamma curve editing, and custom black and white luminance control. It comes with cable, SpyderGuide, and a Quick Start Guide.

Comments

Different printers tend to issue slightly different volumes of ink from their individual print heads, a variance that is detected by color profiling. This results in, for example, better gradation of colors and increased shadow detail. Spyder3Print does a fine job in all respects. It is highly regarded by photographers for its black and white capability. For example, you can print out a set of patches with an extended range of gray and near-gray tones to improve black and white and tinted prints. Used in conjunction with a good quality printer, the system can produce outstanding results.

Version: Spyder3Print (2008)

OS: Windows 2000, XP 32/64, and Vista 32/64; Mac OS X 10.3 or higher

RAM: 128MB

Supported file formats: N/A

Price level: Approx. $500

Address: Datacolor, Digital Color Solutions, 5 Princess Road, Lawrenceville, NJ 08648, United States

spyder.datacolor.com

www.spyder3.com

Spyder3Elite

Vendor: Datacolor

Purpose: Display calibration for professional photographers and studios

Description

Spyder3Elite is a display calibration solution that includes the elegant Datacolor Spyder3 colorimeter with its seven-detector color engine, large light aperture, and desktop cradle/ tripod mount. Aimed at professional photographers who are serious about color, Spyder3Elite is capable of profiling the latest in wide gamut, LED backlight, and AdobeRGB displays as well as popular LCD, CRT, projector, and notebook displays.

One key feature of the Spyder3 colorimeter is its ability to measure automatically the ambient light that exists inside the studio and which will affect the way you perceive colors on your display. The vendor notes that it has the intelligence to distinguish between true lighting changes and random fluctuations caused by studio flashes or shadows.

Like Datacolor's printer-calibration product (Spyder3Print), Spyder3Elite offers unlimited, user-defined choices for white point and gamma, together with white luminance and black luminance. With these sophisticated controls, expert users can optimize shadow detail as well as ensure that the colors displayed will match those on a lightbox or the intended output device. Non-expert users have plenty of guidance from the wizard-driven user interface, but there is also an Expert Console that shows all the calibration parameters and actions within a single window.

As an alternative to typical gamma settings, Spyder3Elite offers a calibration option called L-Star Technology, which generates tonal response curves for open shadows and detailed highlights. Some photographers like to work with L* as a monitor gamma rather than with the more frequently used 1.8, 2.2, or 2.5. This is said to eliminate the compromise of 2.2 in shadow detail and 1.8 in highlight detail.

Comments

A dramatic improvement on the highly acceptable Spyder2Express, Spyder3Elite uses a colorimeter that increases light sensitivity 400%, giving much greater accuracy. It is also more convenient to use, with its fast ReCAL option that allows you to perform quick re-calibrations more frequently, thus ensuring accuracy before every vital shoot.

Apart from the beauty and precision of the instrument that comes with the package, perhaps the main appeal of Spyder3Elite is the clever way it caters to both expert and non expert users. Today, most photographers are either using or considering the use of color management, beginning with monitor calibration. Even contributors to iStockphoto.com are encouraged to use monitor calibration to ensure color accuracy, for which purpose iStock recommends Spyder3Elite as the ideal tool.

Version: Spyder3Elite (2008)

OS: Windows 2000, XP 32/64, and Vista 32/64; Mac OS X 10.3 or higher

RAM: 128MB

Supported file formats: N/A

Price level: Approx. $280

Address: Datacolor, Digital Color Solutions, 5 Princess Road, Lawrenceville, NJ 08648, United States

spyder.datacolor.com

www.spyder3.com

Spyder3Pro

Vendor: Datacolor

Purpose: Mid-range monitor-calibration system for serious photographers

Description

Spyder3Pro is Datacolor's mid-range monitor-calibration system, aimed at serious and professional photographers who need to ensure high color fidelity in their work. It comes with the new generation Spyder3 colorimeter, a precision instrument with a seven detector color engine, large light aperture, and an embedded ambient light sensor. It differs from Spyder3Elite (see that entry) in being substantially less expensive, but lacking the Expert Console and many advanced features.

Spyder3Pro offers four gamma choices: 1.8, 2.0, 2.2, and 2.4; and four color temperature choices: 5000K, 5800K, 6500K, and native—thus giving 16 target combinations. What the vendor calls a SpyderProof Function lets you zoom into images to analyze highlights, shadow detail, color, or tonal response. You can check for saturated colors, skin tones, gradients, and black and white, all on the same screen using four quadrants, and then softproof the images with your profiles.

Spyder3Pro has dual monitor support and works equally well on Apple Macs or PCs.

Comments

Not many photographers require all the sophistication of Spyder3Elite, and for most users Spyder3Pro is the less complex and easier-to-use option. The Spyder3 colorimeter is a joy to use with any monitor. You can remove the suction cap, which is useful only for increasingly obsolete CRTs, and back-tilt your flat panel display to ensure good contact. Because monitor color changes over time, it is best to calibrate fully every month, and then use the fast ReCAL option to perform a quick check before important shoots.

Version: Spyder3Pro 3.0.1 (2008)

OS: Windows 2000, XP 32/64, and Vista 32/64; Mac OS X 10.3 or higher

RAM: 128MB

Supported file formats: N/A

Price level: Approx. $170

Address: Datacolor, Digital Color Solutions, 5 Princess Road, Lawrenceville, NJ 08648, United States

spyder.datacolor.com

www.spyder3.com

Spyder2express

Vendor: Datacolor

Purpose: Entry-level monitor calibration in three easy steps, for true-to-life on-screen color

Description

Spyder2express is an easy-to-use product that lets you calibrate your monitor in just a few steps, using a software wizard to guide you through the process. It is aimed at photographers, designers, and gamers who want really accurate color on their LCD or CRT displays.

Spyder2express comes with a Datacolor Colorimeter with a calibration time of just five minutes. It connects to the computer via a USB port and hangs down in front of the screen using either suction cups (for CRT) or a counterweight (for LCD) to keep it in position.

Gamma and color temperature choices cannot be changed on this entry-level product (gamma and white point are fixed) and there is no multiple-monitor support. For greater control you need to obtain the higher-level product, Spyder3Elite, which comes with the new generation Spyder3 colorimeter. (See that entry.)

Comments

For many photographers, Spyder2express is a useful starting point in color management. Its natural competitor at the lower end of the price range for monitor profilers is PANTONE huey. (See that entry.) Reviewers find the hardware component of Spyder2express more robust than the ultra-slim huey, but they point out that huey has more features, including ambient light reading, and tends to be a lot faster. Both huey and Spyder2express are leapfrogged in both features and precision by Spyder3Elite.

Version: Spyder2express (2008)

OS: Windows 2000, XP, and Vista; Mac OS X 10.3 or higher

RAM: 128MB

Supported file formats: N/A

Price level: Approx. $80

Address: Datacolor, Digital Color Solutions, 5 Princess Road, Lawrenceville, NJ 08648, United States

spyder.datacolor.com

www.spyder3.com

PM5 PhotoStudio Pro

Vendor: X-Rite

Purpose: For making color profiles of all devices in a studio photography workflow, using a spectrophotometer

Description

PM5 PhotoStudio Pro lets you create and edit color profiles for devices such as monitors, digital cameras, and printers, including hexachrome devices. It has been developed with the studio photographer in mind, particularly commercial photographers who need color fidelity throughout the workflow. Its specific modules are:

- Digital Camera (ICC profiling)

- Monitor (ICC profiling for both CRT and LCD displays)

- MultiColor Output (ICC profiles for RGB, CMYK, hexachrome, and CMYK + red/green output devices)

- Editor (edit lightness, contrast, saturation, white point, or gradation curves)

- ColorPicker (convert spot colors to process color)

- MeasureTool (data collection and profile computation)

- DeviceLink (create ICC compatible device linking workflows for RGB and CMYK color spaces, plus direct linking between devices)

- i1 Process Control Bundle (includes devices for measurement of control strips like the Fogra Media step wedge)

Other PM5 products are available for graphics arts professionals. PM5 Publish optimizes results from digital or traditional printing systems and PM5 Publish Plus expands the gamut of printers to CMYK+N based multicolor workflows.

Comments

It is usually best to buy this type of software as part of a bundle, in this case with the i1Pro spectrophotometer. When scanning becomes tedious, you can add automation any time with the i1iO chart reader that reads 500 patches per minute, or the i1iSis automatic reader, which can scan 2,500 patches printed on a single A3 page. PM5 is an industry standard that gives the kind of accuracy and consistency you would expect. It gets five stars (out of five) from c|net and other publications.

Version: PM5 PhotoStudio Pro (2008)

OS: Windows 2000, XP, and Vista; Mac OS X 10.3.9 or higher

RAM: 128MB

Supported file formats: N/A

Price level: Approx. $2,500

Address: X-Rite Incorporated, 4300 44th Street SE, Grand Rapids, MI 49512, United States

www.xrite.com

Summary

Not nearly as difficult as color theory, color management has been made as simple as possible for users, with single-click monitor calibration and easy-to-use color profiles that travel with the image from one device to another. Color-management software is dominated by two companies—X-Rite and Digital Color Solutions (Datacolor)—with other offerings by Kodak and PictoColor. X-Rite has brought together technologies from Europe and the United States, melding them into multiple product lines to cater to all color-management needs. Most of the products described in this chapter are complete solutions that include either a colorimeter for measuring emitted light from a monitor or a photospectrometer for measuring reflected light from printed color swatches.

30

Color Tools

Most photographic software has at least some form of color manipulation, but there is a class that can be separated from the rest because these tools are concerned specifically with color. They could be called "extreme color tools."

Color theory is not rocket science—it is a whole lot harder. At least rocket scientists do not have to deal with imperfectly understood processes of the human visual system. Whatever changes you make to the color of a photograph, there is always someone who will be unhappy with it. Despite all the color tools in Photoshop, developers have therefore added some extras that allow you to manipulate color in different ways.

HVC Color Composer Professional builds on the Munsell color system so that you can make sure every color you work with is in-gamut when printed. Full Spectrum RGB provides a non-linear transformation to images, making them richer and more vibrant. For intense, and even lurid, sci-fi colors, there is Final Impact, while back in the naturalistic world Color Adjuster is another tweaking tool for the truly color-sensitive photographer.

Color Adjuster

Vendor: SoftWhile

Purpose: Adds to Photoshop's standard color adjustment functionality

Description

Color Adjuster adds to Photoshop's already extensive color tools with a Cubic Bézier spline to provide greater control over curves. It lets you add control points to color curves, even if the curve is behind another one. On the displayed image you can place

probe points and obtain a readout of the color mix on three vertical bars representing red/cyan, green/magenta, and blue/yellow spectra. There is also a color temperature adjustment tool on the same panel.

Comments

Color Adjuster is one of those ingenious plug-ins that tends to get overlooked in the crowd, but it can be a useful color-tweaking tool for those with a good eye for color. Its companion product for adjusting tones is Tone Adjuster. If you buy one, you really need the other.

Version: 1.0 (2008)

Plugs into: Photoshop 7, CS, CS2, and CS3; Photoshop Elements

OS: Windows ME, 2000, XP, and Vista

RAM: 128MB

Supported file formats: Major formats

Price level: Approx. $30

Address: info@softwhile.com

www.softwhile.com

Figure 30.1

Color Adjuster adds another unique way of adjusting colors to Adobe Photoshop.

Final Impact

Vendor: Cybia

Purpose: Series of plug-ins for color correction, black and white conversion, intense coloring, and random color

Description

Final Impact is a series of Steve Upham's best plug-in filters for photographers. They aren't freebies, but are very low-cost. They are:

- HotShot: Image enhancement and color correction, with 18 sliders and 70 presets

- RetroGrade: Classic black and white film reproduction (see Chapter 12, "Black and White Conversion")

- Fluoron: Vibrant color changes for artistic impact, 11 sliders, 80 presets, with sci-fi effects

- Alienator: Random color regeneration, ironically with lots of controls

 plus:

- Vivida: A free sample filter for boosting image colors, with 9 sliders and 20 presets

Comments

All the Final Impact plug-ins support RGB 16-bit mode for 48-bit images. Anyone designing a science fiction book jacket would appreciate the intense coloring capability of Fluoron, Alienator, and Vivida. They are all great fun to use and highly recommended.

Version: Final Impact 1.2 (2008)

Plugs into: Photoshop and compatible editors

OS: Windows 95, 98, ME, 2000, XP, and Vista

RAM: 128MB

Supported file formats: Major formats

Price level: Approx. $8

Address: steve@cybia.co.uk

www.cybia.co.uk

Full Spectrum RGB

Vendor: Tribeca Labs

Purpose: Lets you expand the spectral capabilities of a digital camera to all the colors of the visible spectrum

Description

Formerly DCF Full Spectrum, Full Spectrum RGB modulates the colors of RGB, making them deeper, richer, and—according to the vendor—more lifelike. It processes the image to impart a slightly different coloring: more red, orange, and blue, less pale green and yellow. In doing so, it mimics the colors that are seen in natural, high-intensity daylight.

The vendor contends that digital cameras do not correctly reproduce hues in a way that is consistent with how we perceive them. Blue skies look too pale, violet flowers lose some of their rich coloring. The solution is the non-linear transformation embodied in Full Spectrum RGB. It has no effect on exposure, color temperature, or white balance. It simply extends the color range, with the result that many images look more appealing.

Comments

If you are unhappy with the look you are getting from Photoshop and have a nagging feeling that the grass is greener elsewhere, you can experiment with this plug-in. It gives your pictures a richer appearance. Warmly reviewed at the time of its launch, it also won the DIMA 2006 "Innovative Digital Product" award. Users like its combination of automatic and manual controls, with the option to save settings for use on other photographs.

Version: Full Spectrum RGB 2.0 (2008)

Plugs into: Photoshop 7.0, CS, and CS2

OS: Windows 98, 2000, and XP; Mac OS X

RAM: 356MB

Supported file formats: RGB file types only

Price level: Approx. $50

Address: Tribeca Labs, 648 Broadway Suite 700, New York, NY 10012, United States

www.fullspectrumrgb.com

HVC Color Composer Professional

Vendor: Master Colors

Purpose: Color selection tool, working in proprietary HVC color space

Description

HVC Color Composer is a color selection tool that uses a new proprietary color space in which the three values are hue, value, and chroma. The vendor claims that this is the only color space that makes perceptual sense. It uses a technique of color quantification that takes account of how human beings actually perceive color. Whereas other color spaces such as HSB, RGB, Lab, or CMYK make compromises for the sake of simplicity, HVC makes visual accuracy its top priority. The result is more natural-looking color, plus the capability of making accurate measurements of the contrast between any two colors.

Figure 30.2
HVC Color Composer Professional, running here in Photoshop Elements, helps you create harmonious palettes.

The concept of choosing colors based on their contrast with other colors was one pursued by Albert H. Munsell (1858–1918), who developed a color-notation system based on hue, value, and chroma dimensions. It was used for many years to identify the colors for mixing paints. HVC Color Composer extends Munsell's very practical approach, bringing it up-to-date with computer processing. It can identify any colors that will be out-of-gamut in printing and it marks them as such.

HVC Color Composer has the same basic layout as the color picker in Photoshop and performs much the same function, but with different results. You can limit the number of colors in a palette using Accuracy and Depth controls, and then export them to Photoshop's Swatches palette. If you want, this can become your chosen palette for all the applications in Creative Suite.

Comments

HVC Color Composer is clearly a useful tool for designers because it produces wonderfully harmonious palettes, but can photographers derive benefit from it? The answer is yes, especially in taking pictures for print where accurate color reproduction is critical, such as fabric and interior design catalogs. On these projects a photographer can work with a designer, both using HVC Color Composer to achieve perfect color combinations.

Version: HVC Color Composer 1.4 (2008)

Plugs into: Windows Photoshop CS, CS2, CS3; Photoshop Elements 4 and 5; Mac Photoshop 7, CS, CS2, and CS3 and Photoshop Elements 2, 3, and 4; Adobe InDesign 3.0 or 4.0 (Windows version in development)

OS: Windows 2000, XP, and Vista; Mac OS X

RAM: 512MB

Supported file formats: As host

Price level: Standard version $50, Professional version $130

Address: Master Colors LLC, 3905 State Street, Suite 7-144, Santa Barbara, CA 93105, United States www.master-colors.com

PhotoKit Color

Vendor: PixelGenius

Purpose: For applying precise color corrections, automatic color balancing, and creative coloring effects

Description

PhotoKit Color provides a comprehensive set of coloring tools that extend the standard Photoshop facilities. In particular it allows photographers to reproduce traditional photographic processes digitally using Photoshop. It offers a full range of filters, including infrared, sunshine filters, color transfer effects, a nocturnal day-for-night effect, and many others. There is also a Film Effects series that simulates several generic chrome film emulsions.

Comments

PhotoKit Color 2.0 works well with Photoshop, using separate layers on which to apply its many different effects. It allows you to enhance specific colors, for example in making skin tones warmer or cooler according to taste, or in removing color casts. But it also has purely creative effects, such as black and white split toning and cross processing, which will appeal to many photographers. With the new interface, called PixelGenius Toolbox, PhotoKit Color is easy to use, displays a large preview, and allows you to replicate effects from one image to another. However, you need to be a good judge of color and the product is therefore aimed at professionals and advanced amateurs.

Version: PhotoKit Color 2.1.1 (2008)

Plugs into: Photoshop CS, CS2, and CS3 (will not work in Photoshop Elements)

OS: Windows XP with SP2 and Vista; Mac OS X

RAM: 256MB

Supported file formats: As host

Price level: Approx. $100

Address: PixelGenius, 624 West Willow Street, Chicago, IL, 60614, United States

www.pixelgenius.com

Viveza

Vendor: Nik Software

Purpose: Selectively correct and enhance either color or light, or both

Description

A pro-level tool, Viveza uses the vendor's proprietary U Point technology to provide a convenient interface for making corrections to color and light on selected parts of the image. With this method, the user places U Point powered Color Control Points directly onto areas of color, such as sky, skin, or grass, and then makes rapid adjustments to brightness, contrast, or color.

The great advantage of using the U Point system is that you no longer need to make complicated selections or use layer masks to separate the area to be adjusted. You can identify one point or several points, and the enhancements are automatically blended throughout the image to give smooth and accurate results.

Comments

Among interface tools, U Point is a particularly brilliant invention, and it is good to see the vendor packaging it in a new program. It has been available previously in Nik Color Efex Pro, which is used by Nikon to extend the functionality of its RAW converter and image editor Nikon Capture NX. In Viveza, U Point brings great speed and precision to the task of enhancing images. Wedding and portrait photographers who have tried it find it easy and intuitive to use.

Version: Viveza 1.0 (2008)

Plugs into: Windows Photoshop 7 to CS3; Photoshop Elements 2–6, and compatible applications; Mac Photoshop CS2, CS3; Photoshop Elements 1–4, and compatible applications

OS: Windows 2000 Professional, XP Home Edition, XP Professional, and Vista; Mac OS X 10.4 and later

RAM: 256MB

Supported file formats: As host

Price level: Approx. $250

Address: Nik Software, Inc., 7588 Metropolitan Drive, San Diego, CA 92108, United States

www.niksoftware.com

Summary

Every so often, a software developer tries a new approach in an attempt to make color manipulation easier or more intuitive. Some of the better examples have been included in this chapter on color tools. If you are a designer who needs to create harmonious color spaces with the assurance that they will print accurately, try HVC Color Composer Professional. If you are a photographer who wants to make subtle color changes to different sections of the image, try Nik Software's new pro-level tool Viveza. Alternatively, if you simply want to add to the already extensive color facilities of Photoshop, try PhotoKit Color from PixelGenius. All of them have qualities that are not found elsewhere.

31

RIP Software

All printers use a RIP (Raster Image Processor) to turn vector-based documents into a dot pattern so they can be printed. Even bitmapped images consisting solely of pixels need to be further "rasterized" into a language understood by a printer, making the RIP an essential and unavoidable component in digital printing. However, the on-board RIP that comes with the printer can be very inferior, even failing to do justice the machine's own ability to lay dots of ink onto paper. For this reason, an industry has grown up to develop software RIPs that can make a better job of it.

Software RIPs have been so successful they have come to assume greater and greater responsibilities, even providing last-minute opportunities for a little extra editing. At the very least they allow you to optimize printing for a specific combination of printer/paper/ink, for which they are designed to coax every last ounce of quality from your image files. Their particular role is to fine-tune the image so that you can produce the perfect fine art print, or the most accurate proof, or clean color separations for screen printing. Some of them are therefore geared to high productivity with features such as soft proofing, batch printing, job grouping, color management, image nesting, and overnight printing. Others are dedicated to generating quality prints one at a time.

RIPs for Photographers

With increasing frequency, photographers are installing their own printing facilities, either for proofing purposes to anticipate the appearance of the end product, or else to create display prints for clients or themselves. Software developers have recognized the importance of this growing market and have responded with versions of their production RIPs, or, in some cases, designed a RIP from scratch with photographers in mind.

Until recently, one stumbling block tended to be the fact that many photographers were Mac-based, whereas most RIPs are PC-based. This has been largely resolved by porting RIPs to the Mac environment and by the Mac being able to run PC software. For serious photographers, it was always a false issue because a RIP, which places high demands on processing capacity, really needs its own dedicated machine. There is no reason why this should not be a PC running Windows on a network composed chiefly of Macs. Mixing and matching is now common practice.

Buying a RIP

With 60 or more brands of RIP available, it is not easy to make a purchasing decision without extensive research. The list of software given here has been restricted to brands that are widely acknowledged to be useful to photographic studios and design businesses. Even so, a direct comparison between them is almost impossible, owing to the fact that vendors have many ways of structuring their product lines. All of them have different prices for small, medium, and large format printing, plus extra charges for high-productivity software. Quite a few have "add-ons" to perform one or two additional functions, whereas some lines are fully modular. One of those mentioned (which one will be clear from the text) has a product line of mind-boggling complexity, with modular client/server products, each one of which is also available in a stand-alone version. Then there is the QuadToneRIP, by comparison a model of simplicity that does a single job superbly well.

ColorBurst X·Photo

Vendor: Compatible Systems Engineering
Purpose: PostScript Level 3 compatible RIP for fine art and photography printing

Description

A PostScript Level 3 compatible RIP for fine art and photography printing, ColorBurst X·Photo allows you to print directly from an image-editing or layout application, such as InDesign, Photoshop, Illustrator, and QuarkXPress. One key feature is job management, normally only found in more expensive RIP applications, with a hot folder that is accessible across a network. You can reorder, delete, or place jobs on temporary hold. The software ships with the SpectralVision Pro full-featured ICC profiling software package. ColorBurst X·Photo is SWOP-certified on Epson Stylus Pro printers.

ColorBurst X·Photo is part of the ColorBurst Queue Series, which also includes X·Proof with Pantone matching for design proofing; X·Proof Plus with custom spot colors, color bars, and job titles for proofing and certification; and X·Proof 3800 for printing to the Epson Stylus Pro 3800 only.

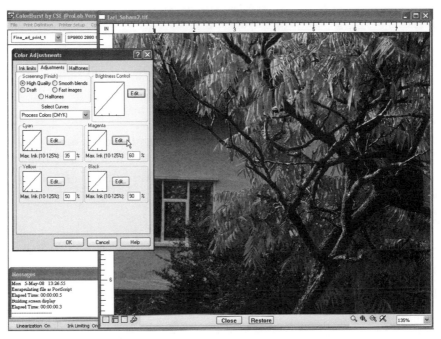

Figure 31.1
ColorBurst X·Photo gives precise adjustments for fine art printing.

Comments

You need a spectrophotometer to use the software properly, creating a linearization test target with the aid of the SpectralVision Pro package. The RIP will then linearize the printer automatically. Creating a custom CMYK profile for the printer is somewhat more involved, but essential if you want to maximize the quality of each ink/media combination. With these color-management procedures in place, ColorBurst X·Photo will produce consistently great prints.

The ColorBurst RIP won both the sub-20-inch and 20-inch-and-greater printer categories at the Digital Imaging Marketing Association (DIMA) 2008 Printer Shoot-Out awards, a sure indication that it should be on any photographer's short list.

Version: ColorBurst 5 (2008)

OS: Windows 2000, 2003, XP, and Vista; Mac OS 10.4 or later

RAM: Windows 768MB, Mac 1GB

Supported file formats: PS, EPS, PDF, CMYK, RGB, Lab, 16-bit and color-mapped TIFF files, CMYK, RGB JPEG, and RTL raster files

Price level: Small format $800, medium format $1,100, large format $1,600

Address: ColorBurst Systems, CSE Inc., 44710 Cape Court #142, Ashburn, VA 20147, United States

www.colorburstrip.com

Harlequin RIP

Vendor: Global Graphics Software

Purpose: High-performance RIPping engine, sold only through OEM partners for different branding

Description

The Harlequin RIP underpins an entire industry, being sold through the vendor's OEM partners who use its flexible architecture as the basis for their own products. Harlequin technology is used for driving 100 output devices, from vendors such as Agfa Gevaert, Hewlett-Packard, and Kodak. RIPs based on it include:

- Express RIP, from Compose Systems

- RipMate, from Esko Graphics

- Fusion RIP, from Fusion Systems

- Torrent RIP, from HighWater Designs

- Prediction RIP, from Latran Technologies

- Rampage RIP, from Rampage Systems

- RTI Rip-Kit, from RTI (RealTimeImage)

- JET Rip, from Song & Company

- TorayRIP, from Toray Industries

- Navigator RIP, from Xitron

Capabilities of the Harlequin RIP include PostScript interpretation, native PDF support, JDF-enabled workflows, and integral color management, trapping, and imposition.

Version 8.0 of the Harlequin PLUS Server RIP, first shown at Drupa (the world's main printing event) in 2008, introduced several new features. It can now natively process files in the new XPS print format (which allows users to create, share, print, and archive documents) available with Windows Vista. It also supports PDF 1.7, the PDF/X-4 standard, JDF 1.3, and the HD Photo format with its extended dynamic range and superior compression capabilities. All of these facilities will flow through to the products that are based on the Harlequin RIP.

Pre-press specialist Hamillroad Software has developed a high-performance TIFF output plug-in for the Harlequin RIP called Lightning TIFF. It's designed to replace the standard TIFF plug-in. It is worth noting because it can quadruple the performance of the RIP.

Comments

It would be difficult to work in the graphic arts industry without coming across Harlequin RIP technology in one form or another. It is included here for completeness and because photographers may find themselves using a Harlequin-based RIP or a soft-proofing system such as FirstPROOF that connects to it.

Version: Harlequin 8.0 (2008)

OS: Multi-platform

RAM: N/A

Supported file formats: PGB, TIFF, and others

Price level: On application

Address: Global Graphics Software Ltd., Building 2030, Cambourne Business Park, Cambourne, Cambridge, CB23 6DW, United Kingdom;

Global Graphics Software Inc., 5875 Trinity Parkway, Suite 110, Centreville, VA 20120, United States

www.globalgraphics.com

Ilford Studio

Vendor: Ilford Imaging

Purpose: Fully integrated printing system for photographers with a special software RIP to give color prints the look and feel of traditional photographs

Description

Designed to help professional photographers make color prints in-house at half the cost of outsourcing them, Ilford Studio is an integrated printing system with a special software RIP that gives color prints the look and feel of traditional photographs. Its RIPstar component is actually a variant of Onyx PosterShop. Ilford's development team has created media profiles to match various printer, ink, and media combinations for the best output quality (the firm supplies its own GALERIE range of papers). Its print-management facilities include batch printing, job grouping, and nesting images for the most economical use of the media. By using either the automatic cutting feature or optional roll take-up, the vendor says you can leave the system to make a print run overnight.

Comments

After making an extensive test of Ilford Studio with an Epson 7600 printer, *Professional Imagemaker* magazine concluded that it gave a "flawless performance," which is high praise indeed. Being part of the Oji Paper Co., Ilford Imaging has more interest in selling substrate materials than equipment, but it has put this excellent system together, supported, it has to be said, by rather poor marketing backup. Fortunately, photographers know quality when they see it. The output speaks for itself.

Version: Ilford Studio 2.0, Version 6.0 (2008)

OS: Windows 2000 and XP

RAM: 2GB

Supported file formats: CMYK TIFF

Price level: Turnkey systems, with Epson printer $6,000 to $12,000

Address: Ilford Imaging Switzerland GmbH, Vente Marché Suisse, Case Postale 160, CH1723 Marly 1, Switzerland

www.ilford.com

ImagePrint RIP

Vendor: ColorByte Software

Purpose: Software RIP that lets you print directly from an image editor or layout program

Description

ImagePrint RIP is a complete printing solution that is fully compliant with ICC workflow, designed specifically to meet the needs of photographers. Instead of using a PostScript interpreter, it has a PTAPP (Print Through Application) option that lets you print directly from an image editor or layout program. Its huge range of sophisticated features includes black and white dark room effects, quadtone printing, wide gamut technology, queue management, true borderless printing, embedded profile management, shadow point adjustment, Phatte Black option, an autoprint hot folder utility, automated layout modes, and image layout editing.

ImagePrint works with the mid-range market of printers including Epson, Encad, Hewlett-Packard, Roland, and Colorspan. It can be used in a mixed network environment where Windows and Mac machines exist side-by-side.

Comments

Widely regarded by fine art photographers as one of only three or four options for serious printing (others are StudioPrint and Ilford Studio), ImagePrint RIP has the advantage of running on both Windows and Mac platforms. Experts are agreed that it takes printers to a new level, beyond anything that can be achieved with the standard printer software. One big ImagePrint advantage is the extensive profile library on which users can draw freely to get the best results for various printer/paper/ink combinations.

Version 7.0 has added significant improvements to the page layout area. You now receive visual feedback about the physical page size as well as printable area. A new Smart Crop feature allows you to crop images more precisely, and a Border Browser allows you to add artistic borders to your images. These improvements, like many of the software's other features, are very helpful to photographers who print their own work.

Version: ImagePrint 7.0 (2008)

OS: Windows 2000 and XP; Mac OS X

RAM: 512MB

Supported file formats: JPEG, TIFF, TGA, SUN, SGI, and PSD

Price level: Small format $900, medium format $1,500, large format $2,500

Address: ColorByte Software, 10004 N. Dale Mabry Hwy., Suite 101, Tampa, FL 33618, United States

www.colorbytesoftware.com

Onyx PosterShop

Vendor: Onyx Graphics

Purpose: Software RIP for high-quality inkjet and screen printing

Description

PosterShop is a step up from the company's entry-level RIPCenter, having an additional Preflight application for large-format color proofing and printing. The preflight component provides an on-screen proof and tools for correcting color without affecting the original.

For the busy photographic studio, PosterShop supports printing to two inkjet printers simultaneously, with multiple hot folders containing all the job settings. Even when the printers are different models, the RIP ensures a unified workflow. It runs on Windows, but, as a network device, can accept images from both Windows and Mac.

A world leader in large-format RIP software, Onyx also has another RIP called ProductionHouse for high-production environments. In version 7.0, both PosterShop and ProductionHouse come with a new wizard-driven Media Manager application that makes it easier to obtain the right profile for each type of media. It gives you a standard report about how the various media will perform in different applications such as fine art, CAD, signage, POP, proofing, and photographic reproduction.

Comments

Of all the RIPs on the market today, Onyx PosterShop consistently appears on most shortlists recommended by experts. It comes with a wide range of screen dot patterns simulating traditional screen printing, together with screen options for spot color separations. These and many other features make it one of the most powerful and versatile RIPs available.

Version: Onyx PosterShop 7.0 (2008)

OS: Windows 2000 Pro Server; XP (both with latest service packs) and Vista

RAM: 2GB per CPU (if dual CPU)

Supported file formats: PostScript, PDF files and major formats including TIFF, TIFF/IT, 8-bit and 16-bit TIFF, 4GB TIFF, JPEG 2000, PSD, Kodak PhotoCD, ER Mapper, MrSID, JPEG, Targa, Scitex CT, DIB, GIF, PCX, and BMP

Price level: RIPCenter approx. $1,695.00, PosterShop approx. $3,300

Address: Onyx Graphics, 6915 South High Tech Drive, Salt Lake City, UT 84047, United States

www.onyxgfx.com

PHOTOGATE

Vendor: ColorGATE

Purpose: Software RIP for photo and fine art reproductions

Description

Aimed at photographers, designers, and agencies, the PHOTOGATE software RIP in the ColorGATE range comes in both Pro (with PostScript for document printer) and Raster (bitmap formats only) versions. It is ideal for printing to aquarelle, hand-made, or photo and fine art paper, producing both high-quality color and black and white prints. With the PHOTO&FINEART Module you can print neutral grayscale images, take account of the effects of ambient light, and print with added tints.

Comments

ColorGATE has a whole range of client/server RIP products, based around PRO-DUCTIONSERVER. Somewhat confusingly, the individual modules are also available as stand-alone software packages. The output from PHOTOGATE is clearly excellent, but until recently it was almost impossible to understand the upgrade paths, combinations, and alternatives, given the poorly translated literature offered by the vendor. This has been partially corrected by a new Website and some new documentation. However, the ColorGATE tagline "Pleasure for Production" still sounds odd in English.

Version: PHOTOGATE 5.1 (2008)

OS: Windows 2003, XP, and Vista; data from Mac OS/Unix/Linux can be sent via the virtual printer (PortMonitor)

RAM: 256MB (1GB recommended)

Supported file formats: PostScript 3, PDF 1.6, PDF/X-1a, EPS, DCS 2.0; JPEG, TGA, TIFF, BMP, PCD, and PSD

Price level: Small format $1,200, medium format $1,600, large format $2,000, raster-only versions also available from $600

Address: ColorGATE Digital Output Solutions GmbH, Grosse Düwelstrasse 1, 30171 Hannover, Germany

www.colorgate.com

PhotoPRINT

Vendor: SA International

Purpose: A family of client/server RIP products for high print production environments

Description

PhotoPRINT is a family of software RIPs, each with a wizard-driven interface for ease-of-use, aimed at corporations and institutions, print shops, design companies, and large photographic studios. They include PhotoPRINT SERVER-ULTRA (for ultimate control), PhotoPRINT SERVER-PRO and PhotoPRINT SERVER (with cost-saving features), PhotoPRINT DX (with two-device capability), and PhotoPRINT SE (for the single-workstation environment). Each one seamlessly integrates the Adobe RIP Engine, the only product to do so at the time of writing.

For smaller production environments, the entry-level PhotoPRINT SE is intended for use with a single wide-format printer. It comes with more than 325 certified ICC output profiles, plus the ability to edit them or (with a Color Calibration wizard upgrade) to create new ones. It allows you to send jobs for print direct from your layout/design application, such as Adobe Photoshop, Illustrator, QuarkXPress, or CorelDRAW.

Comments

Renowned for its ease of use, PhotoPRINT allows you to prepare documents or images for printing by dragging and dropping TIFFs, JPEGs, and PDFs directly into the queue. You then have full control over output, using ICC profiles for the chosen printer/ink/media combination.

Version 6.0 was a major upgrade, featuring a new user interface, a new point-and-click color correction tool, an ability to break jobs down into smaller parts, and a new Print wizard that takes you step-by-step from adding a new job through to printing it. All the versions can be purchased online at competitive prices from Macro Enter Corporation (www.macroenter.com).

Version: PhotoPRINT 6.0 (2008)

OS: Windows XP and Vista; Mac OS X 10.2

RAM: 1GB

Supported file formats: TIFF, JPEG, PDF, and other major formats

Price level: SE edition $1,000, DX $1,500, Server $3,500, Server-Pro $4,300, Server-Ultra $5,300 (all approx.)

Address: SA International Inc., International Plaza II, Suite 625, Philadelphia, PA 19113, United States

www.scanvecamiable.com

PosterJet

Vendor: Eisfeld Datentechnik

Purpose: Very fast software RIP that processes as it prints

Description

PosterJet is a powerful package for large-format. It handles 12-color printing on both the HP Designjet Z-series and Canon's imagePROGRAF series. With some justification the vendor claims "PosterJet is the fastest RIP software in the world." It achieves this high-speed capability by being able to process and print at the same time, working on a line-by-line basis while managing color and interpolating the data.

Designed for a production environment, PosterJet has excellent job-handling facilities with a high degree of automation. It offers full support for ICC color management, yet requires practically no training. Printer linearization is automatic with the firm's Intelli-Lin technology. It supports more than 200 graphics file formats and according to the vendor takes only seven seconds to print (that is, to start printing), whatever the format.

PosterJet can print on several printers simultaneously, using the vendor's SimuPrint technology. It supports multi-page documents containing different page sizes, the nesting of multi-page documents, and the special functionalities found in new Canon and HP printers.

Comments

Being able to "RIP-on-the-fly" means that PosterJet really is a speedy RIP. The latest version has made it substantially easier to use. It is designed for corporate and institutional use, but many small design bureaus, advertising agencies, photographers, and print shops are also using it successfully. Kall Kwik in London uses it with Canon and HP printers.

Version: PosterJet 8.0 (2008)

OS: Windows 2000 SP3, XP, 2003 Server, and Vista; Mac OS X

RAM: 256MB (512MB recommended)

Supported file formats: More than 200 formats

Price level: One server, five clients from approx. $550

Address: Eisfeld Datentechnik GmbH & Co., Eisfeld Datentechnik GmbH & Co., Hugo-Eckener-Str. 31, 50829 Köln, Germany

www.posterjet.com

ProofMaster

Vendor: PerfectProof

Purpose: Modular RIP, with multi-featured base product plus further product options

Description

ProofMaster is a software RIP that comes as a base product consisting of the RIP, color engine, an editor for on-the-fly adjustments, and two custom-built drivers. To this core technology you can add other product options including:

- Certify! (certification to a choice of many industry standards)
- 1-bit option (for three types of 1-bit proofs)
- Advanced Color (ICC printer profiles)
- Advanced Editor (for wide format printing and sign making)
- SoftProof (with additional features besides those offered in the base product)
- RasterCreator (turns your printer into image-setter)
- Cut! option (adds full-fledged cutting capability)

The modular approach means you can expand your investment in ProofMaster as your company grows. The product is aimed at photographers, advertising agencies, color separators, and offset, gravure, newspaper, flexo, screen, and wide format printers.

Comments

The problem with modularity is that customers are never completely sure if they have the best configuration until acquiring all the extras. In this case, fortunately, the base product is one of the most fully featured available. ProofMaster 3.1 is fully native on Intel-based Macs: another important point, as most RIPs are PC-based. Independent tests (www.large-format-printers.org) have shown it to be a viable option for the CMYK proofing environment, although it is aimed at the widest possible market (photographers, advertising agencies, and more).

Version: ProofMaster 3.1 (2008)

OS: Windows XP Pro SP2, and Vista; Mac OS X 10.4.8

RAM: 4GB

Supported file formats: Major RAW formats; PS, PDF (X3, X1a), EPS, PSD, Illustrator .ai, nCT/nLW, DCS2, and TIFF/IT

Price level: Up to 24 inches wide approx. $2,550, up to 44 inches wide approx. $3,350

Address: PerfectProof USA Inc., 3 Webb Place, Dover, NH 03820, United States

PerfectProof Europe NV, 4 Wayenborgstraat, 2800 Mechelen, Belgium

www.perfectproof.com

www.proofmaster.net

QuadToneRIP

Vendor: Roy Harrington

Purpose: A RIP for black and white inkjet printing TIFF format, using inks with four tones instead of four colors

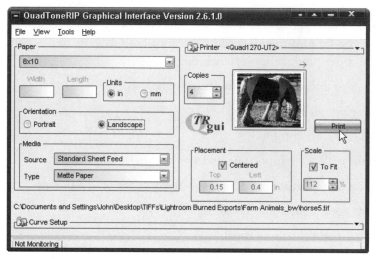

Figure 31.2
QuadToneRIP gives black and white specialists complete control over printing.

Description

Roy Harrington's QuadToneRIP provides "color management" for black and white inkjet printing in TIFF format, using quadtone inksets (four tones instead of four colors). Developed by a skilled black and white landscape photographer who shoots in large format, it produces outstanding results and is highly regarded by experts. It works with several kinds of Epson inkjet printers and with both standard and custom dedicated black and white inksets.

Profiles already exist for many printer/ink combinations, but you can create a new profile for an inkset using a densitometer or spectrophotometer. The software includes facilities for making full black and white ICC profiles for printing and soft-proofing within Photoshop and other editors. QuadToneRIP requires "a fair amount of memory," according to the developer. Good documentation, tutorials, and a user group are available.

Comments

If you happen to use an Epson printer and are keen to obtain the best possible black and white prints, QuadToneRIP is a natural choice. It is a first-rate product, greatly admired by black and white photographers who refer to it as QTR. Several accomplished black and white photographers have written extensively about their use of QuadToneRIP, including Paul Roark (www.paulroark.com), Clayton Jones (www.cjcom.net), and Ron Reeder (www.ronreeder.com).

First-time users have been known to use QTR for a printer loaded with color inks rather than UT (Ultratone) inks. Note: this does not work.

Version: QuadToneRIP 2.6.1 (2008)

OS: Windows 2000, XP Home, XP Pro (recommended), and Vista; Mac OS X 10.2, 10.3, and 10.4, or 10.5 (recommended)

RAM: "A fair amount" (1GB, fair enough?)

Supported file formats: TIFF

Price level: Approx. $50

Address: Roy Harrington, PO Box 3962, Los Altos, CA 94024-0962, United States

www.quadtonerip.com

Shiraz

Vendor: Applied Image Technology

Purpose: Multi-platform client/server RIP for a wide variety of large format printers

Description

Shiraz is a third-party software RIP that has all the features expected of a product for large format printing: PostScript Level 3 and PDF compatibility, excellent ICC color management, linearization and ink limiting, support for spot colors, workflow and queue management, and high-quality screening. It can process and RIP at the same time, making it fast to operate. Editing functions include layout, tiling, sizing, and cropping.

One of the key selling points of Shiraz is its availability for practically every large-format printer on the market, not only HP Designjet, Mimaki, and Canon machines, but also the Osprey, Phoenix, Spitfire, and Valuejet models from Mutoh. It comes in three editions—Lite, Server, and Server Plus—in six European languages.

- Shiraz RIP Lite: For photographers and small sign shops with a single printer.
- Shiraz RIP Server: For medium-size sign and copy shops; unattended operation; and batching and nesting facilities.
- Shiraz RIP Server Plus: For pay bureaus and big sign shops; accepts custom profiles/spot colors from advanced users.

Comments

Formed in 1995 with the purpose of creating a RIP aimed at the large-format market, AIT's Shiraz is now used in over 30 countries by more than 5,000 customers. It is based on the Jaws RIP engine from Global Graphics, and is available online from Macro Enter Corporation (www.macroenter.com).

Version: Shiraz 6.4 (2008)

OS: Windows 2000, XP, and Vista; Mac OS X 10.4.8 and above; Linux Red Hat or Suse

RAM: 1GB

Supported file formats: PostScript Level 1, 2, and 3, not in Photo edition, PDF, EPS, TIFF, and JPEG

Price level: Lite $650, Server $850, Server Plus $1,050

Address: Applied Image Technology, 30 Churchill Square, Kings Hill, West Malling, Kent, ME19 4YU, United Kingdom

www.applied-image.com

SoftRIP

Vendor: Wasatch Computer Technology

Purpose: Software RIP with high-definition output using a 16-bit color pipeline

Description

SoftRIP formats image files for both small- and large-format inkjets, and for specialist applications such as textile printing, labels, sportswear, and contour cutting. It offers Wasatch's proprietary Precision Stochastic Screens (PSS) half-toning and 16-bit rendering for high-definition color quality. The vendor claims that even files that arrive to the RIP only 8-bits deep also show substantial benefit, being promoted to 16-bits prior to color management and maintained there for half-toning. PSS works especially well with dye sublimation and other processes that involve extreme dot gain, helping to eliminate artifacts such as "stairstepping" (banding) or "rainbowing" (banding in different colors).

Wasatch SoftRIP comes as a full edition for large-format inkjet printers, and in special editions for small format and desktop printers. The special editions have the same features as the full version, differing only in the size of printers they support.

The vendor has also brought out a range of "exclusive editions," each dedicated to a specific brand of printer: Canon, HP, Epson, Mutoh, and Roland. It you have just one brand of printer, this is a good option as you get SoftRIP's premium RIP features at an entry-level price.

Comments

With its 16-bit pipeline, SoftRIP has virtually eliminated tonal banding. It is recommended by Dr. Nicholas Hellmuth's FLAAR information network (www.large-format-printers.org) partly for that reason. He calls it "the preferred software at our university." It is ICC-aware, can drive a wide range of different printers, and copes admirably with giclée printing.

Version: SoftRIP 6.3 (2008)

OS: Windows 2000, XP, and Vista

RAM: 512MB

Supported file formats: PostScript Level 3, PDF, EPS, TIFF, JPEG, GIF, PNG, PSD, BMP, PCX, PPM, PCD, TGA, DCS2, and MrSID

Price level: Desktop $600, small format $1,200, exclusive editions $1,500, large format $3,000 (all approx.)

Address: Wasatch Computer Technology, 333 South 300 East, Salt Lake City, UT 84111, United States

www.wasatch.com

StudioPrint RIP

Vendor: ErgoSoft

Purpose: Inkjet RIP software for the highest quality printing and support for more than 200 printers

Description

Winner of many awards, StudioPrint is a color RIP that provides a high level of control over job layout and image management and acts as a dedicated print server. It is described succinctly by the vendor as being like "a high-definition tuner, only for your inkjet printer."

Highly favored by photographers for its excellent image quality and color accuracy, StudioPrint is not hard to use, especially with the new features such as job ticketing in v.2008. It supports density and ICC profiles for CMYK and several other configurations including CMYK plus eight additional inks, also combined with light inks. For black and white, a specially developed dithering method allows printing in up to seven shades of black. As a result, StudioPrint achieves exhibition-quality tonal gradation on good-quality printers. It contains over 200 printer drivers and allows you to make on-the-fly changes to print parameters.

StudioPrint supports the following inkjet printers: Canon, Encad, Epson, HP, Mimaki, Mutoh, Roland, and Seiko. It supports the following spectrophotometers: Barbieri, ColorScout, HP BuiltIn Device, Techkon, and X-Rite. It supports the following color

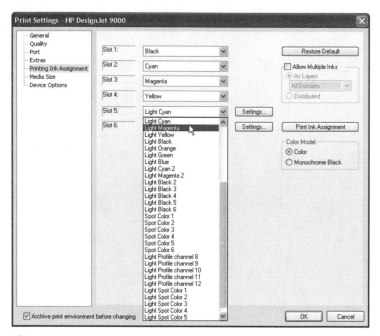

Figure 31.3
The Print Settings dialog box in StudioPrint RIP.

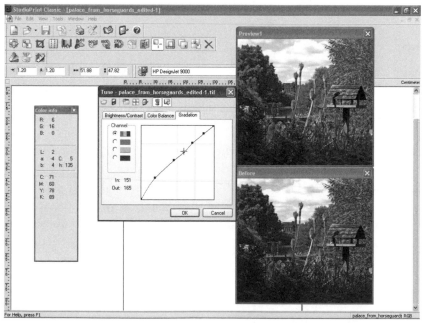

Figure 31.4
StudioPrint RIP offers plenty of last-minute tweaking for perfect results.

spaces: RGB, CMYK, sRGB, and LAB. Its image-processing functions include scaling, rotation, tiling, cropping, and color/brightness correction. Among its "extras" are spot color support via the Photoshop spot color channels.

Comments

Founded in Switzerland in the 1980s, ErgoSoft AG developed PosterPrint for large format graphics and TexPrint RIP for digital textile printing. In contrast, American subsidiary ErgoSoft US (founded in 2001) from the start chose to target digital photography and fine art printmaking, and offers the StudioPrint RIP to give photographers "the highest level of control over the printing process."

Version: StudioPrint 12.0.6 (2008)

OS: Windows XP and Vista

RAM: 1GB

Supported file formats: Import filters TIFF, BMP, and JPEG

Price level: Small format $850, medium format $1,300, large format $2,300

Address: ErgoSoft US LLC, 34 Technology Way, Nashua, NH 03060, United States

www.ergosoft.net

Summary

Raster Image Processors (RIPs) are needed whenever you print a document or an image. They create a dot pattern appropriate to the particular combination of printer, ink, and paper being used. Embedded RIPs that come with the printer are inferior to the software RIPs described in this chapter. All professional photographic printing requires the use of an effective RIP, especially in high-quality inkjet printing with 8- or 12-color cartridges. Modern RIPs go the extra mile in providing many auxiliary features, including batch handling, color management, and even last-minute color correction. The products discussed in this chapter are just a selection of the more than 80 RIPs available, but they are all among those that are best suited to photographic printing. Most RIPs are PC-based, but the ImagePrint RIP runs on Macintosh as well. QuadToneRIP has a great reputation among black and white specialists, whereas ErgoSoft's StudioPrint has been developed specifically for fine art printmaking and digital photography.

Virtual Proofing

If ever there was a "no-brainer" in the graphic arts world, virtual proofing is it. It is faster, cheaper, and more accurate than conventional proofing. It requires no physical transportation of paper on the back of a motorcycle through rush-hour traffic. It enables convenient, collaborative viewing that brings all parties together—designer, pre-press, agency, client, and sometimes even the photographer. People can zoom into pages at pixel level, add their annotations, chat about them in real-time, and do all this from the comfort of their own office or their holiday home in Hawaii. Worried about security? It has encryption. Worried about the color? Good point; but the color management is foolproof. And only a fool would refuse to embrace virtual proofing now that it has reached a mature stage of development.

Photographers who care about the quality of their work as it finally appears in magazines, brochures, catalogs, and so on should try to insert themselves into the virtual proofing loop. All too often, a picture looks great as an inkjet print, but fails to impress when it gets reproduced on other media. Virtual proofing can help everyone concerned with a project have realistic expectations about the final quality of the output.

Note

A word about terminology—"soft" and "virtual" proofing are used interchangeably but do not always refer to the same process. Soft-proofing can also mean non-color critical proofing on an RGB display to check the components of a page to be printed. True virtual proofing, by contrast, involves viewing CMYK simulations on a high quality, carefully calibrated monitor. Output is taken from the RIP, which shows the exact effect of using a particular printer/paper/ink combination, complete with trapping, and accompanied by the job ticket containing all the appropriate metadata. Virtual proofing aims to be a true WYSIWYG representation of the final output.

SWOP

If virtual proofing sounds like a "no-brainer," why are there still some doubters? The chief reason is that many people who buy print do not have sufficient confidence in non-tangible media. It is different if you work with a trusted supplier who can ensure that your own systems and viewing facilities are ideal, but the lack of standards in the early adoption phase of virtual proofing prevented universal acceptance.

Some print service providers like RR Donnelley Premedia Technologies (www.premedia technologies.com) have long offered virtual proofing as a standard part of the workflow. Yet the tipping-point in the uptake of the new, paper-free techniques did not occur until IDEAlliance (www.swop.org) launched its combined SWOP/GRACoL monitor proofing certification program in 2007. This paved the way for a move toward open rather than proprietary systems. RR Donnelley's ShareStream soft-proofing system, which allows customers to inspect all their production files online in high resolution, is itself now fully SWOP-certified. In the future, when virtual proofing is universal, print buying may become a much speedier process in the global marketplace.

DALiM DiALOGUE

Vendor: Dalim Software GmbH

Purpose: Online soft-proofing server application for real-time collaborative access

Description

Part of an extensive range of workflow automation products, at the time of its launch DALiM DiALOGUE was the only JDF-enabled virtual color proofing system on the market. (JDF, or Job Definition Format, is a new technical standard that automates job workflow by carrying both the content and the instructions for how this content should be treated by each JDF-enabled device.) Designed as a stand-alone product for Mac OS X, DALiM DiALOGUE fits into many workflows, which ensures that users can check files for both content and color accuracy. It provides remote, collaborative facilities for examining high-resolution files across the Internet, with full annotation, zoom in/out, navigation and real-time chat functions. It leverages the color-management capabilities of the Macintosh.

One of DALiM DiALOGUE's most remarkable features is its zoom capability—5,000,000% for both pixel and vector data. This zoom capability enables viewers to see images at their most fundamental level in order to check trapping information.

Comments

DALiM DiALOGUE is one of the most advanced virtual color proofing systems, with excellent collaborative facilities and SWOP certification (www.swop.org). Each at a

different location, photographer, designer, and client can check proofs, chat, place notes, take densitometer readings, check production parameters, and agree on final approvals without having to leave their locations. DALiM DiALOGUE was the first online soft-proofing product for Macintosh OS X and won *MacWorld* "Best of Show" award at its launch (2003). It has also been approved by *Time Inc.* for all its press proofs.

Version: N/A (2008)

OS: Mac OS X 10.3 and later; Linux

RAM: 512MB

Supported file formats: All major industry file formats, including PDF, PDF/X-1a and PDF/X-3 (including 2003 specs), Scitex CT/LW, DCS, DCS2.0, TIFF, TIFF-IT, PostScript, EPS, and JPEG

Price level: On application

Address: Dalim Software GmbH, Strassburger Strasse 6, D-77694 Kehl am Rhein, Germany

www.dalim.com

FirstPROOF

Vendor: Hamillroad Software

Purpose: Family of pre-press soft-proofing products to add to Harlequin (or TIFF-based) RIPs

Description

The FirstPROOF family of soft-proofing products for Harlequin or TIFF-based RIPs has brought much-needed performance improvements to the computer-to-plate (CtP) RIP workflow. It allows you to make the kind of checks that were once possible with film but are no longer standard with CtP—checks, among others, for moiré, orientation, and content. It comes in three editions:

- Lite: A simple, free utility for tracking and viewing ripped jobs.

- Standard: Includes high-performance viewing and navigation; zoom in/out; rotate and mirror; search multiple RIP facility; grid and guide lines to check object alignment; and black trap checking.

- Pro: Includes all of the above, plus measurement tools (distances, areas, screens, and densities); moiré inspection; ink limit tool; page registration checker; separation handling (rotate and merge); and ROOM ("Rip Once, Output Many") proof printing of the separations being viewed.

Comments

FirstPROOF is well conceived and engineered. For example, being a "remote on-screen proofing system," it utilizes the processing power of the machine on which it is installed, not the CPU of the RIP. You can put the RIP into "hold mode" so that it does not print

before you have inspected the work in FirstPROOF. Highly acclaimed by pre-press managers in the UK, the product is sold worldwide through distributors in each country or state. Hamillroad's main distributor is Compose System Limited, of Hong Kong, which markets the product worldwide as Compose Visual Proof.

Version: FirstPROOF Standard and Pro 5.0 (2008)

OS: Windows NT, 2000, XP, and Vista; Mac OS 9.x, OS X 10.2.x, 10.3.x, and 10.4.x

RAM: 2GB

Supported file formats: Harlequin PGB format and TIFF

Price level: Standard approx. $750, Pro approx. $1,300

Address: Hamillroad Software Limited, Whitehall House, Longstanton Road, Oakington, Cambridge, CB24 3BB, United Kingdom

www.hamillroad.com

ICS Remote Director

Vendor: Integrated Color Solutions

Purpose: SWOP-certified virtual contract proofing system

Description

Remote Director is a SWOP-certified virtual contract proofing system that plugs into any workflow solution and sends proofs directly to your client's desktop. It allows all interested parties, no matter where they are, to view, collaborate, and comment on both the color and content of virtual proofs. This provides a complete, auditable record of the proofing process, culminating in a final, legal sign-off.

Top digital photographer Jack Bingham (www.nevergetcaughtonfilm.com) has commented: "Remote Director might just be the next thing photographers can't live without." And not only photographers, but agencies, clients, pre-press shops, and printers can all benefit from a product with these facilities. Remote Director runs on commercially available hardware (PC and Mac), supports both RGB and CMYK workflows, and requires no specialized technical knowledge to use.

Comments:

Remote Director's SWOP certification has been its greatest selling tool. The first virtual proofing system to gain certification, it can produce proofs that are visually identical to the SWOP Certified Press Proof, defined in ANSI CGATS TR 001. As a result, it has found good levels of acceptance among advertising agencies, newspapers, and magazines in North America, the UK, Europe, and the Far East. In North America it is distributed by Chromaticity (www.chromaticity.com), in the UK by Target Colour (www.targetcolour.com), and in Europe and the Far East by various other resellers and OEMs.

Version: Remote Director 3.6 (2008)

OS: Windows 2000 with SP3, XP with SP2, and 2003; OS X 10.4

RAM: 1GB

Supported file formats: TIFF, EPS, JPEG, PDF, and any active image in Photoshop

Price level: On application

Address: Integrated Color Solutions, 60 Madison Avenue, Suite 1105, New York, NY 10010, United States

www.icscolor.com

Kodak Matchprint

Vendor: Eastman Kodak

Purpose: Virtual proofing software with one-button monitor calibration

Description

Kodak Matchprint enables accurate, consistent viewing of CMYK color reproduction on LCD computer monitors. It is easy to use, offers one-button monitor calibration, has SWOP certification, and supports a relatively small number of high-quality monitors including Apple Cinema Displays. It derives a spectrophotometric model from a hard copy reference of the user's choice and then makes the necessary transformations for display on the RGB monitor. Color rendition options include newspaper, SWOP, or Matchprint Software Colors. Quality is maintained by a five-minute calibration of each monitor every 24 hours using a Kodak-supplied colorimeter.

Features of Kodak Matchprint include dual-monitor support, zooming to pixel level, and ability to annotate the image with on-screen notes.

Comments

Kodak, being a brand that is practically synonymous with color quality, signaled that virtual proofing had arrived when it entered the market with the Matchprint Virtual Proofing System. Users report that it has dramatically increased production efficiency, with page quantities up and costs down. Matchprint has the essential features needed for virtual proofing and is backed by a world class service organization.

Version: Kodak Matchprint 5.0 (2008)

OS: Apple OS X 10.4.6 to 10.4.11

RAM: 512MB

Supported file formats: For color critical viewing (CMYK only): DCS2 (Single File Composite), EPS, PDF, PDF/X 1A, PostScript, Scitex CT/LW, and TIFF. For content viewing only: JPG (CMYK and RGB), one-bit TIFF, and DCS

Price level: On application

Address: Kodak's Graphic Communications Group, 343 State Street, Rochester, NY 14650, United States

www.graphics.kodak.com

PROOF-it-ONLINE

Vendor: PROOF-it-ONLINE

Purpose: Web-based proofing and approval-management solution

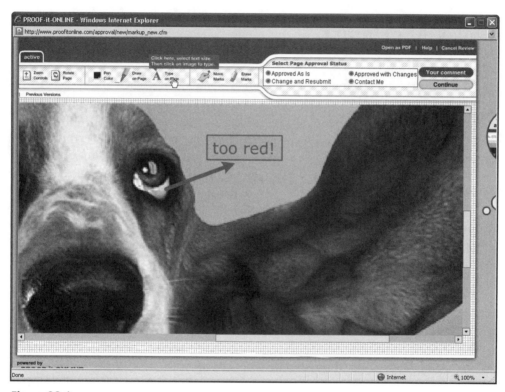

Figure 32.1
PROOF-it-ONLINE is a Web-only virtual proofing system with online commenting.

Description

PROOF-it-ONLINE is a Web-based solution for increasing the efficiency of the creative approval process. It is offered as a monthly subscription with personal plans and several levels of business plans available. Subscription levels are based on the number of proof pages issued each month, ranging from 20 pages on the lowest Personal plan, up to 800 pages on the Premium Plus plan.

Aimed at advertising agencies, printers, publishers, designers, and other professionals in the graphic arts industry, PROOF-it-ONLINE eliminates the need for expensive IT infrastructure while at the same time providing a high level of security, with 128-bit encryption available on top-tier systems. Features include collective access to allow clients to see all of their jobs in one location, job tracking with Track-it ID, and full annotation facilities. A TeamTrack option lets the proofs pass through a "middleman," such as an account executive, before going on to the end client for final approval.

PROOF-it-ONLINE integrates with your Website in such a way that your client might not even realize the service is not your own.

Comments

PROOF-it-ONLINE's success speaks for itself. It has been an enormously popular application, bearing in mind that many companies go on to invest in virtual proofing systems of their own. The company has responded to requests to add features, making it fit very nicely with the way people in different companies (photo studio, ad agency, and end client) need to collaborate. For example, if you need approval from more than one reviewer, you can call upon the Review Team feature in the Contacts menu. This speeds up the approval process by contacting all the team members when you post the proof. If you are tired of sending PDF files to and fro, here is another, much faster and more economical way of doing it.

Version: PROOF-it-ONLINE 3.0 (2008)

OS: Browser-based—Internet Explorer, Netscape, AOL, and Safari browsers

RAM: 256MB

Supported file formats: PDF, GIF, and JPEG (preferred formats)

Price level: Personal plan approx. $40 per month, Professional plan $150 per month, Premium plan from $300 per month, Premium Plus plan $750 per month

Address: PROOF-it-ONLINE, Research Triangle Area, 200 Cascade Pointe Lane, Suite #106, Cary, NC 27513, United States

www.proofitonline.com

Summary

One of the most useful spin-offs from the development of color management has been virtual proofing—the new, speedy, paperless way of checking and approving proofs. In true virtual proofing, the software creates accurate simulations of how a document is expected to look when printed. This simulation is then shared among all interested parties who may be in different rooms, cities, or countries. Management and job-tracking features form a large part of the system, enabling efficient communications and administration. PROOF-it-ONLINE has enjoyed great success as a Web-based system, but companies with larger printing requirements will need also to look at the other products listed.

Part VI

Keeping It All Running Smoothly

This part covers the following topics:

Backup Software

For tax and accounting purposes, backing up is a legal requirement; for images, it is common sense. Photographers vary in the extent to which they back up their images, some of them placing perhaps a bit too much trust in their hard drives, others being sufficiently paranoid to back up even their backups.

Make a Plan

What every photographer needs is a data recovery plan, and the first step toward making such a plan is to recognize the distinction between archiving and backup. Because photographers usually take care to archive their images, there is often an assumption that little will be lost in the event of a system crash that destroys only current work. It is very easy to underestimate the inconvenience of losing even a day's work, especially if it takes two more days to recover from it. A far better policy is to have a proper backup procedure in place, together with appropriate software that will assume the responsibility of carrying out vital backup tasks automatically.

A data recovery plan looks at all the "what-if" scenarios, such as: what if the studio is raided and we lose all the computer equipment? Do we risk prosecution for loss of business data? Who would be affected? What will be the financial loss? With a huge choice of data recovery systems and services available, finding a preventative cure should not be a problem. A photographer with partners or employees should take the trouble to document the recovery procedures and make sure that everyone knows where to find the document—and related disks—in case of emergency. Keep the plan up to date with a yearly review, especially if the business is expanding. You may need to move from one backup solution to another.

Solutions

Available backup solutions include tape, cloned hard drives, CDs/DVDs, hardware RAID (multiple hard disks that can tolerate one or more of them going wrong), and various online services. All these solutions require software to get the data from one type of media to another, at a scheduled time or on demand. Here you have two options. You can use the facilities provided in your operating system, or you can purchase software that has been designed specifically for backup applications.

Microsoft Windows Vista and Apple's OS X Leopard have improved backup hugely for their respective brands. Apple, in particular, offered quite poor backup until the introduction of Time Machine, which gives users the flexibility to select source and destination, time of backup, and other important parameters. To create a local backup, you need to connect a second non-booting hard drive to your computer. The operating system takes care of the rest, backing up by default at midnight, unless you tell it otherwise.

Yet even Time Machine was only a partial solution. Apple released an API (Application Programming Interface) to third-party developers, expecting them to finish the job by providing a comprehensive range of robust backup options. Third-party backup software is rarely expensive, but it does a better job, more conveniently, than you can achieve with the standard tools offered by your operating system.

If you are a professional photographer, the type of backup you need depends largely on the size of your business and how it is organized. For example, do individual photographers use their own workstations, or do they pool images into a large database? If people work on their own, they may need a Personal Data Recovery (PDR) solution that enables them to take a "snapshot" of their hard drive, writing the entire contents including the operating system to another disk. This is where third-party software will always be superior because it is independent of the operating system, enabling users to reboot even when their OS is corrupted.

In the market there are a greater number of good backup solutions for PC than there are for Macintosh. The proportion of entries does not reflect this imbalance, being weighted in favor of Macintosh in recognition the fact that most photographers are Mac-based. Using any one of these products can improve your level of protection significantly, always with the proviso that backup copies must be kept at a separate physical location to be truly effective.

Déjà Vu

Vendor: Propaganda Productions
Purpose: "Preference pane" in Mac System Preferences, for scheduled backup of important folders

Description

Déjà Vu exists as a "preference pane" in Mac System Preferences and can be used to schedule backup of important folders or, if necessary, the entire computer. You can clone your system disks with it, perform backups on demand, back up only those files that have changed since the last backup, back up over a network, or mirror the contents of folders. It is localized for English, French, German, Italian, Dutch, Swedish, Japanese, Traditional Chinese, Ukrainian, Finnish, and Russian.

Comments

The vendor gives no address (which might give users a feeling of déjà vu), but reports of the software are generally favorable. Justin Williams at MacZealots.com, for example, found the only problem with it is the amount of system resources it takes up when running a backup, making the computer unusable for simultaneous tasks. Others have found Déjà Vu great value, and one reviewer (plasticsfuture) who finds nearly all Mac backup software disappointing was prepared to give it a qualified recommendation.

Version: Déjà Vu 3.4.2 (2008)

OS: Mac OS X 10.4 or higher

RAM: 256MB

Supported file formats: N/A

Price level: Single user approx. $25

Address: info@propagandaprod.com

www.propagandaprod.com

DriveClone

Vendor: FarStone Technology

Purpose: Clones your hard disk, or a partition of it, for total recovery

Description

DriveClone does exactly what it suggests: clones your hard drive or one or more of its partitions and then stores all the files, partition information, settings, preferences, and security information as a compressed archive. You can burn the image of the drive on to CD/DVD or to a USB external hard drive. It has several features such as RAID support and imaging across multiple hard drives that make it appealing for the serious professional, but simple enough for the home user to install and operate.

Comments

Because DriveClone works in pre-OS mode, not even a catastrophic system failure can stop you from recovering all your data from the stored image. DriveClone Pro, a slightly more expensive edition, offers a system snapshot capability and a universal restore

feature that allows you to restore a complete Windows-based system to a different hardware configuration. This is useful if you need to replace failed hardware and have difficulty matching your original configuration. FarStone Technology specializes in PC backup and has several other products for this purpose.

Version: DriveClone 5 (2008)

OS: Windows 2000, 2003 Server, SmallBusiness Server, XP Professional, and Vista 32- and 64-bit

RAM: 64MB

Supported file formats: N/A

Price level: DriveClone approx. $40, DriveClone Pro approx. $55

Address: FarStone Technology, 6 Morgan, Suite 160, Irvine, CA 92618, United States

www.farstone.com

Norton Ghost

Vendor: Symantec

Purpose: Versatile utility for backup to nearly all media

Description

One of the most mature of backup utilities, Norton Ghost backs up to nearly all media including CD-R/RW and DVD+-R/RW drives, USB and FireWire devices, and Iomega Zip and Jaz drives. It detects storage devices automatically, analyzes your system, and even gives advice about "best practice" while it is being installed. Other key features include backup encryption, automatic monitoring and optimization of backup disk space, and an informative interface for easy configuration and management. It works particularly well with Maxtor (Seagate) external drives, via the Maxtor OneTouch button interface.

Among the new features in the most recent releases of Norton Ghost is Symantec ThreatCon integration. ThreatCon is a measurement of the global threat exposure to viruses, worms, and malware "in the wild." When a specified threat level is reached, Ghost makes a backup automatically, hopefully before any problems have reached your machine.

Comments

You do not often see products reach double-digit version numbers, but Norton Ghost is an exception (although two or three versions seem to come out every year). With a long history, it ought to be good—and it is. Easy to install and configure, it shows all the scheduled backups in a single view so that you can compare the relative protection level given to each device. One very useful feature is the simple "Back Up Now" button for backup on demand. PC only, unfortunately.

Versions: Norton Ghost 14.0 (2008)

OS: Windows XP Home/Professional and Vista

RAM: Windows XP 256MB (512MB or greater recommended), Vista must meet minimum Vista OS requirements

Supported file formats: N/A

Price level: Approx. $70

Address: Symantec Corporation, 20330 Stevens Creek Blvd., Cupertino, CA 95014, United States

www.symantec-norton.com

Figure 33.1
Norton Ghost creates automatic backups or backs up on demand.

O&O DiskImage

Vendor: O&O Software

Purpose: Makes a complete image of a computer or individual drive

Description

O&O DiskImage lets you make a complete image of an entire computer or individual drive, enabling you to recover quickly from system failure. It offers two methods—complete imaging, with the option of "forensic" reproduction of everything including unused sectors, or incremental imaging. It has 128-, 196-, and 256-bit encryption and can split images across multiple drives automatically.

Figure 33.2
O&O DiskImage makes backups easy with a choice of six basic tasks.

With DiskImage, you can burn created images onto CD/DVD or any type of removable storage media, check the results for damage, and use high levels of compression. The software has native support for Windows x64 versions.

Comments

Ideal for Windows users, O&O DiskImage makes a backup without any fuss. If you have a problem with your computer, just run the backup and everything is restored to that point. You do not even have to have the software pre-installed on the system for it to work. The vendor, with commendable marketing flair, calls it "our BareMetal technology," meaning that it will revive your system using a specially designed start CD rather than obliging you to create your own rescue CD.

Version: O&O DiskImage 2.2 (2008)

OS: Windows 2000 Pro, Server 2003 all editions, XP 32-bit/64-bit, and Vista 32-bit/64-bit

RAM: 256MB (512MB for Start CD)

Supported file formats: N/A

Price level: Pro edition approx. $70, Server edition/single computer approx. $360

Address: O&O Software GmbH., Am Borsigturm 48, 13507 Berlin, Germany

www.oo-software.com

Paragon Drive Backup

Vendor: Paragon Software Group

Purpose: Creates a backup of your hard drive, including the operating system

Description

Drive Backup creates a backup image of your entire hard drive, including the operating system, with all your preferences, settings, applications, and data files. One of its key features is "differential backup," which allows you to create the copy with just the changes that you have made since the initial system backup. A built-in scheduler turns it all into a completely automatic process. Restoring the data is equally straightforward, allowing you to repair the failed system using a bootable "recovery CD."

Comments

Aimed at individuals, but usable in a corporate setting, Paragon Drive Backup is a reliable backup system for hard disks and networks. The vendor's "hot backup" technology lets you keep your applications online while desktops and laptops are getting a hard disk backup. Competitively priced, Paragon Drive Backup typically gets "4 points out of 5" ratings from most reviewers, solid if not exciting. But who needs exciting backups?

Version: Paragon Drive Backup 8.5 (2008)

OS: Windows 98, NT4, 2000, XP, and Vista

RAM: 128MB (256MB or greater recommended)

Supported file formats: N/A

Price level: Personal edition $30, Professional edition approx. $80

Address: Paragon Software, 3150 Almaden Expressway, Suite 236, San Jose, CA 95118, United States

www.drive-backup.com

EMC Retrospect

Vendor: EMC Corporation

Purpose: Backup and recovery software

Description

EMC Retrospect works with Windows and Macintosh computers (separate editions) and can restore a file, a folder, or your entire hard drive. Its main features are rapid installation, auto-backup, restore to prior points in time, choice of "keep all versions" or "keep current version only," backup of files in use, and easy backup drive rotation for extra protection of your data.

There are many editions—the professional edition would be adequate for most small photographic studios, whereas the workgroup and server editions are available for larger organizations. There is even a home edition, with much-reduced functionality.

Comments

EMC Retrospect gives you excellent protection against system failure, enabling you to get back up and running in about five minutes. Although the product range is extremely extensive, from home users all the way up to the enterprise, it works best in the category known to the trade as SMB (small to mid-sized businesses). This is where it has its primary market and where it has won awards. It was voted best in this category in the *Storage* magazine "Quality Awards" in 2005, according to SearchStorage.com.

Among the most useful features in EMC Retrospect is the way it deletes old backup data, a process called "pruning." It is reassuringly stable, works efficiently in Disaster Recovery (DR) mode, and can be left safely to run unattended in its normal backup mode. Retrospect Professional comes with two client licenses, but additional licenses can be purchased as add-ons to protect client machines on the network.

Version: Windows v.7.5, Mac v.6.1 (2008)

OS: Windows Servers NT 4.0, 2000, 2003, XP 32/64, and Vista 32; Mac OS 9; Mac OS X 10.1.5 to 10.4, or OS X Server 10.1.5 to OS X Server 10.4

RAM: 256MB (512MB recommended)

Supported file formats: N/A

Price level: Express, for home use $30, Retrospect Professional, with two client licenses $120, Retrospect Single Server $680, many other editions; see vendor

Address: EMC Corporation

www.emcinsignia.com

Silverkeeper

Vendor: LaCie

Purpose: Free Macintosh backup utility used by many photographers

Description

Silverkeeper is a free and fairly basic Macintosh backup utility favored by many photographers. It allows you to make a bootable backup to any removable storage device using a FireWire, USB, IDE, ATA, or SCSI interface. It was not designed originally to burn DVDs, although this can be done indirectly with another application if you select folders and do not attempt to back up over multiple disks. It has automatic scheduling.

Comments

If all you want is simple backup, this product could meet your needs. It will not back up over a network, but you can schedule days or times for backup of your hard disk (which the vendor expects will be a LaCie hard disk) with full automation. At the time of writing it is not intended for use with Macintosh Leopard (OS X 10.5.x), which has its own Time Machine backup. Says the vendor: "A fix is being investigated."

Version: Silverkeeper 1.1.4 (2008)

OS: Mac OS 9.2.2 or later and OS X 10.2.8 (not 10.5.x)

RAM: 256MB

Supported file formats: N/A

Price level: Free

Address: LaCie S.A.S, 17, rue Ampère, 91349 Massy Cedex, France

www.lacie.com

SuperDuper!

Vendor: ShirtPocket

Purpose: Creates a perfect copy of your hard drive on an external drive

Description

SuperDuper! creates a perfect copy of your hard drive on an external drive, providing the facility to reboot immediately from the external disk. Shareware, it runs on both Intel and Power PC Macs, takes around 10 minutes to back up 50GB data, and performs updates even when another backup application has carried out the initial cloning operation. It uses the "exclude" model of backing up and is a very useful alternative to Apple's Backup utility.

Comments

David Nanian's SuperDuper! is highly regarded by users who find that it faithfully preserves their files, including metadata. It requires no special expertise to install or operate. However, it is not designed to back up to CDs, DVDs, or tape, but rather to an external FireWire drive. You need to check that this external drive will actually boot the computer, as some FireWire drives will not.

SuperDuper! works well alongside Time Machine in Leopard, allowing to you store a bootable backup next to the Time Machine volume. Why would you need both? All the answers, or at least a good argument for being doubly careful, can be found in the vendor's 60-page user's guide. A free trial is available.

Version: SuperDuper! 2.5 (2008)

OS: Mac OS X 10.4 or later

RAM: 256MB

Supported file formats: N/A

Price level: Approx. $28

Address: dnanian@shirt-pocket.com

www.shirt-pocket.com

Synk

Vendor: Decimus Software

Purpose: State-of-the-art Macintosh backup with archival and scheduling features

Description

Synk lets you make bootable backups of both PowerPC- and Intel-based Macs, either partially or wholly, according to scheduled operations. With it, you can back up your Mac to other Macs and PCs or to external hard disks, including iPods. For expert users it has many sophisticated features, including full N-way synchronization that the vendor claims as an industry first.

The Synk 6 product line has three editions—Synk Backup, for archival backup of the whole system or selected folders; Synk Standard, with two-way synchronization and additional customization of the process, and Synk Professional, with "deep configurability" for expert users. It is localized in English, Finnish, French, German, and Italian.

Comments

As a graduate student, Benjamin Rister took over development of Synk from its previous author Randall Voth. He re-wrote the whole program, and then later formed a company to do it all over again. The result is an outstanding product that's more flexible than Apple's Time Machine. It can work with networked servers running Windows or Linux, and requires minimal space to hold the transferred data.

Synk does not copy everything: it uses intelligence to sift out Safari caches, temporary files, and files in the trash. Check the Help files to find out what is likely to be excluded. It proves the old adage that there is nothing like a good crash for cleaning up your hard drive.

Versions: Synk 6.0 (2008)

OS: Mac OS X 10.4 or later

RAM: 256MB

Supported file formats: N/A

Price level: Synk Backup $25, Synk Standard $35, Synk Professional $45

Address: Decimus Software, Inc., 182 Rosewood Dr., Pittsburgh, PA 15235-4321, United States

www.decimus.net

Summary

Unlike breaking up, backing up is not hard to do. It is simply a matter of devising a data recovery plan and then installing the right software, many examples of which have been described in this chapter. Choose your backup media (hard drive, DVD, and so on) and set a backup frequency and time. You can rely on the backup facilities that are included as standard in the latest Windows or Macintosh operating systems, or opt for an alternative solution from an independent supplier. In most cases, the alternatives are the more fully featured products. For example, Synk from Decimus Software is a Mac backup that works even more efficiently than Apple's own Time Machine.

34

Data Recovery

Poles apart, here are two examples where data recovery may be needed—simple, inadvertent deletion, and serious data loss through damage to the medium or corruption of the files stored on it. Most data recovery software is designed to cope with both extremes and everything in between. As long as the data have not been overwritten, there is a good chance that you can recover over 90 percent of the "lost" data.

General-purpose data recovery utilities can recover image files as well as other files, but software developers now offer specialist programs that display thumbnails of the recovered images so that you can pick and choose which ones you would like to keep. Image-recovery software comes with algorithms that are optimized for images, meaning that they are on the lookout for JPEG, TIFF, and RAW encoding and therefore more likely than non-specialist programs to succeed in locating the missing data.

Procedure

The first rule of any data recovery process is "stop!" You must stop writing data to the disk, card, or whatever type of media you were using. That obviously includes reformatting the media in response to a polite invitation that says "This drive is unformatted. Would you like to format it now?" All is not lost if you do go ahead and reformat, because some utilities can overcome even this hurdle, but it is best not to write anything at all on top of the data you want to recover. Equally, you should save recovered files to a separate physical location.

The first step is to consider whether the drive in question is a system drive or a data drive. If you have lost images from your main hard disk, which holds the operating system, you need to shut down the computer, take out the drive, and mount it on another machine as a data drive. All you need is a screwdriver and calm nerves. Photographers

who have only one computer will need to acquire another drive and reinstall the operating system before they can run any data recovery software. Fortunately, nine times out of ten, the drive at fault will be a data drive, a DVD, or a storage card. To recover data from these, you simply run the software. With most brands you can actually run the free trial, wait to see if your images appear in thumbnail form, and then pay the license fee and save them to another disk.

The Choice Is Yours

Searching on the Internet will reveal a bewildering number of data recovery programs, many of them offering similar facilities—thumbnail display, selection, and save. Some are biased towards saving RAW files, others can save over a hundred formats. Some are dedicated to CompactFlash and other storage cards, others specialize in recovering data from optical media. Trying to locate the right package for the job can be frustrating, so I hope that the selections in this chapter will be really helpful to busy photographers. All of these utilities come from reliable sources and have been tested by independent reviewers.

CardRecovery

Vendor: WinRecovery Software

Purpose: Data recovery of images, video, and sound from most types of memory card

Description

CardRecovery recovers lost, deleted, corrupted, or formatted photographs and other media files from most types of memory card, including SmartMedia, CompactFlash, secure digital, memory stick, MicroDrive, xD picture card, multimedia card MMC, MicroSD, and MiniSD. It finds the data on the card and then allows you to preview the images in thumbnail before saving them to a specified destination. The whole process takes around three minutes for a 1GB SD card over a USB 2.0 connection.

Comments

CardRecovery is safe to use because it performs read-only operations on memory cards. It does not move, modify, or delete any data. It even retrieves Exif information along with the images. If you accidentally reformat your memory card, remember: all is not necessarily lost. There is a good chance CardRecovery can help. In fact, the vendor's list of testimonials from satisfied users is one of the longest you are likely to see.

Version: CardRecovery 4.1 (2008)

OS: 95, 98, 2000, NT, ME, XP, 2003, and Vista

RAM: 64MB

Supported file formats: Major RAW; JPEG, GIF, TIFF PNG, BMP, AVI, MPEG, MOV, ASF, MP3, MP4, WAV, ZIP, and RAR

Price level: Approx. $40

Address: WinRecovery Software, 1901 60th Pl., L1169, Bradenton, FL 34203, United States

www.cardrecovery.com

Digital Photo Recovery

Vendor: Galaxy

Purpose: For recovering lost, deleted, and formatted digital photos on removable media

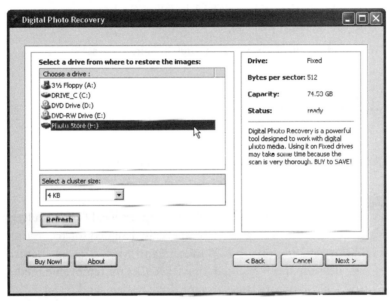

Figure 34.1
Digital Photo Recovery takes you step-by-step through the recovery process.

Description

Digital Photo Recovery is a versatile package that lets you recover image files in all formats from most types of media, including SD cards, CompactFlash, and hard drives. With the addition of the vendor's add-on Camera Pack software, it supports RAW formats, including Canon CRW, Kodak DCR, Nikon NEF, and Fuji RAF. It is completely risk-free because it makes no modifications to the data and does not overwrite any storage medium.

Digital Photo Recovery is "free to try" with the save function disabled. The Power Pack edition contains the recovery software plus the Camera Pack.

Comments

Designed especially for digital photographers, Digital Photo Recovery recovers images from an exceptional range of media. According to users, it has helped in situations where other recovery tools have failed. With its low price and non-destructive approach, it is certainly worth trying in an emergency. The vendor is very supportive, with a customer service team that handles queries seven days a week.

Version: Digital Photo Recovery 2.0.3 (2008)

OS: Windows 95, 98, ME, NT, 2000, and XP

RAM: 256MB

Supported file formats: Major RAW (with additional Camera Pack); JPEG, GIF, RiFF, TIFF, AVI, PNG, BMP, MPEG, MOV, WAV, MIDI, and QuickTime

Price level: $30, Camera Pack $20, Power Pack $40

Address: Galaxy Inc., 163 Third Avenue, New York, NY 10003, United States

www.photosrecovery.com

Digital Picture Recovery

Vendor: DTIData

Purpose: Recover lost, deleted, and formatted digital pictures on removable media

Description

Known chiefly as an operator of a "no fix, no fee" data recovery service, DTIData offers many recovery software packages, including this one, specially designed for recovering digital images. Available in versions for both Windows and Mac, Digital Picture Recovery can recover lost, deleted, and formatted digital pictures on removable media such as flash cards, SmartMedia, memory sticks, floppy drive readers, and so on.

Comments

It is difficult to test data recovery software in normal circumstances, but photographers who have experienced crashes report that Digital Picture Recovery succeeded in recovering most of their files. It can take several hours to work its way through a really massive drive, but it gets there in the end, recovering data that have not been overwritten or completely wiped.

This vendor also sells Recover It All in editions for Windows, Mac, and Solaris, to recover damaged, deleted, or corrupted volumes even from disks that have been initialized. However, documentation leaves a lot to be desired, despite a White Paper bemoaning the decline of standards in the data recovery industry. This is possibly because the vendor is a full-service data recovery lab in both the U.S. and UK, concentrating on services rather than product marketing.

Version: N/A (2008)

OS: Windows 2000, 2003, and XP; Mac OS X

RAM: 256MB

Supported file formats: N/A

Price level: Approx. $40

Address: DTIData Inc., 1155 South Pasadena Ave., Pasadena, Florida, United States

www.dtidata.com

DiskInternals Flash Recovery

Vendor: DiskInternals Research

Purpose: Flash memory file recovery tool to restore corrupted and deleted photographs

Description

DiskInternals Flash Recovery restores corrupted and deleted photographs, even if a memory card has been reformatted. It works with most storage media, including hard drives, external drives, cameras, and flash memory devices such as SmartMedia, CompactFlash, memory stick, MicroDrive, xD picture card, flash card, PC card, multimedia card, and secure digital card. Described by the vendor as "a professional product for professionals," it handles RAW files in its fully automatic mode.

An evaluation version of the product allows you to see but not save the recovered images. The vendor guarantees that the software will save them once you buy a license for it.

Comments

DiskInternals Flash Recovery is the "Editor's Pick" on Recovery Review (recovery -review.com), a site that carries information about hundreds of data recovery products. Another product from the same vendor, worth mentioning, is DiskInternals CD & DVD Recovery, for recovering data from CDs and DVDs. Both products have been popular downloads at shareware sites.

Version: DiskInternals Flash Recovery 2.5 (2008)

OS: Windows 95, 98, NT4, 2000, XP, and 2003

RAM: 16MB

Supported file formats: Major RAW and image file formats

Price level: Approx. $40

Address: DiskInternals Research, Pacific Business Centre, P.O. Box 34069 #381, Seattle, WA 98124-1069, United States

www.diskinternals.com

Don't Panic

Vendor: ImageRecall

Purpose: Recovery of accidentally deleted or corrupted files from memory cards and USB storage devices

Figure 34.2
Don't Panic's wizard interface is reassuringly simple, despite the scream.

Description

Don't Panic Photo Edition is utility software for recovering files on memory cards and USB storage devices that have been accidentally deleted or corrupted. It features a bright and easy-to-use interface, is speedy to operate, and is part of a well-established product line.

New features in the latest version include a thumbnail viewer, improved support for RAW formats, a secure/erase feature, plus the option to burn recovered files directly to CD and DVD. Don't Panic recovers files from xD picture cards, CompactFlash, secure digital, memory stick, multimedia cards, and microdrives, as well as from newer formats such as RS-MMC, MiniSD, and MicroSD.

Don't Panic is available in the U.S. from FlashFixers (www.flashfixers.com).

Comments

The developer of Don't Panic runs a recovery service in the UK for professional photographers, national newspapers, and government authorities and has now made its software available for more general use. Although it is not guaranteed to recover all images, it usually recovers at least 95% of them. It was warmly reviewed by *PC World* ("works like a champ") and described as "a real life-saver" by *Practical Photography*.

Version: Don't Panic - Photo Edition (2008)

OS: Windows 2000, XP, and Vista; Mac OS X 10.4 or higher

RAM: 256MB

Supported file formats: Major RAW formats; JPEG, AVI, MOV, WAV, WMA, and many others

Price level: Approx. $40

Address: Media Innovations Group, 1st Floor Penarth House, Otterbourne Hill, Otterbourne, Nr. Winchester, Hampshire, SO21 2EZ, United Kingdom

www.imagerecall.com

eIMAGE Recovery

Vendor: Octanesoft.Com

Purpose: Recovers digital photo files from defective or damaged media

Description

eIMAGE Recovery is a low-cost utility that recovers digital photo files from defective or damaged media. It can also restore images that you may have deleted accidentally. It works with SmartMedia, CompactFlash, Sony memory sticks, IBM micro drives, flash cards, floppy disks, and other types of "digital film."

Comments

Mentioned in *The New York Times*, it has to be good, although the developer hides behind an email address. The product has a bright and cheerful interface. It invites you to select the type of files you want to recover by clicking check boxes, and then it swings into operation. It shows thumbnails of the recovered images and lets you save them to disk. The vendor's online tutorial shows how easy it is to use.

Version: eIMAGE Recovery 3.0 (2008)

OS: Windows 98, ME, NT4, XP, and 2000

RAM: 64MB (128MB or more recommended)

Supported file formats: Major RAW formats; BMP, GIF, JPEG, PNG, TIFF, RIFF, AVI, MIDI, MOV, MPEG, and WAV

Price level: Approx. $30

Address: sales@octanesoft.com

www.eimagerecovery.com

File Scavenger

Vendor: QueTek Consulting Corporation

Purpose: File "undelete" and data recovery utility for Windows

Description

File Scavenger lets you recover files that have been accidentally deleted, but it is also a full data recovery program. It can rescue files even when the volume in question has been deleted and its original position and size are no longer known. You can install the software on another hard drive or run it from a portable device such as a memory stick. Like all recovery software, it can only recover files that have not been overwritten by new data. However, on computers with sufficient RAM it can scan extremely large volumes holding hundreds of megabytes of data.

Comments

File Scavenger can be used to recover data from hard disks, floppy disks, ZIP disks, memory sticks, flash cards, and RAID (Redundant Array of Inexpensive Disks). If Windows says your files are corrupted, all may not be lost if you run this utility. In most cases, it will recover more files than you would have thought possible. The vendor is a well-known specialist in RAID rescue, offering recovery services of all kinds, including remote assistance and both remote and offsite recovery.

Version: File Scavenger Version 3 (2008)

OS: Windows NT, 2000, 20003, XP, and Vista

RAM: 256MB

Supported file formats: N/A

Price level: Personal use $50, professional use $180

Address: QueTek Consulting Corporation, 2650 Fountain View, Suite 122, Houston, TX 77057, United States

www.quetek.com

IsoBuster

Vendor: Smart Projects

Purpose: Recovers data from optical media such as CD, DVD, BD, and HD DVD drives

Description

From Smart Projects, IsoBuster is a highly specialized program for recovering data from CD, DVD, Blu-ray, and high density DVD drives. In other words, it recovers from optical media. It supports all the relevant formats and common file systems, far too numerous to mention here. It lets you mount the media and gives you access to all the file systems that are present, not just those that are shown selectively by a standard operating system. If you are having problems with your backup or archive disks, IsoBuster is a natural choice.

Comments

As the developer claims, IsoBuster really is "the ultimate CD, DVD, BD, and HD DVD data recovery tool." It is very good at finding lost picture data, supports a colossal range of file formats, and supports over 40 languages including Lithuanian. IsoBuster recovers video data as well as image data. The vendor is not very forthcoming with mailing addresses, preferring to rely on its cyberspace reputation, which is favorable. The product is listed by Irfan Skiljan, the developer of the popular image browser IrfanView, as "great software." Others agree. It has worked for many photographers and is very good value for money if you have a removable disk problem.

Version: IsoBuster 2.3 (2008)

OS: Windows 95, 98, ME, NT 4.0, 2000, 2003, XP, and Vista

RAM: 256MB

Supported file formats: All possible CD, DVD, and Blu-ray (BD and HD DVD) formats

Price level: Personal version $30, Business version $50

Address: Smart Projects, support@isobuster.com

www.isobuster.com

MediaRECOVER

Vendor: MediaRECOVER

Purpose: Digital photo recovery software for all types of media

Description

MediaRECOVER enables you to recover lost images, files, and data from any type of media, including CompactFlash, secure digital SD, xD-picture card, SmartMedia, memory stick, memory stick duo, memory stick PRO duo, memory stick PRO, MMC, RS MMC, miniSD, Zip disks, floppy disks, hard drives, and CD/DVDs. The latest version has RAW image and metadata previews, prior to saving the images. Users of Hasselblad, Leaf, Phase One, Leica, and other professional camera systems can recover their RAW data using MediaRECOVER.

The Pro version has additional features, such as a Format utility that writes new system files and a Wipe utility that deletes old files from a removable drive, thus helping to prevent fragmentation errors. MediaRECOVER is localized for Spanish, Italian, German, French, Czech, Turkish, Russian, Polish, Korean, Japanese, and Traditional/Simplified Chinese.

Comments

MediaRECOVER has improved its support for hard drive recovery, making it a very comprehensive solution in the data recovery market. The company behind it is a market leader in a very competitive field, despite becoming embroiled in litigation with a rival.

Widely reviewed and tested, MediaRECOVER is good value, continues to be developed, and has won the "American Photo Editor's Choice" award two years running.

Version: MediaRECOVER 4.0 (2008)

OS: Windows 2000, ME, XP, and Vista; Mac OS X

RAM: 128MB

Supported file formats: 250 file types

Price level: Approx. $30, MediaRECOVER Pro $50

Address: MediaRECOVER LLC., 2361 E. Everglade Ct, Chandler, AZ 85249, United States

www.mediarecover.com

PhotoRescue

Vendor: DataRescue

Purpose: Recovers lost pictures from any type of media used by digital cameras

Description

PhotoRescue can recover data from SD cards, CompactFlash, memory sticks, microdrives, and other media. It displays thumbnail previews of the images it recovers, and then saves them to a location of your choice. Its algorithms are optimized for JPEG, TIFF, GIF, and BMP files, but it also supports RAW files such as CRW, NEF, ORF, and MRW together with many types of movie files.

Comments

First introduced in 2001, PhotoRescue is a widely used and thoroughly proven product. It won "Best Product" award in the Dutch *Personal Computer Magazine,* (May 2003), and has since been improved and upgraded. It was also reviewed in-depth by editors at *Imaging Resource* (www.imaging-resource.com), who found it "hard to beat," and called it "our hands-down favorite."

Version: PhotoRescue Wizard 3.1, Expert 2.1, Advanced 2.1 (2008)

OS: Wizard 3.1 Windows XP and Vista; Expert 2.1 Windows 98, 2000, and XP; Mac OS X 10.2 and above

RAM: 128MB (or twice as much RAM as the card)

Supported file formats: Major image and movie formats. Pre-recovery preview for JPEG, TIFF, NEF, compressed NEF, and CRW files

Price level: Wizard and Expert version approx. $30, Advanced version $100

Address: DataRescue sa/nv, 40 Bld Piercot, 4000 Liège, Belgium

www.datarescue.com

R-Studio

Vendor: R-tools Technology

Purpose: File recovery tools with full RAID recovery

Description

R-Studio is a powerful set of tools for recovering files on Windows or Linux systems. It works on local and network disks even when partitions have been formatted, damaged, or deleted. One of its strengths is RAID recovery: it treats hardware RAIDs like ordinary drives and volumes, and its Unformat tool recovers data that have been erased from software RAIDs. Other products from the same vendor include the inexpensive R-Undelete, a file undelete solution for Microsoft's FAT (File Allocation Table) and NTFS (New Technology File System) file systems.

R-Studio can handle FAT12, FAT16, FAT32, NTFS, NTFS5, and EXT2FS file systems. It can recover data even if FDISK or other disk utilities have been run, if a virus has invaded, if the FAT has been damaged or the Master Boot Record destroyed.

R-Studio Emergency, a constituent part of the R-Studio package, can be run in an emergency on Intel-based Macintosh, Linux, and UNIX computers/servers from a CD.

Comments

Whether you simply want to undelete a few files or recover data from a seriously damaged hard disk, perhaps even a RAID array, R-Studio can help. It has a clear, Explorer-style interface, gives full details about every file it recovers, and does a good job of recovering pictures. Several independent reviewers and users have tested it and praised it very highly, especially when it has rescued them from serious data-loss situations.

Version: R Studio 4.2 (2008)

OS: Windows 9x, ME, NT 4.0, 2000, XP, 2003, and Vista; and, over network, recovers files from Linux and Mac

RAM: 32MB

Supported file formats: N/A

Price level: Approx. $80

Address: R-tools Technology Inc., 10520 Yonge Street, Unit 35B, Suite 232, Richmond Hill, ON, L4C 3C7, Canada

www.r-tt.com

Stellar Phoenix Photo Recovery

Vendor: Stellar Information Systems

Purpose: Mac photo recovery software for all digital media

Description

Stellar Phoenix Photo Recovery Software for the Macintosh (there is a separate package for Windows) can recover image files from any type of digital card reader or storage media that can be mounted as a volume. However the memory card has been corrupted—whether by pulling it out while the camera is on or by turning off the camera during a write process—it can recover recorded data. It displays the images it finds and then allows you to recover them.

Comments

Indian developer Stellar Phoenix specializes in software for recovering lost data, with a wide range of products, including a version for the PC that recovers video as well as still images. The developer also offers software for full data recovery on Macintosh (at three times the price of the Photo version). Not yet widely reviewed, Stellar Phoenix Photo Recovery comes from a reliable vendor, but is limited in its range of features.

Version: Stellar Phoenix Photo Recovery 1.0 (2008)

OS: Mac OS X 10.3.9 and above

RAM: 256MB

Supported file formats: All major RAW formats; JPEG, TIFF, BMP, GIF, and PNG

Price level: Approx. $40

Address: Stellar Information Systems Limited, 205 Skipper Corner 88, Nehru Place, New Delhi-110019, India

www.stellarinfo.com

Summary

Whether through accidental deletion or physical damage to the storage medium, files can disappear from immediate view but may not necessarily be lost forever. Data recovery software allows you to recover files from SD cards, CompactFlash, and hard drives, while some will work with nearly all storage media. Many people first encounter data recovery software when they are already in an emergency situation, but it helps if you can familiarize yourself in advance with how these packages work. Usually, you can try them, and if you can locate your lost data you may proceed to purchase the software prior to saving the rescued files. Some recovery software, such as Digital Picture Recovery from DTIData, is dedicated to image retrieval on removable media; CardRecovery is dedicated to retrieving files from memory cards; File Scavenger will tackle anything from floppies to RAID. Whatever your data recovery need, you will find a potential solution listed in this chapter.

35

Pro Studio Software

Professional photographers might use software from most of the categories in this book, even the quick-fix software, but there are also specialist applications that are business-oriented as well as photo-oriented.

Business and aesthetic functions can be kept entirely separate, as they are in fashion photography. Here the objective is to create a few great shots of publication quality, so the software used for processing and enhancing them can be entirely different from another program that keeps track of the billing.

For other photographers, particularly those engaged in wedding, sports, schools, and events, the business and production elements go hand-in-hand. For example, a school's photographer needs to produce printed output in a range of different packages, any one of which might be ordered by each of the hundreds of individuals who have their picture taken on a given day. Image data, identity data, and order data all have to travel together to the printer, while other information needs to be extracted for invoicing. Bearing in mind that a large studio will have a team of photographers, most of them out on location, it is easy to see that the logistical problems will begin to run wild unless they can be tamed by the appropriate software.

Several developers have addressed the needs of busy studios, coming up with a variety of solutions. There are some that are more suited to portrait studios, being database-driven with strong contacting features. Both PI/E from RLW Concepts and The Photographic Organiser (TPO) from Productive IT are built on FileMaker Pro and do a fine job of tracking costs, contacts, sales, and billing, with great reporting features. Like the more marketing-oriented SuccessWare they could be described as "studio-management software," although TPO also has production capability.

A new breed of production software creates a proper interface between the photographer and the lab that does the printing. This, arguably, is the most efficient approach for high-throughput studios that offer a wide choice of package to the customer. Software from ExpressDigital and Timestone makes it possible for the photographer to deliver print-ready images to the printer, complete with text, graphics, and layouts. The printer uses a special module of the vendor's software to accept the instructions. Photographers using this type of software report significant increases in efficiency and turnover.

ExpressDigital Darkroom

Vendor: ExpressDigital Graphics

Purpose: Complete workflow tool for professional photographers, in multiple editions

Description

ExpressDigital Darkroom is a complete workflow tool for professional photographers. It comes in three main editions—the Core edition for emerging professionals, advanced amateurs, and digital enthusiasts; the Professional edition with special features for portrait, wedding, sports, and event photographers; and the Assembly edition, with even more features for school, team sports, and group photographers.

All the editions present you with an attractively designed interface, with different viewing modes for browsing, viewing, processing, and so on. The vendor groups its huge range of features under Capture, Manage, Enhance, Proof, Sell, and Print. The Pro and Assembly editions enable direct capture with industry-standard cameras, whereas all editions have full support for RAW files, ICC color profiles, and photo metadata, together with rename and reformat facilities. Its management features allow you to catalog photos by customer, sitting, event, or location. You can also add notes to your photos; search catalogs by customer, event, location, or notes; catalog photos by school, group, or event; and use bar-coding for quick data entry.

There are extensive image-enhancement features in all editions of ExpressDigital Darkroom, including non-destructive image editing such as crop, scale, move, and rotate. It also includes black and white conversion with retro, sepia, or duotone colors. You can add text and change exposure, contrast, brightness, shadow, and tone. The software also offers professional red-eye removal, grey card click balance, and built-in color adjustments and filters. A major feature is its inclusion of 150 graphic templates and ability to take additional templates from authorized third-party vendors. The Pro editions also have green screen chroma key and Retouch Workshop with clone, blemish, paint, dodge, burn, sharpen, and blur tools.

Sales tools are well implemented, with a Pro Services section that lets you manage a PhotoReflect.com Internet storefront. It gives you easy access to manage the pricing, shipping, discount, and tax details that are shown to the customer, together with reports of the transactions and other activity on the site. At a glance you can see how many orders are pending or what promotions are currently offered. ExpressDigital Darkroom also has built-in connections to labs via its Labtricity service (www.labtricity.com), which connects professional digital photographers to digital-enabled professional labs.

Comments

A very popular workflow tool among event and school photographers, ExpressDigital Darkroom won the 2005 "American PHOTO Editor's Choice" award. It is a direct rival to the IWS products from ImageWare Systems and has broadly similar features including the vital connection package that enables far-flung laboratories to accept printing from photographers using the system. Widely available via professional photographic outlets, it is spreading beyond North America to the UK, Australia, Scandinavia, and South Africa.

Version: Darkroom Core Edition 8.9 (2008)

OS: Windows XP Pro

RAM: 512MB

Supported file formats: Major formats

Price level: Core edition $500, Pro edition $1,400, Assembly edition $2,000

Address: ExpressDigital Graphics Inc., 9200 E. Panorama Circle Suite 150, Englewood, CO 80112, United States

www.expressdigital.com

Photo One

Vendor: Granite Bear

Purpose: Studio management with full customization to fit an individual business

Description

Photo One is a studio-management system that comes in both Basic and Professional editions to meet the needs of both small and large studios. It allows you to store all your clients' details, including phone numbers and email addresses, while also making a note of upcoming birthdays and anniversaries. With this information, you can build a closer relationship with clients by keeping in touch with them at times when they might be prepared to place another order.

Other features common to both editions include a light table for editing images, proof printing, order writing, and uploading to the Web. The software keeps a complete history of each customer's orders and payments, which you can consult at any time.

There is a calendar facility to schedule appointments and a "to-do" list so that you remember when next to get in touch.

The Professional edition has an area set aside for weddings, with special fields for recording important information like the newlywed couple's future address. Other Pro features include improved security for client data, batch commands that can be applied to several functions including ordering, and a special section for those who photograph high school seniors.

Comments

Photo One is used by professional consultants (like Mike Scalf, www.mikescalfphoto.com) who specialize in helping photographic studios set up administrative systems with the right policies, procedures, and documentation. It has one or two limitations. At the time this was written, it does not support wireless systems and there is no general ledger for day-to-day accounting, although it links directly to QuickBooks software, which you have to buy separately.

However, Photo One provides excellent facilities overall, including bulk scheduling, for keeping track of all the data associated with photographing high school seniors, plus credit card processing from multiple workstations. If you want to see in detail what it can and cannot do, there is no better place to look than the Photo One's Buyer Guide, at the vendor's Website. Photo One was given a "Hot One" award by the trade journal of the Professional Photographers of America.

Version: Photo One 9.1.19 (2008)

OS: Windows 2000 or later

RAM: 512MB

Supported file formats: Exports comma-delimited text CSV, dBase (DBF), Excel XLS, XML, and HTML

Price level: Basic edition, single user $1,650, Pro, single user $2,550 (both approx.)

Address: Granite Bear, LLC., 1 Federal Street, Bldg 101, Springfield, MA 01105, United States

www.photoonesoftware.com

PI/E

Vendor: RLW Concepts

Purpose: Business-management tool for the photographic industry

Description

PI/E stands for "Pro Invoice/Estimate," a business-management database system designed for all types of photographic business, of whatever size. Built on FileMaker Pro, it has all the administrative tools you need to run a business successfully, tracking jobs from first contact right through to final invoice and payment.

Among the many facilities in PI/E are sales tax report generation for state and federal taxes; tracking of client sales, vendor costs, representative sales, and stock agency sales, together with all payments associated with these transactions. You can use it to track your crew and employee billings and costs, as a contact database for client contacts, and to maintain equipment inventories and schedules. It generates a huge number of forms, reports, lists, and labels for all phases of job production.

Comments

After so many years in the market, with a string of impressive-looking clients to its name, it is surprising that PI/E is so poorly presented and explained. The vendor states the obvious, such as "all forms print on your own letterhead." (Well, yes, if you use your own paper, but should that be listed as a primary feature?) Being built on FileMaker Pro, it is undoubtedly a stable and reliable system. Any attempt to make an equivalent solution from the tools in FileMaker would take weeks of work, but equally, a substantial effort is needed to learn how to use PI/E. Photographers may find that administration with this kind of tool is best delegated to an office manager.

Version: PI/E 6.3.18 (2008)

OS: Windows 98 or later; Mac OS 9 or later

Requires: FileMaker Pro 5.5 or 6.0

RAM: 256MB

Supported file formats: Major formats

Price level: Single user version $1,200, multi-user version $1,400

Address: RLW Concepts, 403 S. Curson, Los Angeles, CA 90036, United States

www.piesoftware.com

StudioPlus

Vendor: StudioPlus Software

Purpose: Studio-management software for portrait studios, in three editions plus OnLocation module

Description

For professional photographic studios, StudioPlus is a family of software that combines scheduling, marketing, client database, invoicing, and order tracking with a complete digital workflow. It is designed to be a complete solution, bringing together other vital software such as Photoshop, QuickBooks, Microsoft Office, and ICVerify credit card processing into one seamless suite that can accomplish every task you need to do. It even works with a Palm or Pocket PC handheld computer.

There are three main editions of StudioPlus:

- StudioPlus Lite, aimed chiefly at portrait photographers, with a client database, scheduling, and marketing functions and some digital workflow.

- StudioPlus Professional, with additional order tracking, invoicing, analysis and reporting features, plus a full digital workflow.

- StudioPlus Enterprise, for portrait studios that have multiple locations, with transfer data facilities and group reporting.

New features in StudioPlus enable users to create custom multi-image composites for many purposes, including multi-image wall portraits, album pages, holiday cards, and sports cards. The photographer can then sit down with the customer and make a selection of pictures to fill the composites, all without needing to use alternative software. There is also an add-on module for the Professional and Enterprise editions called OnLocation, which effectively takes StudioPlus on the road via a laptop. Although designed to run in a Windows environment, StudioPlus will run on a Mac using Apple's Boot Camp, Virtual PC, or Parallels.

Comments

Like one of its main competitors (Photo One from Granite Bear), StudioPlus integrates with other products to provide a complete range of functionality for photographic studios. The main strength of both products is the boost they give to marketing a photographer's services to an existing client base. The StudioPlus workflow concept preserves RAW files as "masters," still a valid approach for many photographers, even in an age of non-destructive editing. The OnLocation module is a valuable addition, bringing Wi-Pics integration, bar-coding, hot-folder capture, and digital order-taking capabilities that many professionals will find essential.

Version: StudioPlus Version 2007 (seventh major upgrade)

OS: Windows 2000, XP, and Vista; Mac OS X

RAM: 256MB

Supported file formats: Major formats

Price level: Single user version Lite $800, Professional version $1,700, Enterprise version $3,700, OnLocation module $700

Address: StudioPlus Software, LLC., 600 S. Main St., Suite 120, Cambridge, MN 55008, United States
www.studioplussoftware.com

Note

The Wi-Pics system (www.wi-pics.com) connects to a camera via the CompactFlash port and transmits images to a remote server. Using one of its configurations, event photographers can use bar-code scanning to link images to preprinted cards for handing out to potential clients.

SuccessWare

Vendor: SuccessWare

Purpose: Studio-management software for tracking, pricing, and planning

Description

SuccessWare is professional studio management software that offers extensive tracking, pricing, and planning facilities, with good privacy and security features to prevent unauthorized access.

SuccessWare tracking features could scarcely be more comprehensive; the vendor lists more than a dozen pages of them, too numerous to be listed here. They come under the following categories: client tracking, direct mail, financial tracking, inquiries, orders, prospects, reporting, scheduling, session tracking, to-do lists, and vendor tracking.

Pricing features are similarly extensive, ensuring that the studio prices its products accurately, always taking account of the cost of doing business. For example, it takes in costs from suppliers' lists and automatically suggests updates to your prices when suppliers increase their charges. It also has great flexibility, enabling similar products to be sold at different prices in different markets.

Business planning is the third strand of SuccessWare, enabling the photographer to put together business plans in support of bank loans and lines of credit. It has powerful cash-flow forecasting, creates a monthly capital budget, and keeps a full record of income received from all sources. For the long term, it creates a five-year plan, showing projected sales growth, indicating the break-even point, and helping you to form a marketing plan for each product line. With SuccessWare, the photographer soon gets to know how many sessions the studio needs each month to make a profit.

Comments

Rather than attempt to become involved with the photographic workflow, SuccessWare sticks to business. Its tracking, pricing, and planning features are well-conceived and cover all bases, whereas the latest version even prepares standard balance sheets showing assets, liabilities, and net worth. Users report that it works well for them and is not too difficult to learn, despite its scope.

Version: SuccessWare 5.0 (2008)

OS: Windows 2000, XP, 2003 Server, and Vista; Mac OS X 10.3, 10.4, and 10.5

RAM: 512MB (1GB recommended)

Supported file formats: Major formats

Price level: Single user version $1,500, up to three users $2,500 (both approx; leasing terms available from approx. $50/month

Address: SuccessWare, Inc., 11800 Fawn Lake Pkwy., Spotsylvania, VA 22553, United States

www.successware.net

The Photographic Organiser

Vendor: Productive IT

Purpose: Integrated business-management software for photography studios

Figure 35.1

The Photographic Organiser will help you "keep tabs" on every aspect of your photographic business.

Figure 35.2

TPO helps you build and manage an efficient database of contacts.

Description

The Photographic Organiser (TPO) is a studio-management system widely used by professional photographers in the UK. It has an integrated viewing module with a multi-image arranger to place images into templates for client viewing, together with a very wide range of job tracking, contact management, sales/marketing analysis, and accountancy features.

TPO is aimed at all professional studios, from one-man bands to large photographic businesses. It can work in a mixed network environment and its main menu can be personalized to each user. Although extensive in its scope, it is not especially difficult to use. For the photographer who wants to get truly organized, it offers tightly integrated job management, diary, and contacting functions. The "My Day" feature presents you with all your personal tasks when you log on, with appointments, contact reminders, work in progress, internal email messages, stock check, and to-do list—all on one screen, together with an indication of which other staff are online.

The contact database retains a history of everything you printed for each contact, including letters, invoices, and statements. Client names and addresses can be used within the built-in word processor with its 100+ template letters, greatly easing the burden of mass-mailing. There are full job tracking and management facilities for social, commercial, and school photography, plus a Weddings & Functions module with fields for additional information. It will print your wedding contract, too.

Viewing facilities include a preparation area for importing, selection, and sorting, with the option of opening any image in Photoshop for more detailed editing. TPO's multi-image arranger provides a choice of 56 instant arrangements, with up to 16 pictures on the page. They include many attractive layouts that are ideal for portrait photography.

TPO's sophisticated accounting features include sales and purchase reports, cashbook functions, nominal ledger report, and general reports including VAT Return.

Built on FileMaker Pro, TPO comes with an OEM copy of the retail product FileMaker Pro 6.

Comments

After 14 years in the market, TPO has become a mature product, used by hundreds of studios in the UK. Its chief virtue is its tight integration. This means that you can make good use of the data you gather and enter in one module by accessing it from another. For example, you can examine "Sales by Source of Enquiry," a particularly powerful feature for the working photographer. Yes, you could customize FileMaker to your own requirements, but do you have the time?

Version: TPO version 7.1 (2008)

OS: Windows 98 SE2, ME, 2000, and XP; Mac OS 8.6, 9, OS X 10.1 or later

RAM: 512MB

Supported file formats: Major formats

Price level: Approx. £1,000 (UK), annual re-registration fee £25

Address: Productive IT (UK) Ltd., 75 The Campions, Borehamwood, Hertfordshire WD6 5QG, United Kingdom

www.productiveit.co.uk

Timestone Range

Vendor: Timestone Software

Purpose: Digital imaging workflow software for school and sports photographers

Description

Developed in Australia, the Timestone range of applications takes care of the entire digital workflow for school and sports photographers. It is a complex, modular range consisting of several production/printing applications, each designated Neo, from which the photographer chooses the most appropriate, together with a remote photographer application—CapturePost, DataPost, or OutPost.

The Neo applications let you collect, arrange, and match the images and data, correct the color and perform cropping, and then export the images and data for the creation of portrait packages, group photos with name-under, composite photos, memory mates, trader cards, ID cards, book marks and novelty items, yearbooks, certificates, magazine covers, and proof sheets. The versatility and production capacity of the application depends on its level—NeoPak (for the production of plain packages); NeoPak Plus (low-volume production); NeoPack/Professional (high-volume production); NeoComposite (production of composite group pages); and NeoGroup (for traditional group pages with name-under).

CapturePost is a single-screen remote capture application designed for image capture from a tethered digital camera. It supports nearly all cameras, has bar-code matching, and lets you correct subject details, add new subjects, and enter order information.

DataPost prepares data for both CapturePost and the Neo applications and can be used in the lab or remotely. It lacks the production functions of the Neo applications, but comes with ordering and group name options.

OutPost is designed to be the "missing link" between photographer and laboratory, allowing photographers to design, correct, and prepare packs, and then send them to the lab in a print-ready state for printing. The lab itself needs to have NeoPack/Plus or NeoPack/Professional.

Comments

The Timestone products are not as hard to use as a brief description might suggest. Quite the opposite: they are tailored very neatly to the needs of school and sports photographers, with the emphasis on speeding the workflow and eliminating logistical errors. Although the development team is in Australia, the support level in the United States is by all accounts very high, with direct North American representation. However, there is no local support in the UK or Europe at the time of this writing. Potential users of workflow software for these applications are strongly advised to shortlist Timestone as an up-and-coming alternative to the market leaders.

Version: NeoPack/Professional 3.1.0, CapturePost 3.1.0, DataPost 3.1.0, OutPost 3.1.0 (2008)

OS: Windows 2000 and XP

RAM: 256MB

Supported file formats: Major formats

Price level: Prices on application from regional representatives

Address: Timestone Software, P.O. Box 26, Sassafras Gully, VIC 3787, Australia

www.timestone.com.au

QuickBooks

Vendor: Intuit

Purpose: General purpose accounting package for small businesses

Description

QuickBooks, a general accounting package, is listed here because it is used by so many professional photographers. It requires a lower investment than those packages designed specifically for photo studios, although obviously it is not as closely tailored to the workflow. That said, it is so superbly equipped with tracking facilities for sales, taxes, inventory, employee time, expenses, and customer payments that it has most of the features required.

For larger businesses, QuickBooks does a fine job of managing payroll and payroll taxes, and keeping all the data organized in one place with Customer, Vendor, and Employee Centers. In the Customer Center, you can instantly view any customer's balance, transaction history, and contact information; in the Vendor Center you can view your balance with any supplier and see a list of purchase orders, bills, and payments; and in the Employee Center you have instant access to all paycheck and contact information for every employee. You can also add credit card processing, create shipping documents from within the program, generate professional-looking forms, and import customer, vendor, and product information via Excel data import templates.

Comments

There are some significant advantages to using a mainstream product instead of opting for an industry-specific package from a smaller developer. First is the fact that it is much more likely to be kept up-to-date, an important factor as regulations are always subject to change. Second, the package is bound to be more cost effective because it has a wider market. Third, as your business grow you can upgrade to higher editions or purchase additional licenses. For many photographers these factors outweigh any possible down-side.

QuickBooks Pro may be all you need, but if you are putting together a business plan, it is better to get QuickBooks Premier with its features for generating sales and expense forecasts. Getting started with either product is very straightforward; and there are plenty of training opportunities at Small Business Development Centers in the United States.

Version: QuickBooks 2008

OS: Windows XP (SP2 or later strongly recommended), 2003 Server, and Vista

RAM: 512MB of RAM (1GB recommended)

Supported file formats: Spreadsheet and word processing formats

Price level: QuickBooks Pro $200, QuickBooks Premier $450 (both approx.)

Address: Intuit, Inc., 2632 Marine Way, Mountain View, CA 94043, United States

quickbooks.intuit.com

Summary

Professional photographers have the option of using an all-in-one solution that will let them adjust their images and manage their business, but increasingly they choose best-of-breed photo processing software and an entirely separate system for running the studio. Both kinds of software are discussed in this chapter. ExpressDigital Darkroom is a complete workflow tool with facilities for pricing, shipping, tax, and so on. SuccessWare and The Photographic Organiser both concentrate on the business aspects of professional photography. SuccessWare is strong on forward planning; TPO successfully integrates all relevant functions, from client contact to invoicing and reporting. All the products listed are "photo-specific" except for QuickBooks, a popular general accounting package that may be all you need for running your business.

36

Pro Tools for Web, Wireless, and Remote Access

Brought together in one category because they all involve the concept of distance (actually because there is not a sufficient number of them for separate categories), these tools all have much to offer the professional photographer.

Sports and wildlife photographers often use remote control, and it's made possible by Wi-Fi systems like Nikon WT-2A and WT-3A, Canon WFT-E1A (note: "A" is not appended outside the U.S.), and Wi-Pics from DICE America. But there is also software that lets you control several cameras from a single PC using FireWire or USB cables: DSLR Remote Pro is an exciting product with many potential applications.

Pixagent ITP Professional supports both the Nikon and Canon wireless standards and acts as an efficient FTP server for wireless image transmission. Pocket Phojo lets you transmit images from a Pocket PC.

Professional Web tools for photographers include the Clickbooq hosting and management system; Aurigma's Image Uploader, which you can add to a Website so that users can more easily upload their images; and the highly sophisticated image library system for photo agencies called Fotoshow Pro.

Clickbooq

Vendor: Clickbooq, Inc.

Purpose: Website creation, management, and hosting solution for professional photographers

Description

Developed especially for professional photographers, Clickbooq is a Website creation, management, and hosting solution that allows you to create a full-featured Flash Website in a few minutes. It is all done from a normal browser and requires no special knowledge of Flash or HTML. There is no software to install on your own computer.

Clickbooq offers a wide range of standard features including instant updates, storage for thousands of images, custom backgrounds, unlimited Web galleries, IPTC data support, slide shows and music, and hundreds of design options. You can have your own domain name (such as a .com address) that links through to your area of the Clickbooq site.

With a 1GB hosting plan, a photographer can store over 5,000 images on Clickbooq.

Comments

Clickbooq benefits from being a latecomer to the online photo hosting business. Its design is sleek and up-to-date, making many other services appear slightly dated. It shows off images to perfection, pre-loading them in the Flash viewer for a very fast and comfortable viewing experience.

To use it you need a broadband connection, a fast computer, and some image resizing software. The interface is simple and offers two navigation schemes: a classic, left-hand menu design or a top-down version that stays hidden when not used. If you do not like Flash (and not everyone does), Clickbooq is probably not for you. But it means you can disable all right-clicks more effectively than you can with HTML-based sites. The end result is a clean, professional presentation of your images.

Version: Clickbooq 1.0 (2008)

OS: Any browser running Flash plug-in version 9 or higher

RAM: N/A

Supported file formats: Major image formats

Price level: Setup fee $200, subscription $70 per month, $700 per year, hosting $10 per month, $100 per year (all approx.)

Address: info@clickbooq.com

www.clickbooq.com

DSLR Remote Pro

Vendor: Breeze Systems

Purpose: For remote control of Canon DSLR cameras from PC, using FireWire or USB cables

Description

A remote control solution for Canon cameras, DSLR Remote Pro allows you to control one or more cameras from a single PC, view the pictures while you are shooting, add IPTC data automatically, store the images locally, and conduct time-lapse photography. Its features include automatic bracketing (up to 15 shots by varying the shutter speed or aperture), image preview in black and white or color, overexposure warnings, grid overlay for accurate alignment, and focus point overlay to assist focusing.

Comments

There are dozens of potential applications for this exciting product, especially using the auto-bracketing feature. With this technique you can make high dynamic range (HDR) images that would be impossible to take with manual operation of the camera. Birdwatchers and other wildlife photographers can hook it up to sound or movement sensors to capture close-ups of the subject with wide-angle lenses.

Shortly after its launch, DSLR Remote Pro was highly praised by Michael Reichmann on his Website The Luminous Landscape (www.luminous-landscape.com). He called it "a revelation" because it places full-sized images on to the computer screen within seconds of taking them remotely. This means you can play with exposure, color balance, and compositional changes, and then examine the effects without delay. Quite apart from all its other applications, DSLR Remote Pro is clearly a great educational tool.

Versions: DSLR Remote Pro 1.7 (2008)

OS: Windows 98 SE, ME, 2000, XP, and Vista

RAM: 512MB

Supported file formats: Canon RAW and JPEG

Price level: Approx. $95

Address: Breeze Systems Limited, 69 High Street, Bagshot, Surrey GU19 5UH, United Kingdom

www.breezesys.com

Fotoshow Pro

Vendor: Fotoshow Pro

Purpose: Internet image library system for pro photographers and agencies

Description

Fotoshow Pro is an image library system with a scalable architecture that installs on almost any Web server. It enables professional photographers and agencies to place images online where they can be searched and purchased by users. Web-based administration tools allow you to modify the library structure, edit captions, attributes, and keywords, and delete or move the images.

An example of Fotoshow Pro in operation is Photo Resource Hawaii (www.photo resourcehawaii.com), a library of stock photographs from 50 top Hawaiian photographers.

Comments

Fotoshow Pro is an excellent platform for anyone who wants to establish and run an online photo hosting service. It is fully customizable to your own brand, can support an almost unlimited number of images, and has very good account management facilities. The Standard license does not include e-commerce facilities, which are an extra and incur additional fees. However, fees are one-time only and there are no royalties to be paid.

Version: N/A (2008)

OS: Windows; Mac OS X; Linux; UNIX

RAM: 1GB

Supported file formats: Major image formats

Price level: Single-site licenses from $4,000

Address: Fotoshow Pro, 368 Broadway, Suite 403, New York, NY 10013, United States

www.fotoshowpro.com

Image Uploader

Vendor: Aurigma

Purpose: Image-uploading solution for Website developers

Description

Image Uploader is an image uploading solution that Web developers can add to their sites for the convenience of users. Easy to operate at the client end, it allows users to navigate folders on their computer via a standard browser, select the files they want to upload, and send them to the Website with just a few clicks. Image Uploader is embedded into the HTML code of a Website, and its appearance is fully customizable to blend in with the site's design.

Image Uploader generates up to three thumbnails and uploads them along with files themselves. It also provides facilities to rotate the image prior to uploading. Despite its name, it can upload Word documents, PDF documents, and Zip archives as well as images. You can specify file-filtering rules to select only images, screening out any other formats.

Image Uploader is aimed at a broad market, including online photo hosts and print suppliers, photo blog hosts, and various industries such as insurance, estates, health care, and so on that use image databases.

Figure 36.1
Aurigma Image Uploader's Multiple Descriptions mode lets your Web visitors add supplementary information to their files.

Comments

Image Uploader comes from a company that produces many useful programming tools, including Graphics Mill, a toolkit for most imaging tasks. Ease of use, from the user's point of view, has helped to make Image Uploader an industry standard. Before it arrived, batch uploading was a tedious operation, involving one-at-a-time uploading using HTML. It can be configured to resize images as they arrive, thus reducing traffic and increasing upload speed. For photo businesses that run hosting sites, it can be an excellent solution.

Version: Image Uploader 5.1 Dual (2008)

OS: Windows 98, NT, 2000, XP, 2003, and Vista

Server platforms: ASP, ASP.NET, JSP, PHP, Perl, and so on

Client side: ActiveX (IE browser only) and Java

Supported file formats: JPEG, TIFF, GIF, PNG, BMP, and others

Price level: Single domain from $184, single IP from $800

Address: Aurigma Inc., 5847 S. Lawrence, Tacoma, WA 98409, United States

www.aurigma.com

Pixagent ITP Professional

Vendor: Pixagent

Purpose: Workflow-oriented FTP server for wireless image transmission

Description

Pixagent ITP Professional is a workflow-oriented FTP server that enables the professional photographer to get greater benefit from the use of wireless image transmission. It fully supports Nikon WT-1 and WT-2 and Canon WFT-E1 wireless standards, while also supporting DICE America's Wi-Pics.

ITP can generate full-screen displays of images as soon as they are received by the server—ideal for checking composition or for displaying your images to an audience. You can shoot in RAW+JPEG, leaving the RAW files on the memory card while displaying the JPEG image, but it also has a RAW-only workflow, with processing carried out via the use of Photoshop droplets. Its image analysis modes alert you to any potential exposure problems and allow you to deal with them while you are still shooting. Other features include batch renaming, to replace the DSC_ portion of the filename with variables to allow multiple shooters access to the same directory while keeping files separate.

You can configure your camera to access ITP over the Internet, although this is a more complex procedure than doing so over a local network, as it requires manual configuration. You also need to know your home network's IP address, another potential problem as service providers often allocate dynamic IP addresses that can change at any time. If you want to set up the system for frequent transmission, it is far better to acquire a static IP address.

Another product from the same developer is PocketITP, a PDA-based FTP server that shares the same server code as an earlier generation of the desktop version. It lets you administer the server directly from the PDA, mostly with one-handed operation without putting down your camera.

Comments

Created by Canadian developer Thomas Sapiano, Pixagent ITP Professional has features that make it almost indispensable if you use Wi-Fi for workflow acceleration. For example, one new feature on the Pro version allows you to automate repetitive processing tasks while you are continuing to shoot other material. Documentation is good (there is an 80+ page manual) and the product itself is easy to use with an excellent reputation among event photographers.

Version: ITP 2.0 (2008)

OS: Windows 98 or later

RAM: 15MB

Supported file formats: Major RAW formats; JPEG, TIFF, and WAV

Price level: ITP 2.0 Professional approx. $60

Address: tsapiano@pixagent.com

www.pixagent.com

Pocket Phojo

Vendor: Idruna Software

Purpose: Turns a Pocket PC into an image editing and transmission station

Description

If you want to connect to the Internet on location, Pocket Phojo is an application that turns a Pocket PC into an image editing and transmission station. You simply take the CF card out of your DSLR, plug it into the Pocket PC, and send the images back to the office via FTP or email. It allows you to browse, edit, and tag the images before transmission, making it a tool that is especially useful to professional photojournalists.

Pocket Phojo is fully compatible with Nikon's WT Wireless Transmitters, which eliminate altogether the necessity for memory cards, except for backup. The only requirement is for a Pocket PC with at least 64MB of RAM (256MB preferred). It can be connected to cameras with a USB output via cable and has pre-configured connectivity to the Internet.

Comments

Most journalists would use a laptop for sending images back home, but if you are traveling light, Pocket Phojo is an alternative option. It was first reviewed in 2002 by DPReview, where it won warm approval despite being buggy, since when many professional event photographers and paparazzi have tried it with similar results. They have found it easy to learn, with processing facilities that rival those of some desktop programs. Most have found bugs, but they get fixed fairly promptly, making Pocket Phojo a useful tool that may achieve wider appeal as broadband extends to mobile devices.

Version: Pocket Phojo 5.0 (2008)

OS: Windows Mobile 2003, Windows Mobile 5.0 and 6.0

RAM: 256MB (preferred)

Supported file formats: RAW and JPEG

Price level: Approx. $490

Address: Idruna Software Inc., 40960 California Oaks Road #324, Murrieta, CA 92562, United States

www.idruna.com

Summary

In future editions of this book, some of the products listed in this category may be spun out into categories of their own, but for now, "Web, wireless, and remote access" covers miscellaneous solutions that many professionals in the photographic industry may find useful. If you need to control your DSLR remotely, DSLR Remote Pro from Breeze Systems has all the features you need. If you want to make it easy for people to upload their images to your Website, turn to Aurigma's Image Uploader. Check out Clickbooq if you need to present your own images online in a sleek, professional format. Or take a look at Pixagent ITP Professional if you want to explore the full potential of wireless image transmission.

Analysis and Diagnostics Software

The casual photographer and even most professionals do not need to concern themselves with advanced analysis and diagnostics software. Used for checking the optical performance of cameras and lenses, or for analyzing the performance of a computer system, this type of software is strictly for experts, scientists, magazine editors, or people who suffer from obsessive-compulsive pixel-peeping disorder. The tools in this chapter have been included for these specialized users.

Acolens

Vendor: Nurizon Software

Purpose: Lens-analysis with tools for correcting geometric distortion in images

Description

Acolens is a lens analysis/image correction tool, with preset lens profiles and facilities for making your own with the addition of the Acolens Reference Chart. Each profile can be used for making corrections to the various kinds of geometric distortion caused by that individual lens.

The vendor uses mathematical variance analysis to detect how far the lens deviates from ideal performance in respect of geometric distortion, vignetting, and lack of focus towards the edges. Algorithms calculate actual and desired values, and then corrections can be made to the image. Sometimes a photographer may want to keep one type of distortion as part of the composition, so that option is preserved.

Comments

One of the great benefits of digital photography is the relative ease with which geometrical distortion can be corrected by software. To do this, the characteristics of the individual lens must be known, which is why Acolens provides its analysis tools. For interior, architectural, and product photographers, such a toolkit is highly desirable. Acolens is a professional solution that is both optically sound and easy to use. At its launch, it won the "Photokina Star—Highlight of Photokina 2006" award from German photography magazines *digit!* and *Photo Presse*.

Version: Acolens 1.3.0 (2007)

OS: Mac OS X 10.3.9 or later

RAM: 256MB (512MB recommended)

Supported file formats: Major RAW formats; TIFF and JPEG

Price level: Standard edition $335, Full edition $495 (both approx.)

Address: Nurizon GmbH., Stadtdeich 27, 20097 Hamburg, Germany

Nurizon Inc., 169 8th Avenue, Suite 5F, New York, NY 10011, United States

www.nurizon-software.com

DxO Analyzer

Vendor: DxO Labs

Purpose: Professional test package to check the image quality of any image capture device

Description

DxO Analyzer is a unique software tool that uses advanced mathematics to measure key properties and optical faults in all kinds of image capture devices, including DSLRs. Used by journalists, magazines, and camera manufacturers, it produces a mass of data from a relatively simple test target on which is a matrix of small black dots.

Using DxO Analyzer is a two-step process. First, the tester shoots the target under controlled conditions, using a reference DSLR fitted with the particular lens being tested. Several shots are taken at each combination of aperture and focal length. Focus error is eliminated by micro-bracketing between groups of shots.

In the second stage, DxO Analyzer examines the results, looking for tiny variations of position and shape among the dots in the matrix. It measures sharpness with exceptional precision and—here is the key point—how it varies across the frame.

There are two editions of the product. The Camera Edition evaluates overall camera performance, and the Component Edition takes a broader range of measurements using RAW data, so that you can differentiate between various components such as optics, sensor, or image signal processing. It complies with all major ISO and industry standards, such as SMIA, MIPC, and I3A.

Comments

The only downside to all this brilliant analysis is the mountain of data, which is really quite difficult for non-mathematicians to interpret. Fortunately, there is a solution. The people at SLRGear.com turn the data into 3D graphs that give, for example, unique insights into lens performance at various focal lengths and apertures. DxO Analyzer is a tool for professional use in the testing lab, although a number of hobbyists are sufficiently obsessive about performance issues to find it a source of endless entertainment.

Version: DxO Analyzer 3.1 (2008)

OS: Windows XP and later

RAM: 512MB

Supported file formats: RAW, JPEG, and TIFF

Price level: On request

Address: DxO Labs, 3, rue Nationale, 92100 Boulogne, France

www.dxo.com

HotPixelRemover

Vendor: Lightning Cube Software

Purpose: Eliminates problematic "hot pixels" from dark areas of the image

Description

HotPixelRemover uses the "dark frame technique" to detect and remove hot pixels from your images. *Hot pixels* are the unwanted bright dots that show up in dark or shaded areas; the dark frame (or "black frame") technique traditionally uses an exposure taken with the lens cap on, keeping the shutter open for the same length of time. The software subtracts the black image from the actual image so that the hot pixels, which are the same in each exposure, cancel each other out.

With the HotPixelRemover software, you take a series of dark frames to cater for different image capture settings and then load them into the program. Removal of hot pixels then becomes an automatic process.

HotPixelRemover image analysis tools allow you to see how badly your camera is afflicted by hot pixels. There is usually an increase in their number as a camera ages. The software allows you to keep track of your camera's performance in this respect over time. You can save analysis results in XML and HTML formats.

Comments

HotPixelRemover is very effective at taking out hot pixels from images of various sizes. It looks at many parameters, including camera make and model, image size, color or monochrome, ISO value, digital zoom value, exposure time, focal length value, and the

date and time when the image was taken. Ideally, you need to generate a sufficient number of dark frames to match these parameters; the more the better. If you do a lot of night photography, HotPixelRemover can save time spent on "spotting out" hot pixels individually.

Version: HotPixelRemover 1.0 (2007)

OS: Windows 2000, XP, and Vista

RAM: 256MB

Supported file formats: JPEG, BMP, TIFF, and PNG

Price level: Approx. $10

Address: sales@lightningcube.com

www.lightningcube.com

Sandra Professional

Vendor: SiSoftware

Purpose: Analysis and diagnostics for computer systems, including disk drives and storage cards

Description

Sandra, which stands for "System ANalyser, Diagnostic, and Reporting Assistant," is a computer analysis, diagnostics, and benchmarking utility that can test most aspects of computer performance including that of disk drives and storage cards. It comes in six versions—Lite (for workgroups only), Pro Home, Pro Business, Engineer, Enterprise, and a Legacy version for home enthusiasts with older computers.

Sandra is widely used by the world's computer press for testing new hardware and has over 5,000 online reviews to prove it. It is included here because it is a great utility for making sure your computer system or network is functioning properly. What is more, it can test individual peripherals such as disk drives and storage cards. For example, if you need to test whether a storage card is genuine, you can run a performance test with Sandra, and if the performance is lower than that claimed by the manufacturer it is likely to be a fake.

Comments

Computers are central to the digital photographer's workflow. If you want to make sure all your systems are functioning properly, you need a diagnostics program like Sandra. It is an outstanding product that has won dozens of awards. Using it is not necessarily as hard as you might suppose, as you can quickly grasp how to measure basic performance and compare it to other, benchmarked components. In this respect it is not unlike a scientific calculator—square roots are easy, but you need at least some training as a computer scientist to get full benefit from it. Remember to back up your system before attempting to run any stress tests on it.

Figure 37.1
Sandra Professional can show you how your machine/network performs against benchmarks.

Version: Sandra XII SP2 (2008)

OS: Windows 2000, XP, and Vista (all 32- and 64-bit); Linux (32-bit); Mac OS X

Supported file formats: CSV, TAB, XML, and so on

Price level: Personal, single user approx. $50, Commercial, single user approx. $200

Address: SiSoftware, PO Box 17273, London, SW5 0WB, United Kingdom

www.sisoftware.co.uk

Summary

Most photographers turn to analytical tools when they think something may be wrong with their camera, lenses, or computer. Others do it out of academic interest, or else in order to review a product for a magazine. Whatever the motive, there are plenty of tools available for testing and benchmarking the various components used in digital photography. Acolens from Nurizon Software lets you analyze your lenses, and then correct any geometric distortion. DxO Analyzer is widely favored by magazine editors and other professionals, but a few enthusiasts also use it. If you are responsible for several computers in a busy studio, Sandra Professional will help you analyze every aspect of their performance.

Part VII

Taming the Workflow

This part contains one important chapter that features two products no digital photographer should live without—Adobe Lightroom and Apple's Aperture.

38

Two Featured Products

Women are generally considered to be much better at multitasking than men, so it was probably a man who invented the term "workflow" to describe a succession of activities that has to be performed in order to complete a given job. In digital photography there are several essential tasks and quite a few more optional ones that need to be completed in a particular order, otherwise the photographer simply cannot complete high-quality work consistently on time.

For all its abilities as an image editor, Photoshop has never been a workflow tool, even though recent versions have improved this aspect of it. The two general functions most required by photographers—fast handling of multiple images and meticulous attention to single images—are diametrically opposed. For this reason, developers have turned their attention to improving workflow by designing new products from scratch, incorporating original features to sort, stack, compare, and select images, with completely non-destructive processing facilities constantly available for adjusting color, tone, and other aspects of image quality.

The result has been Adobe Lightroom and Apple's Aperture. Do they live up to the hype surrounding their introduction, now that thousands of users have had a chance to use them in their work?

Featured Product: Adobe Lightroom

Vendor: Adobe Systems

Purpose: Workflow tool for sorting, processing, editing, and printing digital images

Figure 38.1
Adobe Lightroom packs the entire photographic workflow into just a few screenfuls.

Description

Since its launch in 2007, Adobe Lightroom has become the workflow tool of choice for many professional photographers. It was developed with an unusual amount of input from its target market, a factor that undoubtedly helped make it a practical and intuitive environment in which to work. Its user interface has set new standards in both aesthetics and ease-of-use, despite introducing unfamiliar techniques such as directly grabbing the histogram and stretching/compressing its values.

Although Lightroom initially lacked a suite of retouching tools, it was always destined to become a comprehensive solution for digital photographic processing, editing, organizing, and printing. It began life with all the code from Adobe Camera RAW incorporated into its Develop module, plus a full set of tools for tone and color adjustment, lens correction, cropping, and camera calibration. To this it adds a proper relational database that provides an excellent organizational structure with easy import and export of files to other spaces and applications.

Lightroom's initial lack of retouching and image-editing tools was overcome by the simple expedient of Ctrl/Command+E, which places all the current settings for a particular photograph into a TIFF file, which then opens automatically in Photoshop for further editing. This is still the correct way to do it, although now, with the latest version of Lightroom (2.0 beta is being used for this review), there is a magic retouch brush icon, which, on being clicked, opens a sub-panel with mask, paint, and brush tools. These are a wonderful addition to Lightroom. For example, being able to paint areas of the image with plus or minus exposure is a feature that many photographers will quickly find indispensable.

Spot, cropping, and red-eye removal controls have been placed prominently alongside the brush icon for instant access, and these also open up sub-panels with their respective tools. It is worth noting that among the tools in the cropping sub-panel are the all-important Straighten slider and detachable Straighten tool. It is very easy to forget where these have been hidden if you are in the habit of straightening horizons without cropping the image.

It is a fair question to ask—does the average amateur photographer or even a professional who takes just a few images per day really need Adobe Lightroom, given its remarkable ability to handle thousands of images, cycle through them at speed, and apply adjustments to whole groups of similar photographs with a single "synchronize" command? Probably not, but then, most people possess at least a few tools—whether in the kitchen, the study, or the workshop—that rarely get used to their full extent. If you take a hundred pictures on holiday once a year, you may still find Lightroom irresistible when you see how ingeniously it slides its control panels in and out of view to cater for wide or standard screen sizes, how these in turn are stretchable to increase resolution on the slider controls, and how the program "dims the lights" on everything except the displayed image so you can examine your work more closely.

For the wedding or events photographer who often shoots 2,000 images that need to be whittled down to 50, Lightroom is the obvious solution. It divides the workflow into logical groupings: Library, Develop, Slide Show, Print, and Web.

Library

The program starts and finishes in the Library, where you have access to all your photographs, even those stored outside the managed confines of the Library itself. The Import button takes you immediately to the last-opened folder in your hard disk, a good example of Lightroom's direct approach to most tasks. When you bring in your images you can choose whether you want to use previews embedded in them or let Lightroom make its own. This use of 1:1 previews is one of the key concepts underpinning many of the high-speed operations in the program. To conserve resources you do not need to keep them forever. In the Preferences menu you have the option of determining how long the program keeps them in the preview cache (one day/week/month or always). The default setting is 30 days.

Lightroom allows you to use the same controls whether you work with TIFF, JPEG, DNG, flat PSD files, or RAW files. It never touches the originals, but instead stores all the changes to the image as a set of instructions in its database.

Non-Destructive Editing

Whereas traditional photo editors can mix destructive and non-destructive operations, Lightroom has an entirely non-destructive editing process. Instead of changing the image data, it stores instructions for changing the data, applying them on-the-fly to full-scale preview images so that you can see the effect of any changes you make. In a RAW workflow, which is recommended by the developer, these changes are written into XMP sidecar files. It is only when you export an image that Lightroom needs to create a fully rendered version that takes account of your changes. To create JPEGs for your friends, you select the pictures you need and click Export to bring up a dialog box for choosing file format, destination folder, color space, and resolution.

The user interface makes it easy to apply metadata (Exif or IPTC), which in turn makes it very easy to find images that share specific characteristics. The organizational structure also contributes to this by allowing you to group images by shoot or by collection. An image can appear in only one shoot but in many different collections. There are some gadgets that first-time users might find confusing, such as Filters, which allows you to sift through your collections by setting keywords or invoking presets. If your images disappear from view mysteriously, it is probably because you left Filters on by mistake. It cannot be over-emphasized that Lightroom is a completely non-destructive environment, so you need have no fear that any image will be permanently lost or damaged in any way by processing, whatever you do to it.

Quite apart from its sophisticated navigation and cataloging features, the Library has a Quick Develop section where you can make quick initial adjustments to white balance, exposure, contrast, color, and aspect ratio. A (non-interactive) histogram at the top indicates the spread of tonal and color values, together with four vital pieces of information: ISO, focal length, shutter speed, and aperture. If you want to carry on working on the image you can press Continue in Develop, where you have an entire panel of tools, and where the histogram becomes larger, and, for the first time, interactive.

The Export button, to which you are likely to return after developing the image, leads you to a panel large enough to resemble a tax return. It offers location (with a Show in Explorer option for Windows versions); asks you whether you would like to place the image in a sub-folder or add it to the Lightroom Catalog; gives seven file-naming

options with a chance to alter the filename template; requires file settings such as Format (JPEG, PSD, TIFF, and DNG), Compression (None, LZW, and Zip), Color Space (sRGB, AdobeRGB 1998, and ProPhotoRGB), and Bit Depth (8- or 16-bit). But there is more—don't forget Image Settings, with resolution in pixels per inch or centimeter; or Output Sharpening (surely this was done earlier?). But you're not finished yet: you really need to fill in the Metadata fields, perhaps include some keyword information in XMP, and maybe add a copyright watermark. There is also a Post-Processing option that thankfully defaults to Do Nothing, other options being to open the image in Photoshop or another application, burn the image to a disk, or pay a visit to the Export Actions folder for further, automated instructions.

Develop Mode

When you move to a different module, both the left and right panels change with new sets of tools and indicators. In the Develop module, the informational left panel has a scrollable History that records every action you apply to an image. If you click on any History item it returns the displayed image to that particular state. The History list is like an unlimited, random-access undo, which exists alongside a number of presets that let you see what the image looks like with standard tone-curves applied. Lightroom can display instantly any one of hundreds of versions of an image because it stores just the instructions for generating the image on-the-fly from its cached preview.

One of the most useful features of the Develop interface is the Before & After display that shows side-by-side and split views of two versions of the image in the central viewing area. Note that you can copy the settings of the After view to the Before view, thus giving you a new starting point with which to compare your working image. Lightroom offers special buttons beneath the displayed images to do this, in both directions. If you find yourself with two wrong versions you can always use the History list to go back a few steps.

The Develop module's right panel is divided into sections: Basic, Tone Curve, Color Adjustments, Split Toning, Detail (noise reduction, chromatic aberration, and sharpening), Vignettes (lens corrections, post-cropping), and Camera Calibration. Many photographers say they can do 95% of their correction work in the Basic section at the top without resorting to the tools lower down.

In the Basic panel are white balance with eyedropper selector tool, color temperature presets and sliders, as well as everything you need to set white points and black points, recover highlights, simulate an increase in the fill light, and adjust brightness and contrast. Two other sliders allow you to adjust saturation and "vibrance," the latter being a control that boosts primaries without affecting skin tones. If this vibrance adjuster seems familiar to some photographers it is because it came to Adobe via the acquisition of Pixmantec, the developer of Rawshooter, and now appears also in Photoshop's Camera Raw plug-in as well as Photoshop's Image>Adjustment menu in CS4.

Adobe introduced another slider control in Lightroom 1.1, called *clarity*. This popular tool, also included in CS4's Camera Raw, can be used to make objects stand out from their backgrounds. Moving the slider increases contrast on either side of any edges in the image. It is much more subtle in its effect than you can get by tweaking the image's overall contrast.

The interactive histogram allows you to address four subdivisions of the tonal range independently, with control over highlights, lights, darks, and shadows. You will soon notice that the slider controls refer to them, respectively, as "recovery," "exposure," "fill," and "blacks." Recovery lets you restore clipped highlights with little visible darkening of other parts of the image. If you are happy with your general exposure—the "lights" which account for most of the tones in the picture—you can adjust the "darks" at the lower end of the scale. If the image lacks deep blacks, you can move the black point with the blacks slider.

The Curves sub-panel comes not only with adjustable points but with four slider controls as well, to reshape lights and darks while recovering highlights and increasing blacks. Split Toning allows you to change hue and saturation in highlights and shadows.

Slide Show Module

The Slide Show module now includes several sorely needed improvements. Although it's still not likely to challenge professional slide show software such as ProShow Producer (see Chapter 27, "Slide Show Creation"), Lightroom now offers a more complete set of controls for creating effects such as cast shadows, text overlays, color washes, background images, and 0-20 second timings for both slide changes and fades. The Cast Shadow controls are particularly well conceived, with Opacity, Offset, Radius, and Angle sliders, the last of which also comes with a dial for setting the drop shadow to one/two clock positions. Selecting a soundtrack, however, is still limited to "choose a music folder."

Print Module

More extensive is the Print module, with facilities to format the images into different grids for contact printing or to output whole images to an attached printer. The Print Job sub-panel offers a choice of draft mode or selectable resolution printing. Draft mode in conjunction with the operating system's PDF driver uses data from the preview cache to print perfect contacts that are indistinguishable from those generated with rerendered data. This is a speedy way to print contacts.

Web Module

Finally, the Web module lets you put together pages of photographs for publication on the Web in Flash or HTML format. It offers layout presets together with tools to create your own custom layouts.

Comments

Adobe Lightroom is a classic workflow tool for many, but not all photographers. It is superb for browsing, examining, comparing, and organizing your images as well as for carrying out global processing tasks, in batches or individually. If you have hundreds of photographs from each shoot and need to submit several dozen to your client, it could be the tool for you. If you need to work on one or two selected images in detail or prepare professional-level slide shows and Web pages, you will need many other tools as well. Continued development of Lightroom has added facilities for multi-computer workflows, making it suitable for use by large studios. Lightroom now has folder synchronization, improved sharpening, better noise reduction, and multiple monitor support—all further indications that Adobe aims to make this product the tool of choice for serious photographers.

Version: Adobe Lightroom 2.0 (2008)

OS: Windows XP with SP2 and Vista; Mac OS X 10.4 and 10.5

RAM: 1GB recommended

Supported file formats: More than 140 RAW formats; JPEG, TIFF, and DNG

Price level: Approx. $300

Address: Adobe Systems Incorporated, 345 Park Avenue, San Jose, CA 95110-2704, United States

www.adobe.com

Featured Product: Aperture

Vendor: Apple, Inc.

Purpose: Sorts, compares, selects, processes, edits, prints, and publishes digital images on a Mac

Description

Apple's Aperture is an all-in-one digital image-management system aimed at professional, enthusiast, and aspiring photographers who are attracted by its hundreds of post-production features. Although it runs only on Macintosh, it does much the same as Adobe Lightroom and carries out major functions in a broadly similar way. For example, it offers non-destructive editing; preserves an untouched master file; requires no manual saving of adjustments; and lets you store the images anywhere you choose.

Yet in its organizing ability, Aperture goes even further than Lightroom, making it ideal for event and sports photographers who take thousands of shots on every project. It has an incomparable set of features for examining, comparing, rating, ranking, and selecting images. Among all these features, each user is likely to find one or two favorite techniques. It is hard to believe that anyone could use them all, but they form a compelling reason for buying this software if you are a Mac user.

Figure 38.2
Apple's Aperture is now a mature, full-featured product in Version 2.0.

Figure 38.3
Aperture on iMac is an ideal combination for rapid-fire photo browsing.

Aperture's Architecture and Concepts

Here is a brief overview of some of the concepts and their implementation in Aperture.

Masters

Master files are equivalent to negatives in the sense that they remain stored away, untouched, until needed. If they are "fully managed," they dwell in a Library, the whole of which can be backed up in a vault on an external device. If they are "referenced," they dwell elsewhere, possibly on another computer, on a network, or even on-the-shelf in DVD format. Masters are very likely to be RAW files, but they can also be GIF, JPEG, TIFF, DNG, or PNG files.

When you edit an image, you do not edit the master, but a version of it—and you can create as many versions as you like. If you delete a master, you also remove all the versions of it from the Library, including adjustments and metadata. There is no "undo" facility with this delete, but if you have backed up the Library of managed images in a vault, a copy of the master will still exist in a folder marked Deleted Images. Aperture lets you work with hundreds of thousands of master files.

Projects, Albums, and Folders

Aperture's three "containers," or ways of grouping images, are called Projects, Albums, and Folders. The first of these, Projects, contains the master files. They are like sleeves that hold negatives, only much bigger as they can hold tens of thousands of master files. A master can dwell in only one Project at a time but can appear as a referenced image in many different Albums: collections of photos, very much like physical albums.

The third container, Folders, is the most tricky from a conceptual point of view. You can put just about everything in a Folder, including Projects, Albums, and other elements like Aperture-generated books and Web pages. You can drag a Folder around the file structure and drop items into it. Folders are powerful organizational tools, but, when using them, watch out for the way they swallow the other containers.

Previews

A preview is a JPEG image created by Aperture to represent the original master, together with any adjustments applied to it. Aperture may sometimes display the preview as a thumbnail in the browser window, but when necessary can make it much larger. You have full control over the quality of previews and can even dispense with them altogether, although that is not recommended. Apple originally intended to generate them on-the-fly but decided to store them instead, partly so that other programs—such as iLife and iWork—could access them, and partly so that referenced images would be properly represented even when offline. Moving from displaying the preview to showing the Master image is usually swift, depending on the size of the latter. A new Quick Preview mode loads only the previews in order to accelerate browsing speed.

Importing Images

The starting point in the workflow begins with importing images from either a media card or a disk drive. Having upgraded Aperture's RAW conversion engine, Apple recommends, but does not demand, a RAW workflow. Selecting File> Import> Images brings up the complete Import window where you can select the source and the destination project. The window displays all the thumbnails from the selected card or folder. At this point, very usefully, you can choose which images or groups of images you want to bring into the Library. Alternatively, you can leave the images in their existing location if they are already on disk. Import takes place in the background, but you can begin work on the image even before the process has finished.

Organizing with Stacks

Aperture is particularly useful if you need to sort through dozens of similar shots, such as those taken in burst mode. It has several tools for doing this, of which Stacks is one. You can use it manually, taking images from anywhere in the Library and ranking them alongside a "pick" image, beneath which the stack can be made to collapse. However, its most effective mode is Auto-Stack, which allows you to specify a time interval between shutter clicks. Moving the slider control from the off-position through fractional increments up to one second, dramatically reduces the number of thumbnails displayed. Stacks is also indispensable for people who bracket their exposures. It reduces screen clutter significantly, but the hidden photos can be accessed instantly by clicking on the pick image.

Compare Mode

Following how photographers actually work, Aperture's developers provide an essential Compare mode to help you decide between pairs of images without stacking them. To use it, select an image and press Return. This places your chosen picture on the left side of the viewer, with a green border to distinguish it as the source image. Beside it, Aperture places the next image in your project, which is often from the same burst if you shoot in burst mode. To compare the two, use the Loupe or Zoom features, select one of the images, reject the other, and navigate to a third to continue making comparisons. When you finally have the one you want, give it the top star rating and it will appear at the top of the stack in Stack mode.

The Light Table Tool

A free-form method of examining, grouping, and comparing images, Light Table has features no physical light table ever had. It is expandable (just nudge the edge with an image to make it bigger), can extend way beyond the viewing window, is scrollable in both directions, and the images are all resizable to give you ideas about future layouts. You can create a new Light Table at any time, save it in the Projects panel, and populate it by dragging images from the browser. Sorting tools allow you to expand groups of

overlapping images so that you can see each one whole. You can even select a portion of the Light Table and print it.

The Loupe Tool

In the Kodachrome era, just wearing a personal loupe in readiness for examining slides on a light table was enough to make novice photographers feel like David Bailey, which may be why Apple made such a feature of its virtual counterpart in Aperture. However, its first implementation was criticized because the magnified area displayed only a very unloupe-like circular offset. Further development made it more versatile, with a new, centered option that seems more intuitive than the original offset. Magnification from 50 to 1600 percent is selectable both from the Loupe pop-up menu and the mouse's scroll wheel. You can even separate the Loupe from the cursor, park it to one side, and examine in magnified detail the effect of adjustments as you make them. The tilde key toggles the Loupe on and off.

Exploring the Interface

Apple's reputation has been built on superb user interfaces in all the company's products, from the very first Mac to the iPhone. It was a cause of concern, therefore, that most people preferred the uncluttered interface of Adobe Lightroom to that of the early versions of Aperture. This changed with Aperture 2.0. This version makes much better use of available screen space, leaving more room to display the images. You can switch between three different modes: previews only (Browser); photo displayed in detail (Viewer); or both together (Browser and Viewer), with the previews running in a horizontal filmstrip version of the browser. A double-click on one of the previews brings up the large version; double-click again to return to the dual mode. One of the most useful shortcuts is V, which is used to cycle between the three browsing modes.

On the left of the screen, the three tabs of the Inspector/HUD allow you to switch between Projects, Metadata, and Adjustments panels. Apple grandly calls this "one-key Inspector pane switching"—and you can simply press W to cycle through them, or Shift-I to change the position of the Inspector to the other side of the Aperture window. There is also an option to float the entire panel while you work in full-screen mode with a massive image, plus access to the toolbar at the top and the filmstrip-style browser at the bottom, both of which hide. You can also resize all three of the interface windows.

The Projects Panel

The Projects panel gives access to the entire Library where the latest version offers an All Projects view. Each project in the Library is represented by a single Key Photo thumbnail. When you skim the pointer across this poster image, it cycles through all the images in that project. Double-click on an image to open it in the main interface, or Control-click it to make it the Key Photo in the All Projects view. You can also browse your iPhoto images inside Aperture, importing single pictures or whole events.

The Metadata Panel

Aperture automatically reads the Exif metadata when you import images to the Library. In the Metadata Inspector you can add more details, such as captions and keywords, using the tools provided. For editing, you can select from around 18 metadata views, including Name Only, Caption Only, IPTC Basic, IPTC Expanded, and so on. This helps considerably to cut down the clutter of information, giving you just the details you need.

It is easy to save metadata presets and to replace existing metadata with a new set, on single images or in batches. You can also lift and stamp metadata from one image to another, without affecting any image adjustments. As well as standard IPTC and Exif tags, the AppleScript Dictionary supports access to other types if you need more flexibility. With all these facilities there is little excuse for not including at least a photographer credit and a copyright notice when distributing your images electronically.

Any image can be rated from 1 to 5 stars or marked as a reject. However, you do not have to go to the Metadata panel to do this. Just select the image and press a number key (1–5). The rating is then stored as metadata. To filter the images, you can use the Ratings Search pull-down menu to select the desired star rating.

Keyword filtering is more powerful than the ratings tool, if not as cute visually. If you activate Keyword Controls (from Window in the menu bar), a control bar appears beneath the browser, from which you can add new keywords. You can also use preset buttons to stamp images with a set of keywords, as well as easily create a new preset button using drag-and-drop selection from a list of words. Yes, it is still the most tedious task in the whole of photography, even using Aperture's sleek Query HUD version of it, but without keywords it is very difficult to search large collections of images.

Once keywords are in place, you have plenty of search options to help you find images that meet the criteria you choose. You can refine search criteria with filtering options such as "include any of the following," "...all of the following," "...only the following," and so on. You do not need to be a Google PhD to figure out how to use it, but a logical mind is helpful. Specialist libraries will almost certainly need more powerful indexing and search facilities, but many working photographers will find it adequate.

The Adjustments Panel

The Aperture Adjustments menu starts with RAW Fine Tuning, and then goes on to provide a full set of image-adjustment tools. Their function might be called "image processing" in other software, or "Develop" in Lightroom, but together they constitute the software's main workshop.

RAW Fine Tuning

With the RAW 2.0 Converter, RAW decoding now gives better noise handling, highlight recovery, and color rendering, plus some innovative RAW Fine Tuning controls.

Clicking on these opens a new menu (or "brick," as Apple calls them) with three pairs of slider controls. Boost and Hue Boost allow you to increase color contrast, the latter doing so without greatly affecting certain colors such as skin tones. Sharpening and Edges let you control how much sharpening is applied initially during RAW conversion. The Moiré and Radius pair correct moiré effects and color fringing in patterned objects.

It is a good idea to run a few tests with different settings from all these controls, but do not overdo it. The output from RAW 2.0 is deliberately flatter and more neutral than those created by the earlier version, but it preserves more information. If you have more than one digital camera, you can (and should) create a different preset for each one.

White Balance

White balance adjustment comes with an eyedropper tool that automatically launches the Loupe tool to give a magnified view of a small area of the image. By running the eyedropper over a range of neutral or near-neutral grays, you can select the shade that gives the best result. Color temperature and tint can also be adjusted by slider controls.

Adjusting Exposure

For exposure adjustment there are four sliders. The main exposure control shifts the image data toward the brighter or darker ends of the histogram. A recovery slider rescues blown highlights to bring back lost detail. A third slider shifts the black point to deepen the black tones while preserving light ones, and the brightness slider is used for making midtones brighter or darker. Most image-processing software has similar controls, often with different names.

Highlight Recovery

There is more to highlight recovery than meets the eye. If you have shot in RAW it is very likely that you can rescue blown highlights, bringing back detail that was seemingly lost. This feature is well implemented in Aperture, with precise control provided by View> Highlight Hot & Cold Areas, which overlays red on the overexposed pixels and blue on the lost shadows. To rescue the highlights, you move the Recovery slider to the right; to rescue the shadows, you move the Black Point slider to the left.

The Enhance Menu

Contrast and local contrast (Definition) tools are the first two controls in the Enhance menu. Next are Saturation for overall increase of color saturation, and below it a Vibrancy adjuster increases color without disturbing skin tones too greatly. Three color tint wheels let you add tints to shadows, midtones, or highlights, although this fine-tuning adjustment can require a keen eye for subtle changes of color.

The Levels Menu

A second, tonal histogram appears in the Levels menu, on which you can move black point, mid-point, and white point, to change the distribution of tones within the image. With these controls you can easily correct landscapes that lack contrast or "punch."

Advanced Levels

For more subtle tonal adjustment, Aperture offers quarter-tone control points. Like the midtone control of the Levels menu, these have lower and upper sliders. The right way to use them is to select the range of tones you want to treat separately with the upper slider, and then use the lower slider to brighten or darken those tones. The technique is not quite as familiar to photographers as setting the S-curve in Photoshop, but it does the same job.

The Color Adjustment

Because they can have an impact on color, tonal controls need to be used before addressing any color issues. To make changes to hues, you need to go to the last item in the Adjustments Inspector, the Color adjustment. As well as conventional Hue, Saturation, and Luminance sliders, Aperture 2.0 lets you choose custom hues by selecting them directly from the image. By this means you can change skin tones with great subtlety if you choose a narrow range of affected hues using the Range slider.

Aperture's Key Features

There are several features in Aperture that are worth highlighting on account of their excellent ergonomics or genuine usefulness to photographers.

The Quick Preview

In this special mode, accessed by pressing P, Aperture loads only the preview, not the master image. This makes it much faster to browse, search, compare, rate, or select images, speed being one of the vexed issues in early versions of Aperture. You can always tell when you are in preview mode because the preview images (which are always superior to mere thumbnails) are outlined by yellow rectangles. If you need to work on an image, press P again to change to full resolution. After making the adjustment, pressing P once more takes you back to Quick Preview mode. Aperture will use whatever preview is available, even when you have not made any, defaulting to camera-generated previews for newly imported images so you can get up-and-running immediately after shooting.

The Lift and Stamp Tools

Apple has refined Aperture's Lift and Stamp tools to make them really useful for speeding the photographic workflow. They allow you to lift metadata and adjustments from one image and apply them to another. To reach them, you go to the toolbar to launch

the Lift & Stamp HUD. From there, you can select the specific metadata and adjustments you want to apply from the displayed image to other images in the Library. This can speed up the process, for example, by quickly transferring a white balance adjustment to other images that have been shot under similar lighting conditions.

Retouching Your Images

This tool goes beyond "spot and patch" repairs to provide intelligent retouching with a soft-edged brush. In repair mode, it automatically maps the texture of the surrounding area, giving a perfectly clean result. The brush also has a "detect edge" mode, which allows you to remove blemishes near hard edges such as walls or pillars, without needing to cut and paste chunks of the image. Yet by changing opacity and softness, you have a set of controls to use in the full cloning mode for retouching larger areas.

Baseline DNG

Aperture can read DNG files no matter what model of camera created the original RAW file. Even where the program does not support a particular RAW format, it will at least read a DNG file derived from it.

Command Editor

Expert users love the Command Editor. It allows them to create their own shortcuts, mapping controls to any key. Many of them like to be able to use their left hand to execute commands, while leaving the right hand free to remain on the mouse. Apple has implemented this standard feature very well in Aperture by providing a picture of a keyboard in the Command Editor window. It indicates which keys are available and highlights those that have been used. There is a full set of defaults to which you can make additions or changes as you see fit.

Tethered Shooting

For the studio photographer, tethered shooting support has been a welcome addition to Aperture because it gives immediate full-screen feedback during shooting. To use it, you simply connect a supported camera to the Mac via FireWire or USB, and then launch the Tether HUD to control it. Here you will see some essential information about camera and exposure settings. Before each Tether session, you choose where you want to store the images, the name of the session, and the set of metadata you want to attach to each image.

Output and Publishing

The photographic workflow usually culminates in showing your images, a step that involves printing them or sharing them online. Aperture offers a full set of output options including books, slide shows, DVDs, and help with placing your images into online galleries.

Color Management

Aperture uses Mac OS ColorSync technology to ensure color consistency between imaging devices, such as scanners, digital cameras, displays, and printers. To benefit from it, you need to calibrate your monitor regularly, but if you do so, you will get good color balance in everything from contact sheets to full-sized prints. As long as you have an ICC profile for the output device, Aperture can simulate on your screen how the output will look when it is printed, a technique called *soft proofing*.

Contact Sheets

Another of Aperture's strengths, contact sheet creation is versatile and highly automated. Unless you direct otherwise, the program prints only "pick" images at the top of the stacks, fitting them into a preset format. Among the formats is a "best fit" option, which makes full use of available space. You can then go ahead and print the contact sheet, with selected metadata if required, or save the contact sheet as a PDF file.

Custom Books

Another well-conceived print option is Custom Books, which provides attractive templates for creating and printing books containing both images and text. When you have put one of these together you can have it printed via Apple's print service over the Internet. This output option is no afterthought: the tools are surprisingly versatile and the customizing features make it even more flexible. Perhaps its most striking feature is the ability it gives you to zoom and drag individual images once they have been placed in the layout. It is an operation that makes the simulated book on the screen look even more attractive than the printed version. Clearly it is time for someone to design an animated "soft album" in which choreographed pictures can move, zoom, and, on occasion, burst into song.

Slide Shows

Aperture's slide shows do not quite go as far as the proposed "soft album," but you can put them together with timings and background music. Apple calls these shows "pro-quality," but like those in Lightroom they stop well short of the slide show mastery reached in the heyday of audio visual presentations using real slides on banks of computer-controlled Kodak Carousel projectors.

Saving to DVD

Even if you have backed up your Library to a vault, you may still want to burn a DVD of your most valuable images. One quick way of doing this in Aperture is to use the Smart Folders feature. It allows you to populate a top-level folder according to chosen criteria, such as star ratings, date, keywords, and IPTC metadata. Top-level folders span different projects, allowing you to take all your best images and store them safely on DVD.

It is a good idea to use Automator to add the word "DVD" when you burn the images to disk. This enables you next time to use "DVD" as a filter keyword, to prevent backing up the same images unnecessarily. If you are not sure about programming Automator to do this, look on the Internet at Automator.us/aperture. You'll find this and many other ways of automating import/export of images to and from Aperture.

Aperture Plug-Ins

Before the introduction of Aperture 1.5, Apple announced an export API (Application Programmer Interface) that enabled third-party developers to provide alternative export options as plug-ins. These made it easier for the users to upload images to virtual storefronts and photo-sharing sites, ensuring compliance with requirements for size, format, and metadata. Now, with Aperture 2.0, the program has a full plug-in API that means that it will work like Photoshop, with third-party plug-ins for making adjustments and other extensions to its functionality. A full list of plug-ins can be found at Micah Walter's Website called Aperture Plugged In (www.aperturepluggedin.com).

ApertureToGallery

Gallery is an open source, Web-based photo album organizer created by Bharat Mediratta. It allows you to blend photo management seamlessly into your Website, regardless of whether you are running a large site for a community or a small one for yourself. ApertureToGallery is the interface to Gallery from Aperture.

At this site you can also find Aperture to Picasa Web Albums, ApertureToFileMaker, and two general tools—ApertureToArchive for archiving and ÜberUpload for Aperture for uploading photos to remote servers.

See www.ubermind.com for more information.

ApertureToPBase

ApertureToPBase is an Aperture export plug-in that uploads photos to PBase, developed by David Holmes (www.davidholmes.org). His other uploaders are ApertureToPhanfare, ApertureToSmugMug, and ApertureToZenfolio.

FlickrExport

Aperture users can connect directly to Flickr, one of the most popular photo-sharing sites, thanks to the efforts of Fraser Speirs at Connected Flow, who also created the FlickrExport plug-in for iPhoto. Also available from the same source: Aperture to Final Cut Pro. See www.connectedflow.com.

PhotoReflect.com

Used by thousands of wedding and portrait photographers as a virtual storefront, PhotoReflect.com offers an Aperture plug-in that provides a direct link to the site. Even

by the year 2005, when Aperture first launched, PhotoReflect.com showcased 100 million photos. It has grown substantially since then, helped in part by the ease with which users can now connect to the site without leaving Aperture. See www.photoreflect.com.

Soundslides

Export your selected images straight to a Soundslides project. Soundslides audiovisual authoring software is favored by photojournalists when they put their work on the Internet. See www.soundslides.com.

Other plug-ins include connections to the following photo sites—Getty Images (www.gettyimages.com), iStockphoto (www.istockphoto.com), Photoshelter (www.photoshelter.com), and Pictage (www.pictage.com).

Comments

For sorting out pictures after a shoot, for general image handling, cataloging, and backup, for consistent color management, dual monitor support, creative contact printing, and easy Web gallery loading, Aperture is hard to beat. It raises the question—if you do not own an Apple Macintosh, is Aperture so good that you have to buy one? Were it not for Adobe Lightroom and Photoshop, the answer for any photographer would certainly be "yes!" But the competition is formidable, so there is no clear-cut answer. The best advice for non-Mac users is to see it in action and decide whether its unique facilities, and those of the Mac environment, are worth the switch.

Version: Aperture 2.0.1 (2008)

OS: Mac OS X 10.4.11 or later

RAM: 1GB, Mac Pro 2GB

Supported file formats: Major RAW formats; JPEG, TIFF, GIF, PNG, and DNG

Price level: Approx. $200

Address: Apple Inc., 1 Infinite Loop, Cupertino, CA 95014, United States

www.apple.com

Summary

The featured products presented in this chapter were discussed in greater depth because they shed light on many different aspects of the photographic workflow. Both of them have been created with substantial input from the photographic profession. Both possess exceptionally well designed user interfaces, showing plenty of evidence that the developers have thought long and hard about every feature and its implementation.

In a real sense, Lightroom and Aperture have been made possible by the development of the dozens of other software packages and plug-ins listed elsewhere in this book. All developers are striving for the best solutions to problems that photographers are likely

to encounter; Adobe and Apple have met the challenge successfully. But this is not to say that these two products have all the answers. Far from it. You can equip yourself with software that is even more powerful by acquiring best-of-breed solutions in each of the different categories, from downloading to printing.

Where Lightroom and Aperture have scored heavily is in convenience, in what might be called the input/output ratio. This is the amount of time you need to invest in learning your way around the product compared to the rewards you get from using it. Like all multifaceted software they set a learning curve, but it is one that is well worth climbing.

The aim of this book has been to indicate, wherever possible, what other software deserves the reader's attention and whether or not it may be worthwhile learning how to use it. Time is in short supply for a busy photographer who needs to travel, take pictures, do the processing, bill clients, and have enough time left over to catch up with what else is going on in the world. Software developers would do well to bear this in mind. In Lightroom and Aperture, they have clearly taken it to heart.

Index